GAUGUIN'S NIRVANA

PAINTERS AT LE POULDU 1889–90

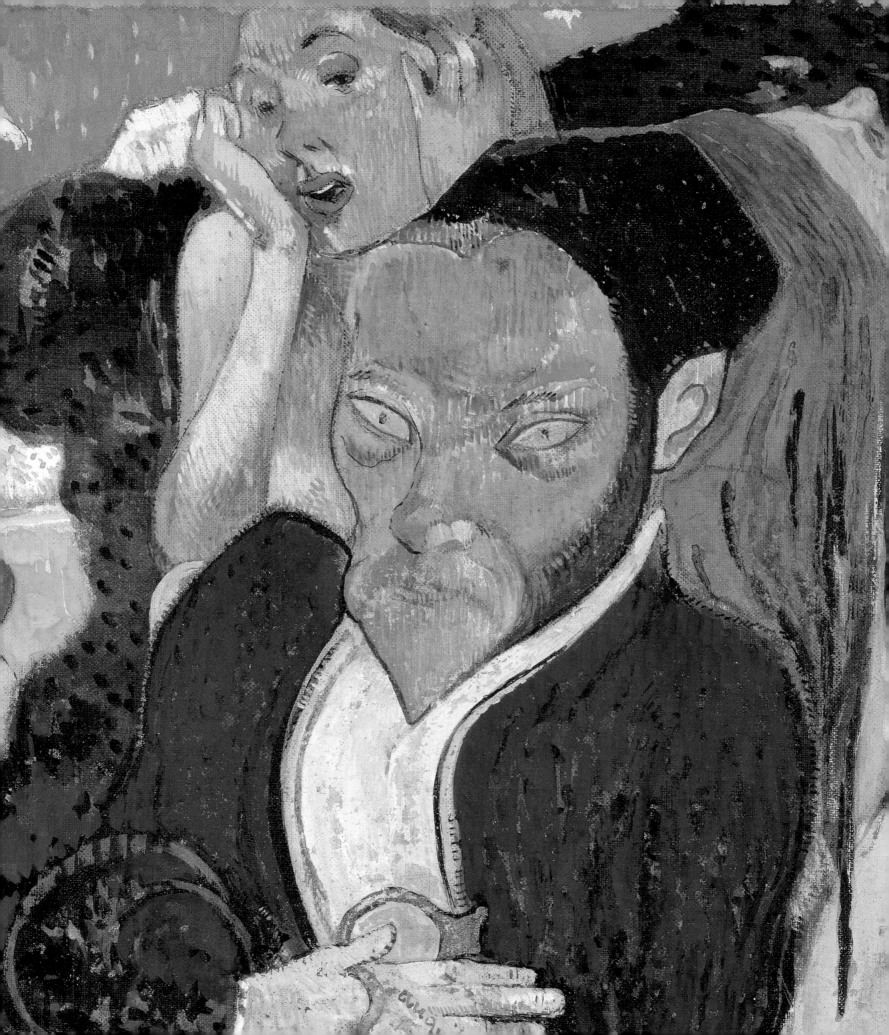

GAUGUIN'S NIRVANA

PAINTERS AT LE POULDU 1889–90

edited by ERIC M. ZAFRAN

with essays by STEPHEN KORNHAUSER

VICTOR MERLHÈS

CHARLES STUCKEY

ROBERT WELSH

BOGOMILA WELSH-OVCHAROV

ERIC M. ZAFRAN

WADSWORTH ATHENEUM MUSEUM OF ART, HARTFORD
in association with
YALE UNIVERSITY PRESS
NEW HAVEN AND LONDON

This exhibition was organized by The Wadsworth Atheneum Museum of Art, Hartford. The exhibition is sponsored by Aetna January 27–April 29, 2001

Designed by Sally Salvesen
Index by Indexing Partners
Typeset in Monotype Garamond
Printed in Singapore

LIBRARY OF CONGRESS CATALOGUING-IN-PUBLICATION DATA
Gauguin's Nirvana : painters at Le Pouldu 1889–90/edited by Eric M. Zafran.
 p. cm.
"Exhibition organized by the Wadsworth Atheneum Museum of Art, Hartford, Connecticut January 27–April 29 2001"
Includes bibliographical references.
 ISBN 0-300-08954-6
 1. Gauguin, Paul, 1848–1903–Themes, motives. 2. Nirvana–Psychology. 3. Painting, Modern–19th century–France–Pouldu. 4. Gauguin, Paul, 1848–1903–Friends and associates. 5. Artist colonies--France–Pouldu. I. Zafran, Eric M. II. Wadsworth Atheneum.
ND553.G27 G379 2001
759.4–dc21 00–011937

Cover illustrations: Paul Gauguin, *Nirvana: Portrait of Meyer de Haan*, Wadsworth Atheneum Museum of Art, Hartford; *Loss of Virginity*, Chrysler Museum of Art, Norfolk
Frontispiece: detail of *Nirvana: Portrait of Meyer de Haan*

CONTENTS

It is with great pleasure that I write to present the first publication to appear during my tenure as director of the Wadsworth Atheneum Museum of Art. This exhibition, *Gauguin's Nirvana*, like our other recent exhibitions devoted to Dalí, Calder, and the *Impressionists at Argenteuil* grew out of a masterpiece in our own collection. In this case it is Gauguin's painting, *Nirvana: Portrait of Meyer de Haan*, selected by Chick Austin and purchased in 1943. It has long been a treasure in the collection, and Eric Zafran, our curator of European Painting and Sculpture, recognized that this small gem would be an effective centerpiece in an exhibition considering Gauguin's works of the brief but intense period 1889–90 when the painter worked primarily in Brittany with Meyer de Haan and several other artists. Dr. Zafran has selected the works to be displayed and has also overseen the production of the catalogue with essays by several distinguished scholars, to whom we are greatly indebted for their varying insights and discoveries. We are also most pleased that once again Yale University Press has, under the guidance of John Nicoll, taken on the publication and distribution of the catalogue.

An exhibition devoted to any one of the Impressionist or Post-Impressionist painters is not an easy or inexpensive undertaking these days. We are most indebted to our various lenders both public and private who have shared their valuable treaures with us, making it possible to carry out the curator's vision. The chief financial support for the exhibition has been supplied by Aetna. For this we are grateful in the initial planning stages to Roberta Huber and Marilda Gándera. As the process progressed we also worked with Venton Forbes, and Brooke J. Penders, and we wish to thank the company's new chairman, William H. Donaldson, for continuing to support this special endeavor in Aetna's hometown of Hartford. To assist the museum in the many aspects of producing the catalogue and reproducing the works of art we are most pleased to acknowledge the assistance of the Florence J. Gould Foundation and its President, John R. Young. The Helen M. Saunders Charitable Foundation Inc. has generously supported the exhibition and for this we are grateful to our trustee, Coleman Casey. The David T. Langrock Foundation through its Chairman, John Hogan, The National Endowment for the Arts and the Netherland-America Foundation have also provided support for the exhibition. In addition Mr. Thomas H. Wysmuller; Dr. and Mrs. Herman Bosboom; Dr. and Mrs. Andrew Hendricks; Mr. and Mrs. J. Hiemstra; Mr. J. William Middendorf II; Orde van den Prince, Afdeling Manhattan; Mr. Jack Polak; Mr. and Mrs. Julien Redelé; The Society of Holland Dames; and Mrs. Alexander Vietor have contributed to the production of the catalogue.

We hope our visitors will relish the opportunity to see this little known aspect of Gauguin's work and have an insight into the development of Post-Impressionist painting in France.

Kate M. Sellers

Aetna is proud to sponsor the Wadsworth Atheneum Museum of Art's exceptional exhibition, *Gauguin's "Nirvana:" Painters at Le Pouldu, 1889–90*, an assemblage of more than forty interrelated paintings, drawings, prints, and sculptures by Paul Gauguin, Meyer de Haan, and others from collections around the world.

By 1889, Gauguin, who abandoned his prosperous brokerage business, his family, and ultimately western civilization to devote himself to his art, became the central figure of the emerging movement called Symbolism. De Haan, who also left a business career to pursue art, joined Gauguin as his confidante, disciple, and patron. Seeking isolated, unspoiled locations in France, they and their circle found a temporary refuge in Le Pouldu, a rustic village in Brittany that served as a place of inspiration and intellectual camaraderie. This revealing exhibition highlights Gauguin's *Nirvana* and the art it produced – still lifes, landscapes, and portraits, as well as wall decorations and sculpture.

Throughout our 147-year history, Aetna has recognized that community programs provide an excellent opportunity to integrate coporate philanthropic values with the interests of our employees and our businesses and the needs of our communities. Today, Aetna supports a variety of programs in health research, education, and the arts that reach from our corporate headquarters in Hartford, Connecticut, to cities throughout the United States and beyond. Through these programs, we help communities celebrate their culture, history and diversity, while enhancing community access to the arts.

Strengthened by the diversity and experience of Aetna's work force, our mission is to serve the needs of the 45 million people who rely on us for health care, dental, pharmacy, life insurance, disability and long term care benefits. As the nation's leading provider of these benefits, we are committed to offering products that are affordable, innovative and flexible, and to providing people the support and information they need to make informed decisions about health care and related benefits for themselves and their families.

ACKNOWLEDGMENTS

An exhibition and catalogue such as this owes its genesis to many individuals. The original idea for an exhibition focusing on Gauguin's *Nirvana* was suggested to me by my oldest friend in the world of art history, Marc Saul Gerstein, Associate Professor and Director of Art History at The University of Toledo at the Toledo Museum of Art, and he has provided continued support and advice as the proposal progressed from idea to reality. This was made possible by the initial support of the Atheneum's former director, Peter C. Sutton, and then by his successor as acting director, Elizabeth Mankin Kornhauser, as well as the acting chief curator, Linda Roth. To enter into the complex world of Gauguin's symbolist images and his interaction with his contemporaries, some already initiated experts were a necessity and we were fortunate in securing the assistance of Bogomila Welsh-Ovcharov and the late Robert Welsh. Fortunately the latter had a chance to review the text of his updated essay on the installation of the inn at Le Pouldu and Professor Welsh-Ovcharov nobly carried out her difficult task of detailing the Gauguin–de Haan relationship in an essay that is a fitting memorial to years of intensive mutual study of the material with the late Professor Welsh. In addition Charles Stuckey, Senior Curator at the Kimbell Art Museum, and a co-organizer of the great 1988 Gauguin retrospective provided both advice and a telling study of Gauguin's thought process in portraiture. Finally by the greatest good fortune, I discovered that Victor Merlhès, the leading expert on Gauguin's correspondence, had an interest in our limited topic, and he is able to publish here for the first time his remarkable findings on the sources of the imagery of Gauguin and de Haan at Marie Henry's inn in Le Pouldu.

At the Atheneum a detailed technical study of the small painting was carried out by our conservator Stephen Kornhauser and his revealing results are also published here. The time spent with him in the laboratory looking intently at *Nirvana* was most illuminating. Invaluable assistance in preparing the catalogue was also provided by Cynthia Roman, Associate Curator of European Painting. We were both aided by our indefatigably cheery and well-organized curatorial assistant, Amy Larkin Gelbach. Help in locating often obscure publications was kindly provided by John Curry Gay and Joel Williams. The museum's librarians John Teahan and William Staples also assisted in this process. For the myriad details connected with organizing even such a modest exhibition as this, we are indebted to Nicole Wholean and Daphne Deeds, exhibition coordinators, and Matthew Siegal, registrar. The funding needed for an exhibition of a nineteenth-century master as famous as Gauguin is considerable and Dina Plapler, former director of development oversaw our successful efforts. For the meaningful exhibition design my thanks as always to Cecil Adams and Marc Giuliano and to the skilled installation crew, Steve Winot and Jack Tracz. It was a true boon for the Wadsworth Atheneum when John Nicoll of Yale University Press became interested in our publications and our cordial working relationship has continued with the present book. The Press has supplied us in Sally Salvesen with both a sensitive editor and a talented designer, ably assisted by Ruth Applin.

Finally, seconding the appreciation of Kate Sellers, I wish to thank both the generous lenders and the funders who made this exhibition possible and brought the idea to fruition in such vivid form.

Eric M. Zafran

Significant contributions to the evolution of the exhibition and accompanying catalogue were made by a number of individuals. I am most especially indebted to Mr. Ko Tokikuni, Professor Robert Tomlinson, and Professor Wayne Finke for their assistance with translations and providing valuable insights and advice. Many other friends and colleagues aided the work of myself and the other essayists, and we wish to acknowledge the following:

Simone Ackerman
David Anderson
Katharine Baetjer
Pierre Ball
Guy Bennett
David Bomford
Carolyn Boyle Turner
Jennifer Bossman
Edgar Peters Bowron
David Brenneman
Janet F. Briner
Cynthia Burlingham
Lisa Calden
André Cariou
Michael Conforti
Philip Conisbee
Claire A. Conway
Magdalena Dabrowski
Susan Dackerman
Agnes Delannoy
Amy Ellis
Richard Feigen
Jay Fisher
Stephen Fisher
Jenny Fleming
Eugene Gaddis
Jim Ganz
Patricia Garland
Jay Gates
Marie-Jeanne Geyer
Oscar Ghez
Jane Glaubinger
Alexis Goodin
Susan Goodman
Elizabeth Gorayeb
Adrian Hamilton
Hillary Harvey
Heather Haskell
Jeff Harrison

Anne E. Havinga
Gregory Hedberg
Bill Hennessey
Fred Hill
Danielle Hodel
Nikki Holwell
Waring Hopkins
Mindy F. Horn
Ay-Whang Hsia
Wladyslawa Jaworska
The Jefferson X-Ray Group
David T. Johnson
Adina Kamien-Kazdhan
Serena Keshavjee
Sarah B. Kianovsky
Shunsuke Kijima
Georg Költzsch
Eberhard Kornfeld
Jelka Kroger
Leila Krogh
Shelley R. Langdale
Ellen Lee
John Leighton
Faith Lewis
Kristin Lister
Henri Loyrette
J. Patrice Marandel
Virginia Solomon Margolius
Peter C. Marzio
Sophia C. McAllister
Maureen McCormack
Neil McMullin
Lynn Mervosh
Harold Moskowitz
David Norman
Clementine Oliver
Curt Oliver
Margaret Ordonez
Fieke Pabst
Michael Pantazzi

Charles Pachter
Nadia Perucic
Carolyn Peter
Ronald Pickvance
Denise Pillon
Henry de Phillips, Jr.
Anne Pingeot
René Porro
Earl A. Powell III
Catherine Puget
Stephanie Rachum
Jock Reynolds
Jennifer Roberts
Andrew Robison
William Robinson
Betsy Rosasco
Eliot W. Rowlands
Edd Russo
Cecilia Sampaio
Bertha Saunders
Margo Pollins Schab
Lisa Schonemann
Tracy Schuster
Christine Stauffer
Mayumi Takahashi
Pierre Théberge
Stanton Thomas
Marianne Verheijen
Judy Walsh
Lori Walters
Joanne Weber
Edyie Weissler
Stephanie Wiles
Rifka Weiss-Blok
Leigh Weisblat
Nancy Whyte
Françoise Witté
Liz S. Ziegler
Ruth Ziegler

MR. AND MRS. ARTHUR G. ALTSCHUL

THE BALTIMORE MUSEUM OF ART

UNIVERSITY OF CALIFORNIA, BERKELEY ART MUSEUM

THE CLEVELAND MUSEUM OF ART

MUSEUM FOLKWANG, ESSEN

MUSÉE DU PETIT PALAIS, GENEVA

WADSWORTH ATHENEUM MUSEUM OF ART, HARTFORD

HARVARD UNIVERSITY ART MUSEUMS, FOGG ART MUSEUM

MUSEUM OF FINE ARTS, HOUSTON

INDIANAPOLIS MUSEUM OF ART

THE LATNER FAMILY COLLECTION

THE ARMAND HAMMER MUSEUM OF ART AND CULTURAL CENTER, UNIVERSITY OF CALIFORNIA, LOS ANGELES

NEW ORLEANS MUSEUM OF ART

THE MUSEUM OF MODERN ART, NEW YORK

THE CHRYSLER MUSEUM OF ART, NORFOLK

NATIONAL GALLERY OF CANADA, OTTAWA

MUSÉE D'ORSAY, PARIS

THE HENRY AND ROSE PEARLMAN FOUNDATION, INC.

MUSÉE DES BEAUX-ARTS, QUIMPER

DR. AND MRS. MICHAEL SCHLOSSBERG

IRENE AND HOWARD STEIN

JUDY AND MICHAEL STEINHARDT

MUSÉE D'ART MODERNE ET CONTEMPORAINE, STRASBOURG

NATIONAL GALLERY OF ART, WASHINGTON, D.C.

THE PHILLIPS COLLECTION, WASHINGTON, D.C.

WESLEYAN UNIVERSITY, DAVISON ART CENTER

STERLING AND FRANCINE CLARK ART INSTITUTE, WILLIAMSTOWN

YALE UNIVERSITY ART GALLERY

PRIVATE COLLECTORS WHO WISH TO REMAIN ANONYMOUS

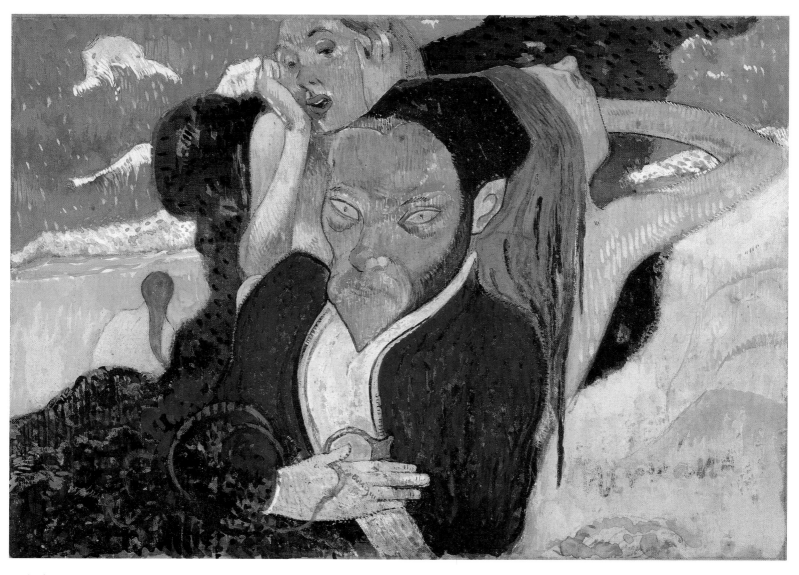

1. Paul Gauguin, *Nirvana: Portrait of Meyer de Haan*, 1889–90, gouache on cotton, 8 ¼ × 11 ⅜ in. (20 × 29 cm). Wadsworth Atheneum, The Ella Gallup Sumner and Mary Catlin Sumner Collection Fund. *Exhibition no. 1*

BOGOMILA WELSH-OVCHAROV

Paul Gauguin's Third Visit to Brittany
June 1889–November 1890

In Paul Gauguin's painting entitled *Flower, Still Life* or *The Painter's Home, Rue Carcel* (Fig. 2), produced in 1881 and exhibited the following year, the thirty-three-year-old artist seems to have anticipated his sojourns in Brittany. The canvas depicts themes that preoccupied him during the next eight years in his odyssey to create a new modern art based on the imagination and the exotic. The viewer is allowed a glimpse of a man listening attentively to his wife playing the piano.[1] In Brittany, music would remain a constant source of comfort and a stimulus for Gauguin's art.[2] The interior holds several objects reflecting his taste, exemplified by the open sketchbook on the table. His emerging curiosity about the exotic is suggested by an oriental-looking ceramic in the background. To complement this figurine, a single pair of *sabots* hangs on the wall. As symbols of rustic life they appear as harbingers of the artist's commitment to seek the primitive life: a search which would ultimately lead Gauguin to escape to Tahiti.

In the summer of 1886 Gauguin discovered the picturesque village of Pont-Aven in Brittany. He revisited the area in the winter of 1888, and his third and seminal sojourn, during 1889–90, was spent working chiefly in the hamlet of Le Pouldu. During that period, Gauguin carved three known pairs of *sabots* (Fig. 3), decorating one pair with, "barbarous arabesques in gold, blue and vermilion"

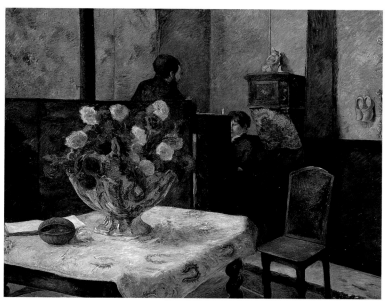

2. Paul Gauguin, *Flowers, Still Life* or *The Painter's Home*, 1881, oil on canvas, 50 ¾ × 63 ⅛ in. (130 × 162 cm). Nasjonalgalleriet, Oslo

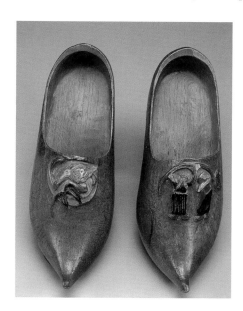

3. Paul Gauguin, *Pair of Wooden Shoes*, 1889, polychromed wood and leather, 5 ⅛ × 12 ⅞ × 4 ½ in. (12.9 × 32.7 × 11.3 cm). National Gallery of Art, Washington D. C., Chester Dale Collection

inspired by Breton motifs.[3] Another pair depicted a fox, an animal which held complex symbolic evocations for the artist; it was a symbol that recurred in several paintings, including *The Loss of Virginity* (Fig. 86), and in his wood relief *Be In Love and You Will Be Happy* (Fig. 77). The writer Charles Morice later commented that Gauguin caused quite a stir when he was seen wearing a pair of his Breton *sabots* on his return to Paris.[4] By the winter of 1888, once again working in Pont-Aven, the artist confirmed his fascination with this strange and remote northern province and commented how this region had affected his subject matter and his new painting style. He enthused to his artist/friend, Emile Schuffenecker: "I love Brittany. I find wildness and primitiveness there. When my wooden shoes ring on this granite, I hear the muffled, dull, powerful tone I seek in my painting…"[5]

Gauguin's trips to Brittany in the summer of 1886 and again in the winter of 1888 (interrupted in 1887 by an eight-month voyage to Martinique in early April),[6] had provided him with new motifs and rich iconography to express the archaic conditions of Breton

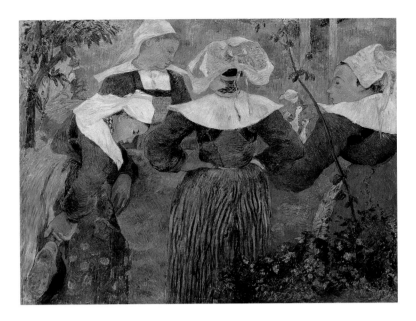

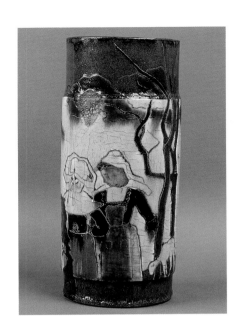

4. Paul Gauguin, *Four Breton Women*, 1888, oil on canvas, 28 ¼ × 35 ¾ in. (72 × 91 cm). Munich, Bavarian State Painting Collections

5. Paul Gauguin, *Vase Decorated with Breton Scenes*, 1886–7, glazed stoneware with incised decorations and gold highlights, h. 11 5/8 in. (29.5 cm). Musées Royaux d'Art et d'Histoire, Brussels

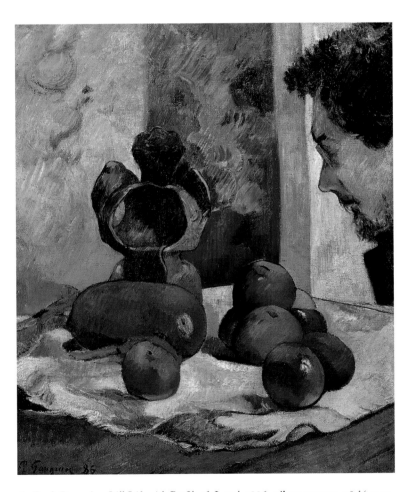

6. Paul Gauguin, *Still Life with Profile of Laval*, 1886, oil on canvas, 18 ⅛ × 15 in. (46 × 38 cm). Indianapolis Museum of Art, Samuel Josefowitz Collection of the School of Pont-Aven, through the generosity of Lilly Endowment, Inc., the Josefowitz family, Mr. and Mrs. James M. Cornelius, Mr. and Mrs. Leonard J. Beley, Lori and Dan Efroymson, and other friends of the Museum

life. By 1886 Gauguin's impressionist style began to be transformed. Two canvases dating from this period, *Four Breton Women* (Fig. 4) and *Still Life with Profile of Laval* (Fig. 6) illustrate his emerging synthetist style in which flat decorative planes, bright color and simplified line were influenced by primitive art and Japanese prints. After his return from Martinique in late 1887, his palette and style changed again to include lush tropical color and a new sense of abstraction and simplification. The artistic experiments initiated in Martinique were continued on his return to Paris, in late 1887, by further study of Japanese art as well as that of Edgar Degas. Then, in Le Pouldu, for his *Self Portrait with Yellow Christ* (Fig. 177) Gauguin developed these motifs to include his personal association with Christ's suffering, a theme that obsessed him during a tortured time in his life in 1889–90, when he identified himself as a mediator between two contradictory worlds – the Christian and the Savage.[7]

Winter 1887–8 also marked Gauguin's first critical encounter with Vincent van Gogh and his circle in Montmartre; their new cloisonist canvases had significant impact on his own developing stylistic simplifications. His meeting with the Dutch artist and his brother, Theo, resulted in a unique relationship that had significant artistic and financial consequences during Gauguin's third visit to Brittany. As manager of the art gallery Boussod, Valadon and Company, Theo van Gogh provided Gauguin with the opportunity to exhibit four recent paintings and five ceramics in his gallery in the winter of 1887–8. Sometime before the summer of 1888, Gauguin completed the firing of his famous *Vase Decorated with Breton Scenes* (Fig. 5), a landmark in the development of his synthetist/cloisonist style.[8] In the summer of 1888 Gauguin returned to Pont-Aven where, in the company of Charles Laval and the young artist Emile Bernard, he completed *The Vision after the Sermon* (Fig. 182). Like Bernard's contemporaneous painting *Breton Women in a Meadow* (Private collection), it marks the culmination of their

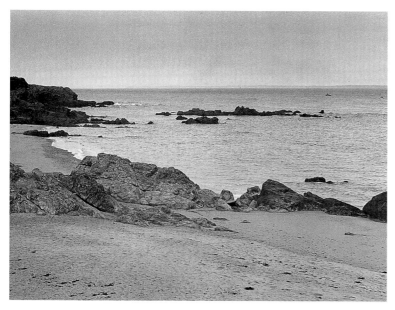

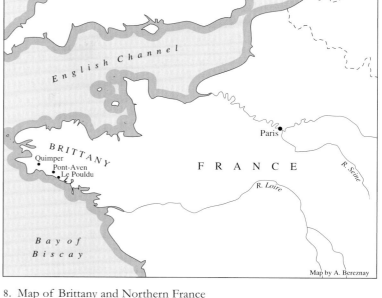

7. The Grands Sables beach, Le Pouldu, 1972. Photograph by Robert P. Welsh

8. Map of Brittany and Northern France

respective researches into a synthetist/cloisonist style. Gauguin's monumental canvas represented his new mature symbolist art, while also revealing his emerging interest in religious associations with peasant life, an iconography that laid the foundation for his artistic explorations in Brittany in 1889–90. As a result of the two months spent working with van Gogh in Arles, Gauguin continued to explore both new technical means and new iconographic motifs in Le Pouldu during 1889–90. Through Theo van Gogh, Gauguin made contact with another Dutch artist, Meyer de Haan, on his return to Paris. This artistic relationship was to prove essential for Gauguin's future artistic endeavors.

While in Arles, Gauguin had evidently been struck by the rapid encroachment of industrial development on country life in the Midi, unlike the archaic conditions still remaining in Brittany. Upon his return there in June 1889, he was impressed once more by the remoteness of the region, particularly the extent to which peasant life remained rooted to the customs of the Middle Ages, its Catholic superstitions, its costumes, and its daily labor on the land. He reiterated his impression of the backward condition of Breton existence in a letter to van Gogh written from Le Pouldu in October: "Here in Brittany the peasants have a medieval air and do not have the sense that Paris exists or that we are in 1889. Totally contrary to the Midi."[9]

Le Pouldu's origins date back to before the Roman occupation.[10] By the beginning of the eleventh century the monks of St. Maurice had settled in the vicinity as well as the dukes of Brittany who built country houses in the rich forested area. In fact, the large open bay of the Grands Sables at Le Pouldu had witnessed fierce naval battles between the English and Spanish/Genoese armada in the fifteenth century and again in the mid-eighteenth century the English landed at this beach in an attempt to seize the city of Lorient.

By the time Charles Chassé, author of a pioneering book on Gauguin's activities in Brittany, visited Le Pouldu in about 1920 it

had evidently become a beach resort, but in the 1880s it was quite undeveloped.[11] The hamlet, with its isolated peasant houses amid undulating dunes, numbered fewer than 150 inhabitants at the time of the artist's arrival in the summer of 1889. It was situated forty-seven kilometers east of Pont-Aven and belonged to the community of Clohars-Carnoët, hemmed in by the Atlantic to the west, the commune of Moëlan to the south, the Clohars-Carnoët Forest to the east and the valley of the Laïta to the north. This tranquil coastal region was bordered by four sandy beaches: Kerrou, Bellangenêt (Belle Angenay), Grands Sables, and Porsguerrec (Pors-Guirec). These coves, situated to the south of the village, are distinguished by craggy, granite rocks, jutting out from the sea; they are encrusted with blackish mussels and seaweed and, when dry, have a jet black sheen (Fig. 7) hence the name *Roches noires* (black rocks). These natural forms – seen for example in his water-color, *The Black Rocks* (Fig. 10) and his painting, *Nirvana* – became an important symbol in Gauguin's work done in Le Pouldu. The steep escarpment above the ocean is covered with vegetation and agricultural fields that lead directly to the beaches and sea. Until the mid-twentieth century the land between Bellangenêt and les Grands Sables continued, as it had in Gauguin's time, to be culti-vated for wheat, and to be employed as pasture for cattle, which by custom were tended by the local girls. Gauguin frequently used these motifs for his landscape and genre paintings during both summers spent at Le Pouldu. He painted a series of canvases in the summer of 1889 based on motifs of Breton children in Le Pouldu. These depicted peasant children in their typical somber costumes at work and play along the rocky shore, *Girl Guarding Cows* (Fig. 9) and *The Flageolet Player on the Cliff* (Indianapolis Museum of Art). Other canvases represent coastal panoramas looking towards the Ile de Groix; for example, *Cows at the Sea Coast* (Fig. 12), and *The Loss of Virginity* (Fig. 86). The peasants pursued their own unend-ing struggle against nature's harsh forces in an attempt to eke out a

9. Paul Gauguin, *Girl Guarding Cows*, 1889, oil on canvas, 28 ⅛ × 35 ¾ in. (72 × 91 cm). Ny Carlsberg Glyptotek, Copenhagen

10. Paul Gauguin, *The Black Rocks*, 1889, gouache and watercolor with ink and metallic paint on paper, 10 × 16 in. (25.3 × 40.6 cm). Private collection. *Exhibition no. 23*

meager existence, and it was precisely this image that Gauguin and Meyer de Haan sought to express in their decorations for the dining room of their lodgings at Marie Henry's inn in Le Pouldu (see pp. 61–71).

Gauguin specifically chose this tiny village as a place of respite from the claustrophobic, and increasingly pretentious, artistic scene that had evolved in Pont-Aven. The thriving economy there, based mainly on flourmills and ever-increasing tourist industry, restricted Gauguin's freedom. Furthermore, his sense of creativity was being threatened by the annual invasion of artists, poets, and writers from different artistic academies and nationalities, who continued to arrive in search of rustic surroundings and cheap lodging.[12] In contrast to this sophisticated atmosphere, Le Pouldu presented not only cheaper living but also the artistic solitude and motifs necessary for his primitivism during an interim period before his first stay in Tahiti in 1891. According to Chassé, Le Pouldu represented Gauguin's "first Tahiti in France."[13] The coastal topography offered more brilliant light and brighter color and attracted not only Gauguin and Meyer de Haan, but also Paul Sérusier (1864–1927) who came to work with Gauguin during the summers of 1889 and 1890. Several other artists also came to stay for short intervals at Marie Henry's inn, including Charles Laval (1861–94); the Dane, Jens Ferdinand Willumsen (1863–1958) and the Irish artist Roderic O'Conor (1860–1940); Ernest de Chamaillard (1862–1931); Maxime Maufra (1861–1918); and Henry Moret (1856–1913), all of whom were based principally in Pont-Aven at the time. That fall of 1889, the writer André Gide, then a young student vacationing in the region, witnessed the activities of Gauguin and his colleagues at Marie Henry's inn and left a notable account.[14] In the summer of 1890, Charles Filiger (1863–1928) accompanied by the engraver Paul-Emile Colin (1867–1949), helped in the completion of the decoration of Marie Henry's dining room. He remained for several years, painting synthetist/religious motifs and evocative lonely landscapes (Fig. 11). After Gauguin's departure from Le Pouldu in the winter of 1890, other artists followed in his footsteps to the hamlet, including Armand Seguin (1869–1903; the Dutch artist, Jan Verkade (1868–1946); and the Dane, Mogens Ballin (1871–1914). This pilgrimage to Le Pouldu in search of Gauguin continued into the twentieth century, and included the fortuitous arrival of the eighty-five–year-old American artist Isador Levy, who helped to attribute to Gauguin and Meyer de Haan the recently uncovered wall paintings in the former inn of Marie Henry (Fig. 89).[15]

By 1888 Marie-Jeanne Henry (January 25, 1859–September 15, 1911), known locally as "Marie Poupée" because of her doll-like beauty, had managed to save enough money working in Quimperlé and Paris to build her inn, known as *La Buvette de la plage* (Fig. 92), located on the chemin Grands-Sables. On the ground floor, her small establishment contained two principal rooms: a dining room for the lodgers abutted by a bar or café for the local denizens – chiefly sand haulers, seaweed gatherers, fishermen and farmers. Approximately one year later, by mid-October 1889, both Gauguin and Meyer de Haan had made this inn their permanent residence until their respective departures in late 1890.[16] Both artists had

11. Charles Filiger, *Landscape at Le Pouldu, c.* 1893, gouache on paper, 10 ¼ × 15 ⅛ in. (26 × 38.5 cm). Musée des Beaux-Arts, Quimper. *Exhibition no.* 48

spent August at the Hôtel Destais, a short walk from the inn, followed by a month in Pont-Aven. On October 14 Meyer de Haan arrived to join Gauguin (see p. 63), who had been working with Paul Sérusier, who was also staying at Marie Henry's inn. According to Chassé, this little household seems to have been filled to capacity by the summer of 1890. The small area above the dining room accessible by a staircase from the pub area, sheltered Meyer de Haan in the big bedroom, Gauguin in the bedroom overlooking the yard and Paul Sérusier in the bedroom overlooking the street. Filiger, who had also arrived by that time, was living in the studio, a lean-to shed attached to the north-east side of the inn. It had recently been cleaned and renovated to provide Gauguin and his pupil with an atelier by that spring. According to Chassé, the maid was accommodated in the pantry adjoining the dining room; Gauguin took advantage of the fact that the kitchen roof just beneath his window allowed him easy nightly access and the opportunity to "fraternize with the maid in the pantry and pass a few joyous moments with her."[17] This close-knit situation not only stimulated great artistic cohesion, but also fostered a liaison between the inn keeper and de Haan. Following the latter's departure in early October 1890, Ida, his child by Marie Henry, was born on June 9, 1891.

During their stay Gauguin and de Haan worked mostly out-of-doors and used the studio only for sculpting. They set off early each morning to spend long periods contemplating and making sketches and notes on the motifs offered by the stark landscape, including farmers' fields enclosed by rustic fences and gateways, rolling hills and winding roads leading to quaint thatched cottages. After this lengthy study, and observation of the striking, oriental-looking inhabitants, the artists would wait for the right atmospheric conditions and then proceed to complete in one sitting, from memory, the desired impression of the selected motif.[18] Paul Sérusier was also intent on capturing the region's essential character, which, he concluded, differed decidedly from that of Pont-Aven. By late 1889, Sérusier, like Gauguin, was weary not only of Pont-Aven's increasing modernity, but also of working in the confined pretty gardens of

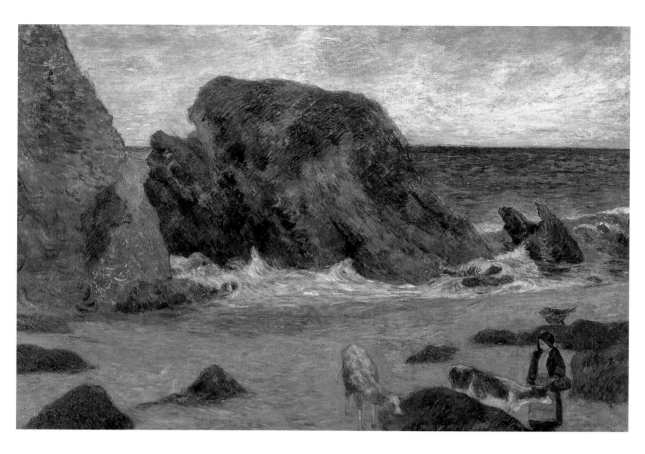

12. Paul Gauguin, *Cows at the Sea Coast*, 1886, oil on canvas, 29 ½ × 44 ¼ in. (75 × 112 cm). Private collection

13. Paul Gauguin, *The Red Vineyard* or *Human Misery*, 1888, oil on canvas, 28 ¾ × 36 ¼ in. (73 × 92 cm). Ordupgaard, Copenhagen

14. Paul Gauguin, *Haystacks in Brittany*, 1890, oil on canvas, 31 ¼ × 36 ⅞ in. (79.3 × 93.6 cm). National Gallery of Art, Washington D.C., Gift of the W. Averell Harriman Foundation in memory of Marie N. Harriman

the town. By that summer he had evidently been converted to Gauguin's synthetist style and was eager to join him at Le Pouldu. He wrote excitedly to Maurice Denis: "In several days I am changing my location in order to be closer to the sea, which is so vast, I love it so, it is the sea which has always given me the greatest inspiration. I am leaving the girls with their beautiful white headdresses, in order to study the little girls in rags, yellow, skinny and strong, who keep their cows on the great rocky cliffs among piles of seaweed."[19] Sérusier's description comes close to a motif that Gauguin had already painted in 1886 and which he sought out again three years later. Gauguin's portrayal of just such a young girl tending animals along the beach below the promontory is captured in his painting *Cows at the Sea Coast* (Fig. 12), dated 1886.[20]

As this canvas reveals Gauguin's decision to move to Le Pouldu

in 1889 was based on his familiarity with the region from his first two visits to Brittany. This painting as well as several others dated 1886, depict motifs of the sea which the artist had studied near and around Le Pouldu.[21] Most, if not all, these "coastscapes" dated by the artist to 1888, were probably executed during the summer and fall of that year when Gauguin, accompanied by others including Emile Bernard and Charles Laval, traveled to this area in search of new motifs.[22]

Gauguin's work in Le Pouldu left an impact on his iconography that is evident during his collaboration with van Gogh in Arles in late 1888. In the Arlesian work that he considered "his best painting of the year," *The Red Vineyard/Human Misery* (Fig. 13), he included a specific reminiscence of Le Pouldu. He sent a note to Emile Bernard identifying the large figure standing at the

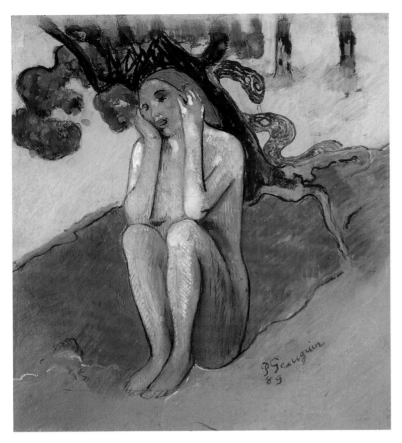

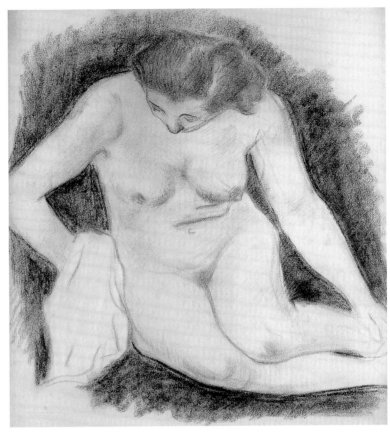

15. Paul Gauguin, *The Breton Eve*, 1889, watercolor and pastel on paper, 13 ½ × 12 ½ in. (33.7 × 31.8 cm). The McNay Art Museum, San Antonio. Bequest of Marion Koogler McNay

16. Paul Gauguin, *Female Nude*, pastel, 23 ½ × 19 ⅜ in. (59.7 × 49 cm). Private collection

left of his canvas as a "Breton woman of Le Pouldu in black with grey apron."[23]

GAUGUIN AND THE VOLPINI EXHIBITION JUNE 1889

Several critical issues relating to Gauguin's activities after his return to Paris in the winter of 1889 are unresolved. In particular, when and where did Gauguin produce six works: two paintings, *Life and Death* (Fig. 179) and *In the Waves* (Fig. 178), the pastel and watercolor, *The Breton Eve* (Fig. 15), and two related drawings (Figs. 16, 17) as well as the sepia wash drawing *The Black Rocks* (Fig. 21) that figured as the title page for the Volpini exhibition catalogue? These works, dated to 1889, depict symbolically charged representations of female nude bathers, illustrating syncretist ideas about life and death as related to the temptation and fall of the Biblical Eve. With the exception of the mixed-media work, *The Breton Eve*, all the above mentioned figures are set against a coastal background identified with Le Pouldu. Later that year, Gauguin employed a summation of the theme in *Nirvana, Portrait of Meyer de Haan* (Fig. 1). However, he reassembled the composition by compressing the original two bathers in his drawing *At the Black Rocks* into a more unified position and introduced a tiny third bather to the left. Both canvases, *Woman in the Waves* (Fig. 178) and *Life and Death* (Fig. 179), along with *The Breton Eve* (Fig. 15), have been dated to the Paris

period sometime after his completion of the eleven so-called Volpini zincographs in January–February 1889.[24] Indeed three of the zincographs in the series include coastal views (Figs. 18–20).[25] For *Bathers in Brittany* Gauguin juxtaposed an earlier Pont-Aven motif of a young bather against the setting of the Black Rocks and introduced a nude figure in the waves that anticipates the theme of *Woman in the Waves*. These coastal motifs in Gauguin's work dated to early 1889 may be explained as reminiscences of a visit to Le Pouldu during an unrecorded winter trip to Brittany.

Until recently it had been presumed that Gauguin's new interest in bather themes related to Le Pouldu motifs must have been spawned after his short trip to Brittany sometime in the winter of 1889. After his return to Paris in April or May, Gauguin was thought to have immersed himself in the arrangements for "L'Exposition de Peintures du Groupe Impressioniste et Synthétiste."[26] Gauguin's resurgence of Le Pouldu motifs has been explained by his trip to Brittany in winter/spring of 1889.[27] There is no epistolary evidence to suggest, as has been supposed, that Gauguin interrupted his six-month stay in Paris with a trip to Brittany before early June.[28] Nor, for that matter, is there any evidence to support a return trip from Pont-Aven to Paris in June to allow Gauguin to organize the first group manifestation of his new symbolist art.[29]

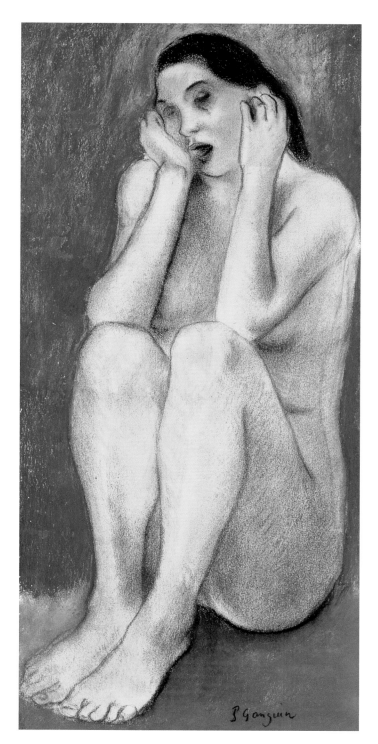

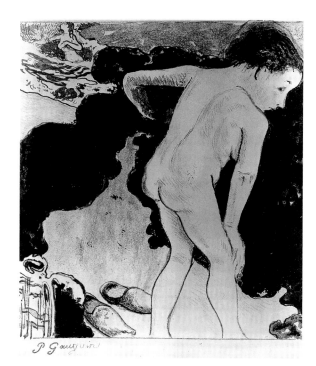

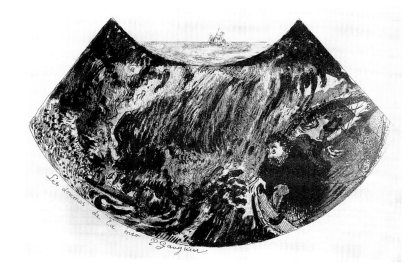

17. Paul Gauguin, *The Breton Eve*, 1889, pastel on paper, 21 × 11 in. (53.3 × 28 cm). New Orleans Museum of Art. Promised and partial gift of Mrs. John N. Weisnstock in memory of Mr. and Mrs. B. Bernard Kreisler. *Exhibition no. 24*

18. Paul Gauguin, *Bathers in Brittany*, 1889, zincograph on yellow paper. Sterling and Francine Clark Art Institute, Williamstown. *Exhibition no. 31*

19. Paul Gauguin, *Dramas of the Sea: A Descent into the Maelstrom*, 1889, zincograph on yellow paper, 17 ¼ × 21 ⅜ in. (43.8 × 54.3 cm). Sterling and Francine Clark Art Institute, Williamstown. *Exhibition no. 30*

20. Paul Gauguin, *Dramas of the Sea, Brittany*, 1889, zincograph on yellow paper, 17 ¼ × 21 ⅜ in. (43.8 × 54.3 cm). Sterling and Francine Clark Art Institute, Williamstown. *Exhibition no. 29*

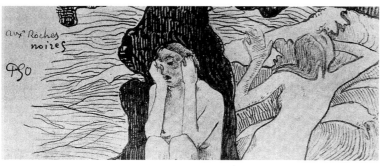

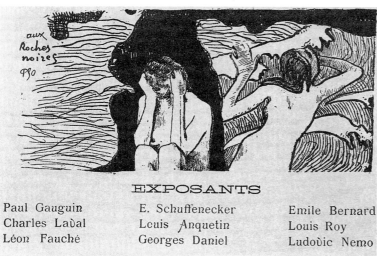

Thanks to Gauguin's friend and financial supporter, Emile Schuffenecker, a location for the exhibition had eventually been found in the Café des Arts, an establishment managed by the Italian, Signor Volpini.[30] This café was conveniently located in the grounds of the 1889 Exposition universelle, near the Fine Arts Pavilion across from the Press building on the Champ-de-Mars. The evidence of a letter, re-dated by Victor Merlhès, reveals that Gauguin had already left Paris by early June and was organizing the exhibition from Brittany.[31] Gauguin's letter to Schuffenecker begins: "Bravo! You have brought it off. See van Gogh, arrange things to the end of my stay." It is evident that by early June Gauguin had received news from his friend that a location had been found for their exhibition. However, the letter has not only been misdated, it has also been erroneously transcribed with three additional inclusions of the phrase, "of my stay", in the first sentence which do not appear in the original letter. This mistake has misled scholars for almost half a century to deduce from Gauguin's remarks that he was in Brittany for a short while and intended to return to Paris after "his stay" in Pont-Aven.

The correct re-reading of Gauguin's remarks to Schuffenecker is of great consequence. First, the letter supports the idea of an uninterrupted stay in Paris and secondly, it confirms that Gauguin did not return, as has been presumed, to the capital in order to transport and hang works for the Volpini exhibition.[32] The letter also reveals that Gauguin's initial selection of artists for the exhibition included Armand Guillaumin, who had participated with him in the last four Impressionist exhibitions. The other proposed candidate was van Gogh. Much to Gauguin's chagrin, both artists declined to exhibit.[33] It seems odd that, although Gauguin was already in the company of Meyer de Haan and Charles Laval at Pont-Aven, he did not consider them as potential candidates for the exhibition. De Haan had been in Pont-Aven since late April and had not yet produced anything to merit consideration. The exclusion of Charles Laval, Gauguin's disciple and traveling companion to Martinique, is more puzzling and may have been based on the latter's delicate health and reputation for working at a very slow pace. However, Laval's exclusion was ultimately reversed, as the printed catalogue of the exhibition indicates.[34] The letter also lists the ten works Gauguin was proposing for the Volpini exhibition in early June. All the works were conveniently stored with Theo van Gogh in Paris. Not a single title included reference to Le Pouldu subjects. Gauguin made no mention of his recent canvases *Life and Death*, *Woman in the Waves*, *The Breton Eve*, nor of the drawing *Black Rocks*. Instead, his list includes one work of his Martinique period, six from his Breton period in 1888 and two created in Arles. One work was titled simply "pastel," which may or may not be *The Breton Eve* that appeared later in the printed catalogue as "Eve – aquarelle".[35]

By the opening of the Volpini exhibition on June 8, there was still no printed catalogue and works therefore could still be added until sometime before July 6, by which time the official Volpini catalogue had been published.[36] By the time the printed catalogue appeared, Gauguin's submissions had been augmented by seven additional works including two from his Arles period, a portrait

24. Paul Gauguin, *Woman in the Waves (Ondine)*, 1889, pastel and gouache on paper, 6 ⅞ × 18 ⅞ in. (17.6 × 47.9 cm). Private collection

25. Paul Gauguin, *Fan with Woman in the Waves (Ondine)*, 1889–90, graphite, brush and gouache heightened with pastel worked with brush and water on green Bristol board, 4 ¾ × 14 ⅛ in. (12 × 38.1 cm). Private collection

26. Paul Gauguin, *The Ondines*, 1889, polychromed wood, 6 ½ × 22 ¼ in. (16.5 × 56.5 cm). Private collection

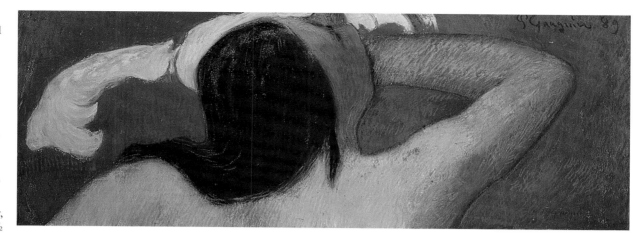

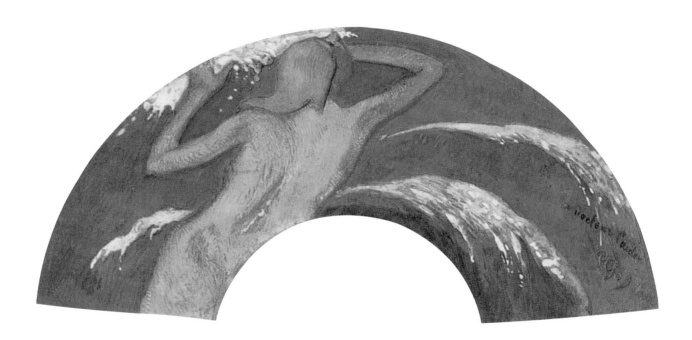

and *The Red Vineyard*, listed as no. 43: *Human Misery* as well as two new works: no. 42, the watercolor *Eve*, and no. 44, the painting *Dans la Vague* (*Woman in the Waves*) (Fig. 178). If the latter two works had already been completed in Paris by the time Gauguin left in June why would he have omitted them from his initial list sent to Schuffenecker from Pont-Aven? Furthermore, it seems likely that it was only after Gauguin's arrival in Pont-Aven that he sent his now-lost drawing in sepia and brush *At the Black Rocks* (Fig. 21). In another letter, written from Pont-Aven in late June of 1889, Gauguin informed Schuffenecker that he was sending a drawing, evidently on the request of his friend, who was apparently over-seeing the printing of the Volpini catalogue. Gauguin wrote: "Here included is the drawing done in haste in order that it can depart as soon as possible. For such things it is best if they are done in advance as one is not always ready and one draws badly when a fast order is requested. Anyway, it seems to me you are making a lot of uproar for this exhibition."[37] Gauguin's original drawing apparently served for someone else in Paris to complete the linecut that appeared on the title page (Fig. 22) of the catalogue,[38] a conclusion supported by evidence of another hand that must have been responsible for the addition of the signature 'PGO'.[39]

Gauguin also informed Schuffenecker: "I have begun a series of *drawings* which I think are interesting."[40] Unfortunately, no documentation exists to ascertain which the drawings were. However, two large-scale pastels related to *Life and Death*, *At the Black Rocks* and *Eve* are possible candidates. His study *Female Nude* (Fig. 16) and its companion piece (Fig. 17) are full-size pastel drawings which appear to have been done from life after a model, and the measurements of the figures in the painting *Life and Death* appear to correspond to the drawings.[41] Gauguin was obsessed not only with the image of the nude symbolizing a fallen, fearful and "sinful" Eve, but also with the figure of the bather confronting waves as a metaphor for procreation and renewed vitality as symbolized by the nude in his Volpini canvas *Woman in the Waves*. The nude facing the waves as symbol of female joy rather than pain, of life rather than death, complemented Gauguin's fascination with the dualities of life and death or the material and spiritual, themes which preoc-cupied his symbolist painting and sculpture in Le Pouldu. Both the pastel, *The Breton Eve*, and *Woman in the Waves* not only anticipated the symbolic background for *Nirvana*, but also appear as a recur-rent motif in several works during 1889: in a cut-down pastel, a mixed-media fan, and a wood-relief (Figs. 24–6), culminating in his major wood sculpture, *Be Mysterious* (Fig. 76) in 1890.[42] The theme also appeared as a decorative background in the colorful *Still Life with Quimper Pitcher* (Fig. 154), although the composition here sug-gests either a now-lost painting or a fanciful reworking of the com-position, since the arrangement of the dominant bather differs from the nude employed for both the Volpini painting and the background of *Nirvana*.

Paul Sérusier's intriguing pencil drawing *Nude* (Fig. 23) appears so strikingly similar in the configuration of her hair and body as to suggest a comparison to Gauguin's Volpini bather and this raises the possibility of their having worked from the same model in the summer of 1889.[43] Gauguin clearly considered the life-affirming

27. Meyer de Haan, *Uriel Acosta*, 1878–88, oil on canvas (after Zürcher)

symbolism of *Woman in the Waves* as a major breakthrough in his symbolist art. For that reason, despite his known despondency that summer, he may have chosen it as the background for his *Self Portrait* (Fig. 31) in order to symbolize his own artistic regeneration, before exhibiting the work at the Volpini exhibition as the procla-mation of his recent synthetist art.[44]

GAUGUIN AND DE HAAN

On August 1, 1888 the thirty-six-year-old Dutch artist, Meyer Jacob de Haan (1852–95),[45] accompanied by his student, Joseph Jacob Isaacson (1859–1942) left Amsterdam in pursuit of modern artistic trends in Paris.[46] Between April 1889 and the fall of 1890 de Haan spent approximately seventeen months in Le Pouldu, as Gauguin's pupil. The relationship proved to be a seminal experi-ence for both of them. Their initial contact in the summer of 1889 was not, as has been previously assumed, via the artist Camille Pissarro, but through de Haan's compatriot, Theo van Gogh.[47] Evidence suggests that de Haan had departed for Pont-Aven by early April and it seems unlikely that he had met Gauguin in Paris prior to his departure.[48] However, by late 1888 during his stay in Arles with Vincent van Gogh, Gauguin would have been aware of de Haan's existence. Van Gogh, awaiting the imminent arrival of Gauguin, had already been apprised of de Haan's famous painting *Uriel Acosta* (Fig. 27), the extraordinary frame of which he particu-larly recalled had cost 2000 francs.[49] Theo had seen a preliminary sketch of the canvas in a photograph which de Haan had brought with him from Amsterdam and he hastened to send his brother an expanded description of the canvas: "The subject is Uriel Acosta before the Tribunal; it was a judicial crime in Jewish history. The composition is nothing like Rembrandt."[50]

De Haan's masterpiece had preoccupied the artist for about a decade and represented the culmination of his studies devoted to Jewish subjects.[51] Since little documentation survives about de Haan's artistic and intellectual life during his early years in Amsterdam, *Uriel Acosta* remains a key work for comprehending some of his presumed expertise about religion, philosophy and especially his interest in Talmudic studies.[52] It appears that his early

conservative religious and artistic associations in Amsterdam had caused him much frustration. Furthermore, his decision to depict the trial of Uriel Acosta, a free-thinking seventeenth-century Jew provoked a critcal response in Orthodox circles in Amsterdam. By late 1889 his experiences in France had led de Haan to achieve a remarkable transformation from his academic manner to a new synthetist style. His sense of liberation from traditional artistic practices impelled him to write with unbound enthusiasm to his great friend Theo the following summer about his future progress. "Whenever I think on the oppressed and melancholy surroundings in which I shuffled around in that sober and narrow-minded art circle of my youth then I feel overjoyed by my liberal ideas and [feel] a robust day [coming] and a great trust in the future."[53] As a pupil of Petrus F. Greive (1811–72) de Haan's artistic development, in Amsterdam, was aligned to an academic tradition; yet he distinguished himself by producing work based on a Jewish genre tradition. De Haan belonged to the "Nederlands Israelitisch" denomination of the Orthodox Askenazi community in Holland,[54] and his paintings were evidently aimed at the sizeable Amsterdam Jewish community. De Haan's predominant interests in serious themes set him apart from the more picturesque Jewish genre tradition which preoccupied his contemporaries. Two works which preceded *Uriel Acosta*, his *The Talmudic Dispute* dated 1878 (Fig. 28) and *Is the Chicken Kosher?* of 1880 (Fig. 29), have been compared in style to the seventeenth-century Flemish genre painter David Teniers and reflect de Haan's connection to the Orthodox Jewish community in Amsterdam.[55]

These canvases were certainly discussed by de Haan and Gauguin in Le Pouldu and may have stimulated the latter's portrayal of his pupil as a philosopher and mystic, seen, for example, in Gauguin's likely adaptation of the pose of the pensive scholar in de Haan's *The Talmudic Dispute* for his portrait of *De Haan by Lamplight* (Fig. 148). De Haan's background and his knowledge of Biblical and Jewish history seems to have piqued Gauguin's interest in the exotic and stimulated him to envision de Haan as a representative of Jewish culture. Furthermore, like Gauguin's own form of Catholicism, de Haan's liberal attitude is revealed by his selection of such subjects as Uriel Acosta. His mysticism compelled him to reject the traditional life and conservative religious beliefs that had provided him with economic security and to seek out new artistic developments. These factors contributed to the formation of a kinship between the two men, and played a significant role in their altruistic abandonment of material comfort in order to create a new modern art. Like Gauguin, de Haan felt that the role of the artist was a sort of divine calling which demanded total renunciation. Chassé compared both painters' lives to those of monks who have chosen a life free from worldly preoccupation and dedicated to hard work. The engraver Paul-Emile Colin, who met Gauguin and de Haan in Le Pouldu in 1890, confirmed to that writer the similarity of both men's characters and professed his admiration for their having "sacrificed everything for Art with the near certainty that they would not profit from their efforts."[56]

Even in height both artists were not as far apart as has generally been presumed. De Haan, who was a hunchback, can not have

28. Meyer de Haan, *The Talmudic Dispute*, 1878, oil on canvas, 36 7/8 × 45 1/4 in. (93.7 × 115 cm). Location unknown

29. Meyer de Haan, *Is the Chicken Kosher?*, 1880, oil on canvas, 25 7/8 × 29 7/8 in. (65.8 × 76 cm). Location unknown

been strikingly disparate in stature from Gauguin. Early descriptions of Gauguin's appearance have produced conflicting reports – by some accounts his eyes were blue and by others were green. Similarly his contemporaries have recollected that he was both tall and athletic. Actually Gauguin was born with brown eyes and is documented as having stood just short of 5 feet, 4 inches tall.[57] His self portraits reveal that Gauguin enhanced his image as well as his physical stature and the color of his eyes, as seen in his portrait dedicated to Eugène Carrière (Fig. 30).

Gauguin's perception of de Haan as a liberal thinker and mystic concerned with spiritual rather than material reality, is reflected in

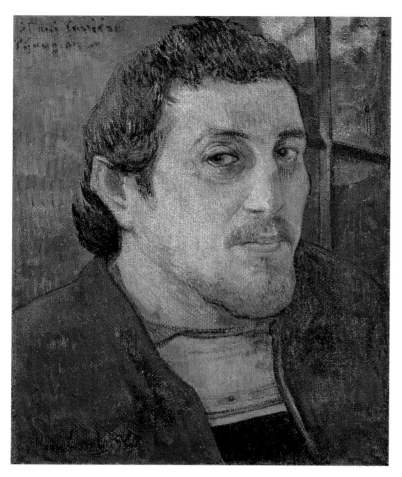

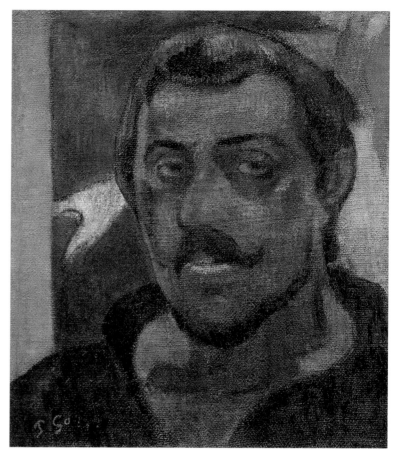

30. Paul Gauguin, *Self Portrait for Carrière*, 1886?, oil on canvas, 16 × 12 ¾ in. (40.5 × 32.5 cm). National Gallery of Art, Washington D.C., Collection of Mr. and Mrs. Paul Mellon

31. Paul Gauguin, *Self Portrait*, 1888, oil on canvas, 18 ⅛ × 15 in. (46 × 38 cm). Pushkin Museum, Moscow

his portraits of his pupil produced in Le Pouldu: a watercolor, a bust in oak (Fig. 98), and his two portraits *De Haan by Lamplight* (Figs. 148, 149) and *Nirvana* (Fig. 1). These portraits, however, have also been viewed as spiteful and satirical characterizations by Gauguin, as a result of the rumors of his sexual rivalry with his pupil for the favors of the young innkeeper, Marie Henry (Fig. 102). There is no actual documentation of any sexual encounter between Gauguin and Marie Henry, except oral accounts provided by her family in the mid-twentieth century. Perhaps Gauguin's unsuccessful attempts in 1894 to reclaim the art and belongings he had left at Marie Henry's inn (which resulted in a bitter court case) may have exacerbated her family's memories, inducing her daughter to recount years later that such shameless assaults on her mother by the artist, himself a husband and father, were met with rebuke and moral indignation.[58] Whether Gauguin did or did not solicit sexual contact with Marie Henry, he appears to have intentionally transformed de Haan's abnormal physical appearance to symbolize not only his pensive character but possibly to allude to his libidinous nature. In comparing de Haan's own more naturalistic portrayals in his *Self Portraits* (Figs. 32, 150) with those of Gauguin, we see that his portraits of his pupil have concentrated on identifying de Haan's prominent physical characteristics, espe-

cially his deformity. The bearded hunchback has been metamorphosed into the figure of a fox/satyr creature, sporting, in three portraits, hoof-like appendages. In his last symbolic portrait, *Barbaric Tales* (Fig. 168), painted thirteen years later on the island of Hiva-Oa, Gauguin's memory of his companion caused him to represent de Haan, once again, as a red-headed, hunchbacked man/creature clad in a feminine mauve tunic, with a claw foot accentuated by blood red nails. In fact, a preliminary sketch for the latter portrait (Fig. 33) reveals Gauguin's imaginative powers as he transposes the crouching figure of an animal seen above the head of de Haan into his pupil's silhouette. Such depictions have made it virtually impossible for writers not to interpret the figure of his deformed pupil as representing a sorcerer, Satan, a fox-tempter, "symbol of perversity" and primal sexual desires.[59]

Several other portraits of de Haan exist, including one by Gauguin, which shed further light on how he was perceived in Le Pouldu. One of Gauguin's earliest portraits of him, an ink and wash drawing (Fig. 34B), produced sometime in the second half of 1889, reveals that Gauguin must have seen a photograph of the preliminary sketch for *Uriel Acosta* which de Haan had shown Theo in Paris the previous year. In this powerful drawing Gauguin depicted the bearded artist in profile similar to the seventeenth-

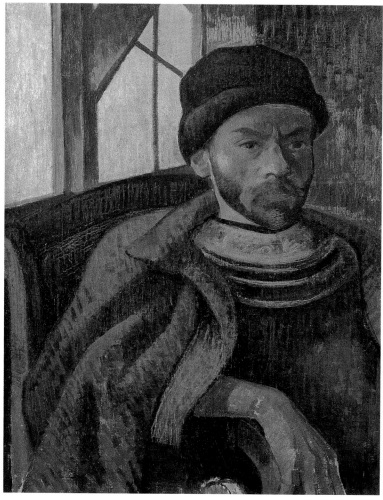

century figure in de Haan's painting. Like the free-thinking Jewish scholar, Gauguin costumed de Haan in a dark gown and white collar wearing a skull-cap similar to the garb still worn by Orthodox Jews of Amsterdam in the 1880s (Fig. 34A). This watercolor portrait of de Haan is contemporary with Gauguin's own growing interest in religious ideas and his personal identification with Christian iconography which manifested itself after he reached Pont-Aven in early June and which occupied a central role in his art for the remainder of the year. During that period, he produced his first breakthrough canvas in this genre, *Christ in the Garden of Olives* (Fig. 72) in which he portrayed himself as the suffering artist/Christ/ martyr. In early June he announced to Schuffenecker: "I have begun a Christ [word deleted] Jesus in the garden of Olives, which will be quite good—, Laval and de Haan the Dutchman, are totally enthusiastic about it."[60]

A previously little-known drawing by Gauguin, representing de Haan (Fig. 35) probably reveals a preliminary sketch for his *Meyer de Haan by Lamplight*. This realistically conceived image of de Haan contains little allusion to the diabolical side of his nature illustrated in the painted portrait. Instead, Gauguin concentrated in his study on revealing the artist's pensive mood as he gazes downward, as if reading a book. The definition of de Haan's cap and the simplified arc of his left shoulder are closely related to the painting.

De Haan's features intrigued not only Gauguin but also Paul Sérusier who represented the bearded de Haan in turban and mantle (Fig. 38) on a sheet of studies made that October.[61] In fact, we can date both Gauguin's watercolor and Sérusier's sketches to after October 14, 1889, when de Haan registered at the inn and before October 17 when Sérusier left Le Pouldu.[62] The date for both artists' portraits is confirmed by Sérusier's inclusion of Marie Henry's seven-month-old daughter, Mimi (diminutive for Marie-Léa), whose infant profile is also included in Gauguin's watercolor

32. Meyer de Haan, *Self Portrait in Breton Costume*, 1889–90, oil on canvas, 15 ½ × 12 ¼ in. (39.6 × 31.2 cm). Private collection

33. Paul Gauguin, *Study for "Barbaric Tales,"* (Fig. 168), Pencil. Cabinet des Dessins, Musée du Louvre, Paris

34A. Portrait of Dr. Bernard Lobe Ritter, 1887, lithograph

34B. Paul Gauguin, *Portraits of Meyer de Haan and Mimi*, 1889, ink, wash and black crayon, 6 ⅜ × 7 ⅝ in. (16.2 × 19.8 cm). Private collection

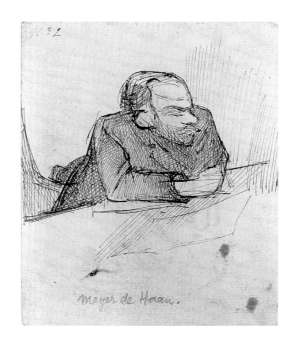
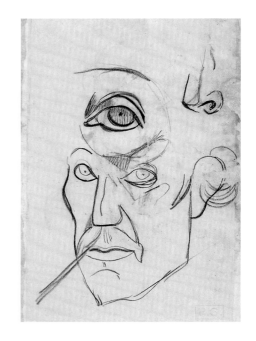

35. Paul Gauguin, *Portrait of Meyer de Haan*, charcoal on paper, 12 ³/₄ × 8 ½ in. (32.5 × 21.5 cm). Private collection

36. J. J. Isaacson, *Portrait of Meyer de Haan*, pen and ink on paper, 5 ⁷/₈ × 4 ³/₄ in. (14.9 × 11.9 cm). Rijksmuseum Vincent van Gogh, Amsterdam

37. Paul Gauguin, *Self Portrait*, 1889, charcoal on paper, 11 ³/₈ × 7 ½ in. (29 × 19 cm). Musée d'Art Moderne et Contemporaine, Musées de Strasbourg. *Exhibition no. 22*

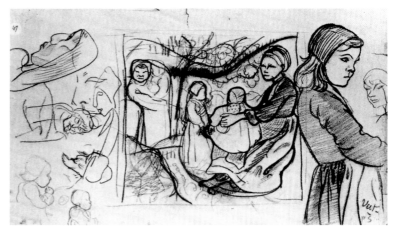

38. Paul Sérusier, *Sheet of Studies including Portraits of Meyer de Haan and Mimi*, 1889, black chalk, 11 × 17 ³/₄ in. (28 × 45 cm). Private collection

39. Paul Gauguin, *Portrait of Roderic O'Conor, Meyer de Haan and Self Portrait*, 1890, graphite on paper, 9 ³/₈ × 17 ½ in. (24 × 44.5 cm). J. F. Willumsens Museum, Frederikssund, Denmark

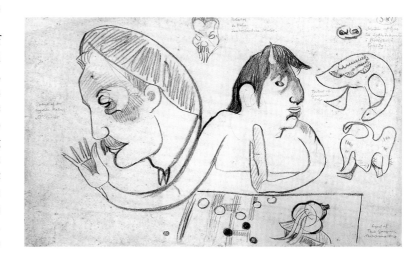

portrait of de Haan.[63] De Haan was also known to the engraver Paul-Emile Colin, who recollected meeting him while accompanying Filiger to Le Pouldu in the summer of 1890 and mentioned his "wily eyes," alluding probably to de Haan's early business associations with his family's matzoh and bread factory. Colin's anti-Semitic tone continued when he compared Gauguin and de Haan's arrangement to that of "Christ lodging with the tax-collector."[64] It would have been known to the artists visiting Le Pouldu that de Haan received financial assistance from Amsterdam, some 300 francs per month, in exchange for having sold his share of the family business.[65] These funds helped to support de Haan's artistic career as well as to pay Gauguin's personal expenses, including his love for tobacco.

Another drawing by Gauguin (Fig. 39), includes a small image of de Haan's mask-like face, prominent forehead and almond-shaped eyes, as well as an ironic portrait of the Irish artist Roderic O'Conor, a self-caricature, and some of the decorative motifs associated with Marie Henry's inn, such as onions, symbols which figured in de Haan's *Still Life with Onions* (Fig. 106) and which, along with two images of geese, embellished the wall and ceiling of the dining room.[66] De Haan's image must have pre-dated his departure from Le Pouldu in 1890, and it provides an example of his image without esoteric satanic references. Gauguin's portrait sketch reveals that his portrayal as a horned devil was clearly associated with his own ironic satanic depiction as the fallen angel in his *Self Portrait with Halo* (Fig. 147), painted that winter of 1889 on one of the doors flanking the

fireplace in Marie Henry's dining room.[67] In contrast to this caricatured portrayal, Gauguin's powerful charcoal drawing *Self Portrait* (Fig. 37) illustrates the artist's intent to simplify his features and to transform his eyes to suggest a hypnotic visionary, not unlike his representation of his pupil's trance-like state in *Meyer de Haan by Lamplight* and *Nirvana*. The portrait drawing is a mirror image of his *Self Portrait with Yellow Christ* (Fig. 177) and it may well have served as a preparatory sketch for the canvas, late in 1889.[68]

While working in Le Pouldu with Gauguin, de Haan radically altered his conservative self-image. The extent of his transformation under Gauguin's guidance is revealed by comparing his own two portraits with those executed by his contemporaries in Paris. The earliest, a small pen-and-ink sketch portrait (Fig. 36) by his pupil, Isaacson, is to be dated to late 1888 or early 1889, a time when both artists were enjoying Theo van Gogh's hospitality in Paris. Isaacson portrays a man from the conservative artistic milieu of Holland. His bearded and hatless figure, dressed in a conventional modern suit, displays no overt allusions to his Jewish origins. However, de Haan's prominent forehead and evident physical deformity have been noted. During a trip to Paris in the summer of 1889, de Haan met Emile Schuffenecker. It was at this time that he visited the Volpini exhibition and posed for his portrait (Fig. 40). His shirt-sleeved, summery countenance is arranged against a background suggesting the French artist's studio, and unlike Isaacson's portrait, obscures his hunchback. Instead Schuffenecker selected two other dominant physical characteristics also featured in Gauguin's portraits: de Haan's famous red hair and his distinctly large, almost paw-like, hands.[69] In contrast to the portraits by his friends, de Haan's *Self Portrait* (Fig. 150), reveals his extraordinary liberation from conventional dress, which had occurred by late 1889 in Le Pouldu while working with Gauguin. His perception had clearly changed to project the image of an avant-garde artist, while, at the same time, emphasizing the connection to his Jewish origins. His costume included a colorful bandana along with a skullcap. His artistic temperament is further accentuated by placing his head against a brightly colored background evoking the decorative flat planes of Japanese prints.[70]

Gauguin's unconventional appearance, and interest in disguise during his Le Pouldu stay are revealed in his evocation of his own exotic persona in the symbolist self portraits, which reflect his interest in mystical associations with Christ and Satan. Gauguin's small drawing of himself in the guise of a Western Indian in Le Pouldu, is an allusion to his own supposed Inca ancestry (Fig. 42).[71] The presence of Mimi's small head establishes that this drawing is also to be dated to the same summer period as Gauguin's watercolor portrait of de Haan and Sérusier's sketches. Gauguin's characterization of himself as a savage was perhaps a remembrance of his visits to Buffalo Bill's pavilion at the Exposition universelle in Paris the previous spring.

During the period June 1889 until early November 1890, Gauguin and de Haan spent approximately twelve months working together primarily in Le Pouldu.[72] By the winter of 1889, de Haan's Dutch manner had been radically transformed by the influence of Gauguin's synthetist style, as his wall painting, *Breton Women*

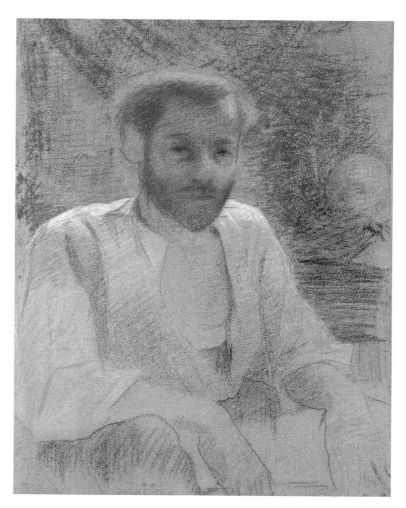

40. Emile Schuffenecker, *Portrait of Meyer de Haan*, 1889, pastel on paper, 22 ³⁄₈ × 16 ¹⁄₂ in. (57 × 42 cm). Musée du Petit Palais, Geneva. *Exhibition no. 49*

Scutching Flax (Fig. 107) attests. Van Gogh had predicted that if de Haan carried out his plan to study the impressionist school he would soon develop a new concept of color and, "a new type of drawing."[73] He added: "If they [De Haan and Isaacson] came here, Gauguin would certainly say to them – Go to Java for impressionist work." Although the drawings referred to by van Gogh are apparently lost, de Haan's *Portrait of Theo van Gogh* (Fig. 41), dating from his stay in the art dealer's apartment, is an example of the powerful expressive style which he brought with him to Brittany. On Theo's urging he had apparently begun to educate himself about avant-garde art in Paris. In a letter written several days before leaving for Brittany he wrote Theo that he had made a visit to the art shop of Julien Tanguy and mentioned having seen one painting by Paul Cézanne, one by Emile Bernard and one work by "Coquin" (Gauguin).[74] While in Paris, Theo likely introduced de Haan to Camille Pissarro who was considered the elder statesman of the Impressionist movement until his recent conversion to the Neo-Impressionist style of Georges Seurat.[75] De Haan must have seen in Pissarro, a Sephardic Jew, who had rejected academic principles for a new democratic art based on revolutionary painting techniques, a role model.

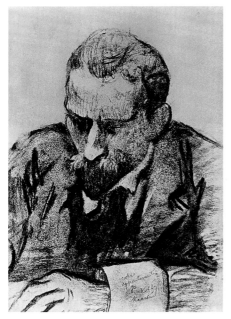
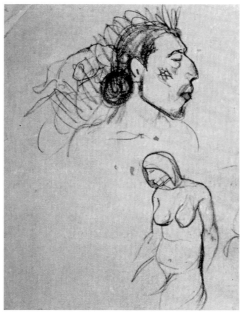
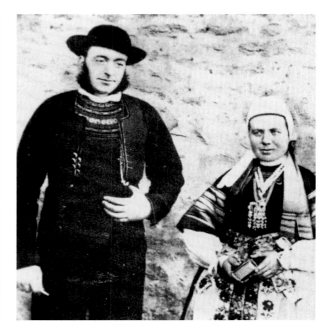

41. Meyer de Haan, *Portrait of Theo van Gogh, c.* 1889, graphite on paper, 8 ¼ × 5 ¾ in. (20.8 × 4.3 cm). Rijksmuseum Vincent van Gogh, Amsterdam

42. Paul Gauguin, *Self Portrait and Other Studies* (detail), graphite on paper, 7 ½ × 11 ¾ in. (19 × 30 cm). Private collection

43. Breton traditions: A: Bridegroom wearing a traditional vest, or *plastron bigouden*. Photograph; B: Drinking vessel known as a *Biberon*; C: Quimper plate

After his arrival in mid-April in Pont-Aven, de Haan seems to have produced little for the first few weeks except sketches that he jokingly threatened to sell as illustrations for travel guides.[76] Gauguin's first reference to de Haan appears within days of the latter's arrival, in a letter to Schuffenecker informing him that both Laval and de Haan were very enthusiastic about his new canvas *Christ in the Garden of Olives* (Fig. 72). Their first encounter must have been brief, since de Haan departed sometime in the second half of June for Paris for a short visit and returned to join Gauguin by mid July. That month Gauguin seems to have divided his time between Le Pouldu and a rented studio on the first floor in a farm situated at Avains on the outskirts of Pont-Aven.[77] He wrote despondently to Emile Bernard in late summer that he was "tied to Le Pouldu by debts" and suffering from accumulated spleen and gall evidently exacerbated by his depression over the critical reception the Volpini exhibition had received chiefly caused by the critic Félix Fénéon's devastating remarks about his work.[78] Upon de Haan's return to Brittany in July, the artists had decided to share accommodation, initially at the café-hôtel Destais.[79] From their new quarters Gauguin announced to Theo: "We are here in Le Pouldu on the sea 5 leagues from Pont-Aven…de Haan has started to work here right away encouraged by the air and the many things that make him smile."[80] After a month working in Pont-Aven, Gauguin returned with Sérusier to Le Pouldu. In early October, thanks to de Haan's allowance, Gauguin and his pupil set up a large studio overlooking the Grands Sables.[81] The Dutchman's financial support allowed them to rent the attic of the only villa in the village

known as "Castel Treaz" or "Mauduit" after its owner, a paper merchant from Quimperlé. The Villa Mauduit's large front windows offered a commanding view of the sea, as well as views of the fields and the village on either side (Fig. 48). Gauguin sent a description of his new studio to Schuffenecker: "There is a view across the sea in front … it is superb in stormy weather and I work there with a Dutchman who is my pupil and a fine fellow."[82] The large-paned windows of the Villa Mauduit are probably depicted in the background of Meyer de Haan's *Self Portrait in Breton Costume* (Fig. 32).

By late 1889, de Haan had assumed a new and distinctly romantic appearance accentuated by his woolen seaman's hat, heavy dark coat and a blue Breton sweater, the front of which bore designs associated with local folklore.[83] This embroidered collar was a modern adaptation of a Breton vest, called a "plastron bigouden," worn throughout the the region on festive occasions, especially as a bridegroom's attire (Fig. 43A). Gauguin, in addition to wearing his *sabots*, enhanced his exoticism by sporting a Breton vest during 1889–91 (Fig. 44).[84] He wears a similar vest in his *Self Portrait* (Fig. 30). The date of this canvas and the double dedication, first to Laval, and then to Eugène Carrière, have caused much speculation.[85] It is interesting to consider Gauguin's *Self Portrait* as a companion piece to de Haan's *Self Portrait* with respect to their selection of Breton costumes. Furthermore, their images are set against the

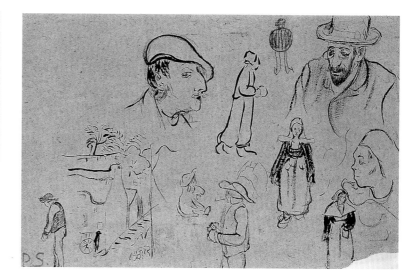
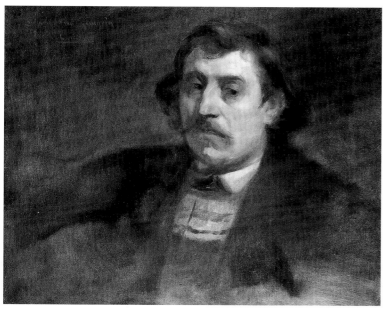
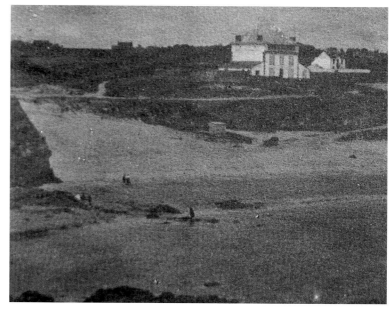

wall of a room whose fenestration resembles that of the description of their new studio at the Villa Mauduit. Gauguin's *Self Portrait*, painted on a coarse canvas, indicates the artist's continuing interest in employing jute as he had done with van Gogh in Arles. His preference for such coarse-grained canvas was probably intended for aesthetic purposes.[86] Gauguin had selected a similar sack-cloth surface to achieve a matte appearance for his summer 1889 *Self Portrait* (Fig. 31), which included the Volpini *Woman in the Waves* as a background motif. Gauguin's usage of jute canvas apparently encouraged Sérusier's work. In the summer 1890 he wrote: "I am using the coarsest canvas possible which I prefer."[87]

Gauguin's dedication of his portrait to Laval could be explained by the latter's presence in Pont-Aven and Le Pouldu in the summer of 1889. That year, Laval also produced a *Self Portrait* (Fig. 45) that must have been completed only after his departure for Paris in October, thus, it need not be considered as an intended exchange for Gauguin's own portrait.[88] A drawing by Sérusier (Fig. 47), likely dating to the summer of 1889 from Pont-Aven, included portrait

44. (*above, left*) Boutet de Montval, Photograph of Gauguin in Paris, February 1891

45. (*above, center*) Charles Laval, *Self Portrait*, 1889, oil on canvas, 18 ½ × 15 in. (47 × 38 cm). Musée National d'Art Moderne, Paris

46. (*below, left*) Eugène Carrière, *Portrait of Paul Gauguin*, 1891, oil on canvas, 21 ½ × 25 ¾ in. (54.6 × 65.4 cm). Yale University Gallery, New Haven

47. (*above, right*) Paul Sérusier, *Portraits of Gauguin and Laval with Other Sketches*, 1888–90, charcoal and ink on tan paper, 12 × 18 ⅞ in. (30.5 × 47.9 cm). Collection of Dr. and Mrs. Michael Schlossberg, Atlanta. *Exhibition no. 47*

48. (*below, right*) The Villa Mauduit, photograph *c*. 1900. Private collection

sketches of both Gauguin wearing his famous beret and Charles Laval in spectacles and hat (not, as has been presumed, a portrait of the Nabi artist Paul Ranson).[89] It is unclear why Gauguin's portrait, originally intended for Laval, remained in Gauguin's collection after his return to Paris in early November 1890.[90] We do know that there appears to have been a rupture in their relationship, per-

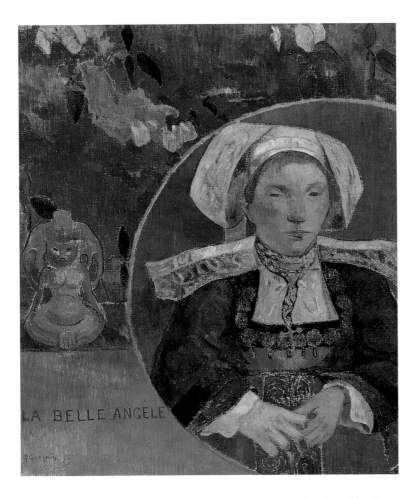

49A. Paul Gauguin, *La Belle Angèle*, 1889, oil on canvas, 36 ¼ × 28 ¾ in. (92 × 73 cm). Musée d'Orsay, Paris

49B. Seal of Duke Jean V of Brittany (1399–1442)

50. *(facing page)* Paul Gauguin, *Young Breton Girl*, 1889, oil on canvas, 18 ¼ × 15 in. (46 × 38 cm). Private collection. *Exhibition no. 6*

the large windows of the Mauduit studio with a view of the fields. That winter, Gauguin sent van Gogh a description of the varied views afforded from those windows including one close to that depicted in this portrait: "above is an immense terrace 15 meters by 12.5 meters high (glass enclosure on two sides). From one side we plunge onto a view of the immense horizon of the sea....we paint directly from the atelier ... from the other side the red sand, fields and some farms surrounded by trees."[94]

Gauguin's appreciation for Brittany's historic past extended to assimilating the region's traditional folk and decorative arts into his work. He incorporated designs that were popular in the manufacturing of Quimper ceramics. In style and decoration these plates (Fig. 43C) often chose the rooster and fleur-de-lis as motifs which reflected the essence of a Breton folk art tradition that had flourished since the eighteenth century. Gauguin's interest in such decorative and symbolic ceramics is illustrated in his use of their forms for his own plate-like gouaches, several of which hung in Marie Henry's inn.[95] During the winter of 1889–90, he painted on cardboard *The Follies of Love* (Fig. 135) in which he included the fleur-de-lis. The motif appears again beneath Meyer de Haan's depiction of *Breton Women Scutching Flax* (Fig. 107), and may have been deliberately placed next to the inscription "Ludus pro Vita" which possibly contained patriotic allusions to France and Brittany.[96]

In *Still Life with Quimper Pitcher* (Fig. 154), Gauguin included a popular Quimper type of drinking bottle, known as a "biberon," (Fig. 43B) to introduce a colorful, primitive note. De Haan used the same ceramic for his panel, *Still Life with Onions* (Fig. 106), painted on the small cupboard door on the west wall of the inn's dining room.[97] Gauguin's treatment of a similar subject (Fig. 51), and another identical version, contains the same Breton earthenware pot as well as a Japanese print from his collection, known to have decorated his studio in Pont-Aven and Le Pouldu.[98] Two other still-life canvases by de Haan depicted the same pot and arrangements of onions. One of these may have been the canvas which Theo received from de Haan in the winter of 1890 with instructions to send it to his brother in Amsterdam. In early Febuary 1890 Theo wrote Vincent about de Haan's recent difficult financial position and at the same time commented on this still life, which, he concluded, revealed his friend's strong artistic progress.[99] He added, that de Haan's canvas contained: "pink and orange onions, green apples and an earthenware pot; it is well thought out with regard to colour values...in a rather bright yellow tone."[100]

haps, among other issues, over a rumored rivalry for the affections of Bernard's younger sister, Madeleine.[91] After Carrière completed his *Portrait of Gauguin* (Fig. 46) in early 1891, representing him wearing his embroidered Breton vest, Gauguin re-dedicated his portrait to his new symbolist friend.

Breton motifs as symbols of the region's ancient cultural origins had emerged in Gauguin's oeuvre during July 1889 in Pont-Aven. *Mme. Satre: La Belle Angèle* (Fig. 49A) was completed before Gauguin settled to work with de Haan in Le Pouldu.[92] She wears her medieval-looking wedding costume and her stylized features resemble those of the primitive ceramic beside her. In Le Pouldu, Gauguin painted another female figure associated with Breton history. His *Portrait of a Young Breton Girl* (Fig. 50) may represent Mademoiselle Thérèse-Josephine Denimal, the young daughter of the Countess de Nimal [*sic*], with whom Gauguin had become acquainted when both women visited Le Pouldu that summer.[93] He selected the same ceramic depicted in his portrait of Madame Satre, perhaps to enhance the young woman's exotic heritage and at the same time to compare the similarities of her features to those in the primitive figurine. The curious assemblage of decorative motifs on the left of the girl must surely allude to specific symbolic associations with her aristocratic origins, since the motifs on the left include the fleur-de-lis and the lion, symbols of both French and Breton royalty. Such emblems were commonly associated with notable aristocratic figures in Breton history (Fig. 49B). The background for this portrait of the young countess Denimal suggests

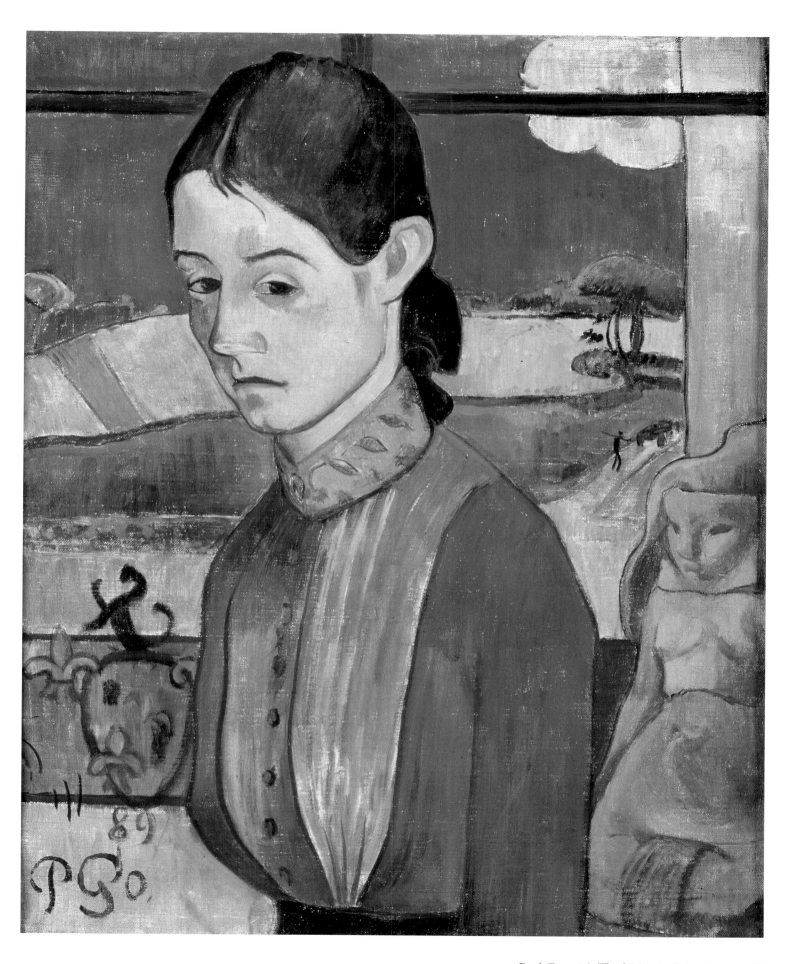

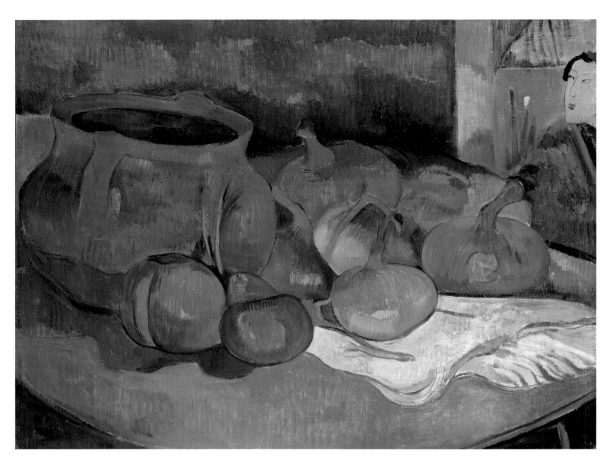

51. Paul Gauguin, *Still Life with Onions*, 1889, oil on canvas, 16 × 20 ½ in. (40.6 × 52 cm). Judy and Michael Steinhardt. *Exhibition no. 14*

52. Paul Gauguin, *Still Life with Apples, a Pear, and a Ceramic Jug*, 1889, oil on panel, 11 ¼ × 14 ¼ in. (28.6 × 36.2 cm). Fogg Art Museum, Harvard University Art Museums. Gift of Walter E. Sachs. *Exhibition no. 8*

53. *(facing page)* Meyer de Haan, *Still Life with Apples and a Vase of Flowers*, *c.* 1890, oil on canvas, 13 ⅞ × 11 ⅜ in. (35.2 × 29 cm). Private collection. *Exhibition no. 38*

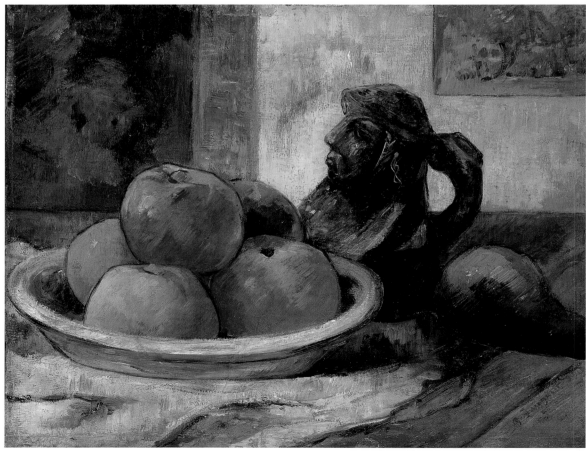

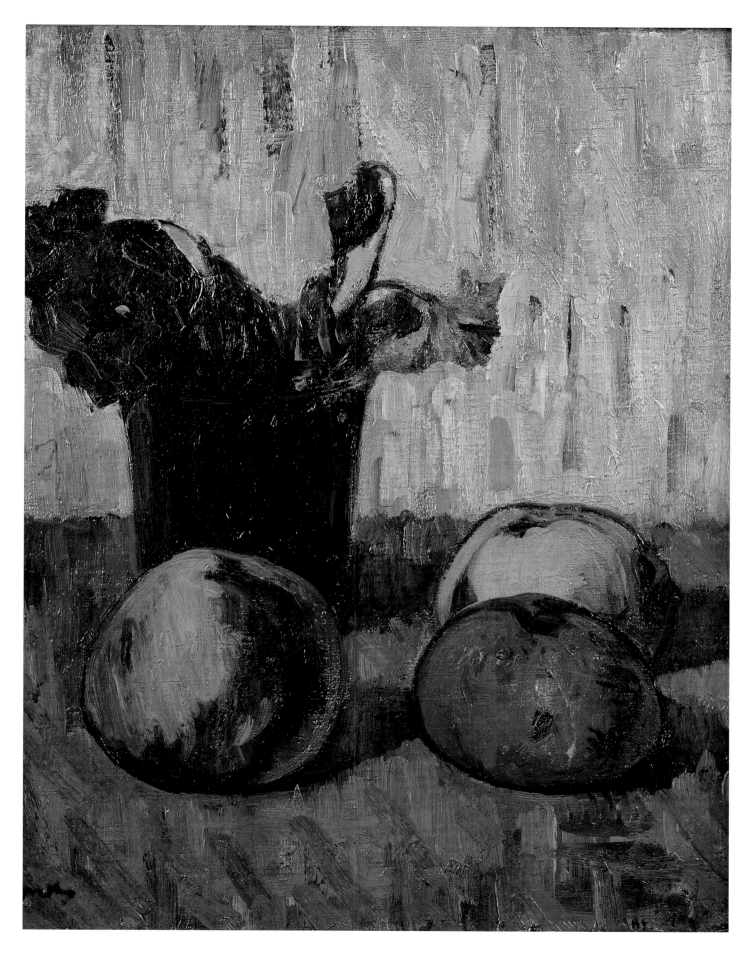

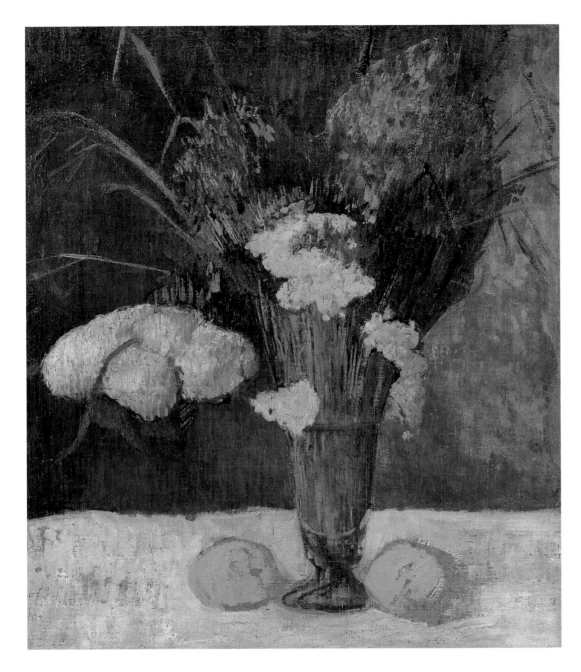

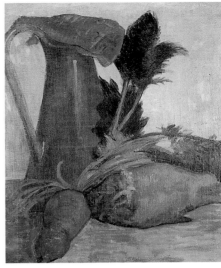

54. Meyer de Haan, *Vase of Lilacs and Snowballs with Lemons, c.*1889–90, oil on canvas, 25 ⅝ × 17 ¾ in. (65 × 45 cm). Private collection. *Exhibition no. 39*

55A. Meyer de Haan, *Still Life: Jug and Beetroot, c.*1890, oil on canvas, 25 ⅝ × 21 ¼ in. (65 × 54 cm). Private collection

55B. Meyer de Haan, *Dunes at Le Pouldu,* 1889, oil on canvas. Private collection

DE HAAN AND GAUGUIN AT WORK

By August 1889, de Haan's work was revealing his efforts to abandon both his dark palette and his academic style; he was making numerous daily sketches and still-life studies. A series of these gigantically conceived still lifes has survived, *Still Life: Jug and Beetroot* (Fig. 55A) demonstrates his transitional style that summer, as well as a continued preference for the monumental compositions associated with his work in Amsterdam. Gauguin reported to Theo: "I am happy in what he is making in the sense that [his work] has changed direction, his old beliefs have begun to be rearranged without throwing him off balance."[101] During Gauguin's visit to Pont-Aven in September, de Haan continued to work steadily alone in Le Pouldu. One of his earliest landscape paintings, *Dunes at Le Pouldu* (Fig. 55B) documents his new palette of blue, green and

ocher/reds as well as his new composition based on large simplified planes. He informed Theo in October that upon Gauguin's return, his teacher had said that: "I had worked frightfully hard and that I had gained a lot without losing my personality," and that he found everything he was doing "très grave." De Haan's landscapes that summer anticipated the synthetist style created the following year in his study, *Kerzellec Valley, Le Pouldu,* the same site that Gauguin painted (Figs. 60, 61) from a more panoramic viewpoint that summer. In the same letter, de Haan acknowledged his gratitude to Gauguin for having put him "on the track" and while the latter had been away, he had made studies every day until he understood what he wanted to achieve and felt that he had been successful in what he produced. But, he conceded to his friend : "I do not yet feel that I am marching on the new road but it will come by

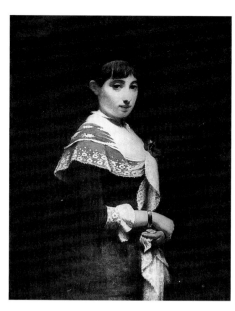

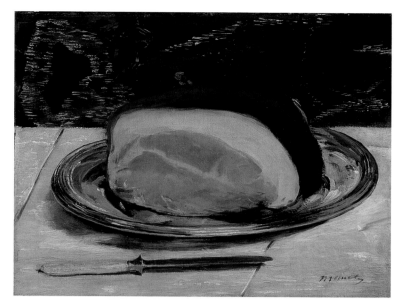

56. Meyer de Haan, *Portrait of a Young Jewish Girl*, c. 1886, oil on canvas, 53 ½ × 39 ⅜ in. (136 × 100 cm). Jewish Historical Museum, Amsterdam

57. Edouard Manet, *The Ham*, c. 1875–83, oil on canvas (32.4 × 41.2 cm). Glasgow Museums, The Burrell Collection

58. Meyer de Haan, *Still Life with Ham*, 1889, oil on canvas, 13 × 18 ½ in. (33 × 47 cm). Norton Simon Museum, Pasadena

59. Paul Gauguin, *The Ham*, 1889, oil on canvas, 19 5/8 × 22 ⅞ in. (50 × 58 cm). The Phillips Collection, Washington, D.C. *Exhibition no. 5*

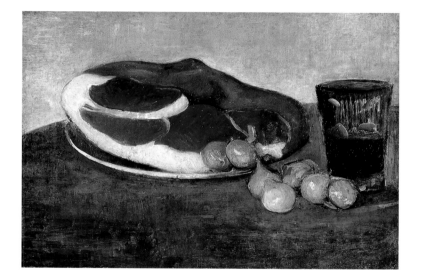

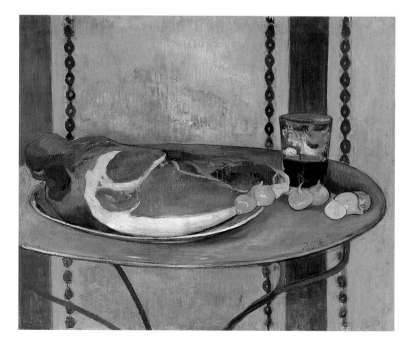

itself. Impressionism is so hard, I could not have imagined this."[102] It is evident from de Haan's remarks that he considered his studies up to that month initial steps towards Impressionism.

The following year de Haan seemed to have moved closer to Impressionism as revealed in two Cézanne-inspired *Still Lifes* (Figs. 53, 54). On the other hand, clearly de Haan had made remarkable progress in adopting Gauguin's stylistic simplifications. De Haan's painting *Kerzellec Farm, Le Pouldu* (Fig. 63) dated 1889, compared to Gauguin's canvas representing the same site the following year (Fig. 62), is an example of his strides to depict the composition in his teacher's synthetist style. The dominant naturalism of de Haan's painting, representing the Kerzellec farm, located a short distance behind Marie Henry's inn, reflects his remaining Dutch realist heritage and color preference. Yet by his simplification of the farm's architectural forms, it illustrates, if not his emerging symbolist interests, at least his conversion to Gauguin's synthetism. In contrast, Gauguin's *Kerzellec Farm, Le Pouldu* adopted a less claustrophobic view and introduced a note of the primitive, yet poetic, realities of Breton life by means of evocative color and narrative detail of farm life. His well-known reverence for Cézanne's art and especially the still lifes, was part of de Haan's curriculum as his *Still Life with Apples* from 1890 reveals (Fig. 53). Gauguin's own indebtedness to Cézanne is seen in the *Still Life with Apples, a Pear, and a Ceramic Jug* (Fig. 52). Gauguin completed *The Ham* (Fig. 59) in Paris after seeing Manet's still life, *The Ham* (Fig. 57), in the winter of 1889. It is far more likely that this work was produced in Le Pouldu in the company of de Haan, as the similar arrangement in the latter's own version of the subject (Fig. 58) suggests. On the other hand, their differing approaches are also apparent by comparing de Haan's somber realism and asymmetrical arrangement to Gauguin's decorative simplifications and expressive use of "exotic pungent colors" in his centralized composition.[103]

De Haan's close artistic relationship with Gauguin by October 1889 is further revealed in two paintings that relate both to his teacher's work and that of Sérusier. De Haan included Marie

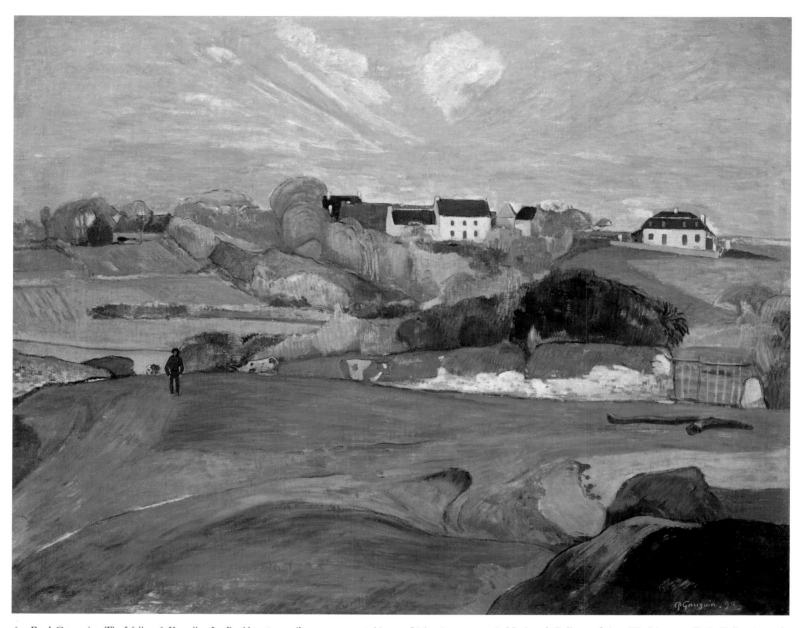

60. Paul Gauguin, *The Valley of Kerzellec, Le Pouldu*, 1890, oil on canvas, 28 ½ × 35 ⅞ in. (73 × 92 cm). National Gallery of Art, Washington, D.C. Collection of Mr and Mrs Paul Mellon. *Exhibition no. 12*

61. Meyer de Haan, *The Valley of Kerzellec, Le Pouldu*, 1889–90, oil on canvas, 23 ⅝ × 28 ¾ in. (60 × 73.1 cm). Private collection, courtesy Galerie Hopkins, Thomas, Custot, Paris. *Exhibition no. 42*

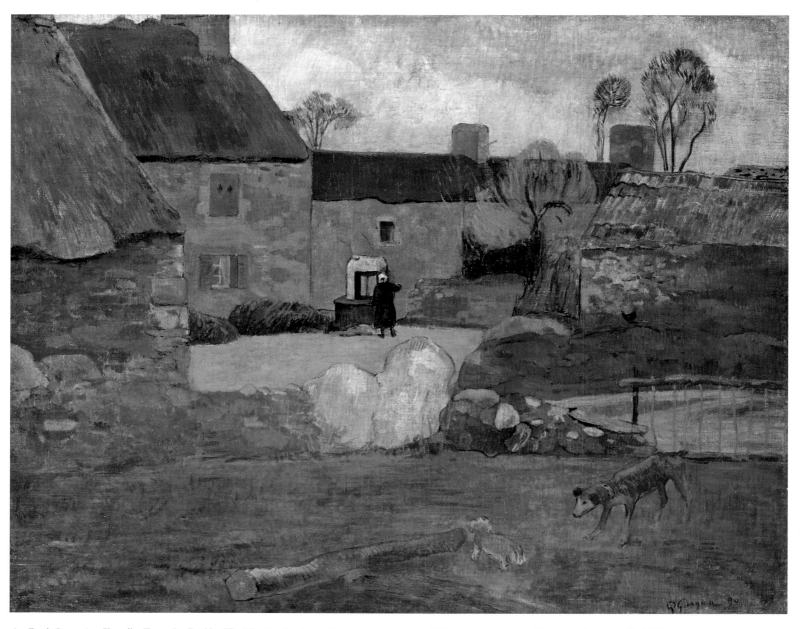

62. Paul Gauguin, *Kerzellec Farm, Le Pouldu (The Blue Roof)*, 1890, oil on canvas, 28 × 35 ½ in. (71 × 90.3 cm). Private collection. *Exhibition no. 13*

63. Meyer de Haan, *Kerzellec Farm, Le Pouldu,* 1889, oil on canvas, 28 ⅞ × 36 ⅜ in. (73.5 × 93 cm). Kröller Müller Museum, Otterlo

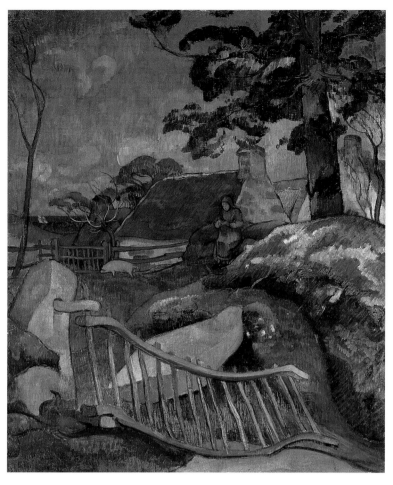

64. Paul Gauguin, *The Gate*, 1889, oil on canvas, 36 ⅜ × 28 ¾ in. (92.5 × 73 cm). Kunsthaus Zurich

65. Charles Laval, *The Gate*, c. 1890, gouache on paper mounted on cardboard, 22 ⅞ × 18 in. (58 × 45.9 cm). Private collection

Henry's seven-month-old infant in *Still Life with Profile of Mimi* (Fig. 94) at the same time as Gauguin and Sérusier had completed their respective portraits of de Haan which also included the infant's head.[104] De Haan's second canvas, *Maternity* (Fig. 102), represented the innkeeper as a sort of Breton Madonna nursing her infant, and must date, if not during Sérusier's stay in Le Pouldu, then shortly after his departure in mid-October. De Haan's earlier portraits of young women (Fig. 56), demonstrate the degree to which his synthetist/cloisonist style had matured by that fall.[105] *Maternity* had been produced independently of Gauguin's guidance and de Haan showed it to his teacher only after its completion.[106] This painting, which held a prominent position on the east wall of the dining room, reveals evidence of possible corrections by Gauguin, as do *Still Life with Profile of Mimi* and *Kerzellec Farm, Le Pouldu* (Fig. 63). These revelations appear to corroborate evidence of Gauguin's additions to one Sérusier landscape in the summer of 1890. In the middle ground of *Thatched Cottage with Three Ponds* (Fig. 69) Gauguin introduced his new divided brushstrokes.[107]

Gauguin's eight months in Brittany from June 1889 to the early days of February 1890 were the most productive period of his artistic career in France. His own intimations of the imminent breakthrough in his art were announced to Bernard when he declared that he hoped to find "an almost new Gauguin" next winter.[108] By the beginning of June he had commenced work on his first major canvas, *Christ in the Garden of Olives* (Fig. 72), which proclaimed his new interest in religious iconography. This canvas, which he feared would not be understood, was not intended to be sent to Theo, who, on receiving a consignment of recent canvases in September, had deemed them disappointing.[109] The summer, nevertheless, resulted in the completion of a series of canvases, mainly in the company of de Haan and Sérusier in Le Pouldu, which captured the varied facets of rustic Breton life. By late 1889, he had completed his allegorical portrait *Bonjour Monsieur Gauguin* (Fig. 101), a canvas mounted on panel with specific personal meaning to the artist whose symbolic presence featured as a sort of introduction on the interior door of Marie Henry's dining room.[110] Included in it was the wooden fence that appears in his Cézanne-inspired study, *The Gate* (Fig. 64), which may have been completed in the company of Laval, as evidenced by the presence of the same thatched farmhouse and wooden gate in Laval's gouache (Fig. 65). Gauguin's reverence for Cézanne explains why he instructed his students to follow similar stylistic experiments by urging them:

"Let's do a Cézanne."[111] Upon Sérusier's return to Le Pouldu the following summer, he too, employed the motif of a traditional wooden fence for his Cézannesque canvas, *The Gate* (Fig. 67) – the same wooden barrier and farm house that both Gauguin and Laval had depicted the previous summer appear in Sérusier's *The Gate with Flowers* (Fig. 66). This study must have been completed sometime before his departure from Le Pouldu at the end of July 1890, because it is clearly related to both *The Gate* and *Bonjour Monsieur Gauguin*.

Sérusier's study of Gauguin's Volpini paintings in Paris followed by his three weeks spent in Le Pouldu in October of 1889 had already converted him to Gauguin's philosophy on the role of nature in art. In mid-October he explained his newly discovered ideas to Maurice Denis stating that there are immutable principles in art that exist apart from nature; a science known to the primitives, as well as Japanese artists, based on laws of impeccable harmonies of line and color. He explained that these aesthetic considerations, when combined with the freedom of the artist's personality, transform a work of art from a mechanical illustration into an expression of the poetic abstraction of nature.[112] Both Sérusier's and de Haan's experiments in Le Pouldu were motivated by these principles. A group of works from the summer of 1890 depicting harvesting themes, including Sérusier's *Seaweed Gatherer* (Fig. 71) and de Haan's *The Farmhouse at Le Pouldu* (Fig. 73B), reflects the synthetism that Gauguin had demonstrated in his own works (Figs. 60, 62). A close connection in both theme and style exists between de Haan's powerfully conceived synthetist canvas

66. Paul Sérusier, *The Gate with Flowers*, 1889, oil on canvas, 28 ¾ × 23 ⅝ in. (73 × 60 cm). Musée d'Orsay, Paris

67. Paul Sérusier, *The Gate*, 1890, oil on canvas, 19 ⅞ × 24 ⅜ in. (50.5 × 62 cm). Musée d'Orsay, Paris, gift of Mlle. Henriette Boutaric, 1983. *Exhibition no. 46*

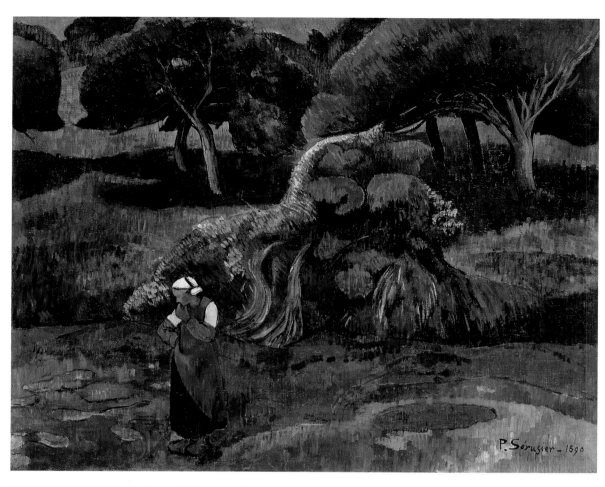

68. Paul Sérusier, *Landscape at Le Pouldu*, 1890, oil on canvas, 29 ¼ × 36 ¼ in. (74.3 × 92.1 cm). Museum of Fine Arts, Houston. Gift of Alice C. Simkins in memory of Alice Nicholson Hanszen. *Exhibition no. 43*

69. Paul Sérusier, *Thatched Cottage with Three Ponds*, c. 1889–90, oil on canvas, 28 ¾ × 36 ¼ in. (73 × 92 cm). Private collection

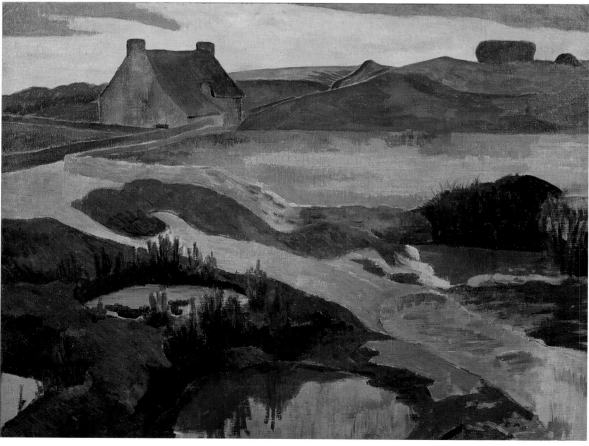

70. Paul Sérusier, *The Little Cowgirl, c.* 1889, oil on canvas, 14 ⅝ × 21 ⅛ in. (37 × 53.5 cm). Private collection. *Exhibition no. 45*

71. Paul Sérusier, *Seaweed Gatherer*, 1890, oil on canvas, 18 ⅛ × 21 ⅝ in. (46 × 55 cm). Indianapolis Museum of Art. Samuel Josefowitz Collection of the School of Pont-Aven. Through the generosity of the Lilly Endowment, Inc., the Josefowitz family, Mr. and Mrs. James M. Cornelius, Mr. and Mrs. Leonard J. Betley, Lori and Dan Efroymson and other Friends of the Museum. *Exhibition no. 44*

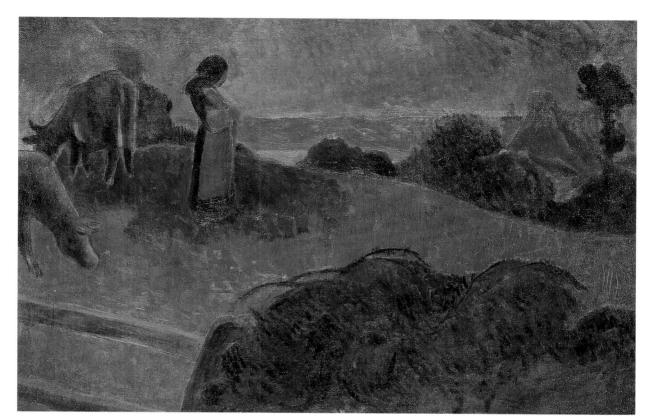

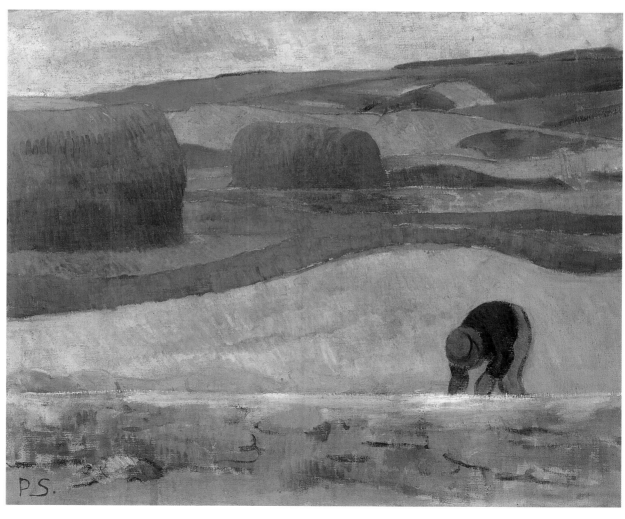

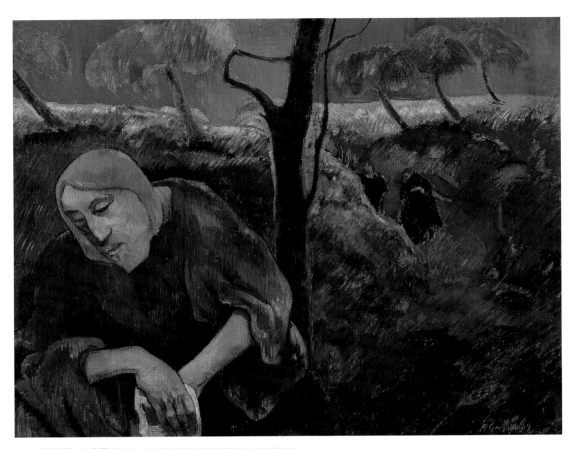

72. Paul Gauguin, *Christ in the Garden of Olives*, 1889, oil on canvas, 28 ½ × 35 ⅞ in. (73 × 92 cm). Norton Museum of Art, West Palm Beach, Gift of Elizabeth C. Norton

73A. Paul Sérusier, *Farmhouses at Le Pouldu*, 1890, ink wash drawing, 14 ½ × 17 ⅝ in. (37 × 45 cm). Private collection

73B. Meyer de Haan, *Farmhouses at Le Pouldu*, c. 1890, canvas, 35 ½ × 28 ¾ in. (90 × 73 cm). Private collection

Farmhouse in Le Pouldu (Fig. 73B) and Sérusier's pen-and-ink drawing *Farmhouses at Le Pouldu* (Fig. 73A). These confirm the transformation of their drawing styles and the artistic cohesion in which they worked during the summers of 1889 and 1890.[113] By Sérusier's second visit to Le Pouldu in July of 1890, he informed Denis: "I live between Gauguin and de Haan…in a dining room at the inn we have decorated and embellished." In that same letter he added that his drawing style had been transformed and that instead of pure color it was preferable to use mixed colors applied in short brush strokes, in other words Cézanne-like strokes,[114] seen in *Thatched Cottage With Three Ponds* (Fig. 69).

Sérusier's departure in mid-October 1889 prevented him from witnessing the culmination of Gauguin's and de Haan's researches, which had resulted in the decoration of the dining room. Upon his return in the summer of 1890, he was evidently impressed by the new monumental scale and powerful abstractions. In particular, de Haan's colorful simplification found in *Breton Women Scutching Flax* (Fig. 107) must have inspired Sérusier's own canvas, *Three Breton Girls at Le Pouldu* (Private collection).[115] His symbolic concept of Breton nature seems to have commenced only by the summer of 1890 as his *Landscape at Le Pouldu* (Fig. 68) indicates. Sérusier's silent, symbolic figure expressing melancholy and the poetic evocations associated with mysterious ancient Breton life had been clearly inspired by Gauguin's canvases completed the previous winter.

By the time Sérusier left Le Pouldu in the summer of 1890, his artistic philosophy and technical practice had been converted to

Gauguin's credo of the existence of a sublime and spiritually pure art unsullied by material speculation.[116] This belief was based on Richard Wagner's famous dictum, which Sérusier is recorded as having inscribed in emerald green on the west wall of the dining room.[117] The key statement read: "I believe in a last judgment where all who have dared to profit from a sublime and pure art and who have soiled and debased it by their greed, by their vile covetousness for material gains shall be condemned to suffer terrible pain."[118] Prior to Gauguin's arrival in Arles in the fall of 1888, van Gogh had also read about Wagner's ideas on music and art.[119] Discussion in Arles would have included Wagner's philosophy on the divine calling of the artist to produce a spiritual work based on the harmonious union of all the arts. Sérusier's inscription on the dining room west wall in 1890 represented an affirmation of the growing interest in Wagner's syncretism by contemporary symbolist artists and writers of the period as a reaction to a Positivist concept of nature.

Gauguin's growing religious obsession was revealed in *Christ in the Garden of Olives*. By the end of 1889, he had completed a series of paintings based on Breton religious life: *The Yellow Christ*, *Self Portrait with Yellow Christ* (Fig. 177) and *The Green Christ* (Fig. 74). At the same time he continued to focus on portraying the harsh struggle of peasant labor, a theme epitomized that winter in his monumental composition, *The Seaweed Gatherers*. The fresco decorations for the west wall of the dining room – de Haan's *Scutching Flax* and Gauguin's *The Spinner* (Fig. 108) – represent the culmination of this theme of rustic life. Gauguin had confided to van Gogh that in Brittany the peasants' medieval clothing, like their Breton language, not only exuded primitiveness but also expressed their religiosity. He noted that Breton peasants held "their hats and all their utensils as if they were in church" and commented that their starkly geometric peasant costume appeared to have been "influenced by Catholic superstitions." He added a sketch to the letter (Fig. 75) advising van Gogh to look closely at the symbolic cross-like configuration on the back of the tunic and particularly the headdress that gave the appearance of garments "worn by religious orders."[120]

That same winter Gauguin's attention turned to his first major sculpture. He announced to van Gogh: "I have made this year unprecedented efforts in work and reflection."[121] This statement referred, in particular, to his recent preoccupation with work on *Be In Love and You Will be Happy* (Fig. 77). This relief reflected his interest in the polar struggles between matter and spirit which had preoccupied him in *Woman in the Waves* and *Life and Death*. However, the sculpture also evidently expressed his concern with his sexual desires. In the same letter he reported that his wood relief was, in both power and harmony, his best work so far, though from the literary point he conceded that it was "very much absurd." He added that he identified himself as the salivating monster who is seen tucked in the upper right section of the work who grasps the principal figure's hand. He described this Courbet-like nude as being situated between the biblical city of Babylon – a symbol of lechery – above left, and the countryside below containing imaginary flowers, where an old grieving woman is depicted

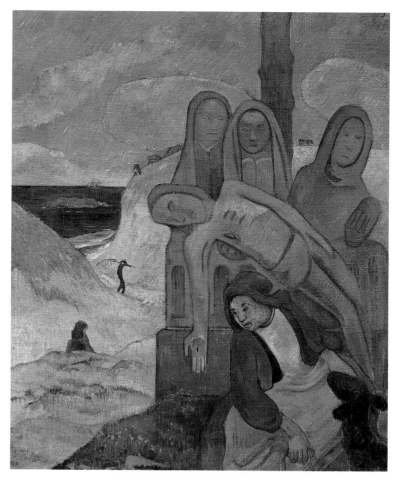

74. Paul Gauguin, *The Green Christ*, 1889, oil on canvas, 36 ¼ × 28 ¾ in. (92 × 73 cm). Musées Royaux des Beaux-Arts de Belgique, Brussels

with the figure of the fox, symbol of "the fateful animal of perversity amongst the Indians." This symbolist sculpture, and its pendant, *Be Mysterious* (Fig. 76), done in the following year, represent the culmination of Gauguin's research since his return from Martinique with compositions for his wood reliefs aimed at rejecting impressionist perspective and the order of the natural world in favor of the abstract organization of mysterious ideas.[122] In order to enhance the symbolic character of the painted subject he waited to find a fine quality linden wood whose smooth grain and hue would enliven the colour scheme and the sensual quality of the nude's skin. He wrote to van Gogh: "You must see the colour of the wood which marries so well with the painted ground…On this waxed wood there are reflections which the light casts on the relief parts which give it richness."[123]

That winter Gauguin employed recurring motifs which are associated with the decoration of Marie Henry's inn in a painting inscribed *Maison Marie Henry* (Fig. 105), on the dining room ceiling decoration, and on a small carved and painted barrel (Fig. 79). Gauguin's interest in the goose as emblematic of farm life at Le Pouldu may also have held ironic allusion to the female inhabitants of the hamlet. His painted oak relief (Fig. 78) may not in

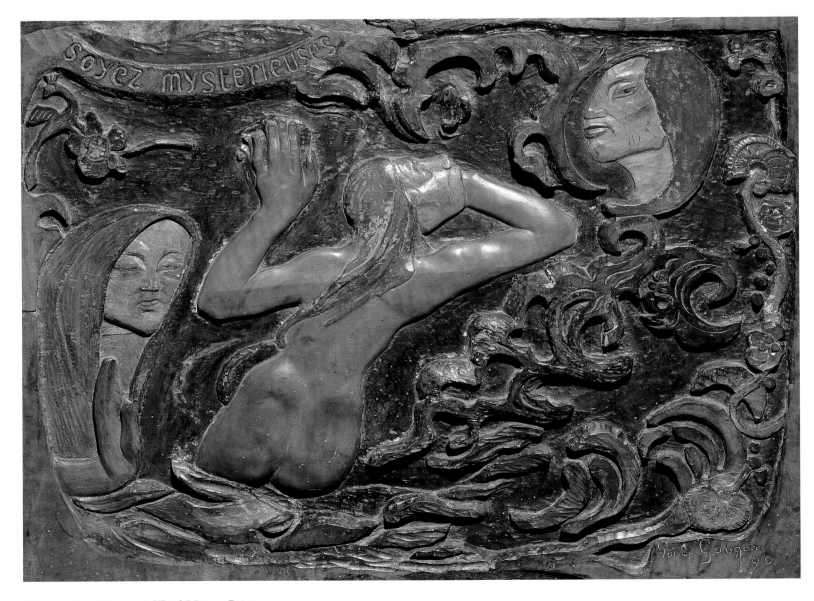

75. Paul Gauguin, Letter to Vincent van Gogh with drawings, late 1889. Rijksmuseum Vincent van Gogh, Amsterdam

76. Paul Gauguin, *Be Mysterious*, 1890, polychromed wood relief, 29 × 37 ½ in. (73 × 95 cm). Musée d'Orsay, Paris

77. (*facing page*) Paul Gauguin, *Be in Love and You will be Happy*, 1889, polychromed linden wood, 37 ½ × 28 ½ in. (95.3 × 72.3 cm). Museum of Fine Arts, Boston, Arthur Tracy Cabot Fund

fact depict swans, but more likely three decorative geese frolicking in water bordered by foliage. It is easy to confuse these long necked birds with their elegant counterparts, but it is geese and not swans that reflect the rustic life and region.[124] He seems to have specifically selected for inclusion the symbolically charged motif of another barnyard fowl – the rooster – for both his barrel, and, in particular, for his bust, *Meyer de Haan* (Fig. 98).[125] In contrast to the erotic quality suggested by the linden wood of *Be in Love and You Will Be Happy*, he selected a rough massive oak for his pupil's portrait, expressing perhaps his traditional values and realist affinities. De Haan's headdress and intensely reflective, orientalized image and closed eyes, suggest the mystical contemplation of an eastern priest/scholar. At the same time the artist injected a humoros as well as an ironic note into his portrait by placing a rooster on top of de Haan's skullcap – an obvious pun on the Dutchman's name.[126] The symbol of the rooster also held religious connotations for de Haan, which he may have discussed with Gauguin. Traditionally, before Yom Kippur, the Day of

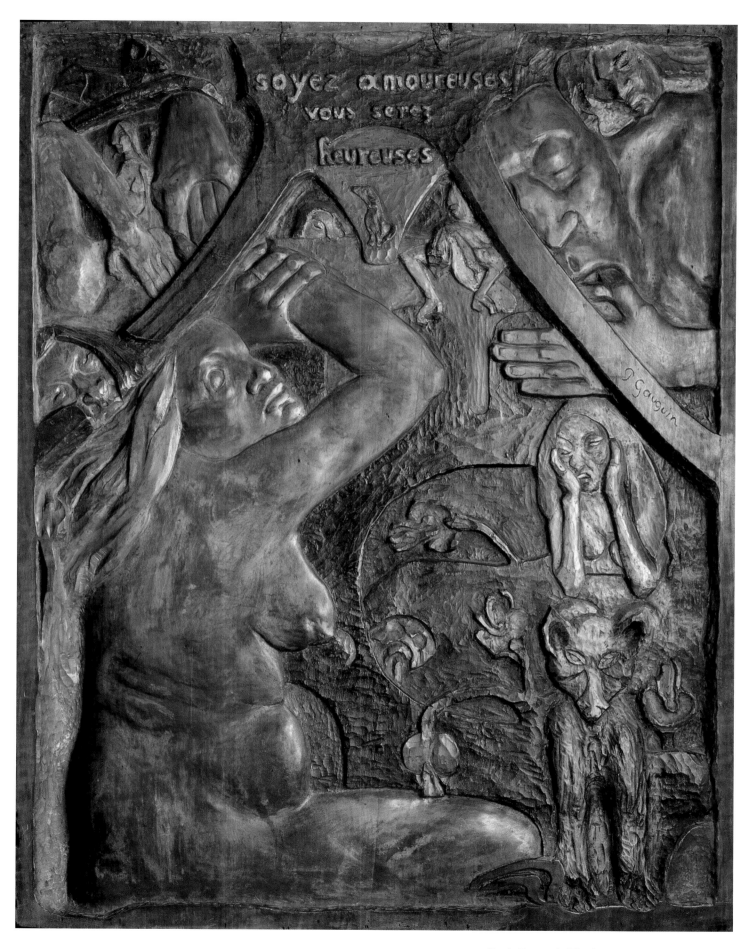

Soyez amoureuses vous serez heureuses

P. Gauguin

78. Paul Gauguin, *The Swans*, c. 1889–90, polychromed wood relief, 7 ¾ × 12 ⅞ in. (19.6 × 32.8 cm). Private collection. *Exhibition no. 20*

79. Paul Gauguin, *Carved Wooden Cask*, c. 1889–90, 12 × 12 × 14 in. (30.5 × 30.5 × 35.5 cm). The Latner Family Collection. *Exhibition no. 18*

Atonement, a rooster is sacrificed in a ceremonial ritual in which the fowl is swung over the male's head.[127] In *Is the Chicken Kosher?* (Fig. 29) de Haan had depicted another Orthodox subject. The oak sculpture was given a prominant position in the inn, on the mantelpiece on the north wall, flanked on one side by Gauguin's *Meyer de Haan by Lamplight* (Fig. 148) where the Dutch artist is portrayed in association with esoteric literature. It has been presumed that the copy of Carlyle's *Sartor Resartor*, placed next to *Paradise Lost* in *Meyer de Haan by Lamplight* must have belonged to Gauguin. By 1888, Carlyle's book in fact, had been read by de Haan, and also associated with his art in Amsterdam (see Figs. 141–3). That year de Haan's admirer, the Dutch writer J. Zürcher, reviewed *Uriel Acosta* then on exhibit in the context of Carlyle's book.[128] In both the painting and the sculpture, the identically posed de Haan expresses two of his quintessential characteristics: his pensive personality and his orthodoxy. Gauguin's portrayals illustrate not only satanic and ironic references to his pupil but also, as Françoise Cachin has noted, the ideal philosophical nature of a man who had "something about him truer to life, of the traditional rabbi and Jewish sage, the man who knows the Good Book and passes on his knowledge."[129] The impact of Gauguin's symbolist portrayal of de Haan in connection with philosophical and mystical books is revealed in Sérusier's association of occult literature with the portait of the Nabi artist Paul

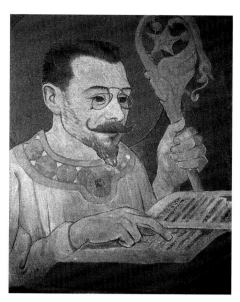

80. Paul Sérusier, *Portrait of Paul Ranson*, 1890, oil on canvas, 21 ⅝ × 17 ¾ in. (60 × 45 cm). Private collection

81. Paul Gauguin, *Preparatory Drawing for The Loss of Virginity*, 1890–91, charcoal and chalk on paper, 12 ¼ × 13 in. (31.6 × 33.2 cm). Marcia Richlis collection

82. Paul Gauguin, *Lust*, 1890, gilded and polychromed oak and pine wood and metal, 27 ½ × 6 × 2 ¾ in. (70 × 15 × 7 cm). J. F. Willumsens Museum, Frederickssund, Denmark

 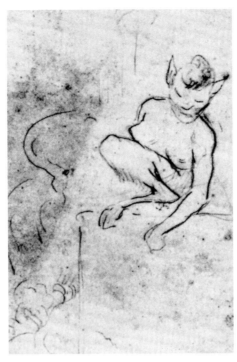

83. Paul Gauguin, *Mystère*, 1889, graphite drawing on lined paper, 6 ⅝ × 4 ⅛ in. (17 × 10.5 cm). Israel Museum, Jerusalem, gift of Sam Salz

84. Paul Gauguin, *A Satyr and Other Designs* (detail), 1887. Album Briant. Musée d'Orsay, Paris

85. Odilon Redon, *Face of Mystery*, 1885, lithograph on paper, 10 ⅞ × 7 ⅝ in. (27.6 × 19.5 cm)

Ranson which was completed after his return to Paris in 1890.[130]

Gauguin's fascination with the new iconographic theme of the fox, which surfaced in *Be In Love and You Will Be Happy*, preoccupied his thoughts during late 1889, and returned again in 1891. He introduced a totemic representation of this figure which, to him, represented the Indian "symbol of perversity," in conjunction with the Christian image of the grieving Eve. A similar context is seen in *Nirvana*, where the figure of the despairing Eve is associated with de Haan's features, which themselves have been described as representing those of a fox–devil.[131] In the fall of 1890, Gauguin apparently produced a ceramic sculpture, which has since been destroyed, inspired by a figure on a Cambodian bas-relief.[132] This ceramic served as model for his oak version, *Lust* (Fig. 82), completed in late 1890, which included an image of a fox. The following spring he presented it to his new Danish artist friend, J. F. Willumsen. Sometime during the winter of 1890/91 Gauguin once again painted this fox-like creature as a symbol of lubricity, presiding over the reclining maiden's breast in *The Loss of Virginity* (Fig. 86), where it is positioned, as in *Nirvana*, against the Le Pouldu coastline.[133] As these works illustrate, Gauguin had replaced the reptile representing the serpent of the Garden of Eden tempting Eve as in his Volpini *Eve* (Fig. 15), with the image of the fox as a symbol of sexual temptation and perversity.[134]

The image of the fox also appears in medieval Bestiaries and Church decoration where the figure symbolized lust, among other vices.[135] In Gauguin's sketchbook (Fig. 33) from his Breton period in 1889, he reveals his gradual transmutations of a dog/fox animal into the figure resembling a fox. Two of these drawings illustrate a process of transformation from the tame looking animal into a sinister and hypnotic fox as he appeared later in *Be In Love and You Will Be Happy*.[136]

Such equations of animal and man appear in Brittany in 1889 as we see in the artist's transmutation of his own visage into a kind of Pre-Darwinian webbed-footed fowl-man for his self portrait aptly titled, *Mystère* (Fig. 83). Indeed, in this image of a bird/man wearing a beret we can read the artist's intention of light-hearted caricature, a genre in which he engaged, both in France and the South Seas.[137]

However, these sketches also confirm Gauguin's anti-naturalist interest by his endowment of nature with improbable reality and ambiguous mystery. Such symbolist reflections may have anticipated his concept of de Haan's fox-like appearance in *Nirvana*. In fact, already in 1887 in Martinique, Gauguin, appears to have presaged de Haan's features in his sketch of a figure representing a hoofed satyr or faun (Fig. 84) that resembles the portraits of his pupil made in 1889, as well as later in Tahiti. De Haan's features have been transformed to incorporate triangulated forms similar to the animal's. In particular the Dutchman's pointed ears resemble those of the mythical creature. Gauguin's animalization of de Haan's features has been seen as a reflection of pre-Darwinian speculation of "animal-in-man," which preoccupied the early seventeenth-century drawings of "Fox Men" by Charles Le Brun.[138] Gauguin's acquaintance with the symbolist art of Odilon Redon since the 1880s was also significant for his interest in transmuting

86. Paul Gauguin, *The Loss of Virginity*, 1890–91, oil on canvas, 30 × 50 ¾ in. (90 × 130.2 cm). Chrysler Museum of Art, Norfolk. Gift of Walter P. Chrysler, Jr. *Exhibition no. 15*

human form to express spiritual and mystical transcendence. He wrote from Tahiti to Redon: "Of you, I have in my head, the recollection of almost everything you have created."[139] Redon's enigmatic monsters, based on diverse artistic and literary sources and modern science, had influenced Gauguin's art by 1889 as in his *Still Life with Japanese Print* (Fig. 183), painted that summer in Brittany.[140]

De Haan's "hypnotic" eyes in *Nirvana* have been interpreted as symbolizing his fox/sorcerer image. However, they can also be compared to Redon's depictions of visionary eyes associated with his portrayal of religious and mystical leaders such as Christ and Buddha. As Redon had done, Gauguin was seeking to express, through de Haan's trance-like stare, his pupil's out-of-consciousness state, a sign of the attainment of ultimate reality in Buddhist and Hindu belief, the final step in spiritual evolution called "nirvana." Both symbolists reflect themes that represent the supremacy of spirit over matter. This was a key issue in the philosophical mystical doctrines that captivated symbolist artists, writers, poets and critics, including J. K. Huysmans, Stéphane Mallarmé and Albert Aurier, between the 1870s and 90s in Paris. The development of this new idealist philosophy and interest in mystical and occult issues resulted from a spiritual revival among a generation in seeking alternatives to Positivist doctrines and traditional religious belief. In this context, Gauguin's symbolist portrait of his pupil in *Nirvana* is interesting to compare to Redon's lithograph, *Face of Mystery* (Fig. 85). Redon's visionary figure is represented as an ancient, bearded, mask-like figure in priestly headdress who, in his trance-like state, presides as mediator over material and spiritual matters. Mallarmé described the mystical figure as a magus and seeker of truth, while Huysmans stated that the primitive image evoked: "a Chaldean Magus, an Assyrian king, old Sennacherib insurrected."[141] This description aptly applies to Gauguin's concept of de Haan's persona, which, by his bearded countenance and costume, evokes the image of the ancestral priest/magus figure of his Jewish heritage. Sérusier was equally intrigued by de Haan's origins, reporting to Paul Ranson that he was a man who: "knows the words of the Hebrew Bible, and even sings the words of the Nabis (prophets) to primitive rhythms."[142]

The literature on Gauguin provides scant first-hand evidence of his esoteric knowledge during 1889–90. We have some idea of his interests reflected by his inclusion of such books as *Paradise Lost* and *Sartor Resartus*, in his portrait, *Meyer de Haan by Lamplight* (Fig. 148). Based upon the inscription of Wagner's credo in Marie Henry's dining room (see p. 63), it is clear that the artist firmly upheld the necessity of a pure and sublime art with the spiritual triumphing over the material. Furthermore, it appears that Gauguin was attracted by the ideas propounded by Balzac in *Séraphîta*, a novel that was probably introduced to the circle by Sérusier during 1889–90.[143] However, given Sérusier's brief three-week stay in Le Pouldu in 1889, it is unlikely that he would have discussed in any depth his recent theosophical interest in esoteric literature including Edouard Schuré's book *Les Grands Initiés* (see p.105) with Gauguin before the completion of *Nirvana*. Furthermore it was not necessary for Gauguin to understand esoteric theories, such as those found in Schuré's popular book or in the Kabbalah, the mys-

tical stream in Judaism, in order to apply them to his symbolist art. In any case, these doctrines did not convert him into a theosophist or Rosicrucian. Schuré's book could not have introduced him to Buddhism since it made no reference to the Buddha in its reconstruction of the living chain of various religions.[144] It remains difficult to determine when Gauguin became exposed to Buddhist concepts. It is clear that by the summer of 1888 Gauguin's contact with van Gogh may have triggered his interest in Buddhist beliefs. While Gauguin was in Pont-Aven, van Gogh dedicated to him his *Self Portrait* which, he explained in a letter, represented his orientalized image suggesting "a simple bonze worshiping the Eternal Buddha."[145] Van Gogh's well known admiration for Japanese art led him to incorporate Buddhist beliefs into his Protestantism, and had probably stimulated Gauguin's own religious ideas by 1889. Prior to Gauguin's arrival in Arles it seems that van Gogh's readings in 1888 had included an article by the oriental scholar Emile Burnouf, published in the journal *Revue des deux Mondes* that summer, and this may have inspired the *Self Portrait* sent to Gauguin.[146] Burnouf's theosophical account traced the common origins of all the occidental and oriental religions including Buddhism, and may have influenced not only van Gogh's image as an Eternal Buddha, but also Gauguin's syncretism for his *Nirvana*. Burnouf's ideas, not unlike those published a year later by Schuré, examined Christianity as having evolved from ancient oriental religions, and specifically identified Buddhism as containing religious concepts in common with Western beliefs.[147] Burnouf stressed that the Buddhist idea of "nirvana," defined as extinction, comparable to the act of the blowing out a lamp and which also means absence of breath, corresponds to the Christian concept of death as *requies aeterna* (eternal rest) or *lux perpetua* (perpetual light).[148] More significantly, in the context of our understanding of Gauguin's portrait of de Haan in *Nirvana*, Burnouf argued that the ideas and practices of Judaism are related to Buddhism. In the fall of 1890, after receiving news of van Gogh's tragic death, Gauguin continued to associate his friend with Buddhist beliefs. He wrote to Bernard: "If he awakens in another life, he will reap the reward of his good conduct in this world (according to the teaching of Buddha)."[149]

Gauguin's collaboration with van Gogh in Arles resulted in a significant example of his emerging religious syncretism in the watercolor inscribed *Ictus* (Fig. 87) produced in 1889 after his return to Paris. In his sketchbook he noted, several words that contain religious associations with van Gogh and Christian themes, as well as his ideas related to esoteric associations. The artist recorded in pencil the following words: "Incas," "Serpent," "Saül," "Paul," "Ictus" and "Sain d'Esprit, Saint Esprit" (Fig. 137)[150] The latter couplet, as well as the word "ictus" held for Gauguin mystical connections with van Gogh's Christianity symbolising their artistic brotherhood. In the winter of 1889 van Gogh sent a letter to Gauguin in which he combined the word "ictus" (the Greek acrostic for "Jesus Christ Son of God the Savior") with a pictogram of a fish (in Greek *icthus*, an Early Christian symbol of faith).[151] Gauguin introduced into the composition of *Ictus* the word itself, as well as the fish symbol, in addition to the newly assimilated oriental motifs inspired by his visits to the Exposition universelle that

87. Paul Gauguin, *Ictus, c.* 1889–90, water-colour and oil on paper, 16 ⅜ × 22 in. (41.6 × 56 cm). Collection of Daniel Malingue, Paris

spring of 1889. This work, completed sometime after the spring of 1889 anticipated the syncretist concept of *Nirvana,* combining Christian and oriental religious iconography. The oriental-looking androgyne nude is posed in a semi-lotus position, with right arm extending towards the east(?) suggesting the Crucifixion, while the left hand approximates a Buddhist gesture.[152] *Ictus* reveals that Gauguin's equations between Christian and oriental symbolism were inspired not only by his discussions with van Gogh, but also with his recent encounters with the art and culture at the various Asian pavilions of the Exposition universelle.

Odilon Redon's syncretism, seen in the illustrations of Gustave Flaubert's *Tentation de Saint Antoine* in 1882, which Gauguin deeply admired, would have been equally relevant for his experiments in assimilating Christian and Eastern religious motifs.[153] Both *Ictus* and *Nirvana* illustrate Gauguin's alacrity in responding to the diverse stimuli available to him. His *Self Portrait with Yellow Christ* (Fig. 177) reaffirmed his interest in representing himself symbolically as mediator between the Christian and non-Christian world, by situating his image between that of the Crucifixion and his ceramic self portrait as a savage. This portrait clearly led to Emile Schuffenecker's own syncretism for his *Self Portrait* (Fig. 151) dated to circa 1890, in which he represented himself between Christian and Buddhist associations. Paul Ranson's *Christ and Buddha* (Fig. 152), dated to circa 1890–92, also included a specific reference to Gauguin's *Yellow Christ* in conjunction with two Cambodian Buddhas. These works not only attest to the influence of Gauguin's syncretism on the avant-garde, but at the same time confirm a mystical interest by modern artists in reconciling the two religious currents represented by Asia and Europe to their supposed original unity.[154]

This new fascination resulted from Gauguin's gradual exploration of ancient and exotic cultures which commenced upon his return from Martinique in late 1887. His ceramics from this period reveal his familiarity with Inca, Japanese and East Indian civilizations. His Martinique trip as well as visits to the Cambodian and Indian pavilions at the Exposition universelle inspired his little statuette, *Martinique Woman* (Fig. 115), a painted terracotta on a wooden base that decorated the wall above the fireplace holding the wood bust of Meyer de Haan. The pose of this sculpture reflects a combination of Martinique motifs that the artist had employed after his return from the Caribbean for one of his wood reliefs and a lithograph. After seeing the Javanese dancers at the Exposition universelle, Gauguin incorporated the hand gesture reserved for the typical opening stance of a Javanese dancer, for the left hand of the figure. His enthusiasm for oriental culture and his penchant for collecting photographs of such exotica are revealed in his letter to Bernard in the spring of 1889. He wrote: "You missed something in not coming the other day. In the village of Java there are Hindu dances. All the art of India can be found there, and the photographs that I have of Cambodia fit into that context."[155] It appears that Gauguin's fascination for Javanese art extended to decorating the dining room at Le Pouldu with a fragment of a sculpture he had found at the Exposition Universelle that represented a Javanese dancer. He also included in his fresco *The Spinner* (Fig. 108), a fanciful re-creation of the traditional sacred gestures associated with Cambodian sculpture and the dances of the Javanese performers as illustrated in a contemporary photograph from the Exposition universelle in 1889 (Fig. 113).[156]

Gauguin's inscription "Nirvâna" is further evidence of his religious syncretism late in 1889 at Le Pouldu. It reveals his view of

the interchangeability of Christian, Buddhist, Hindu and Hebrew philosophies about the cycle of life and death and the concept of ultimate release from earthly passions through attainment of spiritual enlightenment – nirvana. The figure of Meyer de Haan acts both as the catalyst, and the inspiration, for Gauguin's symbolism. In his previous portraits of de Haan, he had explored his pupil's erudite mystical character as well as his exotic origins; here Gauguin assimilates Christian notions of life and death to form a unified theme that is represented by the Buddhist inscription "Nirvâna."

The evidence of the technical study (pp. 143–7) may help to provide us with further clues to Gauguin's initial concept of his work. X-radiography indicates that de Haan's features were originally less oriental, suggesting that Gauguin may have expressly accentuated them to emphasize the middle-eastern origins of the Jewish faith. Furthermore, the report indicates that de Haan's hat and gown have been altered to become more abstract. This fascinating discovery may confirm that Gauguin's syncretism extended to his interest in de Haan's clothing in order to represent both his Orthodox faith and a generic type of religious clothing worn by other eastern personages. Apparently Gauguin not only made the fez-like cap more abstract, but he also altered the gown, which was originally more exotic. Such abstractions in de Haan's appearance may have resulted from Gauguin's wish to present his pupil as a member of all eastern religions, particularly those associated with the mysterious apparel worn by the ancient magus-rabbis of the Semitic world. However, the major discovery of the technical examination is the additional word "Touts" originally written on the painting (Fig. 198) and it will certainly stimulate new art-historical debate. The artist had initially included, and then evidently decided to obliterate, this word above "Nirvâna," thus giving his work a more ambiguous meaning. The word "Touts" seems to be perhaps a slight orthographical error on the part of the artist. If meant to be read as "Tous" in connection with the word "Nirvana," then the translation is "All Nirvana," signifying that *all* the figures reflect both Western and Eastern doctrines about the ultimate truth.[157]

Several years later, from Tahiti, Gauguin, added a phrase in his manuscript, "Diverses Choses," which elaborated on his religious syncretism and may perhaps reveal the meaning behind the use of the word "Touts." He wrote:

> Boudha simple mortel qui ne conçut, ne connut pas Dieu mais conçut et connut *toutes* l'intelligence du coeur humain, arriva à la béatitude éternelle, le Nirvana – la dernière étape de l'âme dans son mouvement progressif à travers des ages différent – *Tous* les hommes par leur sagesse, leurs vertus peuvent devenir des Boudhas.[158]

THE FINAL MONTHS IN LE POULDU AND PARIS 1890–91

By early January 1890, shortly after the completion of the major part of the dining room, Gauguin had already planned to leave Le Pouldu. Ridden by debt, he accepted Schuffenecker's generous offer to pay for his return to Paris in order to pursue his plans to leave for Tonkin.[159] His desperate, penniless situation impelled him to request support for this from the French government and yet at the same time he seems to have considered alternate plans for his future, including founding an atelier in Antwerp with de Haan and van Gogh.[160] In a letter to van Gogh he confessed that de Haan's serious artistic progress, evidenced by the recent completion of *Scutching Flax*, resulted in his pupil's unwillingness to return to his homeland where his compatriots would have reacted against his new stylistic transformations.[161] It appears that by late January, de Haan's own financial situation had also suffered a reversal after receiving news from Holland of his family's unwillingness to continue to support his artistic endeavours in Brittany; by their stringent action they hoped to force him to return to Holland.[162] By the time of Gauguin's arrival in Paris in early February, Theo also became aware of de Haan's difficult financial situation, informing his brother: "His family cannot understand at all why he doesn't stay with them, and seeing that they are terrible Jews they probably think they can force him to come back by cutting off his food supply."[163] By mid-June Gauguin had returned to Le Pouldu and was now considering a voyage to Madagascar. It was probably influenced by Emile Bernard, who also suggested Tahiti as a possible location. Gauguin concluded that Tahiti would indeed be a better destination, especially in consideration of de Haan's "not too good health."[164]

By early August, Gauguin had made up his mind to travel to Tahiti, in the company of de Haan and Bernard, a destination which he now considered would provide him with the tropical paradise he craved. The tragic news of van Gogh's death, which reached them during the first days of August, affected them deeply and terminated any possibility of the three artists travelling together.[165] By September, while completing that year's major sculpture, *Be Mysterious* (Fig. 76), which he described in a letter to Theo as " more beautiful than the first" (*Be In Love*), Gauguin confessed that not only was he without money, but that 1890 had not been a very productive year.[166] During the same month he revealed to Bernard his solicitous behavior towards de Haan in his plans for the voyage to Tahiti. He stated: "de Haan can go only by steamer …In any case we shall leave together de Haan and I. Because he would not venture to go there alone without us."[167] He requested at the same time that Theo seek an amateur who would be willing to purchase his work at a low price in order to settle his debts in Le Pouldu and to travel to Paris to prepare for his voyage. He informed Theo that de Haan was at the moment caught in a struggle with his family who he now perceived were mocking him.[168] Gauguin warned Theo not to discuss with anyone de Haan's plans to leave Le Pouldu. In a letter to Theo, de Haan summarized his progress in Brittany and expressed his joy over his new-found liberal ideas and his optimism for a new future. He confessed his regret that he had reached "a certain age" and that so many beautiful years had been spent "working for nothing." However, he felt that his experience in Brittany allowed him the opportunity, even if at the end of his existence, to make the tiniest contribution to art.[169] Soon after this moving letter, de Haan left Le Pouldu in order to straighten out his affairs with his family. At the same time Gauguin wrote to Bernard and informed

him that de Haan, who he described as a person of "good will," was in Paris trying to patch things up with his family who had been cutting off his support for "quite some time."[170] Gauguin's letter to Schuffenecker in late October reveals that by the time of de Haan's departure for Paris his pupil may also have been aware of another problem: Marie Henry's pregancy. Gauguin admitted to Schuffenecker: "You have seen de Haan, this is a fellow who was well-intentioned. But always has bad luck; he is in a nasty mess up to his neck and perhaps because of me."[171] Contrary to suggestions that Gauguin's spiteful attitude towards de Haan is revealed in his portraits of the Dutch artist, the epistolary evidence indicates that the artist not only continued to support and praise de Haan's artistic progress but also regarded his pupil with sympathy and respect, an attitude demonstrated in his plans to include him as his future traveling companion to the South Seas. In fact, the final parting of the artists appears not to have been as brutally final as has previously been thought. After Gauguin's return to Paris on November 8 he terminated his brief stay with Schuffenecker following a quarrel and moved to new quarters at 35 rue Delambre for the winter 1890/91. What has not been recorded is the fact that this same address also housed Meyer de Haan at that time. The latter likely settled in this small hotel thanks to his Dutch connections. This confirms that both artists continued to spend the winter under the same roof in Paris, just as they had in Le Pouldu.[172] In February it seems that de Haan's connections in Amsterdam also helped to introduce the artist Jan Verkade to Gauguin in Paris.[173] No record exists to provide us with a date for de Haan's return to Amsterdam. However, we do know that by late 1891 Gauguin, now in Tahiti, had not heard from de Haan and was eager to receive news about his pupil from Paul Sérusier. He asked: "And Meyer, what happened to him? No news from him. Did the woman [Marie Henry] get her hooks into him?"[174] Although de Haan seems not to have contacted Gauguin again, he continued to correspond, albeit briefly, with Theo's widow, Johanna van Gogh Bonger, until late 1893 while he was living for a time in the small village of Hatten in Holland. On October 24, 1895, Meyer de Haan, at the age of forty-seven, died of tuberculosis in Amsterdam. The majority of his Breton works and personal effects, including his palette and his Dutch Bible, remained with Marie Henry in Le Pouldu. There appears to have been no effort made by either artist to re-establish contact. Eight years later, on May 8, 1903, Paul Gauguin, at the age of fifty-five succumbed to a probable heart attack, while living on the island of Hiva-Oa in the remote Marquesas.

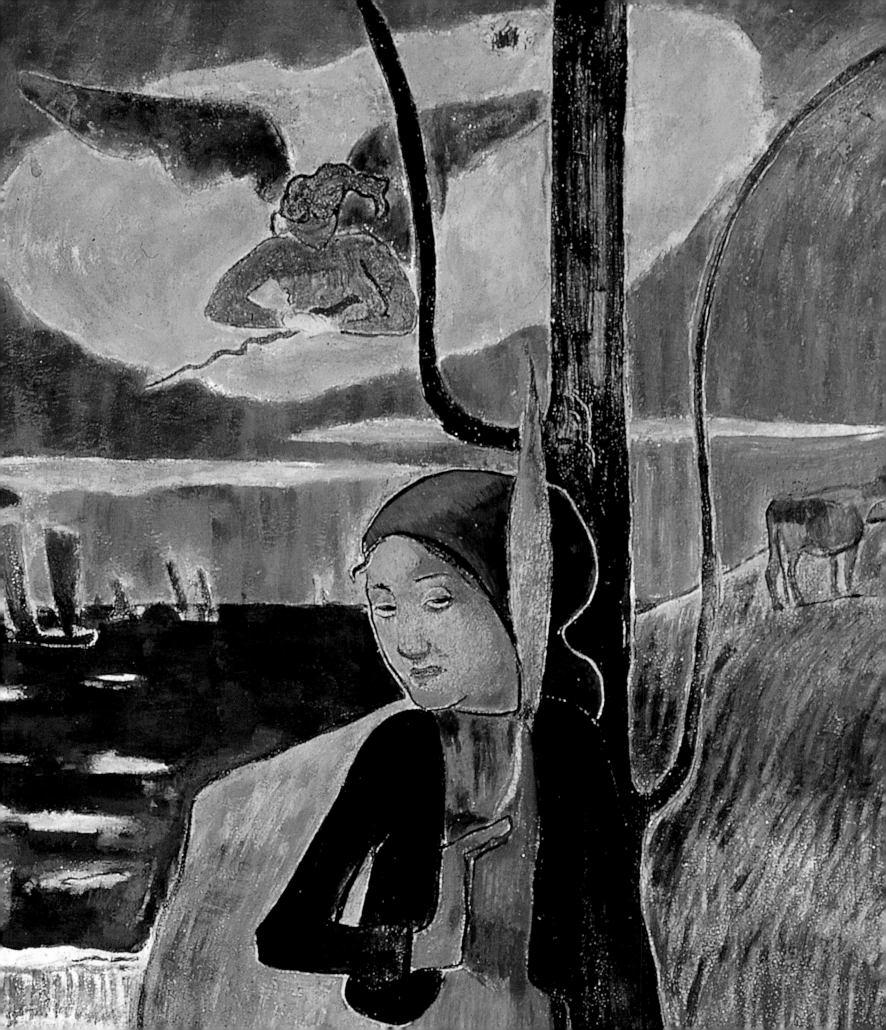

ROBERT WELSH

Gauguin and the Inn of Marie Henry at Pouldu

For many years Gauguin scholarship has recognized the importance of the artist's stay at the inn of Marie Henry in Le Pouldu, Brittany, without having been able to determine precisely the dates and the nature of his collaborations with such painter colleagues as Paul Sérusier, Jacob Meyer de Haan and Charles Filiger. Our knowledge of this period of residence in 1889–90 is based in part upon several contemporary letters, but also upon subsequent eye-witness accounts most of which were presented in the exhibition catalogue *Le Chemin de Gauguin, genèse et rayonnement*.[1] The most valuable of these reports was first published by Charles Chassé in his *Gauguin et le groupe de Pont-Aven: documents inédits* and comprises a description of the decoration of three of the walls and the ceiling of the dining room as remembered by Marie Henry and written down by Henri Mothéré, who had been her companion since about 1893.[2] A photograph taken in 1924 of the fourth wall (Fig. 89), and a photograph of the ceiling (Fig. 90) all but complete our knowledge of the room as decorated by Gauguin and his friends.[3] Before the ensemble can be presented in a systematic manner, however, it is first necessary to establish a reliable sequence for the activities of the artists involved through reevaluation of the old and introduction of new evidence.

The widespread assumption that Gauguin only became familiar with Le Pouldu in 1889, after a precipitous decision to move from Pont-Aven to the remote village, has in recent years rightly been challenged and needs to be revised. Several paintings dated either 1886 or 1888 are now believed to represent coastal settings at Le Pouldu, as are a group of works included in his contribution to the *Exposition de Peintures du Groupe Impressioniste et Synthétiste* (the so-called Café Volpini exhibition) which opened in June 1889 on the grounds of the Exposition universelle. Wayne Andersen noted that three canvases by Gauguin dated either 1886 or 1888 represent the beaches of Le Pouldu, while B. M. Welsh-Ovcharov believes that

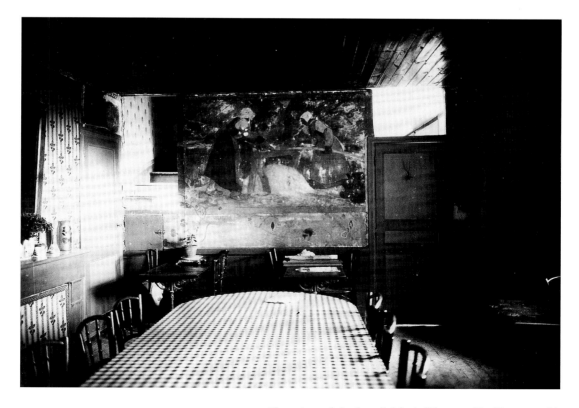

88. (*facing page*) Detail of Gauguin's *The Spinner*, Fig. 108

89. The west wall of the dining room at Marie Henry's Inn, 1924. Photograph

90. The ceiling of the dining room at Marie Henry's Inn (disappeared), 1890. Photograph

we can identify the topography of Le Pouldu in six works executed in a manner similar to one of the zincographs of the "Volpini Series." These were done at the beginning of 1889, before the artist had decided to move to the remote coastal hamlet.[4] Moreover, one can suppose that Gauguin was thinking of the beaches of Le Pouldu when he conceived the famous frontispiece *At the Black Rocks* for the catalogue of the exhibition at the Café. At least one of the two paintings entitled *In the Waves (Ondine)* (Fig. 178), as well as *Life and Death* (Fig. 179) – the latter figured in the 1889 Volpini exhibition – represents the coast at Le Pouldu. It should not be imagined, however, that any of the Le Pouldu subjects executed by Gauguin between 1886 and early 1889 reflects stopovers at the inn of Marie Henry. The land on which it was built was purchased on successive occasions in June 1886 and August 1887 so that 1888 would seem to be a reasonable estimated date of construction for the diminutive building.[5] One might postulate that Gauguin's early visits to Le Pouldu from Pont-Aven were sporadic and were often facilitated by his friendship that began in 1886 with Captain Yves-Marie Jacob, captain in the Customs Service. His assigned line of defense against contraband extended between Pont-Aven and Quimperlé down the Aven river to Port Manech, from there along the coast to Le Pouldu and then up the Laïta river to Quimperlé. Apart from other indications that the friendship between Gauguin and Jacob was close, we know it was in the latter's "customs wagon" that Gauguin and Sérusier arrived in Le Pouldu when they left Pont-Aven for a stay at the inn of Marie Henry in 1889. We also know that in 1886 Jacob came to the aid of Gauguin when the latter was threatened with prosecution; on another occasion he transported the artist to Plestin-les-Grèves, in the Côtes du Nord, and in 1888 he posed for a portrait.[6] All in all, Gauguin must have made fairly frequent use of his friend's services in traveling between Pont-Aven and Le Pouldu during his sojourns in Brittany.[7] He thus became familiar at an early date with the contrast between the inland artists' colony of Pont-Aven with its bucolic atmosphere, and the sparsely populated and rugged landscape setting of Le Pouldu on the edge of the sea.

Since 1921 it has been known that Gauguin first registered at Marie Henry's inn on October 2, 1889 and he departed on November 7, 1890. But nevetheless it has been occasionally speculated that Gauguin and Paul Sérusier had already worked together during the spring and summer of 1889 at Le Pouldu, and that some time in the course of that same year Sérusier collaborated with Gauguin and Meyer de Haan on an elaborate decorative scheme for the dining room of the inn.[8] Both assumptions ultimately derive from the misdating in 1942 by Maurice Denis of a letter he must have received from Sérusier during the summer of 1890 but which he assigned to the previous Summer of 1889.[9] In this letter Sérusier reported regretting not having any more news of Denis and added: "As for me, I live between Gauguin and de Haan in an inn [with] a dining room decorated and ornamented by us." Then he added how much his drawing style and his use of color had been transformed following "all my theories sought after this winter." Apart from the unlikelihood that "this winter" would have referred to 1888–9, before he had studied Gauguin's cloisonist-synthetist works exhibited at the Café Volpini exhibition, 1890 is confirmed as the date of the letter by the mention of a plan by Denis to illustrate Verlaine's *Sagesse*; in his *Journal* Denis mentions first having read these poems around November 1889, that is to say, after Sérusier had already left Le Pouldu that year.[10]

In fact, it is possible to show that Sérusier's visit to Le Pouldu in 1889 was brief and can be documented with near-certainty. A spring trip would hardly have been practicable given Sérusier's responsibilities through June as "massier" at the Académie Julien, and there is no evidence that the encounter with Gauguin the previous autumn, which produced Sérusier's famous painting *Bois d'Amour: The Talisman,* led to close personal contact before the summer of 1889. At this date contact was doubtless renewed when both artists were residing together at the Pension Gloanec in Pont-Aven possibly thanks to the initial enthusiasm which Sérusier felt for the works by Gauguin on display at the Volpini exhibition. A letter from Sérusier informed Denis of his departure from Paris, without doubt after having seen the works of Gauguin exhibited at Volpini's in June and early July 1889. The artist specified that he was going to stay at the Pension Gloanec at Pont-Aven.[11] We can presume that he spent at least the major part of July with Gauguin, since the latter reported in a letter to Emile Bernard that Sérusier departed for the Auvergne on the eve of the arrival of Charles Filiger in Le Pouldu on July 23.[12]

Yet it was not principally with Sérusier as is sometimes said, but with de Haan that Gauguin spent the month of August in Le Pouldu, at the Hôtel Destais, before returning in September to Pont-Aven.[13] Artistic interaction between Gauguin and Sérusier may have been minimal during the summer months, since in a letter that should be dated Friday, September 27, 1889, Sérusier informed Denis that since his arrival in Pont-Aven he had per-

ceived "that Gauguin who is with me [in Pont-Aven] is not the artist of my dreams," noting further that he had yet to show his work to Gauguin because of their differences in art theory and practice.[14]

It was, nonetheless, in this same letter that Sérusier announced his intention "in a few days" of leaving Pont-Aven with its "girls in beautiful white headdresses" and the "little gardens full of flowers," for a coastal site where there were to be found "young girls in rags, yellow, skinny and strong, who watch their cows on the great rocky cliffs, among the piles of seaweed." This obvious allusion to the cliffs of Le Pouldu was perhaps based on a description by Gauguin and was in any case followed by a postscript to the letter written the following Tuesday and headed "Le Pouldu." Since Sérusier here reported his arrival as "yesterday," that is to say Monday, September 30, this confirms his later memory of having arrived "at the end of September" and precedes by only two days Gauguin's inscription in the register of the inn of Marie Henry on October 2. In the same postscript Sérusier indicates his intention to "live 15 days alone with Gauguin," the realization of this plan is corroborated by the fact that Meyer de Haan inscribed himself in the register only on October 14. About this time, in a letter to Denis, Sérusier reports having shared a room with Gauguin for the past "15 days," and his intention of leaving "in a few days" in order first to rejoin his family vacationing in Villerville on the Norman coast, and then to undergo his "twenty-eight days" of annual military service.[15] It thus becomes clear both that in 1889 Sérusier spent at most the first three weeks of October at Marie Henry's inn, and that this stay included no more than a few days when de Haan also was present.

These considerations of chronology have two consequences. On the one hand, they exclude the possibility that Sérusier participated in the initial conception or execution of the decor of the dining room of the inn in 1889. If this project had begun to take shape at that time, he would have spoken of it to Denis in his mid-October letter, and it is revealing that Sérusier is not mentioned in any of the letters written by Gauguin and de Haan in December 1889 where the recently finished decor is evoked for the first time with the greatest detail. Nonetheless, in one respect Sérusier can be credited with inaugurating the idea of the dining room as a shrine of art. We can situate the moment when Sérusier made his contribution in the form of an inscription on one wall. It is the question of a citation of a well-known quotation from Wagner, also found in manuscripts in Gauguin's hand and reputedly in the *Livre d'or* of the Pension Gloanec at Pont-Aven, possibly a source for Sérusier's usage. Sérusier transcribed these two paragraphs in a second postscript to his letter of September 27 addressed to Denis. Sérusier declares that "this credo of our's" (Gauguin's and mine) is inscribed "on the wall of our room," ideas already dear to the heart of Gauguin and apparently of his latest "disciple" as well.[16] Whatever inspiration this quotation may have provided for the subsequent decoration of the room, it should be understood that the inscription never formed a part of the pictorial scheme. According to Marie Henry and corroborated by a witness who had seen the paintings executed by Gauguin and de Haan on the west wall of the room (rediscov-

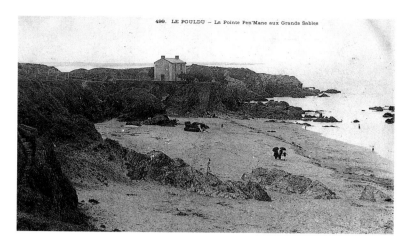

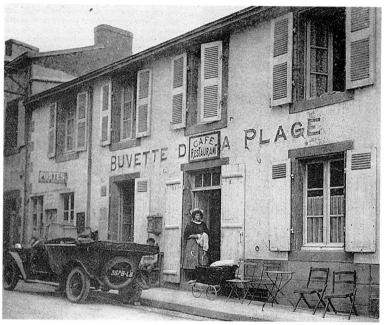

91. The *Grand Sables* bay, Le Pouldu, including the black rocks. Photograph. Private collection

92. The *Buvette de la Plage*, Marie Henry's Inn, Le Pouldu. Photograph. Private collection

ered under the wallpaper in 1924), the quotation was placed under the central painting by de Haan representing two women scutching flax.[17] It is not visible in the photograph of this wall taken in 1924, but that is explained by its location, according to Marie Henry, "on the grey painted base, of the west wall." This confirms my conviction that it was not intended to be part of a global decorative project. At least the inscription, like the principles outlined in Sérusier's letter of mid-October to Denis, testifies to the rapprochement in thinking about contemporary art which had occurred between Gauguin and Sérusier during their brief stay together at Le Pouldu in 1889.

If the relationship between Gauguin and Sérusier did not become fully cemented before October 1889, what then of the relationship between Gauguin and Meyer de Haan? According to Marie Henry, "Meyer de Haan had met Gauguin through the elder Pissarro," but this is at best a half-truth.[18] It was doubtless Theo

van Gogh who was the initial link between de Haan, Pissarro and Gauguin, after the Dutch artist had arrived in Paris in the fall of 1888. It is true that Theo originally sought to have de Haan lodge with, and presumably receive instruction from, Pissarro, but when that proved impracticable, Theo decided to share his own apartment with de Haan. This arrangement lasted from October 28, 1888, until about mid-April 1889, when the latter left for Pont-Aven, due to the impending return of Theo from Amsterdam and his marriage to Johanna Bonger. It is thus more likely that de Haan met Gauguin through Theo rather than through Pissarro. It is equally likely that Theo played a role in arranging for de Haan to become the "student" and at the same time the patron of Gauguin in the Summer of 1889 in Pont-Aven. De Haan arrived at the Pension Gloanec around April 21, and he was joined in June by Gauguin.[19]

On October 22, 1889 de Haan wrote at some length from Le Pouldu to Theo about his progress under the tutelage of Gauguin. He explained that, following a return visit to Paris where he saw the Volpini exhibition, he went through a period of experimentation together with Gauguin at Le Pouldu (that is to say during August, while staying at the Hôtel Destais), and then continued to work on his own chiefly at Le Pouldu after Gauguin had returned for a while to Pont-Aven.[20] In the same letter de Haan records his intention to dedicate a full year to producing drawings and painted studies, before undertaking a finished painting.

It is apparent that at the date of writing to Theo no plan for the decoration of Marie Henry's inn had been conceived. Nor is there any reference in a letter written around November 8 which instead contains a discussion and diagrams of his principal recently completed works, the painting *Christ in the Garden of Olives* (Fig. 72) and the wood relief *Be In Love* (Fig. 77), which he then soon sent to Theo in Paris.[21]

It could not have been long after mid-November, however, that the decoration of the room was begun, since all four walls were reported as fully decorated in a letter of December 13 from de Haan to Theo and one sent just before this date from Gauguin to Vincent.[22] Both letters state that the decoration of the dining room was recently completed in great haste, Gauguin offering this as an excuse for not having answered a letter from Vincent earlier. It is equally apparent from the tone of the two letters that this project was undertaken as a collaborative effort by the two artists, both of whom expressed satisfaction, even pride, in the outcome. Since Gauguin left Le Pouldu early in February 1890 for a four-month stay in Paris, further embellishments are unlikely to have been added before his return to Le Pouldu sometime in May or June of that year, and there is no dependable record of any other artist but de Haan having resided at the inn during Gauguin's absence. The situation changed in the Summer of 1890, first with the arrival, probably in late June, of Sérusier, who not long thereafter, as we have seen reported his presence with Gauguin and de Haan at the inn. However, his stay was interrupted or terminated by a sojourn in the Auvergne begun shortly after the arrival of Charles Filiger and his friend, the engraver Paul-Emile Colin, on or about July 23. Whether or not Sérusier returned to Le Pouldu before going to

Paris is not known, however, Filiger is known to have stayed on at the inn until late 1893 when he moved to nearby Moelan. As for Gauguin, his departure in November 1890 followed shortly upon learning of the debilitating illness of Theo van Gogh and the departure of de Haan for Paris, where he hoped to regain the family support which had been cut off. Hence, apart from the occasional brief visits to Pont-Aven, during the summer and fall of 1890 Le Pouldu remained the principal residence of Gauguin, de Haan, Sérusier and Filiger while in Brittany.

Although not all the works of art used in the dining room are mentioned in the two letters of December 1889 sent by de Haan and Gauguin to Theo, when supplemented by the description given around 1919–20 by Marie Henry to Charles Chassé a reasonably complete idea of the placement of the major design elements can be fashioned.

In their accounts of 1889 Gauguin and de Haan stress that work commenced with the decision of the latter to produce a large mural painting, which de Haan entitled *Labor* and further designated as representing "Pouldu at full harvest time," but which today is known as *Breton Women Scutching Flax* (Fig. 107). Upon its completion, Gauguin painted the remaining wall surface to the left with a representation of what he described as "a peasant woman spinning on the seashore, her dog and her cow" (Fig. 108), but which was later baptized *Joan of Arc*. Only these two paintings are dated 1889 and are described as being on the same wall, but the photograph taken around 1924 (Fig. 89), of the newly rediscovered wall paintings, also includes *The Goose* (Fig. 105) situated on the transom of the doorway to the dining room. On the upper panel of this door one of the two versions of *Bonjour, Monsieur Gauguin* (Fig. 101) hung and on the lower panel *The Caribbean Woman* (Fig. 104). Although undated, it seems probable that all three paintings were part of the original decor, especially since *The Goose* bears the inscription "Maison Marie Henry," and since the other version of *Bonjour, Monsieur Gauguin* (Prague) is dated 1889. The narrow vertical space to the right of the door appears in the old photograph to have contained a scarcely decipherable decorative form. By way of conjecture, this could have been an image of the Virgin Mary executed by Filiger "to finish the decoration of the room...in the form of a pier," as described by the artist's friend, Paul-Emile Colin, a witness to the events of the summer of 1890.[23] Finally, at the lower left corner of the old photograph one notices a small square door, which must have opened onto a small utility closet adjacent to the door leading to the kitchen. This little door must have replaced the one that de Haan had decorated with a *Still Life with Pitcher and Onions* (Fig. 106) and which Marie Henry transported with her when she gave up her establishment in 1893. This still life is doubtless one of the several still-life studies mentioned by de Haan in his letter to Theo in December 1889, it was in any case the work which carried the inscription "I love onions fried in oil" according to Marie Henry's account.[24]

Since this west wall constituted the point of departure for the whole pictorial enterprise, one must ask immediately whether or not an iconographic program was intended? The answer to this question depends on how seriously one takes the subject matter as

93. Photograph of *Breton Women Scutching Flax* and frieze, showing the inscription
LUDUS PRO VITA

given by the artists themselves or otherwise known. The essential question in this respect is the meaning assigned to the so-called "Joan of Arc," (*The Spinner*; Fig. 108) a name possibly derived from the fact that Gauguin had for a time attended school in Orléans, or else simply through a fanciful reading of the armed angel as god's messenger who counseled her that she should take up arms on behalf of national liberation (Fig. 88). Apart from Gauguin's reputation as scarcely a rabid French patriot, the identification seems suspect on other grounds. What would the Maid of Orléans be doing among dunes along the coast, at that moment in her life, and why associate her with spinning yarn and tending cows in the same context? Such symbolic pursuits accord better with the theme of Breton peasant existence as evoked in Gauguin's letter to Vincent van Gogh, and as a complement to the theme of "labor" in de Haan's adjacent mural. The angel with sword, within this context, is most readily explained as representing the biblical theme of the expulsion from Paradise, which accords with Gauguin's well-known preoccupation in 1889 with the general theme of human degradation, including that of Christ. This preoccupation also is found in *Adam and Eve* (Fig. 103) which was displayed in the corridor dividing the dining room from the bar on the ground floor of the inn. Moreover, if this peasant girl might more properly be considered a species of fallen Eve, then Filiger's possible depiction of the "Virgin Mary," could be considered an appropriate and traditional book-end counterpart at the extreme right of the wall as a total composition, given the standard identification of the Virgin as the new but redeemed Eve.[25]

Since the relatively small depictions of a goose and a few onions may be presumed not to contain any overt or hidden profound message, it is the two paintings on the door which deserve greater attention. Of course, *Bonjour Monsieur Gauguin* is directly understood as a visual paraphrase of Gustave Courbet's *Bonjour Monsieur Courbet*, a painting which in fall 1888 Gauguin had viewed together with Vincent van Gogh in the Montpellier Museum. Within the context of Le Pouldu, one might reasonably suppose that Gauguin not only shows himself in the guise of a romantic wandering artist, but also alludes to his literal entrance into the room owned by his then patroness, Marie Henry, and decorated in conjunction with his other patron, de Haan. If this supposition is at all correct, then the choice of this self-image for the entrance door involved a mixture of ironic self-depreciation and self-pity as to the artist's current financial dependency and artistic isolation. The accompanying figure of a Breton peasant woman, seen from the back, may well contain a more despondent symbolism of death, as has been suggested for a similar figure in Gauguin's late-1888 painting *the Red Vineyard / Human Misery* (Fig. 13) and as a generic connotation for the typical black female costume and head-dress of Le Pouldu.[26]

The Caribbean Woman, located just below *Bonjour Monsieur Gauguin* on the inside of the entrance door, and designated by this name in the account of Marie Henry, is an appropriate title, despite the likelihood that the figure was inspired by the image of a Javanese dancer that Gauguin had purloined from the Javanese pavilion of the 1889 Exposition universelle (Fig. 115).[27] Even the title *Lewdness* sometimes assigned to this work is not far from the mark, since Gauguin notoriously equated, at least in his writings, uninhibited sex as a virtue of "primitive" societies, as opposed to the moral hypocrisy of Western civilization. Whatever the meaning of this painting *per se*, it inherently evokes a contrast, however ironic, between the wanderer and the naïve temptress, who thus becomes symbolic both of sexual liberation and death. Indeed, this particu-

94. Meyer de Haan, *Still Life with a Profile of Mimi*, 1890, oil on canvas, 19 ⅞ × 24 ¼ in. (50.5 × 61.5 cm). Private collection

lar temptress, despite her nakedness, is hardly an image of sensual delight, and one must therefore search for another intended meaning, as will be discussed below.

The one other iconographic entity to be found on this entrance wall is the correspondence between the hand gestures of the "peasant girl" on the left and of the "Caribbean woman" on the right. The female figures have hands pointed respectively upward and downward, an allusion to heavenly and earthly spheres in most religions, but particularly within Hindu and Buddhist beliefs. Gauguin's familiarity with such iconographic meanings has yet to be proved, beyond such easily accumulated knowledge of the popular concepts of "nirvana" and the "androgyne." It is thus likely that these hand gestures ("mudras") were derived by Gauguin more from his casually accumulated knowledge of eastern religious iconography than from a profound understanding of eastern religion.[28] At most Gauguin should be considered an artist interested in essential world religions rather than an advocate of any particular system of beliefs.

De Haan's *Labor* (Fig. 107) thus retains its central importance to any interpretation of the west wall of the dining room. With its heraldic juxtaposition of two laboring women and its obvious dominance in scale within the wall complex, this mural painting not only inaugurated but also provided the main focus of the decoration of the entrance wall. *Labor* sets the theme of the wall, while Gauguin's accompanying subjects of a peasant girl at her work, his self portrait derived from Courbet, and his Caribbean woman merely provide an enhanced spiritual ambience in which the theme of labor was implicit. One may conclude that the first wall to be painted set the stage for the hurried efforts at decorating the next wall. A final testimony to the dual and perhaps ambiguous meaning attached to *Labor* is the inscription "ludus

pro vita" roughly translated as: "game of life," which is visible on a photograph of the painting and its decorative frieze below (Fig. 93). Since it may be assumed that this painted frieze was part of the original decoration, it is equally justified to conclude that the definition of hard work as a "game of life" was no coincidental equation.[29]

It is unclear from both the descriptions by Gauguin and de Haan and that by Marie Henry whether or not any meaningful sequence was established in decorating the other three walls of the dining room. In describing the project to van Gogh, Gauguin was content to state: "We started by doing one wall and finished by doing all four, even the window," and it is quite possible that not all elements of the single wall were in place before work on another was begun. However, Marie Henry does state that her portrait was painted by de Haan without being shown while in progress to Gauguin. Nonetheless, he was so pleased by the finished canvas that he painted a frame for it (since lost) and hung it in the most prominent position in the room, namely, as the centerpiece of the wall opposite the entrance. He then flanked de Haan's *Maternity (Marie Henry and her Child)* (Fig. 102) with two of his own landscapes: on the right the *View over Pont-Aven taken from Lézavan* and on the left *Haymaking Season*, which includes at lower right the image of his pet dog. These three components lent the wall a symmetrical tripartite emphasis, even if various smaller images were appended to it. Marie Henry listed "some painted studies on cardboard, two lithographs on yellow paper, a small canvas representing two or three green apples in a blue bowl.[30] Given the wealth of images known to have been preserved by Marie Henry that came from this dining room, it seems likely, as first suggested by John Rewald, that substitutions were made from time to time. If one is right to believe that the setting for de Haan's *Still Life with Profile of Mimi* (Fig. 94) – Marie Henry's first daughter, Marie-Léa – is the dining room, then the three images vaguely indicated at the upper left of the canvas would seem to represent the types of painting mentioned by Marie Henry as accompanying the three principal subjects of this wall. Indeed, unlike Marie Henry's portrait, the two major landscape paintings are almost certain to have been executed before the dining room decoration was begun.

The east wall – the only one having neither door, nor window, nor fireplace – provided a unique opportunity for Gauguin to select his overall composition at will. The symmetrical disposition of the three principal works gives the impression of a pseudo-triptych. Furthermore it is difficult not to associate the portrait of Marie Henry and her nursing infant with the theme of the Madonna and Christ child, and her own first name conveniently supports this. The hay mounds pictured behind Marie, apart from echoing those in *Labor* on the opposite wall, may not perhaps have been intended as an eucharistic symbol by de Haan, a Dutch Jew, but they do reinforce the theme of maternal nourishment nevertheless. Gauguin's choice of accompanying landscape subjects enhances the thematic content of Marie Henry's portrait, since one is a harvest scene and the other includes the church spire at Pont-Aven. A second possible source of inspiration for Gauguin may well have been Vincent van Gogh, who was working on a version

95. Attributed to Paul Sérusier, *Breton Dance*, 1890, oil on panel, 8 ⅛ × 33 ¼ in. (20.5 × 84.5 cm). Private collection

of his famous portrait *La Berceuse: Mme. Roulin* when Gauguin left Arles. His subsequent plan to display it as a triptych through the addition of two flanking paintings of sunflowers was almost certainly made known to Gauguin by either Theo or de Haan. The latter doubtless would have seen a version of *La Berceuse* while staying with Theo, and was possibly aware of van Gogh's instructions to his brother that both Gauguin and Bernard were to be offered examples of this subject.[31] To be sure, the very idea of decorating a room with one's own paintings built upon precedents established by van Gogh at two Paris restaurants and in his Yellow House at Arles, which not only helps explain why the van Gogh brothers were the first to receive a report of the inn decoration at Le Pouldu, but implies that Gauguin and de Haan thought that they would most readily sympathize with the effort.

The south wall, partly visible at the left in Fig. 89, was at the same time the most complex and yet the most predetermined in

format. Due to the central position of the fireplace and the flanking doors – to the kitchen on the right, and to a shallow linen cupboard on the left – there was little opportunity for Gauguin to compose freely in terms of the placement of his chosen objects. His reaction to this problem was as bold as it was novel. He first of all painted his *Self Portrait with Halo* (Fig. 147) and his *Portrait of Meyer de Haan* (Fig. 148). According to his own account to van Gogh, the portraits were painted on the upper door panels of this wall, respectively at the right and left of the fireplace which nearly abutted them (Fig. 97). "The important, larger than life bust of Meyer de Haan, sculpted and painted by Gauguin in a block of massive oak" (Fig. 98) was placed centrally on the fireplace mantel. The block of wood used was indeed so massive that it had to be cut down at the rear to allow for its placement on the mantel shelf, and in size the sculpted face of Meyer de Haan is larger than in his painted portrait by Gauguin, but of the same dimensions as that of

96. Floorplan of the ground floor of Marie Henry's Inn

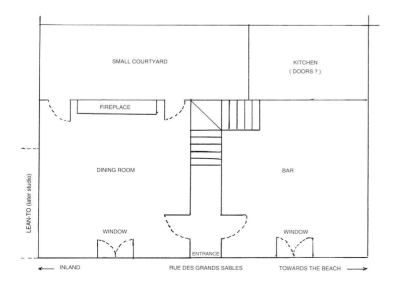

97. Diagram of the arrangement of the south wall of the dining-room of Marie Henry's Inn

98. Paul Gauguin, *Portrait of Meyer de Haan*, late 1889–early 1890, carved and painted oak, 23 × 11¾ × 9 in. (58.4 × 29.8 × 22.8 cm). National Gallery of Canada, Ottawa. *Exhibition no. 17*

the latter's self portrait. Since it is not mentioned in the December 1889 letters of the two artists to Theo and Vincent van Gogh, the bust may not have been in place at that time. Yet, considering its focal placement in the total scheme of the wall, it was almost certainly executed before Gauguin left Le Pouldu to arrive in Paris on February 8 for a stay of approximately four months. The same can be said for the smaller embellishments of this wall, two clay pots "illustrated with small humorous motifs" placed on the mantel flanking the bust sculpture, and the two statuettes situated "on shelves fixed to the wall on either side of the fireplace," none of which required a lengthy expenditure of time by the artist.[32] The only other depiction accompanying this display was a painting executed on the wood on the "lintel of the fireplace" which has been

attributed to Gauguin but which, in the present writer's opinion, is more likely to be by Sérusier (Fig. 95). A similar reattribution seems warranted for *Adam and Eve* (Fig. 103), which hung "outside the room, in the entry hall and above the door of the bar."[33] If Sérusier is in fact the author of these works, then it was to them that he alluded in his letter of the summer of 1890 to Denis (see p. 62): It is unlikely that he would have reported the fact had he participated in the decoration of the inn the year before.

The iconographic meanings of the various representations on this wall have received considerable comment, especially Gauguin's *Self Portrait with Halo* (Fig. 147).[34] If we begin, however, with the portrait bust of Meyer de Haan in wood, it is immediately apparent from comparison with other representations of de Haan by him-

99. Paul Gauguin, *Martinique Woman*, *c.* 1889, painted terracotta and wooden base, h. 7 ⅞ in. (19.7 cm). Henry and Rose Pearlman Foundation, Inc. *Exhibition no. 19*

self or Gauguin, such as the painting on the door, and *Nirvana*, that this diminutive, hunchbacked figure retained a high degree of verisimilitude in the facial features. The intense gaze of the eye and the hand supporting the chin suggest the mien of some sort of philosopher, an effect that is enhanced by the large skull cap he invariably wore. Sitting atop this cap in the wood bust appears a winged creature: a chicken, which may, as has been suggested, refer to the name "de Haan," although the literal meaning in Dutch is "the rooster," rather than "the hen" as more probably depicted by Gauguin. Whatever the intended symbolic meaning of the chicken, de Haan's association with religious and philosophic speculation is unequivocally indicated in Gauguin's painted portrait of him on the door in which are displayed in clear view a French edition of

John Milton's *Paradise Lost* and a copy of the *Sartor Resartus* by Thomas Carlyle. Milton's epic concerns the Fall of Man, and de Haan's red vestment and obviously troubled expression doubtless in some measure reflect contemplation of this theme. It is probably also alluded to in the inclusion of a plate of apples, since this "forbidden fruit" also seems to function as a symbol of temptation in Gauguin's *Self Portrait with Halo*. The lamp is more likely associated with Carlyle's anti-hero, Professor Teufelsdröckh, whose first name Diogenes associates him with the ancient Greek Cynic philosopher whose lamplight quest for an "honest man" would have been known to someone thought to be as well-read as de Haan. Moreover, Teufelsdröckh's preoccupation with clothing as symbolic of mankind's cultural and spiritual condition would have

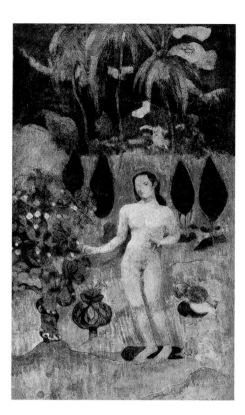

100. Paul Gauguin, *Exotic Eve*, 1894, oil and gouache on board, mounted on canvas, 16 ⅞ × 9 ¾ in. (43 × 25 cm). Private collection

the dining room, and the dancing girl which Gauguin had taken from the Javanese pavilion of the 1889 Exposition Universelle, are nude, and the general association of negresses from Martinique with sexual temptation was made in a letter written in 1887 to his wife.[36] In other letters Gauguin linked sexual liberty with most women living in exotic cultures, an association that undoubtedly included the Javanese dancer. In his bust portrait de Haan scarcely seems aware of the temptresses who flank him, but it can be assumed that human sexuality is one aspect of life about which the artist-philosopher must ruminate. This is equally true of *Nirvana* where the two Breton nudes are probably symbolic of life and death.

The fourth wall, dominated by the window which is hardly visible in the old photograph (Fig. 89), does not lend itself to a reconstruction. As Marie Henry remembered, "the window panes had received an overall decoration drawn from rural life and executed in oil. Bad weather destroyed it in four or five years."[37] It is impossible to identify what figural or landscape subjects made up these scenes; we can merely speculate that the iconography was more bucolic than laden with great symbolic meaning.

As for the decoration of the ceiling, it is only known today from the photograph (Fig. 90). As I have published elsewhere an analysis of this document, I will restrict myself here to a few observations.[38] In December 1889 both Gauguin and de Haan spoke merely of having decorated the four walls of the dining room so the ceiling is the only major element in the ensemble likely to have been decorated by Gauguin after his return from Paris in June 1890, but before the arrival of Filiger and the graphic artist, Paul-Emile Colin, on or about July 23. Contrary to a previous assumption that can be traced to an error of memory by Sérusier, the central image was not Leda and the Swan. Gauguin had used this motif in the zincograph design for a plate that embellished the cover of several copies of his so-called Volpini suite of ten zincographs made in 1889. Instead the depiction is of two geese disposed in a heraldic manner, complemented by four onions, renders suspect the belief that Gauguin was covertly alluding to the de Haan–Henry liaison. Gauguin's inscription in the corner over the entrance to the dining room "ONI SOIE ki mâle y panse" if at all relevant, seems to defend Marie from evil gossip, even if the substitution of "mal" for "mâle" does make a rather prurient pun on the word to evoke a male animal or bird, as for example, a rooster or cock.[39] In essence, the painting of the ceiling seems intended to provide a light-hearted and at best irreverent decorative note, and not a final key to the symbolic meaning of the dining room decoration as a whole.

If any key exists, it is likely to be found in *Adam and Eve* (Fig. 103), which, whether in fact by Sérusier rather than Gauguin, would have been executed as a coda to the general theme of the paintings in the adjacent dining room and not merely as a theme appropriate to the café-bar.[40] The companion subject, the single figure of the *Exotic Eve* (Fig. 100), combines a swaying body, derived from a scene in the Borobudur temple reliefs, and the face of the artist's mother, Aline. Similarly, *Adam and Eve* alludes to the temptation of Eve by the serpent, which appears at the base of the

intrigued both de Haan and Gauguin, whose habit of wearing a variety of exotic garbs is well documented.[35]

In his *Self Portrait with Halo* (Fig. 147) Gauguin appears under a halo, but holding a small snake in one hand, leading to several plausible hypotheses regarding the symbolism of this painting. Self-identification both as a hero-artist and as a tempter-villain can be accommodated within the artist's well-known proclamation about his dual nature as the sensitive artist and the Peruvian savage. There is thus little reason to think that this particular self portrait was conceived in a spirit much different from his 1888 self portrait called *Les Misérables* (Fig. 157) or the *Self Portrait with Yellow Christ* (circa 1889; Fig. 177) in which the dual spiritual and satanic sides of his character are equally apparent. In this context, the portraits painted on the doors flanking either side of the fireplace, need not involve a contrast of symbolic attributes, or in the case of de Haan, an element of satire as has sometimes been supposed. Instead they represent a pair of painter colleagues earnestly struggling to uncover within themselves and in the world about them a productive basis for contemporary creative reality.

There has been much speculation about the relationship between the traces of sexual innuendo discernable in Gauguin's images and the liaison between de Haan and Marie Henry. Whether or not justified in strictly biographical terms, it cannot be doubted that sexual temptation and fulfillment remained a major preoccupation for Gauguin throughout his life. As with the fireplace wall, such a preoccupation is most directly manifested in the placement of the two statuettes to the left and right of the bust portrait of de Haan. Both of these figures, the little kneeling *Martinique Woman* (Fig. 99), which still has its original shelf from

tree. At the upper right are seen Adam and Eve being expelled from the garden of Eden by the angel above and already wearing loincloths, symbolic of their shame. Other symbols included are the lion at the left, a denizen of the Peaceable Kingdom, and at the lower right is found the same bush that is also shown in the *Exotic Eve* and presumably stands for the Tree of Good and Evil bearing the forbidden fruit. This painting was once listed as "No. 3 Paradise lost (1890)," which, apart from the thematic affinity mentioned above with *The Spinner*, links this painting to the title of the book by Milton found in Gauguin's portrait of de Haan.

In sum, the scheme of decoration for the inn of Marie Henry was chiefly conceived and in large part executed by Gauguin, who must have approved and perhaps even inspired some of the subject choices of his "followers" de Haan, Sérusier and Filiger. The program can be read and appreciated on three levels of interpretation. First, there is the decorative aspect cited in de Haan's letter to Theo, "In order that this little room would appear truly convivial (in Dutch *gezellig*), we have decorated all the walls with ornaments having character and style. Wherever possible Gauguin chose to treat the wall and ceiling designs in a predominantly symmetrical fashion. This was of course in keeping with a mainstream tradition of Western wall decoration, and even the exception of the entrance was due to the presence of the door on the right. Second,

there is a striking richness of biographical data contained in the images, especially in the multiple portraits of Gauguin and de Haan, and in the prominent portrait of Marie Henry and her infant daughter. Critics will continue to disagree about specific symbols and meanings attached to these portraits and other depicted figures, but anyone visiting the dining room as originally decorated would have recognized the unusual degree of importance assigned to the three principal residents of the inn. Finally, many of the major paintings of the decor relate to one of Gauguin's primary preoccupations during late 1889. As in his wood relief *Be In Love* and in his painting *Christ in the Garden of Olives* (Figs. 77, 72) Gauguin presents himself and de Haan as outcasts or wanderers at the fringe of an uncomprehending society. Like the "primitive" Breton people he admired for their supposedly unquestioning adherence to "Catholic superstitions," Gauguin depicted himself as a seeker after some primordial religious and philosophical knowledge, albeit in terms of his own non-secular modernity. Above all, he felt himself to be a martyr to his own artistic ambitions and a soul tormented by the conflicting attractions of heaven and earth. It was this dualistic outlook which first became consistently manifest in his works of late 1889 – particularly those displayed at the inn of Marie Henry – and which would continue to inform much of his thinking and art for the remainder of his life.

101. (*overleaf, left*) Paul Gauguin, *Bonjour Monsieur Gauguin*, 1889, oil on canvas mounted on board, 29 ½ × 21 ½ in. (73.6 × 52.8 cm). The Armand Hammer Collection, UCLA at The Armand Hammer Museum and Cultural Center, Los Angeles. *Exhibition no. 4*

102. (*overleaf, right*) Meyer de Haan, *Maternity*, 1889, oil on canvas, 28 ¼ × 23 ¼ in. (72 × 59 cm). Private collection

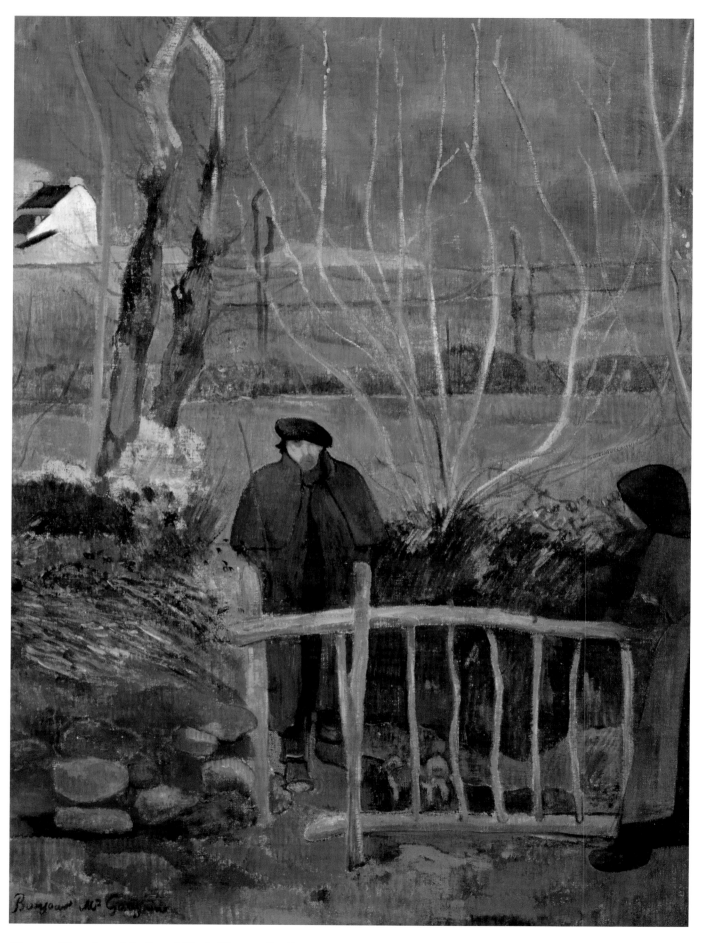

Gauguin and the Inn of Marie Henry at Pouldu

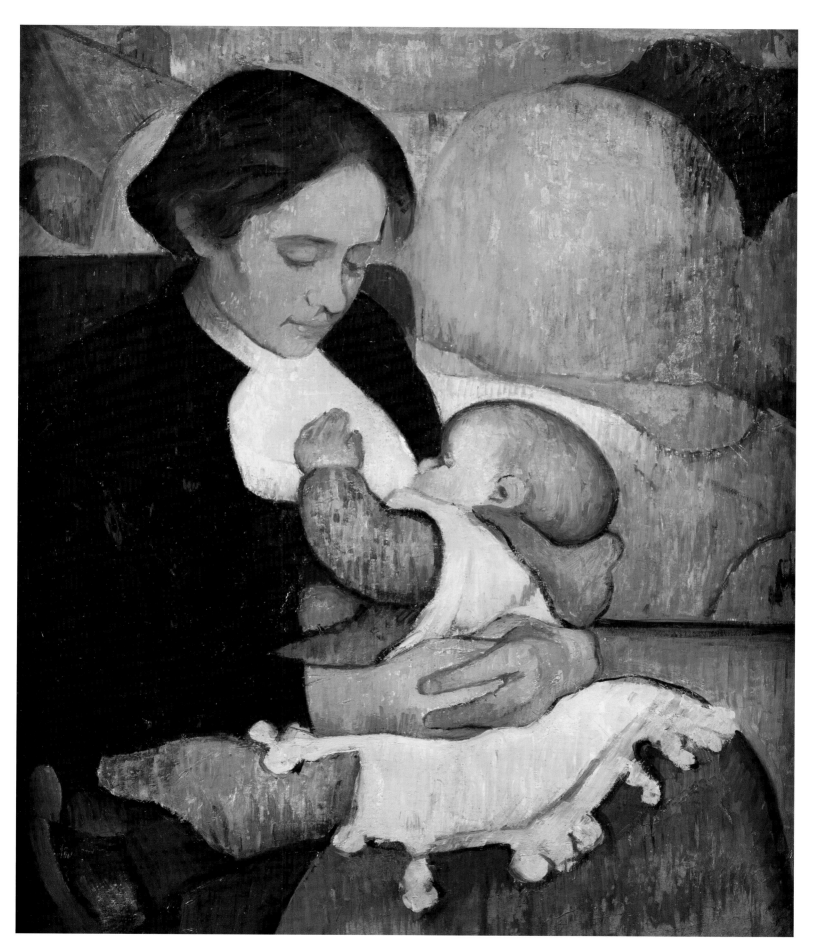

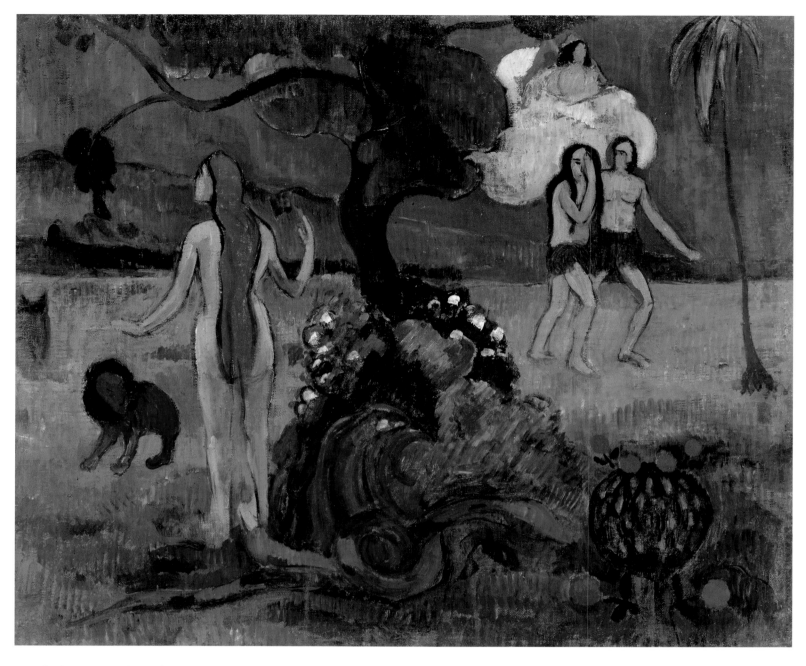

103. Paul Gauguin, *Adam and Eve, or Paradise Lost*, *c.* 1890, oil on canvas, 18 1/8 × 20 ⅝ in. (46 × 55 cm). Yale University Art Gallery. Gift of Mr. and Mrs. Benjamin Bensinger, BA 1928. *Exhibition no. 11*

104. Paul Gauguin, *The Carribean Woman*, 1889, oil on wood, 24 ½ × 20 ½ in. (62.2 × 52 cm). Private collection

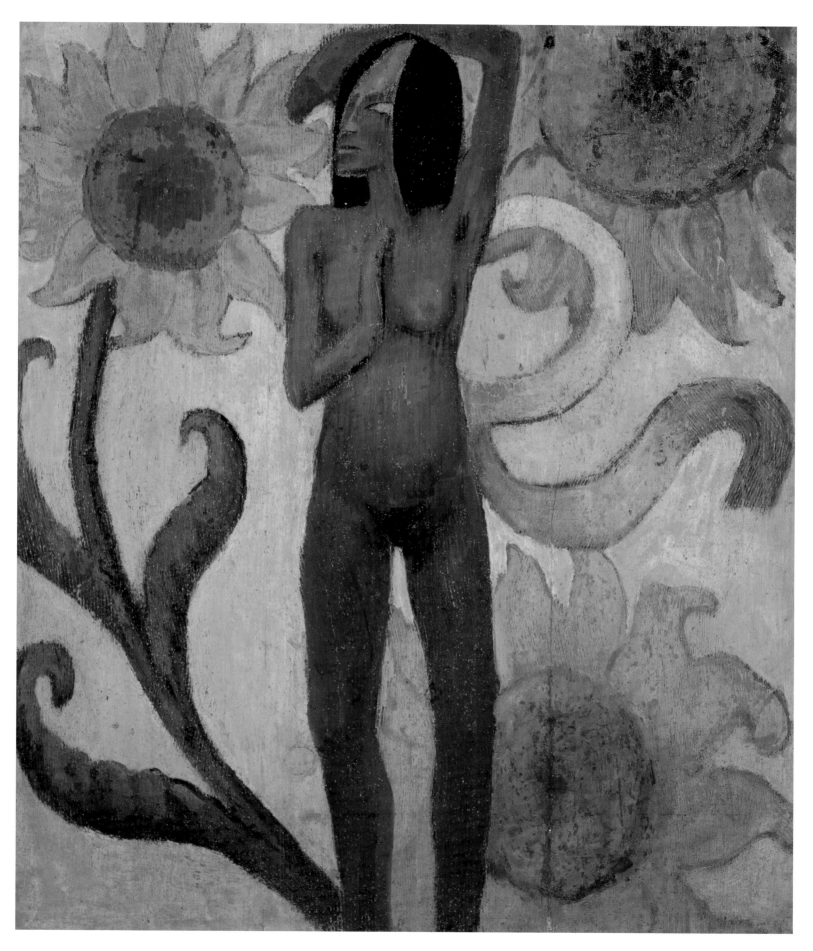

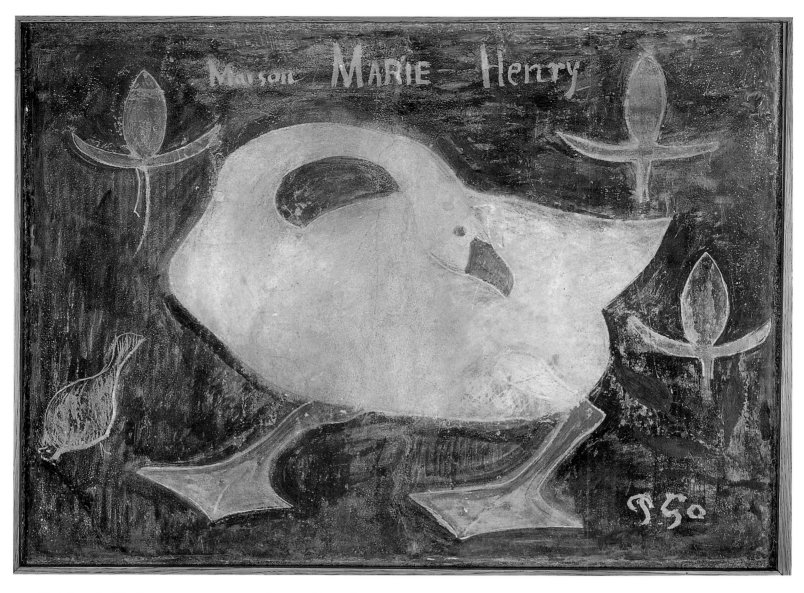

105. Paul Gauguin, *The Goose, c.* 1889, tempera on plaster, 20 ⅞ × 28 ⅜ in. (53 × 72 cm). Musée des Beaux-Arts, Quimper. *Exhibition no. 9*

106. Meyer de Haan, *Still Life with Pitcher and Onions*, 1889–90, oil on canvas, mounted on wood, 11 ¾ × 11 ¾ in. (30 × 30 cm). Musée des Beaux-Arts, Quimper. *Exhibition no. 41*

107. Meyer de Haan, *Breton Women Scutching Flax (Labor)*, 1889, fresco transferred to canvas, 52 ½ × 79 ¼ in. (133.7 × 202 cm). Private collection, courtesy of Nancy Whyte Fine Arts, New York. *Exhibition no. 40*

108. Paul Gauguin, *The Spinner (Joan of Arc)*, 1889, fresco transferred to canvas, 45 ⅝ × 22 ⅞ in. (116 × 58 cm). Private collection

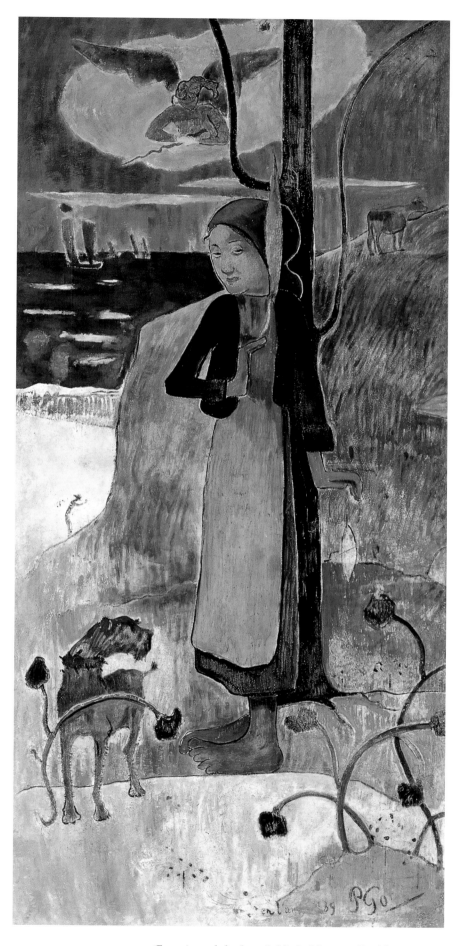

VICTOR MERLHÈS

LABOR. Painters at Play in Le Pouldu

TRANSLATED FROM THE FRENCH

The Exposition universelle of 1889 opened in Paris on May 6, three weeks before Paul Gauguin left the capital to return to Brittany. Organized on a square grid of ninety-five hectares situated between the Trocadéro, the Ecole militaire and the extremities of the esplanade of the Invalides (Fig. 110), this grandiose event lasted six months, brought together some 60,000 exhibitors and attracted 28 million visitors. The choice of the year 1889 was no accident, but was clearly intended to meet the desire to celebrate the centennial of the Revolution and the principles of the Republic with appropriate splendor.

The esplanade of the Invalides was devoted to various pavilions, but principally to an important Colonial exhibition where the French colonies and protectorates were of course predominant. As in 1867 and 1878, the heart of the Exposition was located on the Champ-de-Mars. Along the banks of the Seine, the Eiffel Tower

109. (*facing page*) Detail of Fig. 107, *Labor (Breton Women Scutching Flax)*

110. Exposition universelle of 1889. Panorama of the Champ-de-Mars and the Trocadéro. To the left of the Eiffel Tower, the Palais des Beaux-Arts; to the right, the Palais des Arts Libéraux (drawing by A. Deroy)

111. The Palais des Beaux-Arts

112. The *Café des Arts* in the Exposition universelle: Princess Dolgorouki and her orchestra before the canvases of the "Impressionist and Synthetist Group" (drawing by P. G. Jeanniot; Schuffenecker's *Seaweed gatherers* is visible behind the doublebass player)

113. The Javanese Dancers, in *Revue de l'Exposition universelle de 1889*, vol. 1, Paris, 1890, p. 104 (watercolor by A. Brouillet)

dominated several other imposing buildings also erected for the occasion. At the eastern foot of the tower was the Palais des Beaux-Arts (Fig. 111), and its twin, the Palais des Arts libéraux, was at the southern edge. These immense iron buildings, designed by Jean-Camille Formigé, were sheathed in panels of enameled pink and blue terracotta. They were separated by vast expanses of gardens adorned with fountains illuminated by electric light. Running along their lengths were covered galleries where visitors could find shops, especially cafés, restaurants and brasseries. One of these, at the foot of the Palais des Beaux-Arts, was the Café des Arts (Fig. 112), and its manager, Volpini, agreed to display on its walls the works of an improvised group of unknown painters, baptized for this occasion "Groupe impressionniste et synthétiste." Gauguin was the instigator of this idea, as well as the only participating painter of whom the art world had some knowledge till then. However, he left Paris before Volpini had actually given his agreement to the presentation, and he never even saw the exhibition,

which Schuffenecker, assisted by Emile Bernard, organized that June.[1]

The Palais des Beaux-Arts welcomed a great retrospective of French art. There was the Centennial exhibition for the period 1789 to 1879 as well as the Decenniale, a retrospective devoted to the art of the previous ten years, divided into French and international sections. Of the Centennial exhibit Gauguin wrote: "…this exhibition is the triumph of the artists I have named as having been rejected and scorned: Corot, Millet, Daumier and lastly, Manet."[2] Regarding the Decenniale he declared:

> …entering the Beaux-Arts section so costly for the State, that is to say for us citizens, we remain more disheartened than astonished. […]All this vain world wantonly displays these daubs with a lack of constraint truly beyond belief. It is true that all Europe is in the same situation, won over by Paris' bad taste. […] Overseas painters have hastened to master the official French

115. A: Fragment of ornamentation of a pilaster from Méléa (engraving by Smeeton Tilly, in *L'Art Khmer, Etude historique sur les monuments de l'ancien Cambodge (...) suivi d'un catalogue raisonné du Musée Khmer de Compiègne*, by Count [E. C. Baudier] de Croizier, Paris, 1875, p. 72). B: Paul Gauguin, *Exotic Woman*, painted terracotta on wood base. The Henry and Rose Pearlman Foundation, Inc. *Exhibition no. 19*

114. Exposition universelle of 1889: Pavilion of Cambodia with a recreation of one of the five towers of the temple of Angkor-Wat

style of painting and show us the results [...] pictures just as *common* and academic as those of our own pseudo-artists.[3]

Thus it was not in that exhibition that Gauguin found great subjects worthy of reflection.

He certainly viewed with the liveliest interest everything regarding the decorative and industrial arts in the Palais des Industries diverses, especially the exhibits of carved wood, furniture, glassware, and ceramics, for this section likewise elicited his comments in *Le Moderniste Illustré*. Moreover, it is known that Gauguin attended, at least twice, the performances presented by Buffalo Bill and his troupe outside the official exhibition, near the Ternes entrance way and that this spectacle made a profound impression on him. Finally, the colonial exhibition would have a lasting impact on his thoughts. Algeria and Tunisia each had a *palais*; Madagascar, Guadeloupe, Gabon, the Congo, Senegal, Tahiti, New Caledonia, and Guyana were represented by villages, trading posts, and pavil-

ions. However, it was Asia which, due to the refinement of its products and of its art, aroused the most interest and obtained the greatest success. The Palais de Cochin China, that of Annam-Tonkin and its annex, the Pagoda of Great Tranquility, a reconstruction of one of the towers at the temple of Angkor Wat (Fig. 114), and the Javanese village, whose little dancers — "four goddesses, whom one would have thought had stepped out of Angkor's bas-reliefs"[4] — became instantly popular and undoubtedly fascinated Gauguin (Fig. 113).

Douglas W. Druick and Peter Zegers have sought to determine the influence of the Exposition coloniale on Gauguin, in particular attempting to identify the sculptural sources of inspiration he assimilated into his work following his visits to the Exposition.[5] Without seeking to sum up their detailed findings, abounding in valuable information, one can, however, note that the authors develop the idea – certainly true in great measure – that the main aim of the Exposition coloniale was to exalt the benefits of the

116. Muséum ethnographique des Missions scientifiques (in the center, a Peruvian mummy), in *L'Univers Illustré*, March 9, 1878, p. 153

French policy of colonial expansion and to justify it on the grounds of morality, economics, politics, culture and science. These authors record that the architectural heritage of Cambodia, largely unknown for a long time, had occasioned several research missions after the installation of the French protectorate in 1863. These missions permitted scholars to bring back numerous casts from the temple of Angkor Wat and to assemble the elements of a Museum of Khmer Art whose collections — considerably enlarged — were transferred from Compiègne to Paris in 1878 and presented at the Exposition universelle.

The writers point out that during those years, and particularly in 1889, the Cambodian legacy was used in a way as an element of the rhetoric aiming to celebrate the positive aspects of the colonial plan; to that end Khmer sculpture slowly changed its status, passing from ethnographic document to works of art. In their conclusions D. Druick and P. Zegers express the idea that the influence of this propaganda on Gauguin was considerable and that it led him to cast a fresh eye on the iconographic documents that he had possessed for a long time without apparently paying them much attention, but which in the future he would frequently exploit in his own work.[6] Likewise, Druick and Zegers demonstrate in convincing fashion that several of the works that had decorated the walls of the *Buvette de la plage* in Le Pouldu derive in certain of their poses and gestures from the casts of Cambodian art (Fig. 115) either exhibited in the Khmer Museum installed from then on in the Trocadéro or decorating the reconstructed tower of the Angkor Wat temple. This fruitful research, whose implications go well beyond the revelation of specific sources for some of Gauguin's paintings, calls for some remarks.

Even if it is evident that the Exposition of 1889 constituted an intense stimulus which would nourish the artist's thinking for a long time, it is no less certain that for some months already Gauguin found himself in a state of receptivity, indeed of intellec-

tual agitation, without which he would not have been able to profit from all that was offered to his view and proposed to his mind. In contrast to the Exposition universelle of 1878, that of 1889 was undoubtedly innovative in many ways, but not to the extent that it really offered the sight of things previously unsuspected.

At the beginning of 1878, for example, one of the great events of Parisian life had been the opening of the Muséum ethnographique des Missions scientifiques (Fig. 116), announced as a mere foretaste of an imminent, and much more important Musée ethnographique. Many sculptures, casts, and drawings from the Musée Khmer in Compiègne were exhibited there, pieces which were then shown several months later in the Exposition universelle and which subsequently remained in the Trocadéro palace. There is no doubt that Gauguin went as early as 1878 and perhaps many times to contemplate these riches. Indeed, it would be strange that he, who was pleased to invoke at times his supposed Inca origins, would remain indifferent to the vestiges of the Peruvian civilization that the Muséum ethnographique had revealed to the public: "the throne of the Incas, the portico of Huanaco, the monolithic portal of Tiahuanaco, the Peruvian tombs with their numerous mummies, genuine mummies, some of which are particularly hideous"[7] had then aroused considerable curiosity. Yet it was not until the year 1888 that one of these mummies reappeared for the first time – transformed, of course – in one of Gauguin's canvases. Certainly, one could not say that this borrowing was suggested by imperialistic propaganda; rather, it flowed from the personal reflection of a painter on his art, even if the creation of an ethnographic museum represents to a large degree the cultural and scientific benefit of expeditions organized and financed by a political power. One could make similar remarks regarding the new interest that beginning in 1888 Gauguin manifested for primitive painters and for Japanese and Egyptian art. How can we provide a more general justification for this interest?

Around 1878, Gauguin, at age thirty, was still only a late beginner whose main ambition did not go beyond the desire to become part of the Impressionist school and to exhibit with them in order to emerge from obscurity. The Impressionist aesthetic (its critics might call it an aesthetic of the eye, as Gauguin ultimately did) engaged him for a number of years. By channeling his efforts into the rendering of perception, it imposed upon him a formative discipline, but it severely impeded his imagination and the free flow of fantasy without which there can be no creation: "the artist must be free or he is not an artist," Gauguin wrote to his friend Monfreid, much later. By confining him to the pictorial recreation of essentially visual phenomena, Impressionism held him far away from a world of ideas, intuitions, and emotions which after 1886 he gradually but avidly reappropriated for himself.

In the fall of 1884,[8] suddenly fascinated by graphology, Gauguin began to seek the character of a person in his writing; he was already concerned about a humanity under the outward appearance, a depth beneath the surface, the abstract and symbolic expression of a truth hidden behind the visible world. This preoccupation indicated his necessary evolution toward an art less concerned with transcribing the visible than sensing the invisible.

The cruel separation from his family, in the spring of 1885, probably occasioned in Gauguin the upheaval, the shock after which few illusions endured, and one can assume that this rupture, followed one year later by a break with Camille Pissarro – his friend and mentor – contributed significantly to precipitating his latent evolution. Having lost his job in 1883, fate ordained that in 1885–86 Gauguin also would lose two of the great guideposts of his life: his family and the mentor whose aesthetic he had adopted: the compass and the sextant.

Henceforth compelled to rely only on himself, Gauguin, no doubt, trusted more to his instinct than to any principles. Unable to sell his paintings, he tried to earn some money by making ceramics. In his conviction that all matter must be worked according to its intrinsic nature, he scarcely attempted to impose any Impressionist manner on his clay. On the contrary, to give form and decorate the "small products of [his] great foolishness" (in a word: folly! for which until then his painting had not been noted) he gave free rein to his fantasy. The baroque, the eccentric, the grotesque invaded what he himself at that time called "these monstrosities."[9] It was thus, it seems, in 1886, that in the tips of his revitalized fingers Gauguin could feel the first stirrings of a liberty and a power to be regained.

Without misfortune, or suffering, this reconquest would not perhaps have required two years. But during this time, there occurred the incredible success of the pointillist heresy, the enslaving dogma of painting subjugated to scientific principles. Possessed by the new consciousness of one approaching maturity, Gauguin in Brittany, discovered in the esteem that several young painters expressed for him the support that made him firm in his convictions. Then in 1887 there was the intense if ephemeral joy of departure and renewed acquaintance with the tropics, and, through reading and direct encounters, the re-discovery of Puvis de Chavannes, the promising interest of an admiring and devoted young dealer, Theo van Gogh, as well as the letters exchanged with Vincent before the feverish and decisive experience with the former preacher in Arles. All of this allowed Gauguin to place a healthy distance between himself and Impressionism. From the beginning of the summer of 1888, with his physical vigor and equilibrium restored, Gauguin could reconsider the world and art from a new perspective. Throughout the following months, a wealth of reminiscences, of things seen, read, understood, sensed resurfaced and the artist rediscovered what for a lapse of ten years he had more or less neglected. Freed of the blinders without which he had long believed himself incapable of making his way, he looked in all directions, particularly towards that which the sensuality and positivism of Impressionism had disdained, towards that which Pissarro feared and detested: myth, the supernatural, everything touched by superstition and religion, that with which art has maintained a close relation since time immemorial. In this area, according to his profound temperament, Gauguin now was able to test everything again.

To nurture this imagination, the Exposition and its surroundings offered many attractions: the Musée ethnographique from then on installed – like the admirable Musée des sculptures com-

117. Interior view of the Palais des Arts Libéraux, with the gilt wood Great Buddha of Nara

parées – at the Trocadéro which still housed in its galleries a retrospective exhibition of French art: bronzes, casts, tapestries, book bindings, goldsmith's work, clocks, enamels, reliquaries, ivories and sculpted woods, musical instruments, ironwork, etc. The treasures of castles, abbeys, cathedrals, numerous museums and collectors had been called upon to create an exceptional, though temporary collection; what one writer called "a musée de Cluny, enriched and refined, where only indisputable marvels would be found." He added, "I believe that these epochs of barbarism were enlightened about certain things in a way that we will not surpass even with the lamps of Mr. Edison or the beacons of the Eiffel Tower."[10] This reflection highlights one of Gauguin's basic concerns during this period: freeing himself from the conventions of the present time, becoming ever more absorbed in himself to permit the expression of primitive emotion, retreating ever farther back in time.

The 1889 Exposition universelle — and it was reproached for this — sacrificed much to the *Retrospective*. But commemorating the Revolution was to celebrate the century of encyclopedism, of the Enlightenment. In many respects, this exhibition was hence conceived as a vast, intelligent and broad retrospective of the history of humanity. Thus the Palais des Arts libéraux was almost totally devoted to the *Exposition rétrospective du Travail* to which scholars studying Gauguin have never paid attention. The intention of this exhibition was to retrace, with the aid of documents, objects and authentic monuments the stages in the evolution of human genius from the time of the caveman. The essentially historical and technical nature of the retrospective had not, however, led the organizers to ignore the fact that in all epochs the arts and technology have evolved in concert. Through the choice of the pieces exhibited, art was omnipresent (Fig. 117). It seems certain that it was in 1889, confronted by this unreserved glorification of progress, that the feeling became definitively fixed in Gauguin that rationalism was taking the wrong path, that a regeneration was necessary opposing the simple to the complex, intuition to logic, instinct to reason, liberty to constraint.

118. Retrospective exhibit of the History of Work: plan from the first section (ground floor). A: Samoyedic encampment. Groups of prehistoric archeology; B: First workers in metals; C: Flint workers; D: Shelter under the rocks of the Vézère river; E: First Builders; F: Prehistorical Archeology; G: Sudan Forgers; H: Agave Paper Making by the Aztecs; I: Gallo-Roman merchant of pottery and terra cotta figurines; J: Workshop of Athenian potter (5th century BC); K: Alchemist's laboratory; L: Chemistry; Instruments of Lavoisier; M: History of Work in Oriental Antiquity: Chaldean, Assyrian, Persian epoch; N: Art of printing; O: Workshop of Egyptian weaving and spinning; P: Workshop of a violin maker in the eighteenth century; Q: Japanese and Chinese collections; R: Invention of writing; S: Workshop of Chinese cloisonné enamels; T: Exhibit from Denmark; U: Anthropology; V: Prehistoric Archeology; W: Statue of the Nara Buddha

119. Workshop for the manufacture of Chinese cloisonné enamels (reconstruction by d'Hervey de Saint-Denys, 1889)

The exposition was divided into five sections: anthropology and ethnography; liberal arts; applied arts; means of transportation; military arts. Thumbing through the copious catalogues occasioned by this exposition — the official catalogue of the first section itself alone occupies 250 pages — it seems quite likely that the Palais des Arts libéraux was one of the sites most regularly frequented by Gauguin. All, or almost all of what could interest him seems to have been gathered there. Undoubtedly the inventory of objects displayed along the stands, the installations, glass cases, and various collections which must have attracted his curious and penetrating eyes would be a long one.

The plan of the ground floor of the anthropology-ethnography section gives an idea of the exhibition's organization (Fig. 118). Numerous dioramas animated it, conceived so as to display as faithfully as possible the activity of flint carvers and then of a Samoyed encampment, the studio of a fifth-century Athenian potter or the laboratory of a Renaissance alchemist, etc. A studio for making "Chinese" cloisonnés enamels seems in particular to have attracted Gauguin's attention (Fig. 119), to the point that, several years later in Tahiti, he transposed their memory into one of those little fables of which he was so fond, "The Cloisonné Vases":

...I am going to introduce you through the simple means of a narration into the midst of a Japanese family; farmers nine months of the year, they become artists during the three months of winter. (...) Here then is our Japanese man installed with a copper vase before him, his design in full view beside him. His pincers, scissors, copper wire, those are his tools. Skillfully he gives his laid-out copper wire all the forms represented in the drawing before him, then by means of some borax he solders all these contours on the copper vase; of course in their proper place corresponding to the design on the paper. This operation carried out with great care and skill, filling all the voids with ceramic pastes of different colors is nothing but child's play. The artist has finished his work, he has only to fire his vase...[11]

120. Egyptian workshop of spinning and weaving (reconstruction by G. Maspero, 1889). On the front inner walls, upper register: "The flax field occupies the middle of the scene: four workers rip out the stalks; two others hold fistfuls of stalks that they have ripped out and beat the top of their right hand to made the seeds fall out. To the right, two crouching workers tie the casks under the surveillance of a guard standing behind them; seven casks are already symmetrically lined up above their heads. These scenes are derived from the Khnoumhospou tomb, at Beni-Hassan. To the left, a worker brings a cask on his shoulders to hand it to another worker who passes the stalks through the teeth of an enormous comb on which he places his foot; the seeds and waste accumulate in the comb which leans sharply. This last scene is taken from the Pehni tomb at El-Kab." On the side wall, lower register: "The different phases of the manufacture of thread fill this second register; the spinning, then the glossing, then placing it on bobbins. To the left the directress of the workshop, and behind her a foreman, to the right a director of the workshop are standing and keep watch over the work. These panels are after the Beni-Hassan tombs, except for some inscriptions that were taken from a tomb in Thebes. They represent scenes of industrial life in Egypt, such as occurred some 5,000 years ago."

The space visible on the part of the plan reproduced here is continued on the left by an identical space occupied by the second section, that of liberal arts: astronomy, physics, chemistry, etc., as well as music, painting, sculpture, engraving, a whole corner being reserved for Japanese prints. In the part devoted to sculpture the visitor saw collections of wood, wax, ivories, sculpted marbles plus a number of casts, all accompanied by the appropriate tools and precise explanations relative to the techniques employed. Jules Bouillot, formerly Gauguin's neighbor, who had initiated him into the carving of marble,[12] had illustrated with specific examples the nine stages of the "mise au point" of a marble statuette. A short distance from there, one found the history of the methods of painting through the ages, which was the subject of a didactic exhibit : paintings in encaustic, oil, watercolor, paintings in fresco, distemper or tempera, paintings on glass, faience and porcelain were explained, and sundry fragments of ancient and sixteenth-century fresco paintings illustrated the contents of the notes. A palette of colors employed for fresco painting was exhibited, as well as a fragment of fresco in the process of being painted by the academician J. E. Lenepveu, who had just finished his *Life of Joan of Arc* on the walls of the Panthéon.

Until that year of 1889, Gauguin had never painted in fresco and the word itself, as far as one can tell, had never emerged from his pen prior to his visits to the *Histoire rétrospective du Travail*. But shortly after that here is Gauguin affirming that "a fresco is only a fresco when its color enters wet directly into the plaster."[13] This is

exactly what the accounts summed up in the official catalogue indicate.[14] While it would be rash to draw conclusions from this, one can at least state the facts.

Among the other reconstructed scenes, there was also a studio demonstrating the spinning and weaving of linen in ancient Egypt: four women were shown at work; two of them weave; another, crouching, prepares the unprocessed fibers while the fourth, standing, spins them. On the walls, in four registers one observed the scrupulous but recombined and reorganized reproduction of paintings based for the most part on those of Beni Hassan. On the right bank of the Nile, north of Mallawi, near the former village of Beni Hassan el-Kâdim, a group of thirty-nine hypogeums from the Middle Empire (XI and XII dynasties, *c.* 1780–2000 B.C.) constitutes a very precious funerary ensemble. Excavated in the rock, these tombs of princes of the Antelope nomos were in some cases richly decorated with paintings of exceptional interest. It is there, especially in the tombs of Baket and Khnoumhotep, that the renowned Egyptologist Gaston Maspero had chosen the elements destined to decorate the studio conceived on the Champ-de-Mars. That Gauguin and de Haan, each in turn, stopped before this scene seems more than likely.

On the upper level of the wall, seen frontally in the previously unpublished photograph (Fig. 120), two men work, one leaning toward the other. In perfect symmetry and complementing each other, they tear the flax in handfuls in order to obtain the longest fibers for spinning. The sequence, more faithfully reproduced in

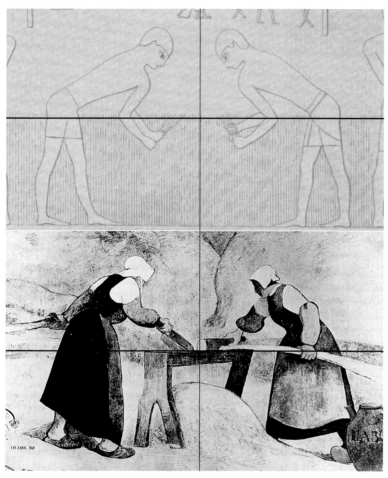

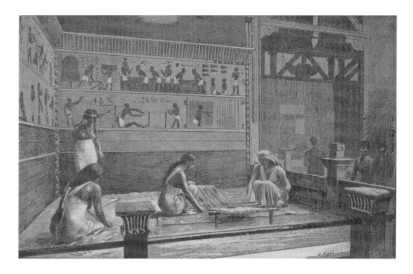

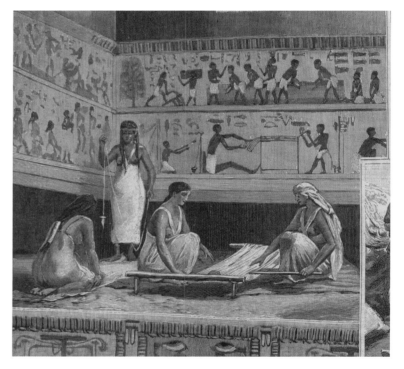

121. Comparative symmetry: ripping up and beating the flax stalks, Khnoumhotop tomb (detail: in I. Rosellini, *I Monumenti dell'Egitto e della Nubia*, 1834, vol. 2; plate xxxv) and Meyer de Haan, *Labor*, 1889, paint on plaster. Private collection

122. "Histoire du Travail – Le Lin en Egypte", in *Livre d'or de l'Exposition*, no. 37, October 26, 1889, p. 589 (drawing by A. Karl)

123. "L'Histoire du Travail dans le Palais des Arts Libéraux: le lin en Egypte", in *Le Monde Illustré*, no. 1700, October 26, 1889, p. 260 (drawing by Pari de Wever, engraved by Charpentié)

I Monumenti dell'Egitto e della Nubia by Rosellini[15] attests to the fact that the symmetry would have been more striking if Maspero had not modified just slightly the unfolding of the scene. This symmetry, so frequent in the art of ancient Egypt, is again found exactly on the walls of the *Buvette de la plage* in the great work by Meyer de Haan (Fig. 121). A coincidence? Perhaps, but one which seems quite striking enough, however, to cause an informed eye to look more closely. Could we be in the presence of the figures that inspired the two Breton women of *Labor*? Without overstating the analysis, one can enumerate the presumptions that would support this hypothesis:

1: The exhibition organized in the Palais des Arts libéraux and the painting of Meyer de Haan have one and the same subject matter : Work. 2: The scene recreated by Maspero concerns most specifically the making of linen — although it could be hemp, a fiber the Egyptians and Bretons worked in similar fashion — and it is also the working of hemp (rather than flax) illustrated in the canvas of the Dutch painter. 3: In the Beni Hassan scene, as in that of Le Pouldu, there is a double symmetry, vertical and horizontal common to the two figures bent over the same object (the flax; the brake).[16] 4: If the movement of the arms is different, the positions of the legs as well as the bodies are extremely similar, and the figures take precedence over the background. Inexpressive, these silhouettes convey no feeling; they merely symbolize Work. 5: But whether hemp or flax, the fiber must be spun. From the achievement of *Labor*, Gauguin followed the lead of his student in painting on the same wall a young spinner no less vertical than those of the *Histoire du travail* and no less hieratic. 6: Finally, on the Great Sands of Le Pouldu as on those of Beni Hassan, we are dealing

124. Proposed reconstruction of the dining room at the *Buvette de la plage* (Courtesy of the Association des amis de la Maison Marie Henry, Le Pouldu).

125. Paul Gauguin, *Harvest, Brittany*, 1889, oil on canvas, 36 ¼ × 28 ¾ in. (92 × 73 cm). Courtauld Institute Galleries, London

with — this point is basic — decorative mural painting, and whether de Haan was conscious of it or not, symbolic painting.

This solid group of presumptions raises at least one question: how could the recollection of the Egyptian workshop have inspired the Pouldu paintings after an interval of several months? The hypothesis of a quick sketch made by one of the two artists cannot be excluded, but no known drawing supports this. It is also possible that one of the two obtained at the Exposition a copy of the plate reproduced here or one of the photographic albums representing several of the reconstituted scenes that were also produced at the same time. But most probably the painters had in their possession one of several prints of *Le Travail du lin* that were published in the newspapers or journals of the time. But when did these appear?

The Eiffel Tower, the colonial Exposition, the gardens and illuminated fountains, the exhibitions in the Palais des Beaux-arts, the Gallery of Machinery, the Cairo street scene, l'Histoire de l'Habitation, etc. offered more impressive spectacles, proposed entertainment less austere and didactic than the Palais des Arts libéraux. This is probably the reason why numerous periodicals that accompanied the current interest in the Exposition universelle seem to have only shown interest in the *Histoire du travail* in the fall, shortly before the Exposition's closing. Despite arduous research, I have found no reproduction of the Egyptian spinning and weaving workshop prior to October 26, that is to say, just prior to the conception and subsequent realization of the Pouldu decoration. But at that date, two different engravings were published, one in *Le Monde Illustré* (Fig. 122),[17] and the second in *Le livre d'or de l'Exposition* (Fig. 123).[18]

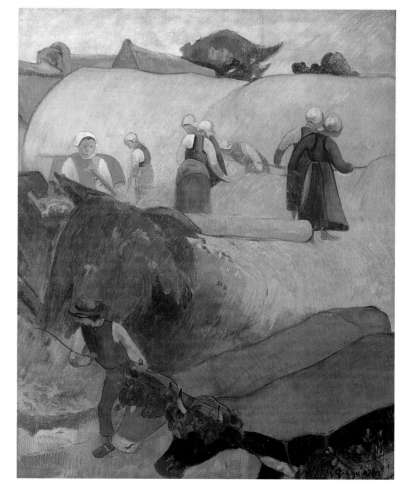

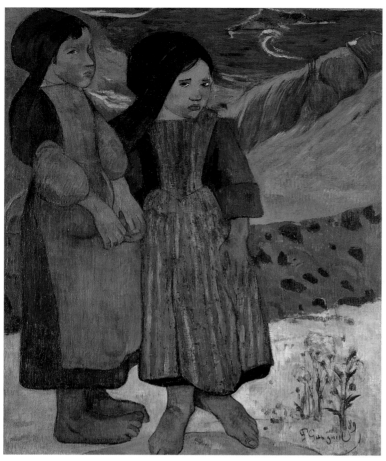

126. Paul Gauguin, *Girls of Le Pouldu*, 1889, oil on canvas, 36 ⅜ × 29 in. (92.5 × 73.6 cm). The National Museum of Western Art, Matsukata Collection, Tokyo. (*The Spinner's* feet are a mirror-image of the feet of the young girl to the left)

Thus it seems that the following genesis can be proposed: in the short days at the end of the Breton autumn, often damp, windy and hardly propitious for work outside, the *Buvette* (Fig. 124), where the painters still took only their meals, appeared more welcoming and warm than the vast studio of the Villa Mauduit. Between de Haan and Marie Henry at least a relationship of some intimacy was established, which was the original reason for the wall decoration to be created there. It was a recollection of a scene from the *Histoire du travail* – a memory sustained by a sketch, a photograph, or more probably by some engraving appearing at the time in the press — which nurtured conversations and reflections. Under the influence of the deep interest Gauguin manifested at that time for Egyptian art and the symbolism of signs, as well as the admiration he expressed for the work of Puvis de Chavannes, after having developed his project in the last week of November, Meyer de Haan undertook the task of painting *Labor*. Barely had he finished his work, than Gauguin took up the section of the wall left bare, and, in an astonishing exercise of creativity, conceived a composition complementary both in terms of theme and style. In effect, the Egyptian workshop furnished the idea of a wall decoration, the theme and the figures that the painters transposed into a Breton universe. By the way of background to his peasant women, de

Haan borrowed the haystacks from a harvest scene painted the very same year at Le Pouldu by Gauguin (Fig. 125), who, for his part, places his *Spinner* in the setting which he had just employed for his *Calvary* or *Green Christ* (Fig. 74): the column of the cross of Calvary is transformed into a tree, the holy women and the crucified man give way to an angel and a young girl whose feet are modeled on those of one painted shortly before (Fig. 126).

The title adopted by de Haan corresponds to one of the key words constantly promoted by the organizers of the Exposition universelle. For example the central porch of the Palais des Arts libéraux was framed by two tall pylons decorated with allegorical figures in enameled ceramic and bore the inscriptions PAX and LABOR.[19] These very words reappeared on the medallions of the footbridges, which were used by the visitors strolling in the area of the Exposition. It would have been difficult to approach the Champ-de-Mars without being struck by these two words (Fig. 127). In this case if the choice of Latin was due to its being the language common to Christian Europe, in de Haan's work it has the effect, of course, of suggesting the idea of Antiquity. From time immemorial Labor was the fate of humanity, and the terracotta jar bearing the word in his painting reinforces the idea that this is an almost timeless scene. Their garb alone differentiates these Breton women from the peasants four millennia removed that inspired them. Escaping time, that is the first step toward abstraction, toward the symbolic.

But *Labor* also has origins in the work of Puvis de Chavannes, the uncontested master of mural painting in the second half of the nineteenth century. His fame was enormous among painters of all types, and Gauguin esteemed him greatly. Latin titles occur frequently in the works of Puvis. In fact an oil sketch titled *Labor* (1862) is the source of the great canvas in the Musée de Picardie in Amiens; of which a smaller version is now in the collection of the National Gallery, Washington, D.C. (Fig. 128).[20] Did de Haan actually know any of the works by Puvis on this theme? We do not know.[21] Nevertheless, for whatever reason he chose the title, it accords perfectly both with the scene of the *Histoire du travail* and the spirit of Puvis's works. *Labor* thus synthesizes something of Egyptian art, and the art of both Puvis and Gauguin. There is also Millet, who had died in 1875, but who was celebrated in glorious fashion by a retrospective showing in the Centennial. Millet is quite closely connected, as are certain details of country scenes from Flemish and Dutch old masters.

In the same museum in Amiens, among the allegorical figures facing his *Concordia*, Puvis placed a *Harvester* and a *Spinner*.[22] Coincidence? No! Concordance. A little later (in 1890?) who knows by what hand (probably that of de Haan, or perhaps another?) were inscribed the words: *Ludus pro Vita* (Game for Life)[23] beneath de Haan's scene of Breton women preparing the hemp on the inn's wall. This was an obvious reference to one of the most famous works by Puvis, *Ludus pro Patria* (Game for the Homeland), an immense canvas glued in 1888 to the wall of the staircase in the Picardie museum and of which there are several variants (Fig. 129). It attests to the fact that for the Pouldu painters the message of the older master continued to be pondered and that *Labor* recognized

127. Access footbridge to the Exposition universelle (detail)

128. Pierre Puvis de Chavannes, *Le Travail*, 1867, oil on canvas, 42 ¾ × 58 ¼ in. (108.5 × 148 cm). National Gallery of Art, Washington, D.C.

LE TRAVAIL

or should recognize that debt. Only *Vita* replaced *Patria*. One thus passed from the collective to the individual, and the ideological difference is not small.

Following de Haan, Gauguin painted what he described in a letter to Vincent as "a peasant woman spinning beside the sea, her dog and her cow" (Fig. 108). Since van Gogh had reproached him for the religious orientation of his recent works, Gauguin took care not to mention the angel whose silent message, however, to a large degree creates the tension in the composition. It is this messenger from heaven who inspired several writers, and quite early on, at least from 1927,[24] with the idea of titling the work *Joan of Arc*. Not only can this interpretation be understood, it can also be defended.

It is said that from the age of thirteen "Jehanne la bonne Lorraine" (*c.* 1412–31) heard the voice of the archangel Michael, and then those of St. Catherine and St. Marguerite who enjoined her to go to the dauphin and have him consecrated as king at Reims and then to deliver France from the English invaders. Legend makes Joan a shepherdess and says that she liked to sing at the base of a very old beech tree, where the beings whom she then called "fairies" spoke to her. The iconographic tradition often depicts her spinning her distaff or guarding her sheep. Having obtained an audience with the dauphin in February 1429, Joan

played a decisive role in the liberation of Orléans in April, defeated the English army at Patay in June and assured the mystical coronation of Charles VII in Reims on July 17. It was during her attempt to save Compiègne that she was taken prisoner one year later on May 23, 1430. The Université de Paris — the city was at that time under the control of the Burgundians, allies of the English – conducted the legal case against her. Declared a relapsed heretic, Joan was delivered to the English and burned alive in Rouen on May 30, 1431, at the age of nineteen. Rome rehabilitated her sixteen years later, and canonized her in 1920. It would be an enormous task to prepare an inventory of all the literary and artistic works that have been devoted to this heroine, the most popular and famous in all of France, inspiration for numerous poets, presented both on the stage and in prose, sculpted in wood and marble, depicted in a multitude of stained glass windows and innumerable engravings and paintings.

Jules Bastien-Lepage (1848–84) was born the same year as Gauguin. He was a student of Cabanel – the academician Gauguin hated above all others – and his first triumphs were as premature as his death. At the Salon of 1880, his *Joan of Arc* (Fig. 130)achieved an outstanding success, inversely proportional to the low esteem in which it might have been held by artists truly interested in moder-

129. Pierre Puvis de Chavannes, *Ludus pro Patria, c.* 1882, oil on canvas, 13 ⅛ × 52 ⅝ in. (33.3 × 134.3 cm). Metropolitan Museum of Art, New York. Gift of Mrs. Harry Payne Bingham

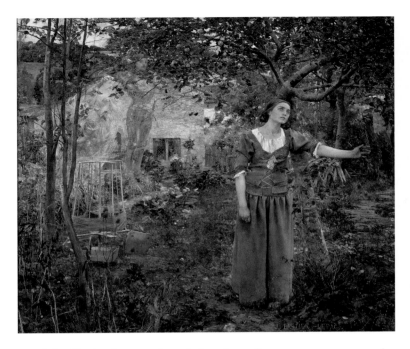

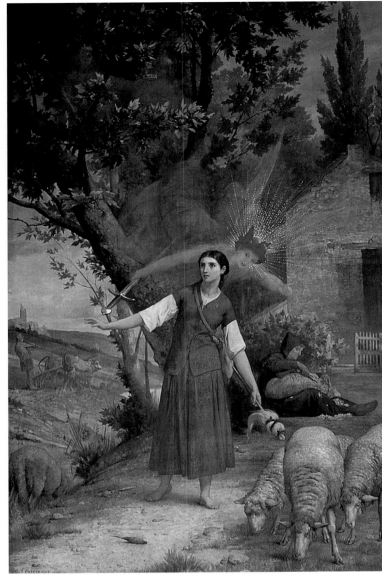

130. Jules Bastien-Lepage, *Joan of Arc*, 1879, oil on canvas, 100 × 110 in. (254 × 279.4 cm). The Metropolitan Museum of Art, New York

131. Jules Eugène Lenepveu, *Joan of Arc's Vision*, 1889, oil on glued canvas. Panthéon, Paris

nity. These seven square meters of inanity, this academic painting nurtured on stereotypes was in truth the prize-winning antithesis of the poetic sensibility that Gauguin sought in his art. Standing in a bosky country setting, the Maid has a moonstruck and submissive air, her hand reaches toward the impossible, toward destiny, toward the sword promised to her. In front of her parents' house, at the foot of a tree, Joan turns her back (she does not see; she hears voices) on the three ectoplasmic beings that dictate her mission to her. The mordant irony of J.-K. Huysmans, who immediately stigmatized the sentimentality of this operetta-like scene, its false naturalism, its flowerets picked one by one, its contrived composition, evidently did not impede the success of this pure product of the Ecole des Beaux-Arts, which was sold shortly afterward — and at an exorbitant price, it is said — and left for the United States.[25] Nineteen canvases by Bastien-Lepage were shown in the Centennial exhibition, and only six by Ingres, five by Daumier....

Another antithesis, but this time to the art of Puvis, was the series of panels dedicated to the story of Joan of Arc in the Panthéon. In 1889 these paintings by Jules Eugène Lenepveu (1819–98) had just been unveiled; this artist was an ordinary academician with a distressing paucity of inspiration, the same one who was chosen to illustrate the technique of fresco painting exhibited a fragment of an unfinished fresco in the Palais des Arts libéraux. In his *Joan of Arc's Vision* (Fig. 131) the same old story: a snipe with dilated pupils has set down her spindle to receive the sword of deliverance from a protoplasmic angel wearing make-up. The sheep, the distaff, the humble paternal home, the two saints curiously perched on the legendary old tree, nothing is lacking in this image from a school manual for an eight-year-old child. "The walls of our Panthéons of Boeotia are sullied by the ejaculations of artists like Lenepveu and 'What's-his-name' from the Institut," exclaimed the young critic G.-A. Aurier in 1891, in the famous article where for Gauguin, "this decorator of genius," the reviewer demanded "Walls! Walls! Give him walls!"[26] Two years later Yvanhoé Rambosson expressed himself in these terms:

An Englishman full of humor whom I was showing the Panthéon said to me in front of M. Lenepveu's tryptich: "If Joan of Arc's execution had to serve as a pretext for such horrors, I deeply regret that my ancestors burned her!" We can only wish one thing, that the Direction des Beaux-Arts, (...) in turn send Lenepveu's fresco to the stake, nurture the flames with its neighboring paintings and finally deliver the freed walls to he who, by all predestination, was destined to sanctify them, to the admirable creator of *Sainte Geneviève sauvant Paris*.[27]

And such was indeed the point of view of Gauguin, who, in 1902 while in Hiva-Oa, wrote:

No doubt unconsciously the State has placed all the leading lights on view before a single man. All that critics could say, all that I have just said, becomes useless, when one is in the Panthéon. Attila's hordes vanquished and charmed by little Geneviève[28] are not at all in the canvases. It is the painters themselves who are the barbarians. Saint Geneviève is Puvis de Chavannes who chases them out of Paris forever. What more beautiful education for painters and critics than that.[29]

No doubt one could evoke many other paintings,[30] but for what purpose? It is certain that those, quite representative of the 1880s had inspired a deep scorn in Gauguin. Let us add, nevertheless, that at the perimeter of the Exposition universelle, and probably only for its duration, a "Musée patriotique de Jeanne d'Arc" had been installed between the Avenue Bosquet and the Landrieu passageway. Perhaps Gauguin visited it?[31] In sum, it is not surprising that some writers spontaneously recognized Joan of Arc in the work from Le Pouldu. There too one sees a young, barefoot peasant girl spinning beside her tree. It is very possible that, wishing to harmonize his work with that of de Haan, Gauguin exploited the theme of the spinner in order to make of a young girl from Pouldu a Joan more poetically true than the stereotyped insipidity of Bastien-Lepage and others like Lenepveu. But in doing so, he took care to complicate the all too simple interpretation of his work: for Joan never saw the sea and the hands of this young Breton girl speak a language that really has nothing Catholic in it. *The Spinner* thus gains in mystery. She can symbolize all the little mystical, hallucinating peasant girls of the world who draw from nature the fervor of a dream and weave a link between the earth and the beyond.

As in *Labor*, therefore, a synthesis; every synthesis is scrounged, for it sums up and unifies heterogeneous elements. Likewise it transcends them. Here the aesthetics and the poetics of Puvis, the dunes of Le Pouldu and the young girls who frequent them, the iconography of Joan of Arc, the angel (and even something more) borrowed from the Italian primitives, the spinner from the Egyptian tombs, the gestures from Buddhist sculptures, all these elements are combined to give birth to a creation of a hieratic mannerism that is neither truly sacred nor truly profane but that leads to dreaming, a suggestive and mysterious creation that maintains its charm and its tension by only answering the questions asked of it with yet more questions, just like the Javanese girls who danced at the Exposition. This synthesis is also decorative; it seems conceived and structured like a stained glass window. Setting aside

132. *The Spinner* (as if transposed into stained glass)

all detail relating to the grisaille (the blackish enamel employed for painting on glass that will vitrify during the firing), a hasty sketch, carried out by thickening a little the compartments of the work divided into panels, gives a vague idea of the cartoon from which a glassworker might have taken his inspiration (Fig. 132). Such a stained glass window would not disgrace a Breton chapel. Three years later the artist would write to Daniel de Monfreid:

Mistrust modeling. The simple stained glass window attracting the eye by its division of colors and forms, that's what is best. In a sense music. To think that I was born to work at an applied art and that I cannot succeed. Whether stained glass or furniture, earthenware, etc...These are in essence my aptitudes, much more than actual painting.[32]

This commentary of the Pouldu "frescos" could clearly be enlarged. In the future, other interpretations will perhaps be proposed; until now, however, no other analysis has succeeded in explaining the genesis of these related works. With regard to *The Spinner*, in my view, it would be a mistake to attribute to it a precise meaning that it has immediately, by a play of hands, taken pleasure in thwarting. Nor do I share the opinion of those who contend that a desire to express an ideological, metaphysical, or esoteric message was motivation for the decoration of the *Buvette de la plage*. On the contrary I believe that, in a healthy emulation nurtured by the concerns specific to each artist, improvisation and the freest fantasy were the rule of the game for the Pouldu painters. The work of de Haan is that of a student to whom his master has subsequently proposed an additional step, by his example and without a superfluous word. Both in antiquity and in the nineteenth century

133. Beni-Hassan, tomb 15, north wall of the main chamber of the tomb of Baket III (detail), from Abdel Ghaffar Shedid, "Die Felsgräber von Beni Hassan in Mittelägypten", *Antike Welt*, Sondernummer, 1994, p. 28

weaving and spinning were closely related. People devoted them-selves to these tasks in Brittany during the long autumn and winter evenings; de Haan had probably been able to make sketches while observing this work.[33] In choosing to paint this domestic task against a background of the harvest, he moved away from natural-ist fidelity and made his own one of those paradoxes by which Gauguin indulged in synthesis. However, his painting does not really "take off"; despite the abstraction, his peasant women with their heavy forms remain somewhat prosaic; still silently tied to the earth. *The Spinner*, on the contrary, rises; like those on the walls of Beni Hassan (Fig.133), she is linked to the dream and to eternity. Often the artisan toils while the artist plays. Such is perhaps the les-son that Gauguin wished to suggest to de Haan: free yourself of a burden, play, rise! Towards music, towards mystery.

On December 13 Meyer de Haan wrote to Theo van Gogh: "...here I have painted a fresco (...) Gauguin painted one too, but smaller and yet totally different – unbelievable." (Would he have had reason to be so surprised if the same subject had not served as a common point of departure?) The question of the techniques employed to complete the mural paintings in Le Pouldu is not clear-cut. According to H. Travers Newton and V. Jirat-Wasiutyenski, "Gauguin and perhaps Meyer de Haan used car-toons to transfer the design of their figures to the wall, incising lines in the wet plaster,"[33] which seems quite logical (whether the plaster or coating, in any case, be dry, dampened or fresh). It is often repeated that the painters worked in oils but neither of these paintings (restored and varnished) has been subjected to tests and analyses that would permit one to determine what were the medi-ums employed. In regard to *The Spinner*, nonetheless, the only work these scholars were able to study – a simple visual examination aided by a raking light – they affirm having detected several joints in the plaster ("three, perhaps four, major horizontal divisions")

which would seem to prove that the painter had really tried to work in fresco by applying only the quantity of coating that he could paint in a single session. It does seem very dubious. They admit, incidentally, that "without the benefit of a full technical study, the information can only be tentative"; the same is true concerning the pigment: "further research and analysis are needed to resolve the matter." If future examinations should confirm the fact that Gauguin tried to paint in true fresco with watercolors applied to a wet coating, could we not find there a new confirmation of the influence that the 1889 Exposition universelle, through its Histoire rétrospective du travail, had on the painter?[35]

The third painting on plaster, which decorated the same wall, was also by Gauguin and represents a goose (Fig. 105). The goose is both woman and love. More exactly, the desirable and desiring woman. Of Romeo's love for Juliet, Pelléas' for Mélisande, Héloïse's for Abelard... it is not a question of elevated poetry here. No! Nothing lasting, nothing transcendent or ethereal in the loves of the goose. But a rapid and unaffected pleasure, a simple and immemorial prose, the joyful satisfaction of a genetically governed appetite: the dynamism of life.

In 1903, while in Hiva-Oa, Gauguin wrote :

I have a rooster with purple wings, a golden neck and a black tail. God he is beautiful! And he pleases me. I have a silvery gray chicken, with ruffled feathers; she scratches, pecks, damages my flowers. That's all right; she is funny without being prudish: the rooster signals her with its wings and feet and immediately she offers her rump. Nimbly, vigorously he then mounts her. Ah! Its quickly done!! (...) The children laugh; I laugh. My God but it's stupid.[36]

Bestial love, then? No, rather sensual pleasure and love without calculation.

After 1886 farmyard subjects appeared from time to time in Gauguin's paintings: most frequently he coupled together a young woman followed by a goose, as if by a parade of the desires that she feels and of those to which she gives birth. It is that the goose populates the countryside, under its downy plumage are found the thighs, those choice morsels, that words have gotten ahead of the painter and have determined his course without his knowledge. The French language, like others, widely uses animal metaphors to characterize human beings in their physiognomy and their pas-sions. Within woman–bird couples, which abound, one can easily distinguish three principal groups: the Romantic woman, first of all, the ideal or divine woman; then the charming warbler, the tur-tledove; from the screech-owl to the magpie, from the jay to the crow, one has no lack of choices to designate the most repulsive, abrasive woman. Between heaven and hell we still find the terres-trial but savory or at least tasty companions, the chicken and the pullet, the hen, the quail, the partridge, and others still, but above all the goose that for Gauguin, probably entertained by its aggres-sive character and seduced by its graphic silhouette, plump and sensual, seems to be a summation of all these various fowl.

In France it is said of a young, inept, and pretentious girl that she is a turkey. Does she only reveal herself to be naive and silly ?

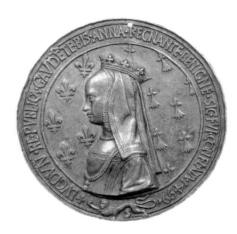

134. Medal struck in Lyon on the occasion of the marriage of Louis XII and Anne de Bretagne, 1499, 116 mm. Bibliothèque nationale de France, Medals Department

135. Paul Gauguin, *Vive les joies d'amour*, 18890 [*sic*] watercolor, 10¾ × 10½ in. (27.2 × 26.6 cm). Private collection

She is a bird-brain, a "goose," a "white goose" if she has kept her innocence. And these familiar but far from vulgar words are in daily usage. Still, if the simple girl has deserved all these nicknames, it is also because of her charm: a little provincial but young and playful, she necessarily guards her beauty. Further, in Gauguin's era the French people still recalled the fable, which Jean de La Fontaine dedicated to the goose's charms. In this story of "Brother Philippe's Geese" the writer tells the tale of how following his wife's death, Brother Philippe, out of hatred of the world and from fear particularly of women, resolved to live in the forest: "He decided to be a hermit; and destined his son to this same type of life." Far from society the child grew up in total ignorance of women and desire. When the boy was twenty years old, Philippe decided it was time to show him the city:

> The young man, flabbergasted / Asked his father: What is that? – They are courtiers. / – And these? – those are palaces. – Here ? – These are statues. / He contemplated everything: when young beauties / With sparkling eyes and enchanting traits / Passed by him; from then on nothing else / Could attract his gaze. / (...) / Ravished as if in ecstasy before this charming object, / He asked his father: And what is that / That wears such lovely garb? / What is its name? This speech scarcely pleased / The good old man, who answered: / It is a bird called the Goose. / Oh, most agreeable of birds! said the son joyously. / Goose, sing a little, so that I may hear your voice. / May one come to know you a little? / My father, I beg you a thousand times and a thousand again / Let us take one to our forest; / I'll take care that its well fed.[37]

Thus "The Geese of Brother Philippe" became proverbial as a designation for women, especially those who are rendered too alluring by the attraction of newness and the fascination of forbidden fruit. Often naïve, always seductive, whether she guards sheep, cows... or her goslings, the goose possesses special charms, that she is not always unwilling to share.

Going back a little in time, "the little goose" represented the totality of poultry giblets presented sliced on one's plate. Giblets? A mere trifle! So "the little goose" came to indicate, at the beginning of the seventeenth century, everything that serves as a detail or accessory, as for example, ribbons, clothing knots, trinkets of attire, those little nothings that can be abandoned without risk to a too-ardent suitor. Thus understood the expression evolved and soon designated (and for a long time), the liberties that a beautiful girl may sometimes prematurely permit their lovers. "According to the rules of love of the time," one reads in Balzac, "Marie de Saint-Vallier allowed her lover the superficial rights of the little goose. She willingly let him kiss her feet, dress, hands, neck, she declared her love, she accepted the attentions and the life of her lover."[38]

With the little goose, it is preliminary love – something of a Danish betrothal, minus the hypocrisy: "I recognize that in Denmark," wrote Gauguin from the Marquesas,

> the system of betrothing has some good in the sense that it does not tie one to anything, one changes fiancé like a shirt, and then it has all the appearances of love, liberty and morality. You are engaged, go strolling, even take a trip; the blanket of betrothal is there to cover everything. One plays with the whole but not that, which has the advantage, on both sides, of teaching not to forget oneself and to make a slip. With each betrothal the bird loses a handful of feathers that grow out again without anyone's noticing.[39]

136. Painting of a white-fronted goose, from the mastaba of Kaemankh, Giza, Dynasty VI (after Patrick F. Houlihan, *The Birds of Egypt (The Natural History of Egypt*, Vol. 1), Warminster, 1986, fig. 77, p. 58)

Ra. Let us remove the signature and inscription from this painting: could one not then believe it to be a fragment of fresco taken from some mastaba?

The ingenious glance backward by curling the little animal in upon itself guarantees a remarkable balance in the work, underlines the sometimes prickly nature of the creature and invites one to wonder — without hope of an answer — about the motive for her about-face. Thus frozen in its movement and placed in the impost, the goose also symbolizes, with all suitable humor, the protector of the *Buvette* — a goose from the Capitol — and its guardian animal. Sixty-third square of the French game of the goose, simple tavern sign, cartouche of an eternally sacred priestess, woman, flower, desire and, who knows? perhaps even more for a new Dutch hermit: myriad connotations, some brief enigmas suffice to make the spectator dream before this synthetic fowl.

> Les hommes savent tant de jeux l'amour la mourre
> L'amour jeu des nombrils ou jeu de la grande oie
> La mourre jeu du nombre illusoire des doigts
> Seigneur faites Seigneur qu'un jour je m'enamoure
>
> Guillaume Apollinaire, *L'Hermite* [44]

Yes! nothing like a duvet of goose down.

Thus a whole semantic and specifically French cultural background maintains and justifies Gauguin's goose. She symbolizes, or rather suggests, simultaneously the restlessness, the desire, and the agitation of love, banter, gallantry, adventure, trifles, there are so many words to designate "the game of love and chance." Young and hardy fowl, at the sign of the Troubled Goose (some indiscreet herb itches her when a gosling asks for her!). Marie Henry in her warm tones rules.

Of the motifs that framed Gauguin's *Goose*, the painter Maxime Maufra had only vague recollection of phallic symbols.[40] Perhaps! But if imagination has free reign, could one not find one of those "imagined flowers"[41] with which Gauguin at times took pleasure in enriching his canvases, like a heraldic motif evoking the marriage of Brittany and France in a stylized synthesis of the fleur-de-lis and the ermine (Figs. 134, 135)?[42] Whatever the case, it is above all a question of an abstract floral ideogram, of some original hieroglyph appropriated by what one might whimsically call the Marie Henry goose cartouche. Calyx, light, fertility, it symbolizes the flower – and one knows the *raison d'être* of flowers: to blossom in beauty, providing nurture to honey bees and, opening to the flames of multiple lights, to joyously perpetuate the species.[43]

Is it necessary to underline the profoundly Egyptian character of this far from anodyne work, as one might believe, but carefully considered, and one that Gauguin insisted on signing? As much as in Chinese and Japanese art, swans, ducks, geese — it is not always easy to distinguish them — are widely depicted in the paintings and bas-reliefs of ancient Egypt (Fig. 136): they are led in flocks, nourished, pursued by hunters; at times they have a religious role. The hieroglyph of the goose, the sacred animal of Amon-Ra, in Thebes, appears on the cartouches of Chou and Onouris, sons of

With regard to Gauguin's painting known as the *Self Portrait with Halo* (Fig. 147), some simple remarks can be contrasted with the confusing interpretations that it has sometimes occasioned. Gauguin was born on June 7, 1848, in the extremely troubled political times of the first months of the ephemeral Second Republic. Three days earlier the republicans had suffered a serious electoral defeat, for which *Le National*, the newspaper on which Gauguin's father was a militant editor, had campaigned. Consequently Louis Napoléon Bonaparte, the future Napoléon III, was elected deputy of the Seine on June 4, and then president of the Republic in December. One might thus *suppose* that from the spring of 1848, Aline and Clovis Gauguin envisioned emigrating, and that this proposal inspired the choice of the name given to their child, placing him under the protection of the apostle invoked against shipwreck. A mere supposition to be sure! Paul was scarcely one year old when his family embarked on the four-month crossing to distant Peru. Clovis Gauguin died at sea. The years passed, Aline made her son a sailor; no sailor is ignorant of the name of his protector.

On his return to Arles, at the end of December 1888, Gauguin penned some terse phrases in his notebook (Fig. 137) regarding some remarks uttered by Vincent van Gogh during the last days they lived together: only twenty words in ten lines. The second line consists of the single word "Snake"; in the sixth line one finds "Saül Paul Ictus."[45] Because Gauguin had been a sailor and had always dreamed of departing for "somewhere else" for Vincent he symbolized "the Traveler."[46] There can be no doubt that in the fall of 1888 Vincent soberly sought to remind his too-profane companion that he bore the name of the first great traveler of Christianity, the apostle of the Gentiles, Saul, who took the Latin surname Paulus. Gauguin paid heed to this. One would barely simplify Vincent's thought in writing that in his eyes the mission of the artist and that

137. Paul Gauguin, Mnemonic notes from his sketch book after his departure from Arles, 1888: "Incas / Snake / Fly (?) on the dog / Black lion / The murderer on the run / Saül Paul Ictus / (to) save your honor (money canv[as]) / Sound in mind / Holy Spirit"

of the apostle scarcely differ: "You will absolutely form a united body with Gauguin and his followers," he wrote to his brother on October 3, 1888. "Thus you will be one of the first, or the first art dealer apostle" (letter 544). This manner of envisioning art as an apostolate surprised, moved, and profoundly influenced Gauguin. One recalls that in Victor Hugo's *Les Misérables*, the charity of an old priest serves to break the hardness of a convict whose redemption is attained through this very beneficence. Through fierce struggles with the angel, Jean Valjean, a gallows bird, becomes Monsieur Madeleine, a man of high conscience and philanthropy.[47] It was as Jean Valjean that Gauguin painted himself in September 1888 in the *Self Portrait* (Fig. 157) that he then sent to Vincent. If one limits one-self to the facial features, the *Self Portrait with Nimbus* (Fig. 147) painted at Le Pouldu is very similar; it is clear that Gauguin was greatly inspired by the canvas he had painted fourteen months earlier. But the nimbus evidences that the rebellious convict has given way to the man of God. Vincent's lesson bore fruit just as the example of the bishop had done in Jean Valjean's heart.

Previous writers who have discussed this *Self Portrait* have often confused the halo and the nimbus. In Christian tradition the halo is the irradiation of the whole body; the nimbus is the irradiation of the head behind which it at first appeared like a vertical disc. Later on in Italian art, it became oblique on the head and then was reduce to a mere streak floating above the head. The color of the nimbus is golden or yellow; it is the specific sign of sanctity. In no case could the representation of the Evil One be accompanied by a nimbus. The *Self Portrait with Nimbus* is incontestably that of a sanctified artist. A somewhat sinister saint, it's true, but must one trust appearances? Did Socrates become more attractive in the course of acquiring wisdom? Did St. Paul change his physiognomy the day of his conversion? He holds a snake in his hand, which derives from the Biblical text: "...in my name, said Jesus of the apostles, they chased off the demons, they spoke new tongues, they will take up snakes in their hands..."[48]

Gauguin, in effect, speaks a new tongue; some specious rhetoric would permit one to maintain that he cures, he exorcises, he chases away the demons, just as Geneviève and Puvis chassed away the barbaric hordes. And as for the snakes... The *Acts of the Apostles* recounts that in the fall of the year 60, Paul, a prisoner of the Romans, embarked on his way to Rome. A hurricane came up and for fourteen days the vessel was in extreme peril. Paul exhorted his companions to show courage, promising them the salvation the angel had foretold. At long last the ship ran aground on a beach in Malta. There, they lit a fire:

> Paul, having gathered an armful of dry wood cast it upon the fire, but the heat caused a snake to emerge and it bit him on the hand. Seeing this reptile suspended from his hand, the local people said to each other: "This man is surely a murderer, for after he escaped from the sea, [divine] Justice does not permit him to live." But Paul shook off the snake into the fire and felt no pain.[49]

In later iconography the snake therefore became an attribute of St. Paul, whose name was invoked to protect against both ship-wreck and snake bites.[50] Given all this, would it seem impertinent to propose that the National Gallery's painting be titled *Portrait of the Artist as St. Paul*? Of course, such an interpretation might invite some ridicule if it were taken too seriously, which the *Self Portrait* itself does not do. Apostle, impostor, the artist experiments and has fun! The devilishly menacing look and the lovelock reveal quite clearly that this great apostle is not an angel.

This painting has specific ties with Gauguin's *Portrait of Meyer de Haan by Lamplight* (Fig. 148). Executed one after the other at the end of November or early December 1889, these highly stylized portraits – a little in the manner of Japanese masks of which numerous models were exhibited in the Palais des arts libéraux – are based on a dominant harmony of warm yellow and red tones, with a subsidiary harmony in cold green and blue hues. They are matched pendants, each occupied a door panel of the same size and stemmed from the same poetic verve. These works are not the result of sudden inspiration. For the *Self Portrait* there exists a sketch (Fig. 138) that constitutes the first idea of it. This drawing, reproduced here for the first time has never even been previously exhibited or mentioned. Its light contours, traced in blue pencil, are somewhat faded, and the contrast has been slightly accentuated for reproduction. As to its role as the origin for the Washington *Self Portrait*, there are but a few evident traits: the schematic face of Gauguin with wide shoulders and long hair, crowned with a nimbus; and on the right what could be a sketch for the floral stems. (A

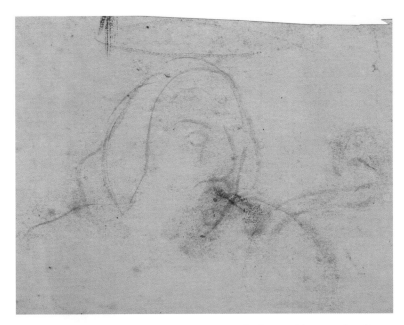

138. Paul Gauguin, *Portrait of the Artist as Saint Paul*, 1889, blue pencil, 2 ⅞ × 3 ⅝ in. (7.3 × 9.3 cm) on a page of notebook paper, private collection

139. Procession of the bonzes in the Annamite pagoda. "The three bonzes dressed in magnificent robes, in red and yellow satin and wearing crowns of black cloth, embroidered with figurines, approach the altar, two kneel, one on each side, the third, carrying in his hand the lotus branch, officiates beside two acolytes, almost as in the Catholic ritual. (...) Then the ceremony ends with a procession in a row, the officiant walking in front, followed by some other bonzes and acolytes, passing and returning in front of the idols and each time individually delivering strange gestures and balancing their steps, to the point of making a sort of a dance from it" (Vital Meurysse, "Les Bonzes et le Temple Bouddhique," *Livre d'or de l'Exposition universelle*, no. 30, October 1, 1889, pp. 465–7 and 473)

certain analogy can seemingly be noted between this motif and the serpentine line of the lotus ceremoniously exhibited during the procession of the bonzes dressed in *red and yellow* satin, in the pagoda of Great Tranquility, in the colonial Exposition (Fig. 139); but though Gauguin probably attended this Buddhist ceremony, it is not possible to draw any conclusions.) The hand and the snake will only appear later. The important thing is clearly the nimbus, which seems to confirm that his original intention had nothing of the esoteric about it. Subsequently, the floral stem was to be stylized and developed into a serpentine network modeled on those found at the feet of *The Spinner*. It is not surprising that from this network of plant forms emerges a snake, but the "apostle's" hand has nothing to fear.

If the hands of *The Spinner* seem to have been borrowed from Khmer art, that in the *Self Portrait* comes directly from ancient Egypt.[51] Some over-scrupulous naturalist will observe – pertinently – that the mouth of this ophidian resembles a beak more than a snake's forked tongue. A hermetist would affirm that this incredible animal with a snake's tail and the head of an ibis – Thot-

Hermes Trismegist, the father of alchemy, had as his sacred animal the ibis, enemy of the snake – thus symbolizes the reduction of opposites. ...For some writers the snake, the apple, and the nasty expression could only indicate the Fallen Angel, the tempter. Others have wished to see in this portrait the symbolism of the supreme initiate. ... In the ordering of dream, the subtlest fictions; in the ordering of reason the easier lucubrations can arise from this work. What we find here is the probable emphasis on avowal and self-derision, ambiguity muddles the interpretation, the creator placed what was necessary into the work so that the interpreter is at his wit's end. And that is the playfulness of the painters at Le Pouldu.

There is yet another unpublished drawing by Gauguin that relates to his Le Pouldu portraits. It is not truly a preliminary study for the *Portrait of Meyer de Haan by Lamplight*, nonetheless in various respects it does herald it (Fig. 140). Here de Haan, wearing his cap, from which there emerge some unruly tufts of hair, is seated, leaning over a book, totally absorbed in his reading or his thoughts. Gauguin already has captured his sunken cheeks, broad nose, and

the exaggerated, slanting arch of the eye sockets; his hand buried under his thick moustache obscures the mouth and chin. As in Gauguin's *Self Portrait*, the neck disappears into the shoulders: "A long neck is gracious but heads on one's shoulders are more pensive," the artist had noted five years earlier.[52] Probably drawn from life this sketch seems to represent the first state, stylized yet entirely realistic, of what will soon become – when the artist has deepened his thought – the enigmatic painting, *Meyer de Haan by Lamplight*. This gives rise to a question of chronology: without being in a position to present a detailed line of argument here, I take the risk of proposing the following order of development. During the height of the summer, at the time of their stay together in the Hôtel Destais, in Le Pouldu, or even in the early fall, the ceaselessly busy hand of Gauguin captured in photographic fashion this moment of de Haan reading. He does it in pen and ink, using a quick, hatched graphic manner reminiscent of that of van Gogh. In so doing he catches his companion engaged in the activity that occupied a large part of the time of this sickly man. Later, in October or November, when the two painters resided at the Villa Mauduit, Gauguin, in the notebook in which he recorded his thoughts on a variety of subjects that concerned him then – on art, the place of woman and the artist in society, etc. – this time drew from his imagination, deliberately stretching the interpretation, the watercolor depiction of Meyer de Haan now in the Museum of Modern Art (Fig. 149). The dish of fruit on the table, the oil lamp, the books with handwritten titles and even the upright chair powerfully evoke certain works by Vincent. Then under this watercolor, on the very same page, in blue pencil, Gauguin sketched the idea that would become his *Self Portrait with Nimbus*. This is not just supposition, for I have been able to verify that the watercolor and the sketch do indeed come from the same page.

This was followed by the decoration of the inn. Meyer de Haan conceives and executes *Labor*; *The Spinner* is painted very soon thereafter. Nothing today permits one to determine in which order the works then follow even if a certain logic suggests that the painting of the impost – *The Goose* – would have permitted putting the finishing touches on the west wall of the room. (It seems that *Bonjour Monsieur Gauguin* was not stuck to the door until later, perhaps in 1890, to cover over an earlier painting on panel, sometimes attributed to Maufra. This is not clear. In the same way we do not know whether the *Caribbean Woman* was painted in 1889 or 1890, but in these two works there are still evident reminiscences of Arles and Vincent). Taken from the notebook, but leaving a bit more space for the lamp, the portrait of de Haan as a Faustian figure would then precede that of the master as apostle, which when concluded would complete the decoration of the entire room with great panache.

So much has been written *à propos* the two books in front of which this new Faust seems to gnaw his knuckles with anxiety. Therefore, it is all the more remarkable that the most basic studies concerning these works and the reason for their presence on the table have never been carried out. It has long been know that the exhibition in Amsterdam in 1888 of Meyer de Haan's great canvas, the work he considered his most important – *Uriel Acosta* – was

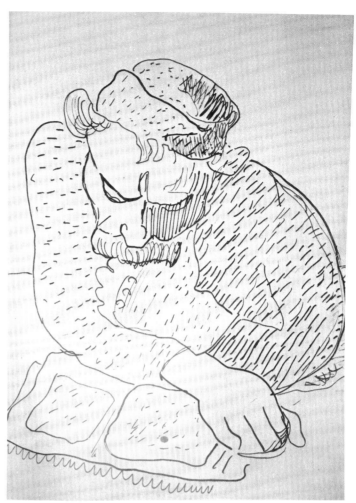

140. Paul Gauguin, *Portrait of Meyer de Haan Reading*, 1889, pen and ink on buff paper, 11 ½ × 7 ⅝ in. (29.2 × 19.4 cm), Kunsthandel Ivo Bouwman, The Hague

accompanied by the publication of a flattering brochure, which also contained the only known reproduction of the painting (Figs. 27, 141). But it has never been said that several years earlier the author of this brochure had also translated Thomas Carlyle's metaphorical and spiritual fable *Sartor Resartus* into Dutch (Fig. 142). One could not then doubt that this author and translator, Jan Zürcher, was a close friend of de Haan.[53] Thus is explained – and in the least esoteric way possible – one of the two books resting on the table. De Haan had brought his friend Zürcher's translation of this *Tailor Retailored* to Le Pouldu, and he perused it one would imagine quite frequently, since it is so rich in meanings as to be read and reread. Such a work could not be summarized; and the fact that de Haan is said to have expressed himself imperfectly in French, would have made it yet more difficult to offer its contents or even its flavor to his companion. Thus the Latin title alone – mysterious hence enticing – of this book of which he was unable even to guess the true significance, must have entranced Gauguin. If every man carries within himself a mystery, then a true portrait must

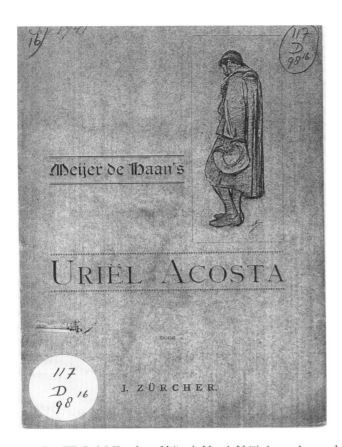

141. Jan [W. C. A.] Zürcher, *Meijer de Haan's Uriël Acosta*, Amsterdam, 1888

142. Thomas Carlyle, *Sartor-Resartus. Het leven en de Gevoelens van den Heer Diogenes Teufelsdröckh. Door Dr. J. W. C. A. Zürcher*, Amsterdam, 1880

reflect the image of that. In the portrait of de Haan the enigma is enhanced by the title of the book he read.

Concerning *Paradise Lost*, everything leads one to conclude that Gauguin had pursued reading it for several months, as a number of his works already seem to constitute variations on the central themes of Milton's poem: the spirit of evil, the temptation of Eve, and the fall. Several French translations existed of that masterpiece; the most well-known and easily accessible was that in prose – but excellent – of the man who, along with Balzac, Lamartine and Hugo, was regarded as one of the greatest writers of the century, the author of the *Mémoires d'outre-tombe*, François-René de Chateaubriand (Fig. 143).[54] Without being able to verify this, it seems highly probable that this was the translation to which Gauguin had access. It would have been easy for the painter to inscribe the full title of Milton's poem on the cover. But what is not visible is "lost" and gains in mystery. This missing Paradise is thus doubly *lost*, perhaps like the thirty-seven-year-old Dutchman, who several months earlier had left his homeland after the resounding affront of a ferocious (though wholesome) critical reception. For if the first drawing of de Haan shows him *lost* in his meditations, the

watercolor and the panel painting suggest – once more not without humor – that this meditation reflects a painful dilemma.

The juxtaposition of titles – a Latinism, two patronymics and a single French word: "perdu" (lost) – is skillful, so skillfully accomplished that it encourages multiple interpretations. The diagonal cutting across the center of the composition and dividing the work suggests reading into the portrait the disarray of a mind split between study and pleasure, between speculation and life, between light and dark, between flesh and the spirit: Faust's old dilemma. Undoubtedly, however, it would only diminish the fascination of this sonorous work to believe that such an explanation is sufficient to provide the absolute key. In no case must the analysis pretend to channel enjoyment, and these pages would have missed their target if they were determined to be the final interpretation, for the illumination which they provide should lead readers to pursue their own ideas. "I love Brittany, wrote Gauguin in 1888, and there I find the savage, the primitive. When my clogs resound on this granitic earth I hear the mute, dull-sounding and powerful tone that I seek in my painting."[55] The surface of the painting is only the skin of the drum; all the ele-

143. The works of Chateaubriand (in twenty volumes). *Le Paradis Perdu* de Milton, Paris, 1857. On the frontispiece: *Adam and Eve Expelled from Paradise* (drawing by Philippoteau)

ments of mystery constitute the emptiness, the "lost," the sound box. And it is thanks to this chest that the skin resounds when questioned. No resonance, no music; only the dull prose of a useless discourse. Milton wrote :

> ...The rest, from Man or Angel the great Architect / Did wisely to conceal, and not divulge / His secrets to be scann'd by them who ought / Rather admire; or if they list to try / Conjecture, he his Fabric of the Heav'ns / Hath left to thir disputes, perhaps to move / His laughter at their quaint Opinions wide / Hereafter, when they come to model Heav'n / And calculate the Starrs, ...[56]

ERIC M. ZAFRAN

Searching for Nirvana

EARLY HISTORY

The first definite record of the remarkable little painting *Nirvana* is in an exhibition catalogue of 1912.[1] At that time the work was in the possession of Francisco Durrio (1868–1940), a Spanish sculptor, jeweler, architect and ceramicist resident in Paris. Known as "Paco," he had became a devoted friend of Gauguin during the latter's brief return to France between 1893 and 1895.[2] They had a mutual interest in sculpture as well as a love of music, and Gauguin painted a portrait of Paco playing his guitar (Fig. 145). Durrio was even invited by Gauguin to accompany him back to Tahiti. He did not do this, but he was present at the farewell party given for Gauguin by his friends before his departure. At this time Gauguin apparently gave Durrio for safe keeping a large number of his works, primarily small paintings, gouaches, and drawings among which was *Nirvana*.[3] The Spaniard treasured these and enjoyed sharing them and tales about Gauguin with his colleagues and compatriots most notably the young Picasso. A mutual but untrustworthy sculptor friend of theirs, known as Manolo, stayed in Durrio's studio during 1904 while the latter was away and, in need of cash, sold the Gauguins, including *Nirvana* to the dealer Ambroise Vollard. When Durrio discovered his loss, Vollard, not wishing to be accused of dealing in stolen property, readily returned all the works to him.[4]

Sixty-one of Durrio's Gauguins were lent to the great retrospective of the painter held at the Salon d'Automne in 1906. Victor Merlhès has suggested that number 119 in this exhibition, listed only as "Gouache sur toile" might have been *Nirvana*.[5]

The 1912 exhibition to which we can be sure Durrio lent the painting was the major *Internationale Ausstellung* in Cologne. In the Cologne exhibition catalogue the work is identified as "Nirvana (Tahiti)."[6] This was a pardonable mistake, due to the exotic nature of the subject and the fact that several of Durrio's other Gauguins were indeed souvenirs of the painter's first Tahitian visit. The error was not repeated in the next public showing. This, as the catalogue proclaimed, was a "Hommage au génial artiste Franco-Péruvien" presented in Paris in 1926. Here *Nirvana* was reproduced in the cat-

alogue, listed as from the "Collection F. Durrio," and identified as "Nirvana (Portrait de Haan)."[7] In later exhibitions of 1928 (at Basel and Berlin) the painting was even more fully identified as "Nirvana: Bildnis von M. de Haan."[8] Durrio's entire collection of Gauguins was exhibited at the Leicester Galleries in London from May to June of 1931, but oddly this time "Nirvana" was not given as a title – catalogue number 67 was simply "Portrait de Meyer de Haan (gouache)."[9] Following this Durrio, although he had long tried to honor Gauguin's wish to keep all the works together, was in such difficult straits, that he finally had to sell some of them.

145. Paul Gauguin, *Guitar Player (Francisco Durrio)*, 1894, oil on canvas, 35 ½ × 28 ⅜ in. (90 × 72 cm). Private collection

They went to Walter Geiser, a collector from Basel. Thus in the next major Gauguin exhibition, *La Vie ardente de Paul Gauguin* in Paris during 1936, there are loans listed from both collectors, but *Nirvana* was now identified as Geiser's.[10] From him it was acquired by Wildenstein and Co. in Paris, where the Wadsworth Atheneum's director, A. Everett Austin, Jr., saw it in the summer of 1937.

As the surviving correspondence attests, Austin had it shipped to Hartford in October of that year. Assuming the work had been "purchased by you in Paris last summer" Wildenstein sent a statement for $2200 to Austin the next month.[11] He may or may not have shown *Nirvana* to the museum's trustee committee for approval, but in any case did not pay the bill. Another was sent from Wildenstein in January 1942,[12] but by then this painting was one of a great many under consideration from New York dealers that had accumulated in the Atheneum's storage. Because of the director's increasingly strained relations with the trustees, as well as a lack of funds, he did not seek approval for the purchase of these works nor could he bring himself to return them. The question of their fate only surfaced in 1943 after Austin took the leave of absence from which he would not return to the Atheneum.[13] Extremely irritated by this predicament, R. W. Huntington, the Chairman of the Museum's Art Committee, wrote to Austin, who had settled for the time at the Garden of Allah in Los Angeles, that he understood Austin was "very much embarrassed over the situation," but that "there is nothing for us to do but to pay."[14] Fortunately for the sake of the Atheneum's future visitors, the overdue bill sent again on November 1 was paid with money from the Sumner Fund on December 20, 1943. *Nirvana* thus formally entered the collection, confirming Austin's talent for spotting remarkable but atypical works by major masters.[15]

In the mid-1940s, his hopes for a career in Hollywood having evaporated, Austin was engaged to write a catalogue of the many paintings acquired during his tenure with the Sumner purchase funds. His highly literate entries reached the stage of being typeset but were never published and still languish in the museum's files.[16] That for *Nirvana: Portrait of Meyer de Haan* reads:

> Gauguin, the Post-Impressionist master of decorative design and exotic color, found in the South Seas the answer to his Romantic passion for geographically distant and novel subject matter. He did much to revive a primitive statement in the face of sophistication, and influenced greatly the French *Fauves* and German Expressionists of the earlier twentieth century. He led the way to many other statements of color simplification currently practiced. Often as here, he is successful in invoking the weird in terms of mystical sentiment.

INTERPRETING NIRVANA

Chick Austin's choice of the evocative word "weird" is certainly apt in discussing *Nirvana*; there is no other work in Gauguin's whole oeuvre quite as mysterious or impenetrable. Austin chose simply not to confront its specific meaning. The painting had by this time received its first publication in a study of Gauguin published in Madrid by Cossio del Pomar in 1930. As is evident from his text, the author was well acquainted with Paco Durrio, and he

146. *Peruvian Mummy*. Musée de l'Homme, Paris

reproduced several works from his collection, including *Nirvana*.[17] Although the sitter is properly identified, there is no attempt to analyze the work, only the simple statement that it is a "cuadro de tonalidades de opalo." Subsequent writers, however, were to delve more deeply into its meaning and developed a range of complex interpretations, some more convincing than others. Most scholars examining *Nirvana* have naturally connected it with the paired symbolic portraits of Gauguin and de Haan (Figs. 147, 148) painted by the former at Marie Henry's inn at Le Pouldu, as well as examining the significance of the two female figures in the background, who are related to the pair of 1889 paintings *Life and Death* and *In the Waves* (Figs. 178, 179).

In a seminal article of 1967, Wayne Andersen recognized that the source of Gauguin's crouching female figure seen in *Life and Death* and also represented by him in several works as a melancholic figure, most notably the *Breton Eve*, was derived from a Peruvian mummy (Fig. 146), which he had seen in the Trocadero Museum.[18] With this pose, as Andersen noted, Gauguin combined "Oriental, slanted eyes" that "symbolize sinful desire," and the writer further pointed out that Gauguin "soon expanded the symbolism of this image further by combining it with the slanted eye of the fox and exploiting the fox's universal significance as sly evil, together with its sexual connotations from Brittany folk-lore and Oriental sources."[19] All these traits he related to the portraits of Meyer de Haan with their "slanted eyes and fox-like face," noting further that *Nirvana*, dated by him to 1889 "shows in the background the temptation and fall of Eve."[20] The fox imagery he rightly observed was prominently repeated by Gauguin in the wood relief *Be In Love* (Fig. 77), where Gauguin famously wrote to Emile Bernard that it symbolized "perversity" and in his painting

The Loss of Virginity (Fig. 86) in which the fox–de Haan identification seems so evident.[21]

Andersen further developed his thesis about *Nirvana* in his book of 1971, where he wrote,

De Haan is placed in the foreground, with the heads of the two women directly behind him, the anguished Eve on his right and the *Woman in the Waves* on his left; he holds before him a plant that twists downward in a serpentine shape. Gauguin habitually places the figure endowed with phallic power between the two Eves... Gauguin's choice of the title *Nirvana* for this work, which follows the familiar theme of loss of innocence leading to death, implies that the scene is essentially one of rebirth.[22]

Writers on Gauguin have provided differing interpretations of the painting, struggling especially over the relationship between the mask-like, distorted image of de Haan and the inscribed word "Nirvana." According to Jean Leymarie in the notes he wrote in 1960 to accompany an assemblage of Gauguin watercolors and drawings:

de Haan stands out against the mysterious, interlocked female figures like some sort of Buddhist divinity sunk in Nirvana (whence the inscription). It was painted soon after Gauguin sustained the impact of the oriental pavilions at the Exposition Universelle of 1889.[23]

For Alfred Warner in 1967 the inscription provided the key, and he wrote:

[Nirvana] refers to a calm or sinless state or condition of mind, attained through the dying out or extinction of sin. When this emancipation is reached by the individual, passion, hatred, delusion, pain, and even outward reality no longer exist for him. The figure in the foreground [de Haan] seems to have reached this stage...His protruding forehead, bulging eyes, and pug nose seem to be caricatured. The large arabesque he holds in his hand forms a G, and "auguin" is written in small letters on the hand. Oblivious of everything around him the sitter pays no attention to the two women in the background whose gestures are meant to express anguish.[24]

In a study of Gauguin's religious thought as reflected in his art, the Reverend Thomas Buser in 1968 found what he believed to be a likely source for Gauguin's vision of Nirvana in a theosophic text that attained popularity in France during the late nineteenth century – Edouard Schuré's *Les Grands Initiés*. Buser describes the painting thus:

In the background of *Nirvana* one woman looks down in terror and another looks up and beyond in the opposite direction. Meyer de Haan with the slanted, almond-shaped eyes of another style and civilization here stares out, through us. It must be more than mere coincidence that this painting seems to be almost an illustration for the following passage from Schuré's book [which we here translate in its entirety].[25]

"The perspectives which open out on the threshold of theosophy are immense, especially if one compares them to the narrow and desolate horizon in which materialism imprisons man or the childish and unacceptable facts of clerical theology. On seeing them for the first time, one is dazed by the thrill of the infinite. The depths of the Unconscious opening up within us, shows us the abyss from which we have escaped, the dizzying heights to which we aspire. Delighted by this immensity, but frightened by the voyage, we ask to no longer exist, we call out to Nirvana! Then we notice that this weakness is only the fatigue of the sailor ready to let go the oar in the middle of the storm. Someone said man was born in the hollow of a wave and knows nothing of the vast ocean spread out before and behind him. This is true; but transcendental mysticism launches our boat through the fury of the tempest, we grasp its grandiose rhythm; and our eye measuring the vault of the heavens, rests in an azure calm."[26]

Also in 1968 appeared Wladyslawa Jaworska's detailed reappraisal of de Haan's career in which she included the portraits of the Dutch artist painted by Gauguin. She agreed with Leymarie that the painter's visit to the Universelle Exposition had influenced the creation of *Nirvana*, but went on to add the further insight that "Gauguin may have undergone the influence, direct or indirect, of reading texts by Schopenhauer on Nirvana." The German philosopher was, as we shall see, regarded in France as a major proponent of Buddhist beliefs. Although Leymarie had not discussed its implications, he had repeated the jist of the Gauguin–de Haan relationship at Le Pouldu as transmitted into the twentieth century by the immediate family and descendents of the inn-keeper, Marie Henry; namely that her choice of de Haan (by whom she eventually had a daughter) over Gauguin "made Gauguin extremely jealous." Jaworska proposes that it was this "desire for revenge" that was the "psychological factor" which pushed Gauguin "to massacre the features of his rival and imbue him with the most demonic traits."[27]

Ziva Amishai-Maisels, in her dissertation of 1969 (published in 1985), *Gauguin's Religious Themes*, offered a carefully considered analysis of the meaning of *Nirvana* and the related works. The "enigmatic" *Self Portrait with Halo* (Fig. 147) with its "seemingly contradictory combination of apples, snake, and halo" was for her "a positive statement of Gauguin's identification with Lucifer the Tempter." This interpretation is "confirmed when the picture is connected with its companion piece, *The Portrait of Meyer de Haan*...(Fig. 148) also sharply exaggerated [which] joins to de Haan a lamp, a plate of apples, Carlyle's *Sartor Resartus* and Milton's *Paradise Lost*. The second book gives the clue to Gauguin's identification with Lucifer."[28] She went on to demonstrate the identification between Milton's concept of Satan and Gauguin's portrayal of himself as a Christ-like martyred leader, seeking a new paradise for his followers. This same duality she points out was also stressed in Carlyle's book, which de Haan probably had to translate for Gauguin since it was in English.[29]

After a discussion of the Eve theme, Amishai-Maisels comes to *Nirvana: Portrait of Meyer de Haan,* which she describes as a "weirdly stylized figure of the tortured Dutch-Jewish artist Meyer de Haan...whose eyes stare hypnotically out of his orange- and wine-colored face..." According to her:

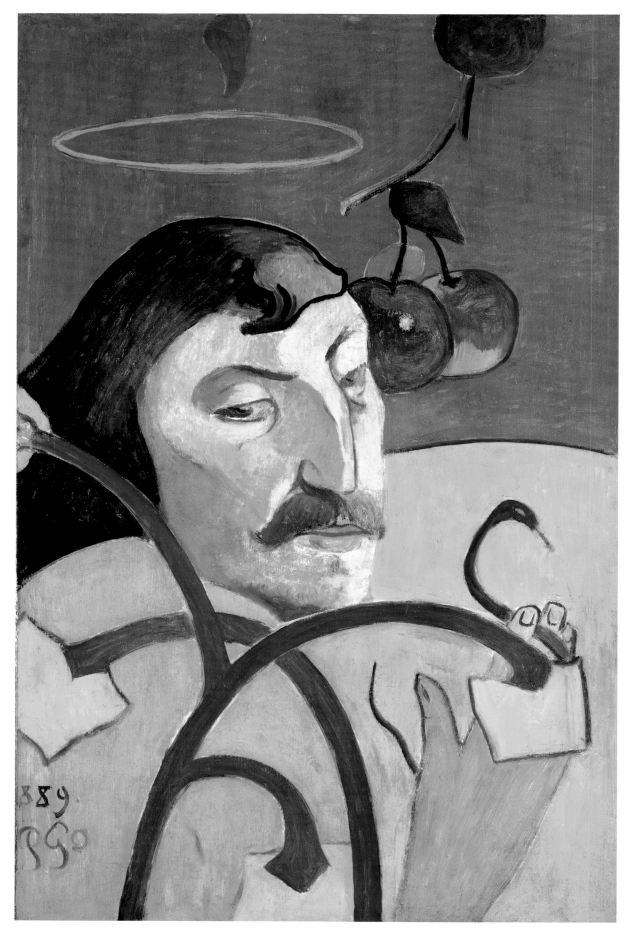

147. Paul Gauguin, *Self Portrait with Halo*, 1889, oil on wood, 31 ⅜ × 20 ⅜ in. (79.6 × 51.7 cm). National Gallery of Art. Washington, D.C. Chester Dale Collection

148. Paul Gauguin, *Portrait of Meyer de Haan by Lamplight*, 1889, oil on wood, 31 ³⁄₈ × 20 ³⁄₈ in. (79.6 × 51.7 cm). Private collection. *Exhibition no. 2*

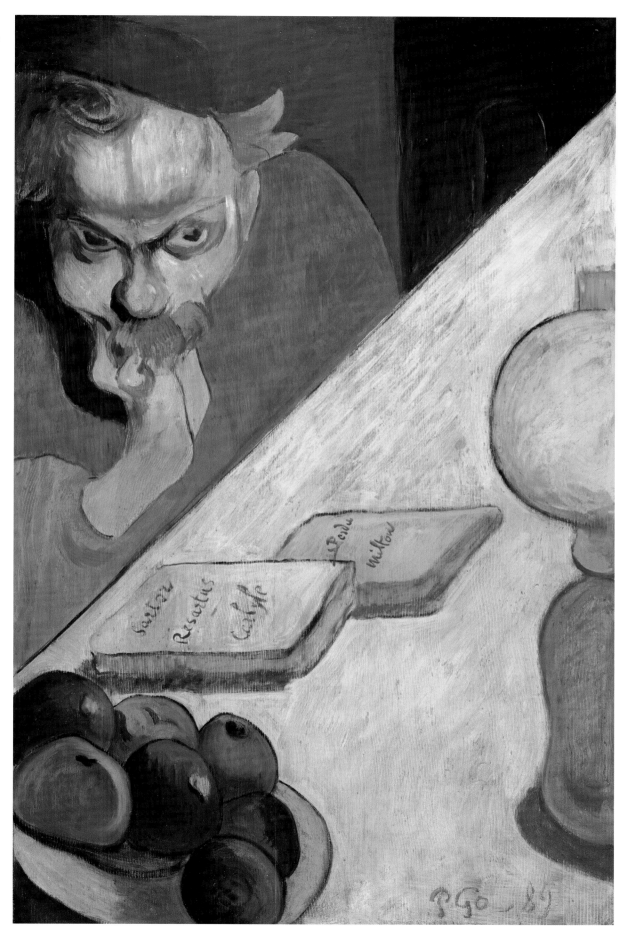

149. Paul Gauguin, *Portrait of Meyer de Haan*, 1889, watercolor over pencil on paper, 6 ³⁄₈ × 4 ½ in. (16.4 × 11.5 cm). The Museum of Modern Art, New York. Gift of Arthur G. Altschul. *Exhibition no. 21*

150. Meyer de Haan, *Self Portrait*, c. 1889–91, oil on canvas, 12 ³⁄₄ × 9 ⁵⁄₈ in. (32.4 × 24.5 cm). Collection of Mr. and Mrs. Arthur G. Altschul, New York. *Exhibition no. 37*

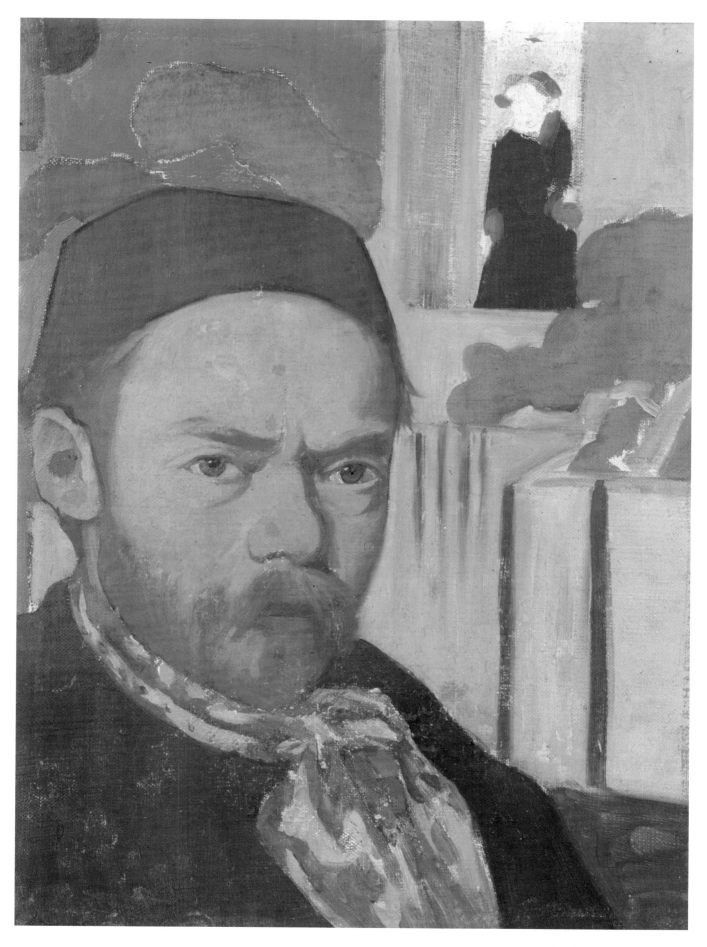

the title here is more ironic than in the works examined above, for it is Damnation that is depicted rather than the blessed state of Nirvana, which is a cessation of existence by reunification with the god-head. Gauguin emphasized the diabolical qualities of de Haan's face: for instance, the widow's peak and the merging of his hair and cap recall the traditional Devil's hood. The figures of resistance and submission appear behind him as emanations of his character, or as the two alternatives between which he is torn. The sexual overtones are stressed by the black rocks, and by the sperm-shaped head of the bather at the left.[30]

Like previous writers, she too found "de Haan's features have been altered to stress a resemblance to the fox in *Soyez amoureuses*," but in addition she identified the hand holding the snake-like G of the signature as Gauguin's, noting that he "is taking an active part in the temptation of de Haan."[31]

A quite different interpretation of the prominent hand was provided by Richard Boyle in the catalogue for the 1971 Cincinnati exhibition devoted to early Gauguin. He wrote that "Gauguin's signature on the subject's hand appears to signify a more practical matter, a reminder, perhaps that he was, financially speaking, in Meyer de Haan's hands."[32]

Another detailed dissertation was devoted to Gauguin's symbolism in 1975 by Vojtech Jirat-Wasiutyński. Published in 1978, it also connected *Nirvana* to the Washington *Self Portrait of Gauguin with Halo,* which the author characterized as presenting Gauguin as "a fallen angel." Of de Haan in *Nirvana,* he wrote, "Gauguin has painted de Haan as the devil with slanted green eyes and pointed ears; he has taken advantage of his dwarfed figure and red hair to suggest that de Haan is the devil of what he ironically labels 'Nirvana,' that is, the Buddhist term for paradise." He continued:

> Gauguin is, quite obviously, using his friend's features to convey certain ideas about life and the role of the artist. That Meyer de Haan is but an alter ego seems quite likely since the snake, which he holds in his hand like Gauguin in the Washington *Self-Portrait*, turns into the initials of Paul Gauguin's name: Gauguin literally 'has a hand' in the painting.[33]

Finally, he explained, "The *Nirvana* referred to Meyer de Haan's specific situation at Le Pouldu: the backdrop visualizes his anguished dilemmas with regard to women."[34]

In 1987 Jirat-Wasiutynski was to further develop his interpretation of Gauguin's *Self Portrait with Halo*. Rather than just a mixture of demon and angel it was a self-representation as a magus, a seer adept in secret Egyptian rites. Like Buser he found a source in Schuré's book. Referring to the process of initiation in the Egyptian occult outlined there, he rightly pointed out the Egyptian attributes of the *Self Portrait,* which include the hieroglyph-like serpent. Further based on a text by another key theophist who assumed the name Eliphas Levi, the writer can assert that "the magus has freed himself from the dominant 'forces of life and death' by learning to 'suffer, to renounce, and to die'." He continues that "stages of self-making and liberation of the magus are reflected in Gauguin's two symbolic portraits of Meyer de Haan." According to his new interpretation, in the *Portrait of de Haan by*

Lamplight the sitter "is shown tempted by the depths of occult knowledge and transformed into a demonic seer." As to the Atheneum's portrait, it "shows de Haan achieving detachment (hence the inscription 'Nirvana') and freedom from 'the forces of life and death,' represented by the bathers at the black rocks."[35] While Jirat-Wasiutyński does not mention the strangely exaggerated and hieratic hand of de Haan, which could equally well have been derived from Egyptian reliefs, he does offer a novel interpretation of the stylized snake held by it. He writes:

> The image transforms the *tefilin* or phylactery, wound around the forearm by Orthodox Jews during prayer, into a writhing serpent. Unlike the serene Gauguin, de Haan seems possessed by demonic powers which radiate from his glowing eyes; he is only just in control of the dynamic spiral as it metamorphoses from leather prayer thong into serpent.[36]

To confirm this interpretation of the *tefilin* and what he identifies as the painter's Jewish cap, he turns also to Levi's text, which pointed out that the two sources of esoteric doctrine were Hermetic texts and the Talmud.[37]

In his more recent assessment of the painting, mainly an analysis of Gauguin's unusual technique and its oriental qualities written with Travers Newton Jr., Jirat-Wasiutyński states that *Nirvana* "was most likely executed at Le Pouldu in August 1889. The background of nudes, beaches, waves reflects the less settled Le Pouldu to which the artist retreated from Pont-Aven, at the same time as linking the painting to the bather pictures of early 1889."[38] The authors go on to summarize the work's meaning:

> The portrait emphasizes esoteric symbolism over likeness and relates to Gauguin's *Portrait of Meyer de Haan by Lamplight*, painted in December as part of the decoration of the inn of Marie Henry at Le Pouldu. It is a symbolic image of the artist as a demonic seer, turning his back on the troubling sensuality of "life and death" and seeking detachment in esoteric knowledge, a depiction that corresponds to de Haan's personal situation in August rather than in December. The inscription 'Nirvana' refers to the Buddhist concept of blissful detachment and reflects the subject's interest in a wide range of religious ideas.[39]

It was indeed the nature of Gauguin's religious ideas, which occupied Philippe Verdier in his 1986 study of the painter's unpublished manuscript "L'Esprit moderne et le catholicisme." Investigating Gauguin's religious/philosophical roots led him to observe that it was through the painter Paul Sérusier that Gauguin was introduced not only to the text by Schuré but also the hermetism of Eliphas Levi, as well as the "théosophie bouddhique" of Lady Caithness, whose influence he finds evident in passages in Gauguin's *Cahier pour Aline*, written in Tahiti in 1893. This brings forth the following vivid description of *Nirvana*:

> A gnome with phosphorescent eyes, lost in metaphysical antinomies, Meyer de Haan, with the figure of despair behind him, the *Eve Bretonne*, seems to be swallowed up by the hell that is existence and from which only return to the non-created, to Nirvana, delivers us. He turns his back on the Undine, who, battered by the waves of life, lifts her head towards the vault of heaven.[40]

Two major exhibitions in the 1980s also provided opportunities for a discussion of *Nirvana* in the context of both Gauguin's work and the development of trends in nineteenth-century French painting. Gauguin, along with his friends and followers were of prime importance in *Vincent van Gogh and the Birth of Cloisonism* organized by the Art Gallery of Ontario, Toronto in 1981. The catalogue entries by Bogomila Welsh-Ovcharov provided her with a first opportunity to present a detailed consideration of the problematic. One key issue, as she rightly noted, had to do with dating. Since the background image of the two women in the rocks was nearly identical to the linecut *At the Black Rocks* (Fig. 22) employed by Gauguin as a frontispiece for the catalogue of the Café Volpini exhibition, the painting must postdate that and was "done some time between the period summer 1889 and fall 1890 when the painters were in intimate contact." In a footnote she is more precise, writing, that she "favours a date of either summer or fall 1889, or shortly following Gauguin's intense involvement with the Eve and Undine imagery in connection with the Volpini exhibition." In analyzing the composition Welsh-Ovcharov notes that there is actually a difference between the Volpini catalogue frontispiece and the imagery in the painting:

> Whereas the seated Eve remains a metaphor of Temptation and Death, the Undine has been removed from the waves and placed against a vague rock configuration. Perhaps this latter placement is a veiled allusion to a known fertility right, although the interests of compositional balance may also have had an effect. In any case, the small nude female on the beach at left presumably is on her way for an immersion in the sea, thereby hinting at the Undine theme as related to the black rock rituals. At the least one may suppose that some sense of contrast between *thanatos* and *eros* is suggested by the two female figures, one cringing in apprehension and the other baring herself to some natural force. The cycle of life and death relates to the Buddhist and Hindu concept of Nirvana, which brings this cycle to a close when earthly passions are extinguished and the individual soul is absorbed into the Supreme Spirit.[41]

Welsh-Ovcharov then takes up "the more troublesome problem of what to make of the slant-eyed main figure." Noting the frequently made allusion to the fox as representative of sinful desire, she continues:

> With this interpretation Meyer de Haan is seen as governed by wily thoughts and lewd designs and the title *Nirvana* is logically seen as intended perversely in the manner Gauguin admitted to with *Be in Love*. His sinister desires might also be thought symbolized by the serpentine vine which is wrapped around his arm and which could be read as a disguised snake with the associations it has with the *Eve* watercolor. Meyer de Haan is sometimes said to have been used by Gauguin on several occasions as a symbol of base cupidity, either because of his deformed stature, or Gauguin's supposed jealousy over his sexual liaisons with Marie Henry, keeper of the inn where they both resided in Le Pouldu. Certainly the painting does not immediately evoke a sense of other-worldly blessed repose and a cessation from psychological torment for the beings depicted, and the Nirvana of

the title must therefore be considered a goal less than fully achieved.

Recognizing that this is not a totally satisfactory explanation for this most equivocal of works, she then poses a counter approach:

> Arguing conversely, it is equally difficult to think of this painting as merely containing thematic ironies, as a kind of satirical joke played by the cynical Gauguin upon his follower and financial supporter...Unlike 'the monster' Gauguin himself in *Be in Love*, Meyer de Haan does not participate directly in the deception or degradation of women, but to the extent that this may exist among the black rocks, he turns his back on it. Indeed, his gesture of hand clasped to heart represents an almost universal, even child-like symbolization of honest resolution, if not religious faith as well. Whether or not the slanted eyes are thought suggestive of a fox, they may also be read as a sign of shrewdness of mind, which is further symbolized in the robe and cap that lend him the appearance of a philosopher-priest...If still situated within the world of earthly passions and torments, he nonetheless comprehends that ultimate release comes only through attaining the state of Nirvana.[42]

In 1988–9 a large Gauguin retrospective exhibition was held in Paris, Washington, and Chicago. Sadly this time *Nirvana* was not exhibited and was only referred to in the context of the catalogue entry on the *Portrait of Meyer de Haan by Lamplight* as being done in the same year.[43] However, at the Paris colloquium in conjunction with the exhibition, the painting was mentioned in several papers. Charles Stuckey first postulated there his idea, further developed in the present catalogue's essay, that the figures behind Meyer de Haan are actually a visualization of his thoughts.[44] The symbolic nature of the background composition was also noted by Isabelle Cahn. She pointed out that the figures in the background are a recomposition, drawn from several previous works including the *Breton Eve*, *Life and Death*, and *In the Waves*, and creating, what she calls, a new "métonymie plastique" in which the woman at the left represents "Eve déchue et morte" while the one on the right is "L'idéal feminin." The inscription "Nirvana" Cahn observed is ambiguously placed – it could be intended as the title of this very work but it could also be on the painting within the painting.[45]

The background of the painting was also the key for Denise Delouche. In *Nirvana*, as in the *Self-Portrait with Yellow Christ* (Fig. 177), she points out it is the background that symbolizes the duality of the personality. She writes that in the former, Gauguin has painted his friend:

> Between the heedless *joie de vivre* of the sensual pleasure and abstinence or remorse. Undine seems to rise up from him and Eve to watch over him, but he turns his back on them. The face of the Dutchman is rendered diabolic, the eyes bestial, and the direct gaze disturbing.

In conclusion she asks:

> How should one interpret such a work? Admiration for the blessed state of his friend? We also know of his jealousy over his rival's success with Marie Henry, despite de Haan's physical disadvantages; de Haan the triumphant tempter devoted to the state of extinguishing human desire...Nirvana?[46]

Naomi Margolies Maurer presents the most recent attempt to plumb the depths of the mysterious *Nirvana*, combining many of the previous interpretations into a complex reading. The painting, which she dates to 1890, just after the pair of Le Pouldu portraits, is described as follows:

> De Haan, who now has the glazed and hypnotized look of someone in a trance, presses the stylized snake of temptation to his own bosom, while behind him, against a backdrop of the eternal sea with its pounding surf, loom Gauguin's figures of the mummy-Eve and the woman in the waves. The fearful Eve who rejects temptation and the receptive risk-taking woman who flings herself into the sea were Gauguin's symbols for the negative and positive ways in which humans approach life experience, particularly experiences relating to love. In conjunction with the painting's title, this imagery provides the key to deciphering this very strange portrait. Nirvana is a state of supraconscious awareness and release from the emotional burdens and limitations of one's own individuality. Nirvana was achieved by the Buddha not through withdrawal from the world's complex realities, but by opening himself up to all the mingled joys and sorrows of existence in order to acquire complete knowledge of life and death. The figures which suggest these alternative responses seem to emanate from de Haan's head as personifications of his own moral conflict, symbols of the ambivalent and contradictory longings which are the heritage of all conscious and choice-making humanity. By clasping the snake to his breast, however, de Haan indicates that he chooses experience and knowledge; the way of the biblical Adam and Eve, the way of the woman in the wave, the way of the adept seeking Nirvana.[47]

She then goes on to examine "the extraordinary treatment of de Haan's face" with its mixture of fox-like, satanic qualities combined with the rapt expression suggestive of mystical insight, so that

> De Haan, who conjures up both the desire for and the fear of enlightenment, is simultaneously an initiate into life's sacred mysteries and an evil seducer, a heroic rebel against society's perversely restrictive moral values and a perverse perpetrator of potential suffering for himself and others. By this mingling of images which evoke such paradoxical ideas and associations in the spectator's mind, Gauguin implies that the life experience embraced by the eager initiate must result in evil as well as exaltation, and that in our Christian culture, whoever chooses this kind of knowledge is perceived not as a follower of Buddha, but as an agent of Satan.[48]

UNDERSTANDING NIRVANA

Since Gauguin chose to inscribe his small portrait of Meyer de Haan "Nirvana," there has naturally been, as we have seen, much speculation as to what he meant by this word. How much in fact could Gauguin, himself, have understood of this and other Buddhist concepts? According to *Le Petit Robert* the term "Nirvana" was first recorded in France in 1844.[49] The source may in fact have been in one of the earliest explanations of Buddhism, which was published that year by E. Burnouf. This author declared that in the study of Buddhism "the most important term, the one

occurring most frequently in texts, and the most difficult to explain is Nirvana." Nevertheless he attempts to do so, writing, "in a very general manner Nirvana is deliverance or salvation, the supreme end that the founder of Buddhism has proposed to human effort." As he points out, this raises several questions of interpretation, the most important of which is, "Is Nirvana the extinction, the disappearance not only of individual life but even of the universal. In two words is Nirvana *le néant?*" This highly charged French term can be loosely translated as "nothingness" or "annihilation." Burnhouf relates that the explanation of Nirvana varies from one sect to another. For what he calls the *théist* it is "absorption of the individual life in god, while for the *athées* absorption of that individual life is the *néant*. But for both Nirvana is the deliverance, it is *l'affanchissement suprême*."[50]

Debate over the meaning of Nirvana must have been a lively topic. One scholar, Jules Barthélemy Saint-Hilaire, who published several tomes about Buddhism, which he regarded as irrational but not "without a certain grandeur," felt compelled to begin the third edition of his *Le Bouddha et sa religion* with a twenty-seven page "avertissement" titled "Le Nirvana Bouddhique." He commenced this by stating that "The interpretation of Nirvana which I have given based upon Burnhouf and so many others has been contested. This does not surprise me. The hope for the 'néant' has become a religion professed to still today by a quarter or perhaps a third of humanity." It is in his introduction, reducing Buddhism to its essential elements, that he explains that Buddha saw life as a series of painful births and transmigrations from which "salvation was offered only in one way – by attaining Nirvana, that is annihilation."[51] In another of his books, the same author quotes an English authority, Spence Hardy, to the effect that "Nirvana is neither a state of sensual enjoyment nor a state of intellectual enjoyment; it is neither a state of the body, nor a state of consciousness. It is neither consciousness nor absence of consciousness. Nirvana must therefore be annihilation, and the being who enters into it must cease to exist."[52]

In his discussion of Buddhist metaphysics, Barthélemy Saint-Hilaire explains that according to the Buddhist sutras:

> There is a distinction to be made between complete Nirvana – the great complete Nirvana and simple Nirvana. Complete Nirvana is that which follows death, when man has known how to prepare for it by faith, virtue, and knowledge; while simple Nirvana may be acquired even during this life, by adopting a certain line of conduct that Buddhism teaches, and of which the Buddha himself sets an example...The process to attain this incomplete Nirvana, the foretaste of the one that follows and remains eternal, is by Dhyana or contemplation, and to put it clearly, by a state of mystic ecstasy.[53]

This may be an explanation for why Gauguin, as discovered by the Atheneum's conservator (p. 146), had originally written the word "touts" above the " Nirvana" on his small cotton composition. Even though it is grammatically incorrect, he may have intended to indicate by this that Meyer de Haan had attained the complete as opposed to simple Nirvana, and by covering it over, he has brought him back to just earthly ecstasy.

In any case, the introduction of the concept of Nirvana into France resulted in a fairly long entry being bestowed upon it in the Larousse *Grand Dictionnaire universel* published between 1865 and 1876. "Nirvahny," as it was spelled there was defined as

> A Hindu penitent who has achieved a state of complete indifference and absolute stoicism… In embracing the condition of nirvana, man ceases to be a man; he begins to become a part of the divine… Having finally attained nirvana, the penitent is no longer of this world. Earthly objects no longer make any impression on his senses. His inclinations, his affections, his thoughts are fixed invariably on the divine which he considers himself already a part of.[54]

When the first supplement of the dictionary appeared in 1878, it presented a more modest entry, but this time not only had a more accurate spelling but also did specifically mention Buddhism:

> Nirvâna – Indian Religion. A state of supreme perfection in which the soul has no more desires or even thoughts, and which is a sort of self-annihilation. Buddhism in this is similar to all religions. Suffering exists; it takes on various forms according to the times or the society.[55]

If Gauguin was not reading the dictionary or books on Buddhism, his understanding of its basic principles or at least the concept of Nirvana may have come to him by a different route. One of the most likely was through texts by and about the German philosopher Schopenhauer, whose pessimistic ideas influenced by Buddhist principles were translated into French in the 1870s and 80s and absorbed by many writers, poets, and artists.[56] So identified with Buddhist concepts of tolerance for all forms of life and even with Buddha himself in seeking "a cessation of striving and the denial of a conscious individual existence"[57] was Schopenhauer that an article about him in the widely read *Revue des deux Mondes* of 1870 was entitled "Un Bouddhiste contemporain en Allemagne." For the author of this Schopenhauer had ingeniously combined Plato and Buddha, and just as in Buddhism proposed that the goal of his philosophy should be the "arrival at the brink of nirvana, of voluntary annihilation, in which one finds salvation."[58] More detailed was Théodule Ribot's small volume of 1874, *La Philosophie de Schopenhauer*. Here was to be found a definition of *nirvana* as "the negation of this world" or the "néant." Ribot explained that Schopenhauer "finds brothers in all the ascetics of all the ages and those aspiring to *nirvana* in the myths of all countries," and that "he counts Buddhism as the religious translation of his metaphysics." Even more tellingly, he stated, "St. Augustine had his City of God. That City of God is what Schopenhauer calls, for want of a better word, *le nirvâna*."[59]

Then in 1880 appeared another slender volume *Schopenhauer. Pensées, maximes, et fragments* assembled and translated by J. Bourdeau, where in the section "Douleurs du monde," one could read that according to Buddhist belief, after a cycle of inexplicable suffering comes that "serene beatitude called Nirvana."[60]

At just about the time that Gauguin painted *Nirvana*, in 1890, there appeared the second supplement to the *Grand Dictionnaire universel*. It did not add anything further to the definition of "Nirvana"

but instead listed a new word, "Nirvanistes," defined as "Partisans of the doctrine of Nirvana." To this was appended a quote from Paul Janet: "The modern Nirvanistes are not in the desert; rather Schopenhauer preaches nirvana while spending every evening at the opera house."[61]

Many of the newly fashionable "Nirvanistes" were to be found in French literary circles, where a fascination with Buddhist and Hindu doctrines flourished. A prime example was Gustave Flaubert's popular *Temptation of St. Anthony* published in its definitive form in 1874. One of the saint's many exotic visions included an appearance by the Buddha, described as:

> A naked man seated in the midst of the sand with legs crossed. A large halo vibrates suspended in air behind him. The little ringlets of his black hair in which bluish tints shift symmetrically surround a protuberance upon the summit of his skull. His arms, which are very long, hang down against his sides. His two hands rest flat upon his thighs, with the palms open.

This singular personage identified as the Buddha relates to the saint his own history, how turning his back on wealth he discovered the miseries of the world, submitted to a variety of temptations, passed through different incarnations, acquiring Virtue and Intelligence, until in his last existence, having preached the law, "nothing now remains for me to do." In a vivid evocation of the annihilation of Nirvana, Flaubert pens as the Buddha's final words:

> The great period is accomplished! Men, animals, the gods, the bamboos, the oceans, the mountains, the sand-grains of the Ganges, together with the myriad myriads of the stars, – all shall die; – and until the time of the new births, a flame shall dance upon the wrecks of worlds destroyed.[62]

Buddhist as well as Hindu concepts and imagery regarding "the illusoriness of phenomena" were also popular with the French poets of the period, such as Leconte de Lisle and Henri Cazalis.[63] Even more significant was the latter's friend (as well as Gauguin's) Stéphane Mallarmé, who if he did not speak of Nirvana did frequently invoke the "*néant*."[64] It became a mark of honor to refer to someone as a "Boudha," and the appellation was bestowed among others on the anarchist writer, Félix Fénéon.[65] Likewise the poet Jules Laforgue identified Mallarmé as "a self-denying Buddhist sage."[66] He also wrote to Gustave Kahn that his mentor, the critic Paul Bourget appeared to him as "lord Bouddha."[67] Laforgue, who spent time in Germany and was enamored with Schopenhauer's ideas, incorporated his own personal vision of the Buddhist Nirvana into his poetry, writing in *Les Complaintes*:

> Puis, fou devant ce ciel qui toujours nous bouda,
> Je rêvais de prêcher la fin, nom d'un Bouddha!
> Oh! Pâle mutilé, d'un: qui m'aime me suive!
> Faisant de leurs cités une unique Ninive,
> Mener ces chers bourgeois, fouettés d'alléluias,
> Au Saint-Sépulcre maternel du Nirvâna![68]

Thus in literature, poetry and philosophy, as well as the plethora of theosophic works, such as that by Schuré noted earlier, Gauguin

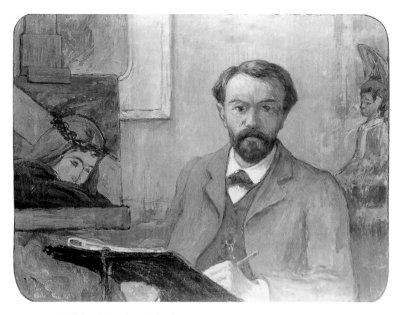

151. Emile Schuffenecker, *Self Portrait*, 1890–92, oil on canvas, 29 × 36.25 in. (73.7 × 92 cm). Private collection

152. Paul Ranson, *Christ and Buddha*, 1890, oil on canvas, 26 ¼ × 20 ¼ in. (66.7 × 51.4 cm). Mr. and Mrs. Arthur Altschul, New York

would have had ample opportunity to gather some notion of Nirvana, if not become a full fledged *Nirvaniste*. But Gauguin was perhaps most attuned to what his fellow artists were doing and thinking. His somewhat chaotic method of absorption was well characterized by Wayne Andersen who observed:

> When Gauguin verbally formulates theoretical ideas, he is hardly original…As in constructing his paintings, he borrows from everywhere: the writings of Delacroix, Charles Blanc, E. Piron; from the ideas of van Gogh and the whole array of Romantic and Symbolist writers: Aurier, Rimbaud, Huysmans, Fénéon, Rémy de Gourmont, Mallarmé, Baudelaire. That they become synthesized, however, was Gauguin's achievement; no other painter more effectively embodied in the workings of his mind and craft the intellectual machinations of a whole generation of poets. His capacity for assimilation was omnivorous to the extreme.[69]

The relevant assimilation of Buddhist doctrines and imagery would, as Bogomila Welsh-Ovcharov indicates (p. 56), have begun in the company of van Gogh.[70] Following the Dutch painter's death in early August 1890, Gauguin even wrote to Emile Bernard:

> To die at this moment is great good fortune for him. It is precisely the end of suffering and if he is reborn in another life, he will reap the fruits of his good conduct in this world (according to the laws of Buddha).[71]

Of earlier painters who had incorporated eastern motifs into their art, Gustave Moreau provides an appropriate parallel to Flaubert in his symbolic mixing of diverse cultures. Concealed in the background niche of Moreau's individual presentation of Salome's dance known as *The Apparition* is a sculpture of a seated Buddha.[72] The younger generation of artists, especially Paul Sérusier, whom

Gauguin encountered in Paris, Pont-Aven and Le Pouldu, were also most intrigued by theosophy and eastern religion. At just about the same time that *Nirvana* was painted some other more straightforward representations of this interest are evident in their paintings. For example in his *Self Portrait* (Fig. 151), Gauguin's loyal supporter Schuffenecker, who wrote about Buddhist doctrines in his letters,[73] presented himself, as if seeking the middle way, posed between a painting of Christ bearing the Cross and a statue of the seated Buddha.[74] An even more creative visualization of this unity of diverse religions is found in the art of Ranson, who frequently depicted mystical magicians seeming to have a family resemblance to the Meyer de Haan of *Nirvana*.[75] Perhaps his best-known painting is the *Christ and Buddha* (Fig. 152) of about 1890.[76] In this image, replete with Arabic inscription and sensuous lotus blossoms, looking as if it had sprung right from Flaubert's *Temptation of St. Anthony*, a yellow Christ obviously derived from Gauguin's various visions of a Breton crucifixion is worshiped by rows of devout monks, and two incarnations of the Buddha float in the foreground. Another artist friend of Gauguin's, Odilon Redon, actually created a series of lithographs based upon Flaubert's text and two of these from the 1890s depict Buddha's mystical appearance to St.

153. Paul Gauguin, *The Buddha*, 1898–9, woodcut printed in olive green on Japan paper, 11.25 × 8.5 in. (28.5 × 21.8 cm). Collection of Irene and Howard Stein, Atlanta. *Exhibition no. 36*

> If I look before myself in space, I have a sort of vague consciousness of the infinite, and yet I am only at the point of beginning. I would then understand that there had been a beginning and that there would not be an end. In this I do not have the explanation of a mystery but only the mysterious sense of the mystery. It is true that a sensation is not a truth. And this sensation is intimately linked to the belief in an eternal life promised by Jesus. Or if we are then not at the beginning when we come into the world, one must believe, like the Buddhists, that we have always existed.[83]

Also in the period before his second departure to Tahiti, Gauguin met and corresponded with the Swedish writer, August Strindberg. In a letter of early 1895 recalling how Strindberg had been frightened by Gauguin's paintings of "the ancient Eve," the painter then goes on to say, "This world could be a Paradise only I could have sketched. While there is a great distance from the sketch to the realization of the dream, it doesn't matter! To envision happiness, isn't this a foretaste of *nirvana*?"[84]

When he was once again in Tahiti, during the years 1897–8, Gauguin, in his letters to Charles Morice and the unpublished manuscript he wrote there entitled "L'Esprit Moderne et le Catholicisme," several times enriched his commentary on Christianity with comparisons to Buddhism. Especially dear to him was the notion, expressed in both sources, that everyone through wisdom could arrive at the final state of "perfectability" and would become Buddhas.[85] As he sought to reconcile his conception of Christ with other faiths, he made another of his few specific references to the notion of Nirvana:

> Christ only understood actual life as a preamble, a transitory age, since it is temporary; but through which one will arrive at a later life of pure spirituality in which will be accomplished without end the realization of perfections with all the stages of happiness which that implies. The same comprehension had already been previously formulated by Buddha, who had considered all of life as different successive states, arriving at last at Nirvana as the last existing state in the infinite.[86]

CONSIDERING NIRVANA

As Bogomila Welsh-Ovcharov has thoroughly documented (pp. 22–6), by late June or early July of 1889 Gauguin was exhibiting seventeen paintings at the Café Volpini. Among them was the one titled *In the Waves* (Fig. 178). Its logical pendant in size and subject matter, *Life and Death* (Fig. 179), painted most likely in Paris based upon recollections of Brittany and now in a museum in Cairo, was not shown.[87] For the frontispiece of the catalogue published in conjunction with this exhibition, Gauguin also prepared a drawing and sent it to Paris. This is most likely the pen study *At the Black Rocks* (Fig. 21) (which, like *Nirvana*, later belonged to Paco Durrio). Reproductions of this now-lost study and the linecut made from it (Fig. 22) reveal how seamlessly Gauguin united the key figures from these two paintings.[88] The despairing seated nude from the Cairo painting is placed at the left against a mass of black rocks, found along the Brittany coast reputed to bring fertility to those

Anthony.[77] Redon then went on to further develop the imagery of Buddha,[78] in turn inspiring later works by Sérusier.[79]

Gauguin himself had long known one source of Buddhist imagery – the famous Borobudur reliefs in Java of which from 1889 onward he always kept reproductions with him.[80] The cross-legged Buddha, appearing here, who ostensibly has achieved the harmony of Nirvana, was employed by him as a basis for sculpture during his first Tahitian period, most notably in the *Idole à la perle* (Musée d'Orsay, Paris). It also served as the basis for two woodcuts. The earliest was in the series of illustrations made for *Noa Noa* in 1893–4 and titled *Te atua*. Then as an isolated image Buddha appears in a later large woodcut of 1898–9 (Fig. 153) possibly intended as a book cover for Gauguin's text on Catholicism. Finally he incorporates this figure into a shrine-like plaque in the very late painting *Still Life with Parrots*.[81]

As Amishai-Maisels pointed out, it was after Gauguin's return to France in the years 1893–5 that he, through Schuffenecker, was introduced to some actual Buddhist texts which had been translated into French and he then incorporated some extracts into his own writings.[82] In his typically syncretic approach he combined these with elements of Christianity and the beliefs of the

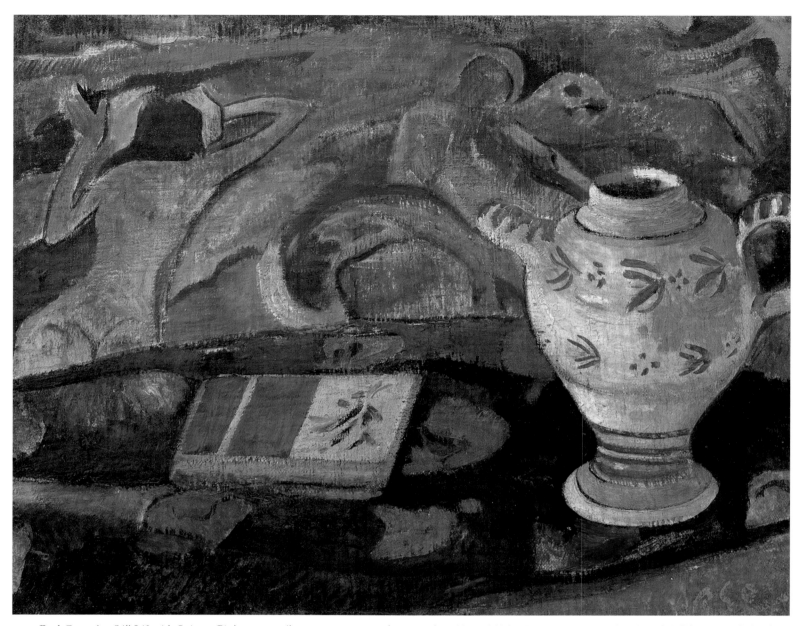

154. Paul Gauguin, *Still Life with Quimper Pitcher*, 1889, oil on canvas mounted on panel, 13 ½ × 16 ½ in. (34.3 × 42 cm). University of California, Berkeley Art Museum. Anonymous gift. *Exhibition no. 10*

who approach them. The nude in back view from the Cleveland painting shown plunging into the waves was later identified by Gauguin as *Ondine*.[89] By eliminating the seated red-haired nude with towel that appeared in the Cairo painting, Gauguin achieved a powerful condensed composition of two female figures, who more explicitly seem to represent the contrast between suffering and joy, infertility and fertility, and most basically life and death. It is against a somewhat more elaborate colored version of this new composition that he situated Meyer de Haan in the Atheneum's painting. A third woman with long red hair seen in back view has been added at the left. The water is the same green shade (perhaps slightly less intense) as in the Cleveland painting and the mystical black rocks are composed of black and golden spots.

This symbolic portrait of Meyer de Haan raises many questions. Did Gauguin simply conjure up from his imagination the condensed color composition that serves as such a charged backdrop? Or could there have been an actual, now lost painting, which he incorporated here as well as in the background of the *Still Life with Quimper Pitcher* (Fig. 154).[90] But while in the latter the pitcher and a possible Japanese book or drawing serve to evoke the exotic and primitive worlds, in the Atheneum's painting it is Meyer de Haan who looms up in front of the composition. His hieratic presence and intense eyes rivet the viewer. One therefore wonders if this unusual painting could have resulted from an actual observed moment. The two paintings that served as the backdrop – *In the Waves* and *Life and Death* – as well as Gauguin and de Haan were presumably all in Paris in late 1890 before de Haan's return to Holland. The paintings, originally in the keeping of Theo van Gogh, may have remained at Boussod and Valadon, even after the dealer was committed to a clinic that October.[91] De Haan's position in the composition of *Nirvana* is such that if he were in front of the two juxtaposed paintings (and it is impossible to say if he is seated or standing), he would block out the intermediary seated nude, and the rest of the composition could then have been improvised around him.

Thus, if we like, we can think of Gauguin's painting as the result of a sudden epiphany. Meyer de Haan purposely posed at the nexus of life and death overcomes earthly concerns and by pursuing an ascetic, mystic path has been dramatically transformed from Gauguin's slightly earlier caricatured depictions of him into the timeless visionary who has arrived at the ultimate state of being – Nirvana.

How much more meaningful to think that this breakthrough vision was achieved in bustling Paris rather than benighted Le Pouldu. Perhaps it served as a final token of friendship between the two men. In all other cases Gauguin and his colleagues produced images of each other, but oddly, considering how much time they spent together, especially in Le Pouldu, there is no record of Meyer de Haan making a portrait of Gauguin. There is also no evidence that *Nirvana* was ever at Le Pouldu. One would imagine that if it had been there, it would have remained among the several other images of the Dutch painter, including his two *Self Portraits*, the painting, sculpture, and drawing in profile by Gauguin, and the pastel by Schuffenecker, that were all kept by de Haan's mistress, Marie Henry.

155. Paul Gaugin, *Sheet of Sketches, c.* 1890. Private collection

The unusual materials of *Nirvana* – the cotton support and golden powder – perhaps also tell against it having been made in the remote village. Gauguin wrote at one point in August 1890 (perhaps exaggeratedly) of his lack of materials at Le Pouldu.[92] Would he have had available there the fine cotton fabric and the gold-like bronze paint to create this little gem? The use of the metallic material, the integration of words into the composition, the shimmering blue color of the fabric, and the whole precious nature and scale of the image serve to make it more "oriental" or eastern than any other work by the painter. It seems to have a clear debt to Indian or Persian miniatures. As Fereshteh Daftari has shown, Gauguin had various opportunities to see such works.[93]

Stephen Kornhauser's detailed technical examination of the painting confirms that Gauguin made significant changes over time to this compositions, which was not his typical manner of working.[94] Most marked is the discovery via infrared reflectography that he painted out the word "Touts" which had been written just above "Nirvana." Perhaps, as we have suggested, he had meant to convey by this "complete or total bliss." In addition he mysteriously veiled the word "Nirvana" itself in a white wash, seemingly to make it more evocative. Or was he trying to cover it over as well? The answer will probably never be known. What we can be sure of is that Gauguin left this small work among his possessions in France when he went off to Tahiti in 1891. Given the amount of reworking made evident by the reflectography and x-ray, it is possible he carried this out after his return when he had become steeped in more vivid, "primitive" mask imagery.

With the exception of the Christs in Gauguin's renderings of the Crucifixion, there is almost no other face or portrait by the painter in his pre-Tahitian period, so obviously mask-like. One significant exception is on a sheet of studies (Fig. 155) of *c.* 1890 that in addition to heads of a child and a lioness includes not only a very severe, stylized mask-face, but also a heretofore unrecognized profile study of de Haan.[95] It was in Tahiti that this mask-face was to develop further on a figure in the 1892 painting titled *Parau na te*

156A. Paul Gauguin, *Parau na te varua ino (Words of the Devil)*, 1892, oil on canvas, 36 ⅛ × 27 in. (91.7 × 68.5 cm). National Gallery of Art, Washington D.C. Gift of the W. Averell Harriman Foundation in memory of Marie N. Harriman

156B. Paul Gauguin, *Study for Words of the Devil*, 1892, graphite on paper, 8 ⅝ × 8 ½ in. (22 × 21.5 cm). Musée d'Orsay, Paris.

Varua Ino (Fig. 156A), or, according to Gauguin, "Words of the Devil." This is an elaboration of Gauguin's recurring theme of the Devil speaking to, or attempting to seduce or corrupt, an idyllic Eve, who is now rendered as a Tahitian woman. If one wishes to make a connection between the mask-like features of this devil and those so often, as we have seen, imputed to the image of Meyer de Haan in *Nirvana*, the task is made even easier by looking at the preliminary drawing for the painting (Fig. 156B).[96] Here (despite the possible derivation of the composition from Degas)[97] the more obvious serpentine incarnation of the masked devil lifts in his raised hand a smiling mask with rounded forehead and pointed chin truly reminiscent of the shape of de Haan's face in *Nirvana*. The marked juxtaposition of the opposites of smiling mask and stone-faced mask suggests the duality of good and evil as well as the choices of life and death evidenced in the Atheneum painting. The Eve in the drawing seems to recoil in horror, unlike the woman in the finished painting who is more puzzled at her sudden awareness of nudity. In any case the question this drawing raises is,

could Gauguin have returned from Tahiti, taken up his earlier work, and redone the face of de Haan to emphasize its primitive, mask-like qualities? If so, then Durrio would have been well aware of the work's significance and could in turn have pointed out its uniqueness among his Gauguin holdings to Gauguin's greatest twentieth-century artistic heir, Picasso.

THE OBSESSIVE IMAGERY OF NIRVANA

The uniquely significant, even talismanic, place of *Nirvana* among Gauguin's many works, is evidenced by the frequency with which images and themes associated with it continued to figure in his art. In creating his individual style and visual conceptions Gauguin was willing to draw on a wide variety of sources – traditional myths, Biblical or Christian imagery, folk art, and esoteric Eastern philosophies and images. This, combined with his evolving symbolist color theories, led him to create his highly original symbolic portraits. Of these *Nirvana*, while perhaps the smallest, nevertheless goes the furthest in the direction of abstraction, distorting the subject's features

157. Paul Gauguin, *Self Portrait with Portrait of Emile Bernard, Les Misérables*, 1888, oil on canvas, 17 ¾ × 21 ⅝ in. (45 × 55 cm). Rijksmuseum Vincent van Gogh, Amsterdam

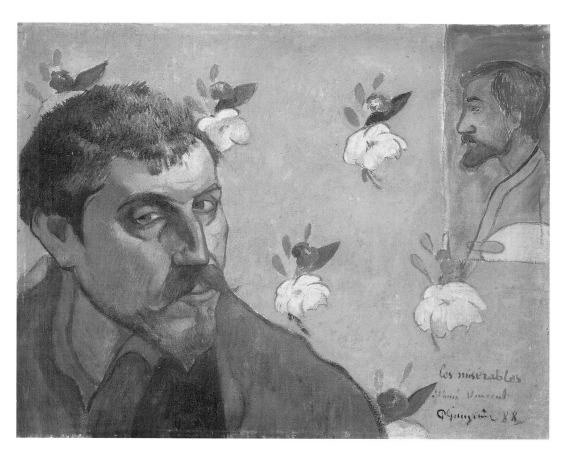

for poetic or philosophic ends. It is also, more than many other of the painter's works, an expression of his obsessive visual imagery and his compulsion to convey his message. The last is demonstrated by the written inscription "Nirvana". Without this over a half century of interpretation and iconographic studies would never have transpired. Gauguin had earlier employed the practice of meaningful inscriptions, most notably in his own *Self Portrait* (Fig. 157) painted for van Gogh and inscribed "Les Misérables" to suggest his identification with the bandit Jean Valjean.[98] The incorporation of writing or text into images could have been inspired in Gauguin by Japanese prints and Persian manuscripts, both of which certainly helped inspire elements in *Nirvana*. In a letter to Emile Bernard from Le Pouldu of June 1890 where he speaks of his current disillusionment with life and art in the West and expresses hope for a new position in Tonkin, Gauguin wrote metaphorically of: "All of the Far East, the great philosophy written in letters of gold in all their art."[99] Here in this work he literally includes philosophy (or at least religion), writing both his own name and the word "Nirvana" in seeming letters of gold.

Nirvana is indeed also unique for the form of the painter's signature. Passing between Meyer de Haan's thumb and first finger is the golden, stylized snake or plant tendril, which makes the letter G. This may or may not, as has been suggested, "give a mystic number,"[100] but it does draw remarkable attention to the creator of the subject, who then spells out the full remainder of his name diagonally across de Haan's rigid hand. Gauguin we know was

interested in the symbolic gestures, "mudras," of eastern art. In his *Self Portrait with Halo*, his own equally hieratic hand is also intertwined with a snake, and in a telling photograph of his hand, it is compressed in a like manner,[101] which is also employed for the figure on the left of *Be Myserious*. He clearly intended this hand gesture to be of key importance in *Nirvana*, and, as the x-ray has revealed (Fig. 201), changed it from the palm-out position to its present state. The compressed hand with iconographic connota-

158. Paul Gauguin, *Arii Matamoe – La Fin royale*, 1892, oil on canvas, 17 ¾ × 29 ½ in. (45 × 75 cm). Private collection

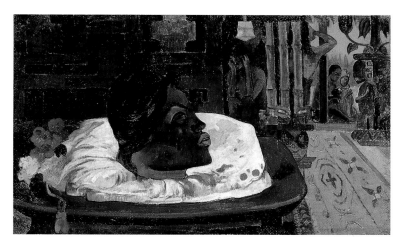

159. Paul Gauguin, *Pont Aven: Village Drama*, 1894, oil on canvas, 28 ¾ × 36 ¼ in. (73 × 92 cm). Private collection

160. Paul Gauguin, *Human Misery*, 1889, zincograph on yellow paper, 17 ¼ × 21 ¾ in. (43.8 × 55.1 cm). Sterling and Francine Clark Art Institute, Williamstown. *Exhibition no. 27*

tions continued to be significant in Gauguin's works, especially in the *Loss of Virginity* (Fig. 86), where a symbolic red flecked flower is intertwined with the exaggerated fingers.

It is perhaps not too far fetched to suggest that in *Nirvana*, through the emphasis on his own name, Gauguin was trying to convey a sense of identification between himself and de Haan. The turned head and strikingly intense eyes of a bearded face represented here remind one of the artist's own *Self Portrait* study in Strasbourg (Fig. 37). It is notable that in all of his depictions of de Haan, Gauguin never shows him actually engaged in his profession as a painter, holding a brush, but rather he is in the guise, depending on what interpretation one accepts, of scholar, thinker, magus, demon, or enlightened being. Perhaps, Gauguin, despite his occasional polite references to de Haan's talent, did not really think much of his pupil as an artist, but most respected him as an intellect to be associated with literary tomes and esoteric concepts such as Nirvana. Many of the elements that occur in the Atheneum's painting continued to obsess Gauguin throughout the remainder of his career and specific motifs continued to reappear.

In Tahiti he produced a series of crude woodcuts, which literally repeat earlier compositions. The background figures of *Nirvana* were among his favorites. The earlier 1889 linecut *At the Black Rocks* for example was recreated in a rough reversed woodcut.[102] A clear echo of the subject is found in the background of the somewhat macabre painting done in Tahiti titled *Arii Matamoe* (also known as

La Fin royale) (Fig. 158).[103] The background mourners for the decapitated monarch include the crouching melancholic Eve type and to her right, although no longer swimming, is the other female figure in back view with long hair and bent arm.

The despairing Eve figure originally in the 1889 print *Human Misery* (Fig. 160) and then seen at the left of *Nirvana* and also in the Boston wood relief *Be In Love* (Fig. 77) appeared again in the interval of his return to France, when Gauguin made brief visits back to Pont-Aven and Le Pouldu during 1894 in a vain attempt to regain the works he had left at the inn of Marie Henry. He may have experienced his own form of melancholic nostalgia, and thus reintroduced the familiar figure in the *Village Drama* (Fig. 159).[104] Again in Tahiti this figure is seen in two woodcuts; one repeats the theme of *Human Misery*,[105] and the other is a variation of the earlier wood carving and like it inscribed "Soyez amoureuses" (Fig. 161).[106] A more developed treatment is evident as the aged figure at the left in the great *Where Do We Come From...* in the Museum of Fine Arts, Boston (Fig. 174). Her counterpart the life-enhancing *Woman in the Waves* or *Ondine* does not appear here, but being, as Edward Henning described, one of Gauguin's "compulsive images,"[107] she had plenty of other incarnations. In addition to those works of 1889–90 noted by Bogomila Welsh-Ovcharov, she also appeared in a fan-shaped watercolor and chalk drawing inscribed "soyez amoureuses" (Fig. 162),[108] as well as two wood reliefs of 1889 – the *Be Mysterious* (Fig. 76) created according to the

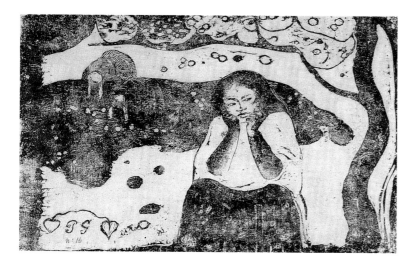

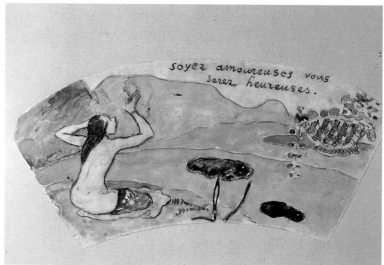

161. Paul Gauguin, *Human Misery*, woodcut on paper, 4 × 7 ¼ in. (10.2 × 18.4 cm). National Gallery of Art, Washington, D.C. Rosenwald Collection. *Exhibition no. 35*

162. Paul Gauguin, *Be in Love and You Will Be Happy*, c. 1894, watercolor and colored chalk on paper, 5 ³⁄₈ × 10 ¹⁄₈ in. (13.2 × 25.5 cm). Private collection.

163. Paul Gauguin, *Decorative project for a Bookcase*, watercolor, gouache, and graphite on paper, 18 ³⁄₄ × 25 in. (47.5 × 63.5 cm). Private collection.

artist as a pendant to *Be in Love* and a smaller panel of two *Ondines* (Fig. 26).[109] It is these same swimmers that form the background (picture within a picture) of the little-known Le Pouldu period *Still Life with Quimper Pitcher* (Fig. 154) in Berkeley. The swimmer taken out of context and appended to a down-turned despairing figure also appears at the center of a design Gauguin prepared for a proposed bookcase (Fig. 163).[110] Later echoes of this figure may be found in some of the early Tahitian paintings of women bathing, such as *Fatate te miti* (in the National Gallery, Washington) and *Vahine no te miti* (Buenos Aires)[111] in which a nude woman seated on a beach is seen in back view against black rocks and a green ocean with foaming white waves. Likewise in the background of the woodcut *Auti te Pape*[112] is another reminiscence of the Ondine.

MEYER DE HAAN IN TAHITI

Just as Gauguin maintained his interest in the concept of Nirvana from the time of the 1889–90 painting, through his later years in Tahiti, so too did he strangely keep alive the image of Meyer de Haan. Gauguin presumably saw him for the last time in early 1891, before de Haan returned to Holland. In a letter of late 1891 sent to Sérusier by Gauguin from Tahiti, he inquires after "Meyer."[113] De Haan was ill, so the two artists did not reunite or even it seems correspond during Gauguin's brief period of return to France, and then in 1895, when Gauguin was back in Tahiti, de Haan died. It is not known if any of their former friends or colleagues informed

Gauguin of this sad event. The painter Louis Roy, who had been the subject of a Gauguin portrait (Fig. 164), clearly learned of de Haan's passing and commemorated the close ties of the two former colleagues in his own symbolic evocation of their time together at the shore of Le Pouldu (Fig. 165).[114]

Gauguin's own recollections may have been more troubled, for in his recreations of the image of de Haan, he employed the depiction he had created in the *Portrait of de Haan by Lamplight* done for the inn at Le Pouldu. As a memento of it, he may well have had with him the watercolor version (Fig. 149) with a portion of a text on the verso.[115] Although it is usually suggested that this was the preliminary drawing for the painting,[116] it is more likely a *replique* for it does not display the bravado, which one would expect in a preliminary study. It is exact in all the details, only exaggerating the height of the body in relation to the table and making the head larger, so that the slanted fox-like eyes are even more prominent. It certainly had the advantage of being easily transportable.

A possible reason for him to think again of his old colleague and especially of this particular representation of him may, as has

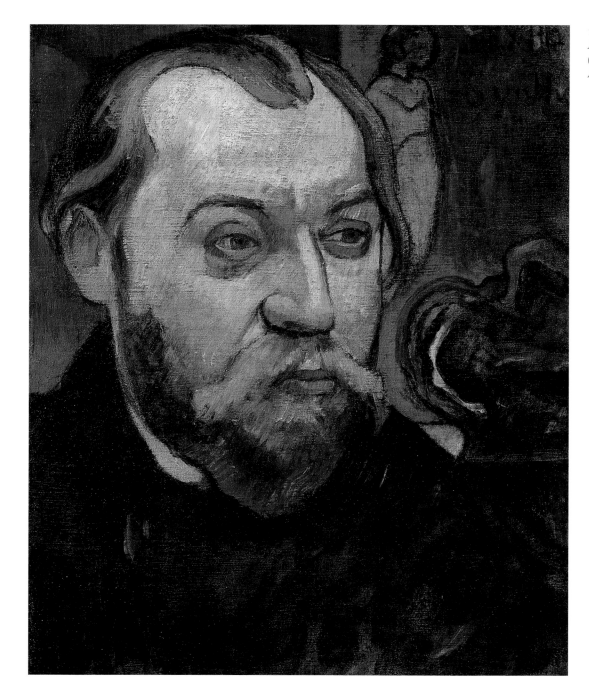

164. Paul Gauguin, *Portrait of the Painter Louis Roy*, 1889–90, oil on canvas, 16 × 13 in. (40.5 × 32.5 cm). Private collection. *Exhibition no. 7*

been noted, have been the availability to him in 1895–6 of the Parisian journal the *Mercure de France* that was serializing a French translation of Carlyle's *Sartor Resartus*,[117] one of the very books Gauguin indicates on the table next to de Haan in both the painting and drawing.

The first reappearance of de Haan in Tahiti is in a rare woodcut (Fig. 169), one impression of which was pasted in *Noa Noa*.[118] The figure of de Haan here seems to confirm the idea that Gauguin was working after his earlier drawing, as the figure is reversed with the hand to the mouth at the right and the raised shoulder at the left. Could there have been in his mind also a reminiscence of *Nirvana*, with two women, sometimes said to be chastising him, placed behind? This woodcut differs from the prototype in that it elimi-

nates de Haan's cap and lower body. These elements as well as the original orientation of the figures, however, reappear in the most elaborate reincarnation of de Haan – the great late painting done at Gauguin's last island home on Hivaoa in 1902. Once again he was responsible for inscribing the work with an ambiguous title, "Contes barbares" (Fig. 168).[119] Here, ignoring realistic relationships of space, de Haan, taken almost exactly from the earlier painting and/or watercolor, looms up in a lush Polynesian setting behind two figures. As in the woodcut the woman on the far side from de Haan has long flowing hair. Comparing the painting with the original source, the innovations are that he now has green eyes; instead of his original red garment, he wears what has been identified as "a violet missionary's dress;" and, most striking of all, a claw

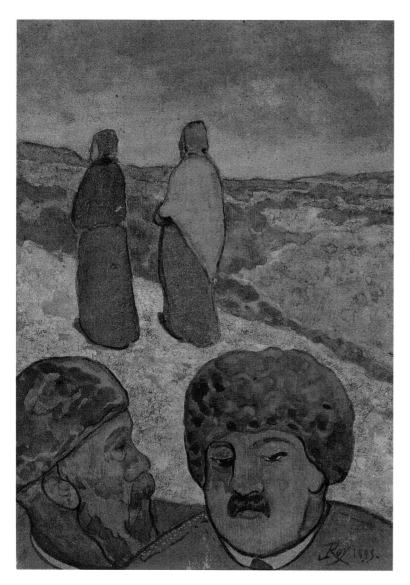

166. Paul Gauguin, *Two Pages from a Sketch Book Showing a Fox and a Dog*, 1888–9, graphite and charcoal on lined paper, 6 ⅝ × 4 ⅛ in. (17 × 10.5 cm). The Israel Museum, Jerusalem. Gift of Sam Salz

167. Paul Gauguin, *Menu with Fox*, c. 1900, watercolor and graphite, 8 ⅛ × 6 ⅜ in. (20.6 × 15.5 cm). Private collection

165. Louis Roy, *Meditation*, 1895, gouache on cardboard, 8 ¼ × 5 ½ in. (21 × 14 cm). Private collection

foot has been added on which he balances his body. Perhaps, again as a recollection of *Nirvana* he appears with what are usually identified as two women, one red haired and the other dark. However, the relationship of the figures is now reversed. De Haan is behind the women, but another connection to the Atheneum's work may exist. As Teilhet-Fisk observed, while the red-haired figure is definitely a Marquesan woman, most likely Tohotaua, the wife of the sorcerer Hapuani, who befriended Gauguin, the seated figure is described as "an attractive androgyne …sitting in the half lotus position so common to Hindu and Buddhist art."[120] This certainly provides a link to the theme of *Nirvana*. Both the pose of the seated central figure and its relationship to the woman are derived from Gauguin's favored source of eastern postures, the photo-

graphs of the Borobudur reliefs from Java.[121] The implication it has been suggested is that in *Contes barbares* there are represented three different faiths, belief systems, or worlds – Judaism (Europe or the West), Buddhism (the East), and native religion (Polynesia).[122] Perhaps the title "Primitive Tales" inspired by Leconte de Lisle's 1862 *Poèmes barbares* also refers to ancient practices shared by these differing traditions. It is certainly very difficult to say, especially as none of the figures, despite what has been observed previously,[123] is obviously talking. Or is it possible, in keeping with Gauguin's method of picturing projected thoughts, that in this case de Haan is the embodiment of the "contes barbares" imagined by the seated "women." If indeed Gauguin had the watercolor drawing with him for inspiration, it is notable that,

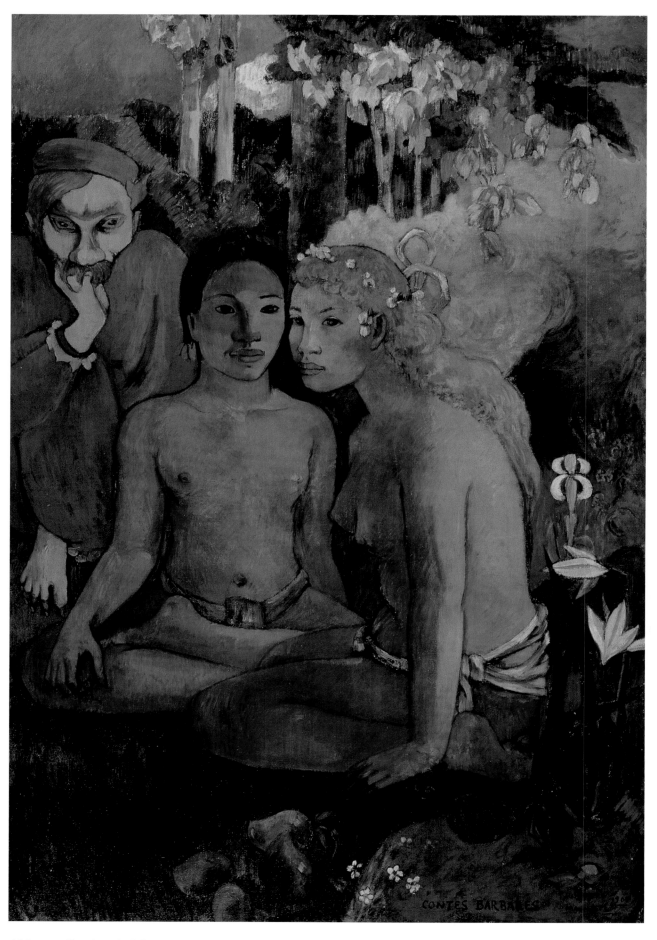

168. Paul Gauguin, *Contes Barbares*, 1902, oil on canvas, 51 ¾ × 35 ¾ in. (131.5 × 90.5 cm). Museum Folkwang, Essen. *Exhibition no. 16*

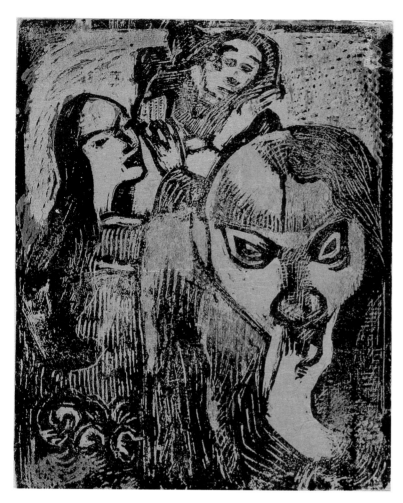

169. Paul Gauguin, *Memory of Meyer de Haan*, 1896–7, woodcut, 4 ¼ × 3 ¼ in. (10.6 × 8.1 cm). Art Institute of Chicago

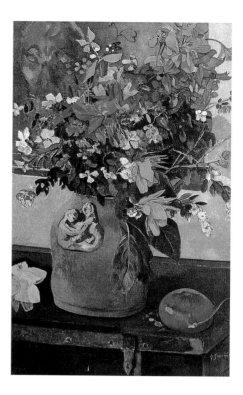

170. Paul Gauguin, *Still Life with Flowers*, 1891, oil on canvas, 37 ¼ × 24 ¼ in. (95 × 62 cm). Private collection.

as in it, he included here a fruit still life in the foreground. In place of the two books, however, we now have the two "female" figures and substituting for the lamp are the iris and lotus, so that symbols of temptation, seduction, and enlightenment are yet again intertwined to convey a mysterious meaning that seems to hover just beyond our understanding.

Gauguin's earlier identification of Meyer de Haan with the fox, his "symbol of perversity," is also a motif that continues, according to several writers, in Polynesia where there were no native foxes. Gauguin sketched the fox seated on its backside, very much as he had in the earlier *Carnet* (Fig. 166), on one of the menus he designed for a Tahitian banquet (Fig. 167).[124] This is a convincing fox, more so than the ones appearing in a watercolor monotype of *Foxes with a Goose*.[125] Another creature that has also been called a fox appears in a number of the Tahitian woodcuts.[126] As a specific invocation of Meyer de Haan, this composite beast has been identified sitting outside a doorway behind two semi-nude women in the 1902 painting *Two Women*.[127] It is this same fox-like admixture that appropriately appears along with the serpent in Gauguin's final vision of Paradise – *Adam and Eve*.[128]

If the characteristic almond-shaped eyes of de Haan are hinted

at in these fox incarnations, his whole visage appears to us once again in the late Tahitian *Still Life with Flowers* (Fig. 170).[129] Just as he had glowered behind a plate of apples in the Pouldu portrait, here Meyer de Haan's distinctive face (and not, as has previously been suggested, Gauguin himself),[130] literally becomes a mask, hung on the back wall. This nearly hidden element may seem abruptly disturbing, but in fact it is an appropriate counterbalance to the voluptuous tropical flowers and fruit, and even more so, in Gauguin's personal iconography, to the coupling figures molded on the surface of the rough vase. Gauguin could not or would not forget the mysterious presence of the Dutchman's bizarre face and continued to be haunted to the end of his days by those intense, all-seeing eyes.

THE AFTER-LIFE OF NIRVANA

It has often been remarked that the so-called "primitive" aspect of Gauguin's art had a marked influence on twentieth-century art and artists.[131] This was especially true in the case of Picasso, whose debt to Gauguin has been widely noted. Both Ronald Johnson and William Rubin report that Picasso and his friend Sabartès visited Paco Durrio's studio in 1901 and "there was much talk about

171. Pablo Picasso, *Study for "Les Demoiselles d'Avignon,"* 1907, oil on canvas, 31 ⅞ × 23 ⅝ in. (81 × 60 cm). Staatliche Museen, Berlin, Berggruen Collection.

Gauguin, Tahiti, and the poem *Noa Noa.*" Durrio even gave Picasso a copy of the poem.[132] John Richardson, in his definitive Picasso biography, suggests that in Paris at the beginning of the twentieth century Picasso spent a good deal of time in Durrio's apartment/studio and absorbed the presence of the various Gauguins housed there.[133] He certainly would have seen *Nirvana* and its composition seems to have inspired Picasso's 1902 ink portrait of his own painter friend Sebastià Junyer Vidal (Fig. 172).[134] Turned to the left the bearded artist abandons his palette for a lyre against which is held his stylized hand. Most tellingly the background shows a number of female nudes embracing the rocks by the sea.

Then in 1906 Picasso attended the large Gauguin retrospective presented at the Salon d'Automne and succumbed even more fully for a time to the influence of the earlier artist. Now, with the realization that the uniquely modern *Nirvana* was in Durrio's collection and possibly also shown in the Salon, its particular role in the formation of Picasso's advanced style has to be assessed. The sources for Picasso's development of proto-Cubistic forms are usually identified as his discovery of African masks and the time he spent looking at ancient Iberian sculpture in the Louvre and then back in Spain. This allowed him upon his return to Paris in late 1906, to plunge in and complete the mask-like face of Gertrude Stein and begin to conceive the figures for *Les Demoiselles d'Avignon*.[135] While full credit for the "primitive" advances in his style can not be claimed for *Nirvana*, the renewed sight or reconsideration of it in Durrio's lodging might just have had a role in sparking the Spanish painter's imagination. Its singular mask-like quality has already been commented upon. The elongated, pointed face, the simplified, angular ear, the nose seen in profile, and especially the eyes, those floating almond shapes with tiny dots set within, as well as the bizarre, highly keyed colors of orange and yellow, and the outlining of forms in black are all elements which Picasso abstracted at this time for faces as diverse as his own *Self Portrait*, the *Gertrude Stein*, *The Sailor*, and the various preparatory heads for *Les Demoiselles* (Fig. 171).[136] Gauguin would undoubtedly have been pleased that his innovative, small work *Nirvana* left behind in Paris could provide an epiphany for another great artist and have an afterlife in one of the major creative breakthroughs of the twentieth century.

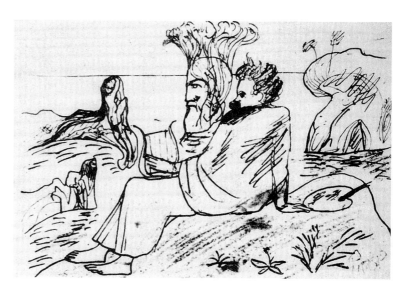

172. Pablo Picasso, *Portrait of Sebastià Junyer Vidal at Majorca*, 1902 or 1903, ink and colored pencil on paper, 6 ¼ × 8 5/8 in. (16 × 22 cm). Private collection.

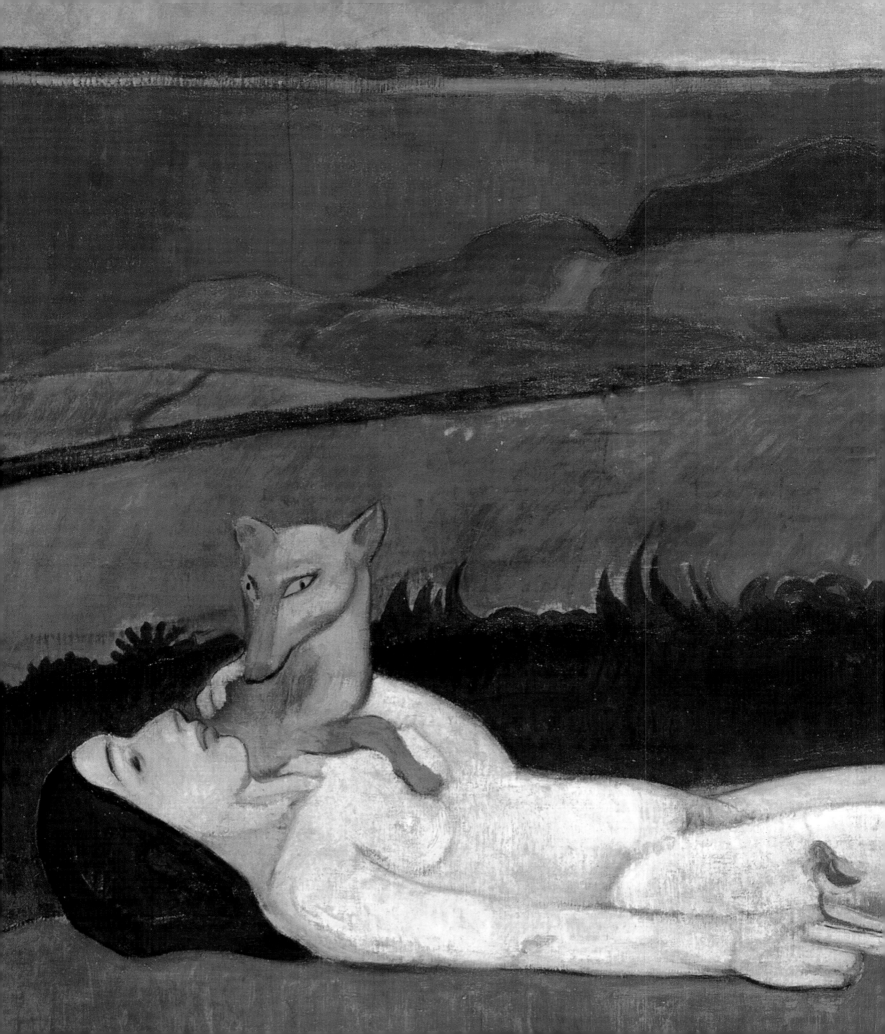

Gauguin Inside Out

"Where?" is Gauguin's fundamental question. As an artist and writer, he was deeply concerned about where his family came from, where he was raised and where he chose to live. And he entitled his most ambitious pictorial allegory *Where Do We Come From? What Are We? Where Are We Going?* (Fig. 174) In the vast majority of any artist's representational images "where" is designated and characterized by the so-called background, the areas of representation surrounding the subject figure or figures. Throughout history the "ground" in the famous "figure–ground" relationship has almost always served pictorially to indicate a real or imaginary exterior place, no matter whether the artist used the precision of perspective to represent particulars of this world or whether the artist used symbolical conventions like gold-ground to designate otherworldly spiritual realms. The representational artist's imagination has the power to place anyone anywhere. What did Gauguin have in mind, with respect to the figure–ground dynamic of his little symbolic portrait of fellow artist, Meyer de Haan, entitled *Nirvana*? "Where" should a viewer understand this figure to be?

The word "Nirvâna," visible at the lower right corner (see Fig. 199), signifies the highest state of existence in Buddhism, Jainism and Hinduism, reached when the mind dissolves into an ocean of peace and all bodily desire is quelled. De Haan appears far from any nirvana in Gauguin's portrait.[1] Indeed, the nude women on the rocky background beach with breaking waves are far too close for de Haan's spiritual comfort. No matter that de Haan's back is turned to them, their proximity would be tormenting, like the approach of sexually charged females in renditions of *The Temptation of Saint Anthony* by Cézanne, whose works Gauguin collected avidly when he had the means to do so.[2] "Soyez amoureuses et vous serez heureuses" (Be in love and you will be happy), the inscription Gauguin used for a late-1889 relief sculpture (Fig. 77) and again for a woodblock print in 1898–9, might be a slightly less inappropriate title for this little portrait of de Haan, who hardly appears content.

Notwithstanding the seemingly sarcastic "nirvana" inscription[3] on the de Haan portrait, there are three different ways to consider the background:

173. (*facing page*) Detail of Gauguin's *The Loss of Virginity*, Fig. 86

174. Paul Gauguin, *Where Do We Come From? What Are We? Where Are We Going?*, 1897, oil on canvas, 54 ⅞ × 147 ½ in. (139.1 × 374.6 cm). Museum of Fine Arts, Boston, Tompkins Collection.

175. Emile Bernard, *Self Portrait*, 1890, oil on canvas, 21 ⅝ × 18 in. (55 × 46 cm). Musée des Beaux Arts, Brest

176. Paul Cézanne, *Man in a Blue Smock*, c. 1895–7, oil on canvas, 32 ⅛ × 25 ½ in. (81.5 × 64.8 cm). Kimbell Art Museum, Fort Worth

(1) as a landscape showing a real rocky beach in Brittany where Gauguin and de Haan lived and worked in tandem for over a year starting in late 1889.

(2) as a fanciful pastoral painting placed in an interior, such as an artist's studio, in which de Haan happens to be posed.

(3) as a vision emanating from inside de Haan so powerfully as to obscure entirely his external real-world whereabouts.

As for the first possible reading, it would seem preposterous that anyone could stay still to pose out-of-doors and feign indifference to the arousing misery of the nude, young women nearby. As a result, the first hypothetical reading of the background casts de Haan as something like the dupe in a slapstick movie, unaware of the goings-on immediately behind him.

The second hypothetical reading relates *Nirvana* to a group of 1889–90 self portraits by Gauguin and Emile Bernard, as well as to contemporary portraits by Cézanne among others. In the Gauguin and Bernard self-portraits, the artists posed in their studios in front of their own pastoral paintings, close in spirit to the Golden Age paintings of Pierre Puvis de Chavannes (Figs. 128, 129) that were so highly acclaimed and frequently emulated in the 1880s.[4] Indeed, observed close-up, these pastoral paintings peopled with female

nudes so monopolize the backgrounds of these self portraits that the artists might seem, like actors on a stage, to inhabit the fantasy settings rather than any pedestrian studio. Less far-fetched, with respect to the daily realities of late nineteenth-century France, is the suggestion that these background paintings literally grow out of the imaginations of Gauguin and Bernard like male fantasies. For example, in a *Self Portrait* (Fig. 31), Gauguin portrayed himself against a background of a detail of one of his many marine paintings, the so-called *In the Waves* (*Ondine*) (Fig. 178), which shows a red-headed nude from the back as she enters the sea (the same figure as in the background of *Nirvana* to the right). By 1890 Bernard had painted two similar *Self Portraits*, the backgrounds of which correspond to nude bather paintings that he began to make in 1887 at a studio in Asnières, just outside Paris (Fig. 175). Not surprisingly, everything in these self portraits is observed, in reverse, as though viewed in a mirror. Not reversed this way, the background figures in *Nirvana* might better be compared to the dressed female figure in Cézanne's earliest known work (a painted screen, today in the Musée d'Orsay, Paris) which provides the art studio background, somewhat incongruous, for his 1890s painting of a seated workman, *Man in a Blue Smock* (Fig. 176). In terms of brushy style and color, Cézanne's primary male figure appears to merge with

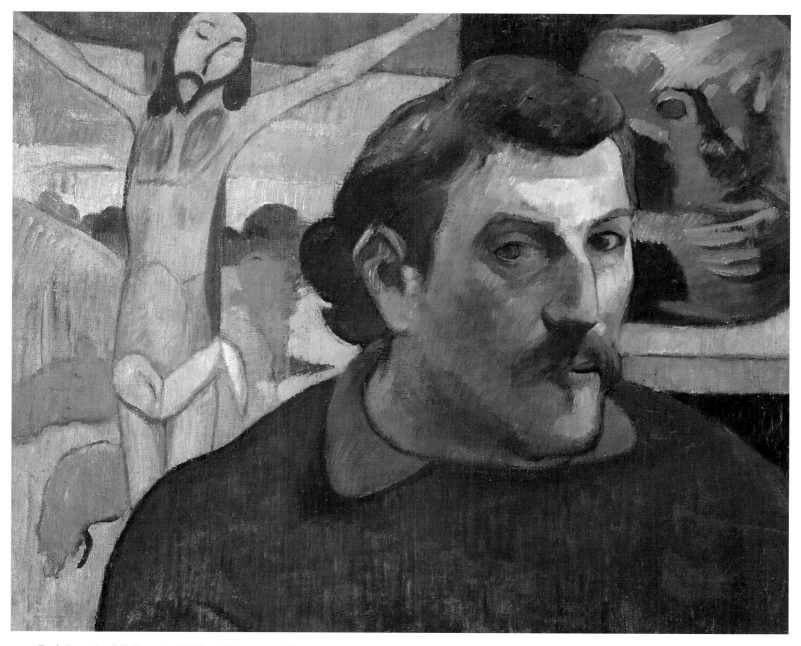

177. Paul Gauguin, *Self Portrait with Yellow Christ*, 1889, oil on canvas, 15 × 18 ⅛ in. (38 × 46 cm). Musée d'Orsay, Paris

this background, thus appearing to listen to the woman represented in the screen behind. Of course, in Gauguin's *Self Portrait with Yellow Christ* (Fig. 177), the artist shows himself with his ear turned as if to listen to a bizarre ceramic sculpture self portrait, the mouth of which is covered and muted by his hand. In *Self Portrait with Yellow Christ* the background images in Gauguin's studio are not simply projections of his artist's imagination, but those projections are themselves self portraits in which he assumes alter egos.

The relatively simple explanation that the background in *Nirvana* represents a work by Gauguin deserves consideration because the identical figures and setting reappear in many other works by him, as if they were an obsession, presumably with special meanings linking one work to the next. The work most closely

corresponding to *Nirvana*, still smaller in scale, is Gauguin's pen and ink drawing, inscribed "aux Roches noires" (Fig. 21). A reproduction of this drawing illustrates the catalogue for the group exhibition of Impressionist and Synthetist painters held at the Café Volpini in Paris between June and October 1889 (Fig. 22).[5] In this drawing the same two nudes who overlap one another in *Nirvana* are shown at a similar beach setting, but as separate entities, side by side. The nude with both her hands raised to her face, on the left in both *Nirvana* and the "aux Roches noires" drawing, is the subject of a painting in the Mahmoud Khalil Museum, Cairo (Fig. 179), and the back-turned, red-headed nude with the Rodinesque gesture of her arm raised to her forehead, visible on the right side of both *Nirvana* and the drawing, is the subject, Ondine, of the already-

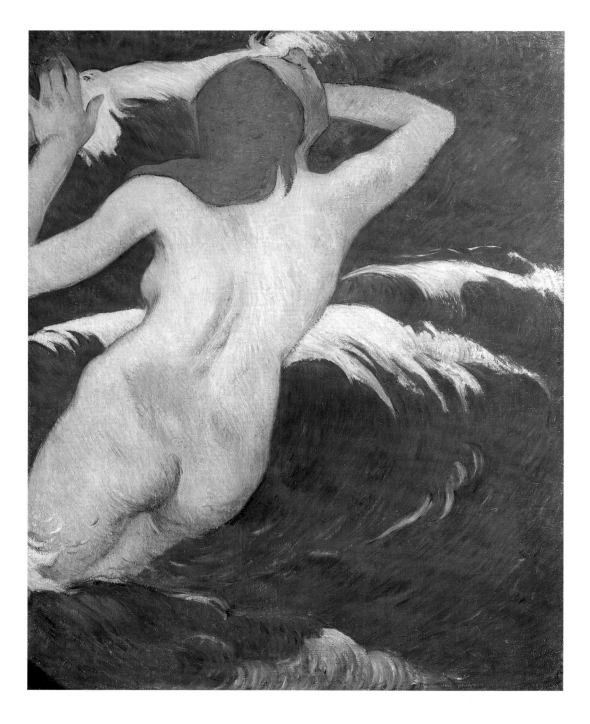

178. Paul Gauguin, *In the Waves*, 1889, oil on canvas, 36 ¼ × 28 ⅜ in. (92 × 72 cm). The Cleveland Museum of Art. Gift of Mr. and Mrs. William Powell Jones. *Exhibition no. 3*

mentioned painting chosen as the background to one of Gauguin's self portraits. The Cleveland and Cairo paintings have the same dimensions and thus are usually considered to be pendants. Both are generally believed to have been painted at Le Pouldu in late 1888 or early 1889, and the Cleveland painting is believed to have been included at the Café Volpini exhibition as *Dans les vagues* ("In the Waves"), whereas curiously the Cairo painting was not, to judge from the titles listed, in the catalogue.[6]

Such similar works aside, however, what finally makes it impossible to interpret the background of *Nirvana* as a Gauguin painting (with the implication that de Haan is posed in a studio) is the fact that no painting with the identical details exists. The possibility that

such a work did at one time exist, and then eventually was painted over or lost, seems highly unlikely, given the absence of any documentary reference whatsoever (in contemporary correspondence, inventories, exhibition catalogues, or newspaper accounts) to what would have been a major work.[7]

That leaves the third option for reading the background of *Nirvana*: as an emanation of de Haan's sexualized mindset.[8] By using the background to "represent" the internalized thoughts of de Haan, Gauguin subverted the conventional function of background as external location. In doing so, Gauguin was keeping pace with the bizarre pictorial ideas of Odilon Redon, whose *Virgin of the Dawn* (1890), for example, shows a disembodied head,

eyes closed, hovering over calm waters gilded by the light of dawn. Or is it dusk? With the large head, the empty landscape appears as thought, in this case as cosmic meditations on birth and death. In several later works, such as his portraits of Yseult Fayet, 1908 (private collection), and Violette Heyman, 1909, (Cleveland Musuem of Art), Redon placed his sitters against fantastic floral backgrounds, thus suggesting the colorful life-force of their inner beings. Considering such works by Redon, it seems noteworthy that the two primary background women in *Nirvana* appear to emerge from de Haan's head, as if his head were a vase and the women were flowers, albeit "Flowers of Evil," such as those evoked in Baudelaire's poem about lesbianism, "Damned Women."

Supposing a connection to Baudelaire is an indirect way of relating Gauguin's *Nirvana* to perhaps the most widely discussed work-in-progress by any artist during the 1880s, Rodin's *The Gates of Hell*.[9] Bauldelaire's sexually charged poetry, in tandem with Dante's *Divine Comedy*, was inspirational to Rodin as he progressed on this awesome State commission, and the uppermost panel, the so-called tympanum of *The Gates of Hell*, which incorporates the famous seated "Thinker" figure situated in front of a relief sculpture of agonizing nudes (Fig. 181), is all but identical in pictorial concept to *Nirvana* (even if hell and nirvana are antithetical in spiritual concept). When Symbolist artists such as Rodin or Gauguin used what would by convention be background areas to represent inner

180. Edvard Munch, *Golgotha*, 1900, oil on canvas, 31 ½ × 47 ⅛ in. (80 × 120 cm). Munch-Museet, Oslo

181. Auguste Rodin, *Gates of Hell* (detail), 1880–1917, bronze. Philadelphia Museum of Art.

thoughts, those thoughts were most often deeply spiritual ones. Edvard Munch's *Golgotha* (Fig. 180) for example, follows the prototype developed by *The Gates of Hell* and *Nirvana*. In Munch's painting a bearded man is facing frontally as if for a portrait, at his back is a crucifixion that appears to sprout from his head, while a crowd of agonized figures pay it homage.

The pictorial conceit that human thoughts can be understood to "blossom" had been used, for example, by Degas, Courbet and Renoir in paintings that juxtapose floral arrangements with women's heads, suggesting the delicate, fragrant beauties of their mental outlooks.[10] Possibly with such precedents in mind, Gauguin developed more or less the same idea in several works predating *Nirvana*. For example, in his *Les Miserables* self portrait painted for Vincent van Gogh (Fig. 157) Gauguin posed himself in front of floral pattern wallpaper. Explaining to van Gogh how the red touches he used to render his face are symbolic of "the volcanic flames that animate the soul of the artist," Gauguin added, "The line of the eyes and nose, reminiscent of the flowers in a Persian carpet, epitomize the idea of an abstract symbolic style. The girlish background, with its childlike flowers is there to attest to our artistic purity."[11] Only months after fleeing Arles to escape van Gogh's frightening self-hatred, Gauguin created possibly the most remarkable of all his self portraits, a ceramic drinking cup in the form of his own head, eyes closed (Fig. 184). The rivulets of red glaze on this head suggest a martyr's blood, or lava overflowing from the artist's head exploding with imaginative thought. Gauguin used this head as a prop for an 1889 still-life painting (Fig. 183), filling it like a vase with wildflowers, thus portraying both himself and the floral emblem for his pure artist's thoughts.

182. Paul Gauguin, *The Vision after the Sermon*, 1888, oil on canvas, 28 ¾ × 36 ¼ in. (73 × 92 cm). National Gallery of Scotland, Edinburgh

183. Paul Gauguin, *Still Life with Japanese Print*, 1889, oil on canvas, 28 ½ × 36 ¼ in. (73 × 92 cm). Museum of Modern and Contemporary Art, Teheran, Iran

184. Paul Gauguin, *Jug in the Form of a Head, Self Portrait*, 1889, stoneware glazed in green, grey and red, h. 7 ⅝ in., (19.3 cm). Kunstindustrimuseet, Copenhagen.

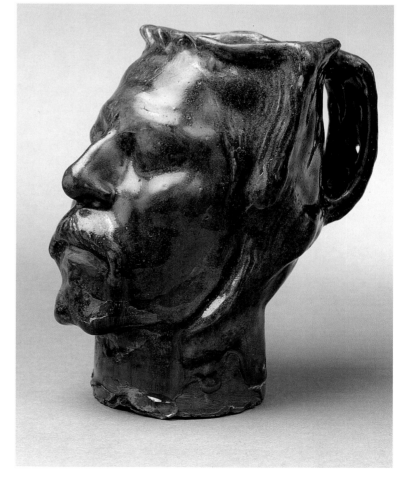

Gauguin's determination to find ways to express how, and where, to show internal mental states in art is most completely documented with respect to *The Vision After the Sermon* (Fig. 182). This painting shows a priest and his congregation of bonneted Breton women, all with eyes closed in prayer, their heads turned towards the intense vermillion background where Gauguin has included an apparition of the Biblical event of Jacob wrestling with an angel. Writing to van Gogh, Gauguin explained, "For myself, the landscape in this picture and the struggle only exist in the imagination

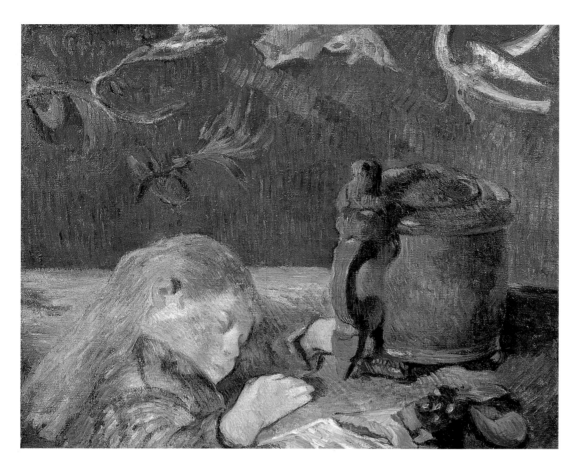

185. Paul Gauguin, *Sleeping Child*, 1884, oil on canvas, 18 × 21 ⅝ in. (46 × 55.5 cm). Private collection.

186. Paul Gauguin, *Sleeping Boy (The Little Dreamer)*, 1881, oil on canvas, 23 ¼ × 28 ⅝ in. (59.5 × 73.5 cm). The Ordrupgaard Collection, Copenhagen

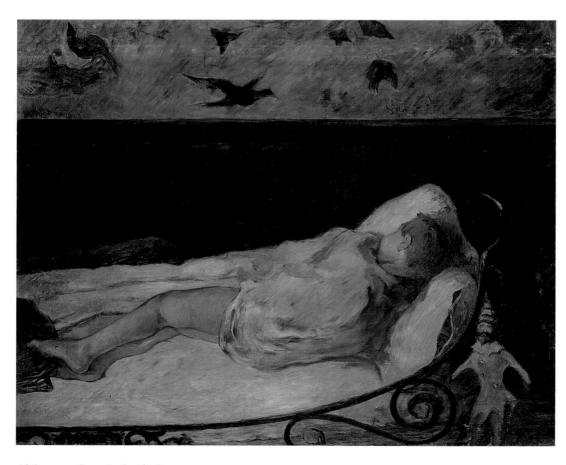

187. Paul Gauguin, *The White River*, 1888, oil on canvas, 22 ⅞ × 28 ⅜ in. (58 × 72 cm). Musée de Grenoble

of the people praying…it is why there is a contrast between the natural people and the non-natural, out of proportion struggle in its landscape."[12] The halo and apples hanging off a branch silhouetted against the same sort of saturated vermilion background in *Self Portrait with Halo* (Fig. 147) should probably be understood in a similar manner, that is, as internal imaginings of the foreground figure, namely Gauguin. Since Gauguin holds a little snake in this self portrait, it has a special conceptual relationship of some sort with *Nirvana*, in which de Haan holds the same attribute.

These works from 1888 and 1889 demonstrate how, for Gauguin, the background need not merely represent where the body is, but can also represent where the mind is, how the areas generally put to the service of external background locales can just as well represent internal realms. The earliest evidence of Gauguin's concern for the externalized visualization of thought is

a genre scene of a sleeping child painted in 1881, for which his four-year-old daughter posed (Fig. 185). While it represents the external locale as a conventional background, the japoniste wallpaper with bird motifs evokes fairy tales, prompting curiosity about what may be on the child's dreaming mind. During his Impressionist years Gauguin returned to the sleeping child theme on several occasions, and in one of these paintings (Fig. 186) a wallpaper decorated with birds in flight similarly makes for a background suggestive of dreams with the power to transport the imagination. In these works, although the background is a factual representation of the external world, it clearly has the capacity to symbolize how the sleeping children in the foreground are temporarily liberated from strict Impressionist adherence to sensory data.

In Brittany in 1888 Gauguin returned to depictions of children

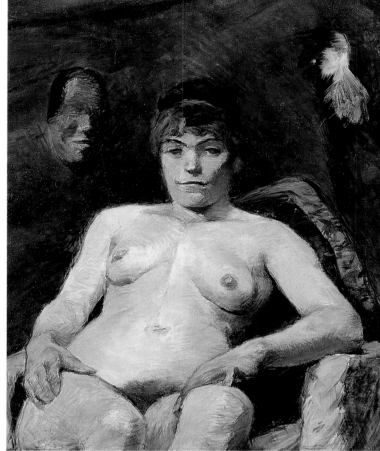

188. Paul Gauguin, *Portrait of Stéphane Mallarmé*, 1891, etching, 5 ³/₈ × 5 in. (13.6 × 12.7 cm). Davison Art Center, Wesleyan University. *Exhibition no. 32*

189. Toulouse Lautrec, *Fat Maria, Venus of Montmarte*, 1884, oil on canvas, 31 ³/₄ × 25 ⁵/₈ in. (80.5 × 65 cm). Von der Heydt-Museum, Wuppertal

heretical to Impressionist dogma, for now he stressed how visual sensory data can stimulate internal emotional reactions. For example, the *Still Life with Fruit* (Pushkin Museum, Moscow), given by Gauguin to his painter friend Charles Laval, includes the face of a little girl observing a fruit-laden tabletop as if to indicate how her internal appetite obviously interferes with her potential to observe in objective Impressionist fashion. For this painting Gauguin reversed the usual figure–ground relationship, placing the girl behind the tabletop. Without resorting to this sort of compositional inversion, Gauguin made much the same sort of point about how desire can internalize external observations in *The White River* (Fig. 187). This work represents a boy in the foreground, preoccupied with his observations of the background scene of bathing adolescent boys, as if eager for initiation into their more adult world. Had Gauguin turned the boy around to face out of the composition, the background here would seem to emanate from his head no differently than from the way the bathing women in the background of *Nirvana* preoccupy the figure of de Haan.

Back in Paris in late 1890, to prepare for his departure for Tahiti in April 1891, Gauguin became obsessed with a new way to signal how the backgrounds in his work deserved consideration as more

than external fact. Referring ultimately to such "gothick" images of dream experience as the white horse in Johann Heinrich Fuseli's *Nightmare* (1781) and the bats in Francisco de Goya's *Capricho 43 (The Sleep of Reason Produces Monsters*, 1799), as well as to creatures in quite recent works by his friend, Odilon Redon, Gauguin now added mysterious animals at the shoulders of figures in his pictures, seemingly to suggest that the figure's internal thoughts were haunted by illogical, even immoral counsel. The most obvious examples are the large painting that Gauguin entitled *The Loss of Virginity* (Fig. 86, detail Fig. 173), and a portrait etching of the great writer Stéphane Mallarmé (Fig. 188). In the painting a stiffly naked female with her legs held tightly together reclines corpse-like on the ground while faraway a procession of villagers approaches her on a road through an unearthly reddish seaside landscape. Whatever meaning Gauguin intended to convey continues to elude viewers, but the mystery of this image resides primarily in the artist's disregard for figure–ground conventions. Put another way, since the figure seems out of place in her pictorial whereabouts, a viewer is obliged to wonder whether the pictorial background indicates reality or instead indicates an emanation of the figure's thoughts under the influence of the fox at her shoulder – uncer-

190. Odilon Redon, *A Large Bird that Descends from the Sky Hurls itself on top of her Hair*, 1888, lithograph illustrating Flaubert's *La Tentation de Saint Anthoine*. Private collection.

191. Paul Gauguin, *Te Nave Nave Fenua (The Delightful Land)*, 1892, oil on canvas, 35 ½ × 28 in. (91 × 72 cm). Ohara Museum of Art, Kurashiki, Japan

192. Paul Gauguin, *Head of a Tahitian Woman*, c. 1892, polychromed wood with stain and gilding, 9 ¾ × 7 ¾ in. (25 × 20 cm). Musée d'Orsay, Paris

193. Paul Gauguin, *Female Nude* (verso of Fig. 192)

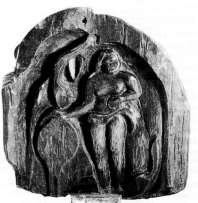

tainties related to the odd discontinuities in the normal figure–ground matrix. The portrait of Mallarmé, with its faun-like pointed ear, is simple to comprehend: the bird on his shoulder is a reference to Mallarmé's translation of Edgar Allan Poe's poems, including "The Raven."

There are surprisingly few contemporary images related to Gauguin's ambition to visualize the mental visions of figures he represents. Among these, the most extraordinary is Toulouse-Lautrec's disquieting full-frontal "portrait" in the nude of the model, Suzanne Valadon (Fig. 189). Valadon appears regally unperturbed, as some dark non-Western mask hanging on the background wall appears capable of whispering powerful secrets into her ear. Gauguin would seem to be recalling this strange image by Lautrec in a transfer drawing made around 1899 of a bare-chested Polynesian model adjacent to a horned male idol head that Gauguin had sculpted during his final sejourn in the South Seas. Lautrec and Redon were among those artists whose interest in figures visited by spirits stemmed from the enormous popularity of Jules Bastien-Lepage's 1879 painting, *Joan of Arc*, (Fig. 130), in which the heroine listens to the apparition of a warrior angel at her back. One of the plates in Redon's first series of lithographs for Flaubert's *Temptation of Saint Anthony* published in 1888, provides a particularly close model for many of Gauguin's characters transported by inner vision (Fig. 190). It shows the head and shoulders of an exotically costumed woman, whose awareness of the bird

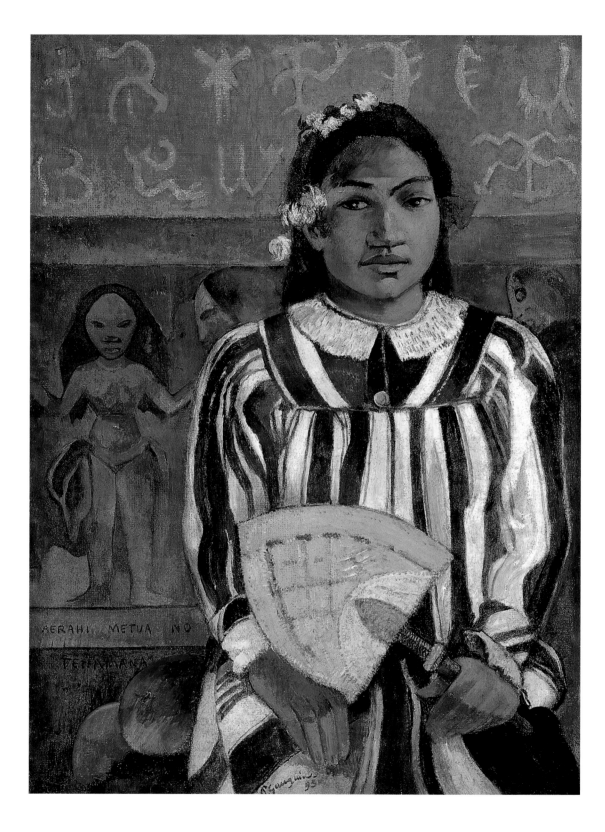

194. Paul Gauguin, *Merahi Metua no Tehamana (Ancestors of Tehemana)*, 1893, oil on canvas, 29 ⅝ × 20 ¼ in. (76 × 52.3 cm). The Art Institute of Chicago, Gift of Mr. and Mrs. Charles Deering McCormick

hovering at her back has nothing to do with her wide-open eyes. The Redon image appears to be a direct source for Gauguin's standing full-frontal nude, *Te nave nave fenua (The Delightful Land)* (Fig. 191). She plucks an exotic flower, while a fantastic lizard with vermilion wings hovers by her shoulder. In this work the background may easily be understood to represent the external reality of her Tahitian environment, rather than as some manifestation of the magical thoughts inspired by the lizard. But a sculpted wooden portrait head of the same model (Musée d'Orsay, Paris) is probably Gauguin's most literal solution to his quest to see a person's internalized thoughts (Figs. 192, 193). While slightly idealized, the woman's face is carefully and realistically carved in the round. But

Gauguin oddly chose not to render the back of her head at all, as if he conceived this sculpture as a face in very high relief. Roughly hewn, the back of the sculpture comes as a surprise, since there Gauguin included a miniature version of *Te nave nave fenua* (minus the winged lizard) in low relief, crudely rendered, as if to suggest a different kind of reality than the finely finished face on the "recto" of this sculpture. The two "sides" taken together suggest that Gauguin intended his cut through this head to reveal, as in cross-section, an internal image of self consideration.[12] Apparently Gauguin revisited this same idea back in France in the mid-1890s when he fashioned a vase as a head, on one side of which a low-relief scene with a horse may similarly be intended as a cross-section illustration of thoughts inside the head.[13] No matter how startling, these overtly diagrammatic and literal attempts to visualize thought pale in comparison to his painted portrait of his favorite Tahitian model, Tehamana (Fig. 194). Inscribed "Merahi metua no Tehamana" (The Many Ancestors of Tehamana), this painting shows the young Tahitian wearing a European-style missionary dress, while in the background Gauguin has included an ancient Polynesian mythological relief and two rows of large glyphs in the style of Easter Island text fragments no longer capable of decipherment. These glyphs did not exist in late nineteenth-century Tahiti, but they eloquently represent Tehamana's inexpressible inner secrets of race and gender, or what Gauguin, the modern Western male, would "see" when he tried to look inside her mind.

More than any other early modern artist, Gauguin experimented with the concept of background as place, inventing dreamscapes and mindscapes that represent the invisible realm of thought as a reality no less potent than visual sense data. But among his close contemporaries and immediate followers Gauguin's attempt to project internal obsessions into pictorial space had strictly limited impact. Beginning in 1895 Edvard Munch seemingly drew upon Gauguin's example for his images of Jealousy, showing a man's anxiety-ridden head adjacent to a background image of his mate's unfaithfulness. And Picasso in his 1901 portrait of the critic Gustave Cocqiot (Fig. 195), likewise may be indebted to *Nirvana*. Just behind Cocquiot's head are apparition-like miniature figures of semi-naked Near-Eastern dancers. The next year Picasso made a drawing of his painter friend Junyer on the beach in Majorca, complete with nude sirens and an antique head with a floral crown (Fig.

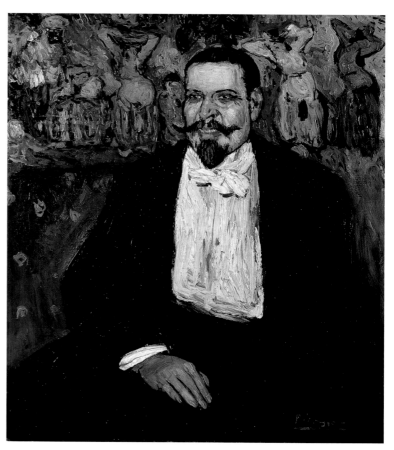

195. Pablo Picasso, *Portrait of Gustave Cocquiot*, 1901, oil on canvas, 39 ⅜ × 31 ½ in. (100 × 80 cm). Musée d'Art Moderne, Centre Georges Pompidou, Paris

172). Gauguin's *Nirvana*, as pointed out by Eric Zafran, was evidently on Picasso's mind. But while Gauguin's idea to represent internal thought as external background in theory opened up a new continent of visual territory for young artists like Picasso, for the most part they left it unexplored. It would eventually take such poetic-minded artists as de Chirico and Chagall to extend Gauguin's subversive treatment of background into a whole new style of art, called surrealism, based on images with inconsistencies, mismatched details and figure–ground relationships to make the mind spin.

STEPHEN KORNHAUSER

A Technical Study of "Nirvana"

Paul Gauguin's unusual picture *Nirvana* has, in the past, presented cataloguers with a notable problem as to its methods and materials of creation. In the earliest publications the medium was identified as gouache.[1] Later this was modified to either oil or essence with gold leaf on silk or linen.[2] Three recent publications have discussed Gauguin's working methods, citing the Atheneum's portrait.[3] In conjunction with the present exhibition, a more detailed examination was recently conducted in an attempt to gain more insight into the artist and his working methods.

DESCRIPTION

Nirvana: Portrait of Meyer de Haan is painted on a finely woven fabric, which has been pulled over a four-millimeter-thick board, measuring 21 × 29 cm, and affixed at the edges with tiny round-headed brass brads placed at equidistant intervals around the tacking edge. Gauguin squared the design area of the fabric in pencil, making it 20.5 × 28.5 cm, slightly smaller than the board dimensions. His working methods are direct and well conceived, laying out the composition in graphite and sometimes fine brush. For the most part, his application of paint is broad, and smoothly laid in, with forms abutting one another, possibly due to the nature of the medium or to his interest in woodblock prints. In some passages he used the bare canvas to define the form. Highlighting and some modeling are achieved with either short vertical strokes or stippling. Where Gauguin attempted to model or change the composition with broader layered areas of color, this was less successful and has caused delaminating of the paint film, especially in the flesh and shirt of the sitter.[4] The outlines of the forms are further emphasized with delicate black or blue lines, at times breaking them up with hatchings of color in much the same way that a coarsely woven fabric would affect a line (Fig. 197).

Gauguin painted in a high-keyed palette, further intensifying the effect by juxtaposing contrasting colors. He played the reds against the greens in the broad areas and contrasted them in the finer hatched areas of the beach figures. He painted with almost pure color, but lightened or softened tones, especially in the background, by adding white. When he used a dark earth tone, for the diagonal rock or the underpaint of the foliage, for example, he applied it as a wash, while the other colors are opaque. He employed a scumble (Fig. 199) to obscure in part the inscribed word "Nirvana," thereby giving it a more mysterious presence.[5] Gauguin applied paint directly to unprimed fabric, which appears to have darkened slightly in areas that were not covered with paint. Only in the subject's flesh and shirt did the artist use a white "priming," either as a means of making corrections or to reflect the intensity of the sitter's flesh. The use of the golden powder in his composition is somewhat unusual.[6] It is used to distinguish the snake (Fig. 196), as well as to impart luminosity to the rocks and texture to the hat. The fact that the metallic powder is beneath the blue of the sitter's coat suggests that the final layer of blue color was added after the metallic powder was applied.

TECHNICAL EXAMINATION

There has been some question about the wood and fabric supports of *Nirvana*, specifically, whether the fabric is linen or cotton. The secondary support over which the fabric is stretched is a laminated

196. (*facing page*) Detail of Fig. 1, showing the signature and the use of metallic powder in the area of the snake.

197. Detail of Fig. 1, showing the hatching technique Gauguin used for some outlines

198. Infrared reflectography of *Nirvana* showing the overpainted word "Touts"

199. Detail of Fig. 1, showing the scumbling over the inscription

alnus alder, a fine-grained wood, native to both northern Europe and the northwest coast of America, used primarily as a utility plywood.[7] It is difficult to ascertain if the board is original to the piece, but there are no secondary nail holes in either the fabric or the board, and the fabric does not show any scalloping along the edges.[8] The fabric is an unusually fine support with a thread count of thirty threads per centimeter in both directions.[9] Thread samples were taken from the support and determined to be un-mercerized cotton that had been sized.[10]

The flat, lean quality of the paint film, ranging from wash to scumble to impasto, can be achieved with both solvent and aqueous paints. Medium samples were studied and found to be gum Arabic. This is the traditional binder for both gouache and watercolor. Presumably *Nirvana* was painted in gouache. No presence of oil was detected in these samples.

Pigment samples were taken from the green water, blue jacket, face of the subject, wave cap, and snake glyph.[11] The greens showed the presence of both arsenic and copper, elements found in emerald green, a pigment synthesized in the early nineteenth century. Although it was considered poisonous, it was still widely used by the impressionist painters because of its vibrancy.[12] It was available in tube, cake and levigated powder form.[13] The blue of the jacket is an artificial ultramarine, known as French blue. It was first synthesized in 1828 and embraced by artists for its intensity as well as its cost.[14] Natural ultramarine, made from the semi-precious mineral lapis lazuli, was more than twenty times as expensive as the artificial version.[15]

The component of the white wave cap is more unusual. It is virtually all lead carbonate. White lead had long been used in both oil and watercolor painting because of its opacity and durability. As a watercolor pigment, it had been superseded by zinc white by the mid-nineteenth century.[16] Although it was known to darken by both artists and manufacturers, it was still available and was sold in cake, pan and tube form as well as in larger quantities called lumps.[17]

Pigments used in the face of Meyer de Haan contain iron and probably reflect the wide tonal range of earth colors available at the time. The white layer beneath was a calcium carbonate unusual in water-based mediums and more traditionally used as a priming layer for oil paintings. The golden serpent (Fig. 196) was also tested. Here, rather than the presence of actual gold, an alloy of copper and zinc or brass was found. Metal powders ground in gum Arabic were available in tube and liquid form.[18]

The technical examination of *Nirvana* in anticipation of the current exhibition employed infrared reflectography (Figs. 198, 201), which revealed notable modifications in the painting's composition. There is graphite underdrawing in the secondary figures creating a more deliberate outline of the figures with minor changes in the angle of the bent arm in the figure on the right. The two figures with their backs to the viewer show Y-shaped under-drawing in the shoulders and nape, possibly a device for placement and symmetry.

The figure of Meyer de Haan has been altered (Figs. 201, 202).[19] The ear, jaw line, and goatee have been reduced, making the head

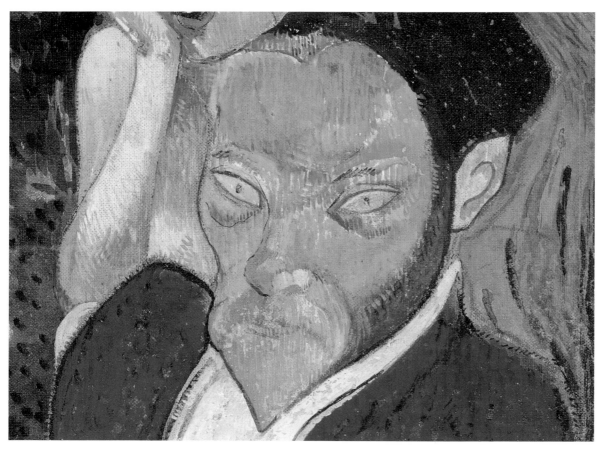

more vertical and the features less exaggerated. The figure's hat has been changed so that it is more abstract as it follows the contour of the figure behind. There also appear to be pencil traces of a rounded eye below the angular left one. Of additional interest is the correction to the sitter's jacket. A more exotic garment lies beneath the present one. It is drawn in both pencil and brush over a brown wash, complete with soft folds, some hatching, and deliberately placed polka dots. The under color is similar to the black rocks, yet the polka dots are smaller and placed more precisely. Gauguin may have intended the sitter to have either a more Eastern appearance or a more amorphous presence in the landscape. The word "Touts" written in graphite in the lower right quadrant of the canvas (Fig. 198) invites additional speculation as to the meaning of the painting.

The x-radiograph (Fig. 200) of *Nirvana* also provided valuable insight into Gauguin's working methods. As was the case with infrared reflectography, the x-radiograph showed no modification of the background figures. The dust-like clusters of particles seen in both the beach figure's hair and the adjacent rock may possibly be either powdered white lead or metallic powder beneath the present surface. Because of their densities, either metal would appear on the radiograph. Of greater significance are the positioning and physiognomy of Meyer de Haan. The x-radiograph shows a more grotesque

image with a protruding forehead, a longer nose and a more rounded ear. In addition to these alterations Gauguin has also inverted the stylized hand. Originally it faced palm out, so that the thumb was at the bottom, rather than at the top as it now appears.

Gauguin appears to have felt more confident in his materials than he did with his imagery. Although he was most masterful when he worked in oils, gouache was an adaptable medium for him. It afforded a smooth satin surface and the ability to work in broad areas of intense opaque color, similar to what he was trying to achieve in his oil painting.[20] Yet, the gouache allowed him to render a small, intimate study of the sitter. The materials were also much less expensive. He struggled with his representation of the sitter. The radiograph provides an insight into Gauguin's initial depiction of Meyer de Haan as even more demonic than the still-unsettling final version. The modifications visible in the infrared reflectogram show the sitter's face to be fuller and somewhat more realistic. What we see now is more stylized. The similarity of pattern in both the rock and the underdrawing of the coat of Meyer de Haan may indicate that Gauguin at one time had intended the sitter to have a metamorphic rather than a corporeal presence. *Nirvana* thus reveals that Gauguin's sense of creative experimentation was constantly in operation, even in such a small and delicate picture as this.

PAUL GAUGUIN 1848–1903
PAINTINGS

1. *Nirvana: Portrait of Meyer de Haan*, 1889–90
 Fig. 1
 Gouache on cotton, 8 ¼ × 11 ⅜ in. (20 × 29 cm)
 Wadsworth Atheneum, The Ella Gallup Sumner and Mary Catlin
 Sumner Collection Fund, 1943.445
 Signed on the hand: *Gauguin*
 Inscribed at lower right: *Nirvâna*
 W. 320

PROVENANCE: Francisco Durrio, Paris; Walter Geiser, Basle: Wildenstein
and Co., London and New York; purchased by the Wadsworth
Atheneum,1943.

2. *Portrait of Meyer de Haan by Lamplight*, 1889
 Fig. 148
 Oil on wood, 31 ⅜ × 20 ⅜ in. (79.6 × 51.7 cm)
 Signed and dated lower right: *P Go 89*
 Private Collection
 W. 317

PROVENANCE: Mlle. Marie Henry, Le Pouldu; Galerie Barbazanges, Paris,
by 1923; Reid and Lefevre, London; Kraushaar, New York by 1926; sold
November 1928 to Mr. and Mrs. Quincy Adam Shaw McKean, Prides
Crossing, Massachusetts; Mrs. Sargent McKean, Beverly, Massachusetts;
Knoedlers and Co., New York until 1958; Private collection, New York.

3. *In the Waves (Ondine)*, 1889
 Fig. 178
 Oil on canvas, 36 ¼ × 28 ¾ in. (92.5 × 72.4 cm)
 Signed and dated at lower center in red: *P. Gauguin 89*
 The Cleveland Museum of Art
 Gift of Mr. and Mrs. William Powell Jones, 1978
 W. 336

PROVENANCE: With Boussod & Valadon, Paris, 1890; Gauguin sale,
February 23, 1891, lot 14; M. Jeanson; Joseph Hessel sold to Gustave
Fayet, Paris, March 1906; sold to Ambroise Vollard, Paris 1907;
Ordrupgaard, Denmark; Galerie Dru, Paris; purchased by Paul Eluard,
Paris, 1923, sale Hôtel Druot, Paris, December 12, 1927, lot 103; Hessel;
Leicester Galleries, London, 1928; sold to Mr. and Mrs. Frank H. Ginn,
Cleveland, 1929; Mr. and Mrs. William Powell Jones, Gates Mills, Ohio.

4. *Bonjour Monsieur Gauguin*, 1889
 Fig. 101
 Oil on canvas mounted on board, 29 ½ × 21 ½ in. (73.6 × 52.8 cm)
 Inscribed at the lower left: *Bonjour M. Gauguin*
 The Armand Hammer Collection
 UCLA at the Armand Hammer Museum of Art and Cultural Center,
 Los Angeles
 W. 321

PROVENANCE: Mlle. Marie Henri, Le Pouldu; Galerie Barbazanges, Paris,
1919; Meyer Goodfriend, New York; sale American Art Galleries, New
York, January 4–5, 1923, lot 107; B. M. Alexander, New York; Howard
Young Galleries, New York, by 1924; Carlton Mitchell, Annapolis;
Count Ivan Podgoursky, San Antonio; Count N. Podgoursky(?), San
Antonio; Mr. and Mrs. Herman Ermolaev, by 1968; Mrs. Mary
Ermolaev, Princeton; sale Christie's, Geneva, November 6, 1969, lot 169;
Dr. Armand Hammer, Los Angeles; to his Foundation by 1988.

A larger slightly different version of this composition is in the
Museum of Modern Art, Prague.

5. *The Ham*, 1889
 Fig. 59
 Oil on canvas, 19 ⅝ × 22 ⅞ in. (50 × 58 cm.)
 Signed at right on the table: *P Go*
 The Phillips Collection, Washington, D.C.
 W. 379

PROVENANCE: Paul Gauguin; Ambroise Vollard, Paris; Reid and Lefevre,
London, 1936; sold to A. Daber, Paris 1936; Etienne Bignou, Paris,
1937; Maurice Cortot, Paris, 1950; Paul Rosenberg and Co., New York,
1951; purchased by The Phillips Collection in 1951.

6. *Young Breton Girl*, 1889
 Fig. 50
 Oil on canvas, 18 ¼ × 15 in. (46 × 38 cm)
 Signed and dated at lower left: *89/P Go.*
 Private Collection
 W. 316

PROVENANCE: A. Denimal; Ambroise Vollard; Wildenstein and Co., New
York; Dr. and Mrs. Max Ascoli, New York, by 1948; sale Christie's, New
York, May 17, 1983, lot 23; sale Sotheby's, New York, November 15,
1989, lot 28.

This is most likely a portrait of Mlle. Denimal.

7. *Portrait of the Painter Louis Roy*, 1889–90
 Fig. 164
 Oil on canvas, 16 × 13 in. (40.5 × 32.5 cm)
 Private Collection, New York
 Courtesy Berry-Hill Galleries
 W.317bis
PROVENANCE: Louis Roy; Olivier Sainsère; Mme. Richer; sale Palais Galliera, Paris, June 18, 1962, lot 34; sale Christie's, London, March 27, 1973, lot 59; Howard Young; Lenoir M. Josey, Inc., by 1986; Private Collection, Houston; Berry-Hill Galleries, New York.

Roy participated with Gauguin, Schuffenecker, and others in the *Exposition de peintures du groupe impressionniste et synthétiste* at the café Volpini in 1889. This portrait from the following year shows Roy in front of a Gauguin ceramic and a poster for the exhibition.

8. *Still Life with Apples, a Pear, and a Ceramic Jug*, 1889
 Fig. 52
 Oil on cradled panel, 11 ¼ × 14 ¼ in. (28.6 × 36.2 cm)
 Fogg Art Museum, Harvard University Art Museums
 Gift of Walter E. Sachs
 W. 405
PROVENANCE: Gustave Fayet, Igny, France, possibly by 1906; purchased from his estate in 1925 by Paul Rosenberg, Paris; Wildenstein and Co., New York; Mr. and Mrs. Walter E. Sachs, New York, by 1929; gift to Harvard, 1958.

9. *The Goose*, c. 1889
 Fig. 105
 Tempera on plaster, 20 ⅞ × 28 ⅜ in. (53 × 72 cm)
 Signed at lower right: *P Go*
 Inscribed: at upper edge: *Maison Marie Henry*
 Musée des Beaux Arts, Quimper
 W. 383
PROVENANCE: At the inn, Buvette de la Plage, of Mlle. Marie Henry, Le Pouldu, until her departure, 1893; Restaurant de la Poste et de la Plage, Le Pouldu, until 1925; purchased by Dr. David M. Levy; exhibited by him at The Fifty-Sixth Street Galleries, New York; to his brother, Isidore Levy, Le Vésinet, in 1977; to his widow, Marie-Josèphe Levy; Marie Sterner Galleries, New York; sale Drouot Montaigne, Paris, May 6, 1999, lot 130.

10. *Still Life with Quimper Pitcher*, 1889
 Fig. 154
 Oil on canvas mounted on board, 13 ½ × 16 ½ in. (34.3 × 42 cm)
 Inscribed at the lower right: *P Go*
 University of California, Berkeley Art Museum
 Anonymous Gift. 1990
 Not in Wildenstein, but accepted by the Wildenstein Institute's Gauguin commission, as confirmed in a letter from Sylvie Crussard of May 25, 1990.
PROVENANCE: Francisco Durrio, Paris; Alfred Pellegrini, Basle ; purchased by Frieda Nadolny in the mid-1920s.

11. *Adam and Eve (Paradise Lost)*, 1889
 Fig. 103
 Oil on canvas, 18 ⅛ × 20 ⅝ in. (46 × 55 cm)

Yale University Art Gallery
 Gift of Mr. and Mrs. Benjamin Bensinger, BA 1928
 W. 390
PROVENANCE: Mlle. Marie Henry, Le Pouldu; Armand Parent, Paris; Stephen Hahn Gallery, New York; purchased in November 1969 by Mr. and Mrs. Benjamin Bensinger; gift to Yale in 1971.

This unusual work has sometimes been attributed to Sérusier, and it is close in technique to paintings by him, such as *The Two Washerwomen in a Landscape* (sold at Christie's New York, May 16, 1990, lot 344). But in the end the painting seems primarily to be by Gauguin, who had in fact seen and incorporated palm trees into other examples of his work that also have rather awkward Biblical figures, such as the *Eve Exotique* (W. 389).

12. *The Valley of Kerzellec, Le Pouldu*, 1890
 Fig. 60
 Oil on canvas, 28 ½ × 35 ⅞ in. (73 × 92 cm)
 Signed and dated at lower right: *P. Gauguin 90*
 National Gallery of Art, Washington, D.C.
 Collection of Mr. and Mrs. Paul Mellon
 W. 398
PROVENANCE: Octave Maus, purchased in 1904 at the *Exposition de la libre esthétique*; Madeleine Maus; Paul Fierens, Brussels; Private collection; Wildenstein and Co., New York; Mr. and Mrs. Paul Mellon.

13. *Kerzellec Farm, Le Pouldu (The Blue Roof)*, 1890
 Fig. 62
 Oil on canvas, 28 × 35 ½ in. (71 × 90.3 cm)
 Signed and dated lower right: *P. Gauguin 90*
 Private collection
 W. 394
PROVENANCE: Ambroise Vollard, until c. 1936; Mr. and Mrs. Emery Reeves, France and Houston, Texas, c. 1950; sale Christie's, New York, May 8, 2000, lot 30.

14. *Still Life with Onions*, 1889–90
 Fig. 51
 Oil on canvas, 16 × 20 ½ in. (40.6 × 52 cm)
 Signed and dated at upper right edge in red: *P. Go 89*
 Judy and Michael Steinhardt, New York
 W. 380
PROVENANCE: Ambroise Vollard, Paris; Jean-Pierre Durand-Matthiesen, Geneva; M. Knoedler and Co., Inc., New York; purchased by Mr. and Mrs. John Loeb, New York, March 1950; sale Christie's, New York, May 12, 1997, lot 121.

Another version – a direct copy – is at the Ny Carlsberg Glyptotek, Copenhagen.

15. *The Loss of Virginity*, 1890–91,
 Fig. 86
 Oil on canvas, 35 × 50 ¾ in. (90 × 130.2 cm.)
 The Chrysler Museum of Art, Norfolk, Va.
 Gift of Walter P. Chrysler, Jr.
 W. 412
PROVENANCE: Gauguin sale Paris, February 18, 1895, lot 42, as "Nu"; pos-

sibly bought in by Gauguin; Comte Antoine de La Rochefoucauld, d. 1948; Comte E. de La Rochefoucauld; sold to Clement Altarriba, Paris; Matthey, Paris, 1949; E. & A. Silbermann Galleries, New York, 1954–5; sold to Walter P. Chrysler, Jr., New York; gift to The Chrysler Museum, Norfolk, 1971.

The recent cleaning of this painting has revealed Gauguin's palette to be even more vivid then previously realized. The stem of the flower extends further from the hand than was visible before, making its intertwining with the crude fingers more serpentine. The flame-like blue grass behind the girl isolates her from the background landscape in a dramatic fashion, suggesting she is a version of the vulnerable Brünhilde. Although first performed in 1870 Wagner's *Die Walküre* was not seen in Paris until 1893, but excerpts from it and the story were certainly known to Gauguin. (See *Wagner et La France*, Bibliothèque nationale, Paris, 1983, pp.159–60, and 171.)

16. *Primitive Tales (Contes barbares)*, 1902
Fig. 168
Oil on canvas, 51 ¾ × 35 ¾ in. (131.5 × 90.5 cm)
Signed and dated at lower right: *Paul/Gauguin/1902/Marquises*
Inscribed at lower right: CONTES BARBARES
Museum Folkwang, Essen, Germany
W. 625
PROVENANCE: Ambroise Vollard; Karl Ernst Osthaus, Hagen, in 1903–4; purchased by the Folkwang Museum, 1922.

GAUGUIN SCULPTURE

17. *Portrait of Meyer de Haan*, 1889
Fig. 98
Carved and painted oak, 23 × 11 ¾ × 9 in. (58.4 × 29.8 × 22.8 cm)
National Gallery of Canada, Ottawa
G. 86
PROVENANCE: Mlle. Marie Henry, Le Pouldu; Ida Cochennec and Léa Lollichon; to the latter's daughter, Mme. Geneviève Millet, Houlgate, Calvados; sale Hôtel Drouot, Paris, June 24, 1959, lot 51; Galerie Otto Wertheimer, Paris, by 1967; Gallerie Les Tourettes, Basle; purchased by the National Gallery, March 1968.

18. *Decorated Cask,* 1889–90
Fig. 79
Carved and painted wood with iron stays, 12 × 12 ½ × 14 in. (30.5 × 31.8 × 35.5 cm)
On loan from the private collection of the Latner Family
G. 84
PROVENANCE: Mme. Marie Henry, Le Pouldu; sale Hôtel Drouot, Paris, March 16, 1959, lot 143; Marlborough Galleries, London.

19. *Martinique Woman, c.* 1889
Fig. 99
Painted terracotta with wooden base, height 7 ¾ in. (20 cm)
The Henry and Rose Pearlman Foundation, Inc.
G. 61
PROVENANCE: Mlle. Marie Henry, Le Pouldu; Galerie Zak, Paris; Henry Pearlman, New York.

Although Gray called the work *Figure of a Martinique Negress*, it is not certain that the subject relates to Martinique

20. *The Swans, c.* 1889–90
Fig. 78
Polychrome wood relief, 7 ¾ × 12 ⅞ in. (19.6 × 32.8 cm)
Private Collection
G. A20
PROVENANCE: Given by Gauguin to the painter Ernest de Chamaillard; Marcel Heskia, Paris; sale Hôtel des Ventes de Brest, December 13, 1981, lot 36.

There is also a bronze version of this subject.

GAUGUIN DRAWINGS, PASTELS, WATERCOLORS

21. *Portrait of Meyer de Haan*, 1889
Fig. 149
Watercolor over pencil on paper, 6 ⅜ × 4 ½ in. (16.4 × 11.5 cm)
The Museum of Modern Art, New York
Gift of Arthur G. Altschul
PROVENANCE: M. J. Hardy; Jacques Dubourg, Paris; purchased by Arthur G. Altschul, July 1959; gift to the Museum of Modern Art, 1976.

22. *Self Portrait, c.* 1889–90
Fig. 37
Charcoal on paper, 12 ⅛ × 7 ⅞ in. (29 × 19 cm)
Musée d'Art Moderne et Contemporain, Strasbourg
Stamped with the estate stamp at the lower right
PROVENANCE: Schuffenecker collection, Paris; M. Comte, Strasbourg, by 1921; purchased by the museum in 1921.

23. *The Black Rocks*, 1889
Fig. 10
Gouache and watercolor with ink and metallic paint on paper, 10 × 16 in. (25.3 × 40.6 cm)
Signed at lower left: *P Go*
Private Collection
PROVENANCE: Sir Michael Sadler, London, before 1944; Leicester Galleries, London; Robert L. Stolper, London, 1971; Private collection, New York; Barbara Divver, New York, by 1990.

24. *The Breton Eve*, 1888–9
Fig. 17
Pastel on paper, 21 × 11 in. (53.3 × 28 cm)
Signed at lower right: *P. Gauguin*
New Orleans Museum of Art
Promised and partial gift of Mrs. John N. Weinstock in memory of Mr. and Mrs. B. Bernard Kreisler
W. 334
PROVENANCE: Jacques Tasset, Montmorency; Mr. and Mrs. B. Bernard Kreisler until 1976; Mrs. John N. Weinstock.

GAUGUIN PRINTS

25. *At the Black Rocks*, 1889
 Fig. 22
 Linecut reproduction of a drawing used for the frontispiece of the
 Volpini exhibition catalogue, 3 ¼ × 6 ¾ in. (7.9 × 17 cm)
 The Cleveland Museum of Art
 Purchased by income from the Dudley P. Allen Fund, 1925

26. *Leda (Design for a China Plate)*, 1889
 Zincograph on yellow paper, sheet 17 ¼ × 21 ⅝ in. (43.8 × 55.1 cm)
 Sterling and Francine Clark Art Institute, Williamstown
 Nos. 26 – 32 are K.1–4, 8 and 11, all formerly in the collection of Dr.
 Herbert Leon Michel, Chicago; purchased by the Clark Art Institute
 in 1962.

27. *Human Misery*, 1889
 Fig. 160
 Zincograph on yellow paper, sheet 17 ¼ × 21 ¾ in. (43.8 × 55.1 cm)
 Sterling and Francine Clark Art Institute, Williamstown

28. *Breton Women Standing by a Gate*, 1889
 Zincograph on yellow paper, sheet 17 ¼ × 21 ⅝ in. (43.8 × 54.9 cm)
 Sterling and Francine Clark Art Institute, Williamstown

29. *Dramas of the Sea: Brittany*, 1889
 Fig. 20
 Zincograph on yellow paper, sheet 17 ¼ × 21 ⅜ in. (43.8 × 54.3 cm)
 Sterling and Francine Clark Art Institute, Williamstown

30. *Dramas of the Sea: A Descent into the Maelstrom*, 1889
 Fig. 19
 Zincograph on yellow paper, sheet 21 ⅜ × 17 ¼ in. (54.3 × 43.8 cm)
 Sterling and Francine Clark Art Institute, Williamstown

31. *Breton Bathers*, 1889
 Fig. 18
 Zincograph on yellow paper, sheet 17 ¼ × 21 ½ in. (43.8 × 54.8 cm)
 Sterling and Francine Clark Art Institute, Williamstown

32. *Portrait of Stéphane Mallarmé*, 1891
 Fig. 188
 Etching on paper, 5 ⅜ × 5 in. (13.6 × 12.7 cm)
 Davison Art Center, Wesleyan University.
 K. 12 IIB
 PROVENANCE: George Davison.

33. *Be In Love*, 1898
 Woodcut on paper, 6 ⅜ × 10 ⅞ in. (16.3 × 27.8 cm)
 Inscribed number *24*
 The Baltimore Museum of Art Print Fund
 K. 56 IIB
 PROVENANCE: G. D. de Monfreid, Paris; G. Kramer, 1951.

34. *At the Black Rocks*, 1898–9
 Woodcut on paper, 4 × 7 ¼ in. (10.2 × 18.4 cm)
 National Gallery of Art, Washington, D.C.
 Rosenwald Collection, 1952
 K. 52

35. *Human Sorrow*, 1898–9
 Fig. 161
 Woodcut on paper, 7 ⅝ × 11 ½ in. (18.5 × 28.8 cm)
 National Gallery of Art, Washington, D.C.
 Rosenwald Collection, 1943
 K. 49

36. *The Buddha*, 1898–9
 Fig. 153
 Woodcut printed in olive green on Japan paper, 11 ¼ × 8 ½ in.
 (28.5 × 21.8 cm)
 Inscribed in ink with the number *12*
 Collection of Irene and Howard Stein, Atlanta
 K. 45B
 PROVENANCE: H.M. Petiet, Paris.

MEYER DE HAAN 1852–95
PAINTINGS

37. *Self Portrait, c.* 1889–91
 Fig. 150
 Oil on canvas, 12 ¾ × 9 ⅝ in. (32.4 × 24.5 cm)
 Collection of Mr. and Mrs. Arthur G. Altschul, New York
 Jaworska 8
 PROVENANCE: Mlle. Marie Henry, Le Pouldu; her daughter, Mme. Ida
 Cochennec, Rosporden; sale Hôtel Drouot, Paris, June 24, 1959, lot 77;
 Marlborough Fine Art Ltd., London by 1961; acquired by the Altschuls
 July 1961.

38. *Still Life with Apples and Vase of Flowers, c.* 1890
 Fig. 53
 Oil on canvas, 14 × 11 ⅜ in. (35.2 × 29 cm)
 Signed at lower left: *MH*
 Private Collection
 Jaworska 32
 PROVENANCE: Mlle. Marie Henry, Le Pouldu; Mme. Ida Cochannec,
 Rosporden; Mme. M. Léa Ollichon, Toulouse; sale Hôtel Drouot, Paris,
 March 16, 1959, lot 166.

39. *Vase of Lilacs and Snowballs with Lemons, c.* 1889–90
 Fig. 54
 Oil on canvas, 25 ⅝ × 17 ¾ in. (65 × 45 cm)
 Private Collection
 Jaworska 20
 PROVENANCE: Mlle. Marie Henry, Le Pouldu; Mme. Ida Cochennec,
 Rosporden; sale Hôtel Drouot, Paris, June 24, 1959, lot 82; sale
 Sotheby's, London, December 10, 1969, lot 49.

40. *Breton Women Scutching Flax (Labor)*, 1889
Fig. 107
Oil on plaster transferred to canvas, 52 ½ × 79 ¼ in. (133.7 × 202 cm)
Dated at lower left: *Ten Jare 1889*
Inscribed at lower right on the jug: *Labo[r]*
Private collection
Courtesy of Nancy Whyte Fine Arts, New York
Jaworska 7
PROVENANCE: At the inn, Buvette de la Plage, of Mlle. Marie Henry, Le Pouldu; Restaurant de la Poste et de la Plage, until 1925; Abraham Rattner and Isadore Levy; sale Sotheby's, London, July 2, 1969, lot 36; Block; Private collection, Luxembourg; Private collection, San Diego; sale Sotheby's, New York, May 11, 1993, lot 39.

41. *Still Life with Pitcher and Onions*, 1889–90
Fig. 106
Oil on canvas mounted on wood, 11 ¾ × 11 ¾ in. (30 × 30 cm)
Initialed at the upper right in red: *M. H.*
Musée des Beaux Arts, Quimper
Jaworska 23
PROVENANCE: Mlle Marie Henry, Le Pouldu; Mme. Ida Cochennec, Rosporden; sale Hôtel Drouot, Paris, March 16, 1959, lot 165; purchased by the French government; deposited by the Musée d'Orsay at the Musée des Beaux-Arts de Quimper in 1960.

42. *The Valley of Kerzellec, Le Pouldu*, 1889–90
Fig. 61
Oil on canvas, 23 × 28 ½ in. (58.5 × 71.1 cm)
Signed at the lower right: *Meyer de Haan*
Private collection, courtesy of Galerie Hopkins, Thomas, Custot, Paris
Jaworska 17
PROVENANCE: Mlle Marie Henry, Le Pouldu; to her daughter Mme Ida Cochennec, Rosporden; sale Hôtel Drouot, Paris, March 16, 1959, lot 162; Mr. and Mrs. Arthur Altschul, New York until 2000; Private collection.

PAUL SÉRUSIER 1864–1927
PAINTINGS
43. *Landscape at Le Pouldu*, 1890
Fig. 68
Oil on canvas, 29 ¼ × 36 ¼ in. (74.3 × 92.1 cm)
Signed and dated at the lower right: *P. Sérusier 1890*
Museum of Fine Arts, Houston
Gift of Alice C. Simkins in memory of Alice Nicholson Hanszen
Guicheteau I, no. 29
PROVENANCE: Private collection, Switzerland; sale Arthur Tooth & Sons, London 1966, to Alice N. Hanszen, Houston; by descent to Alice C. Simkins, San Antonio, 1977; to the Museum of Fine Arts, Houston, 1979.

44. *Seaweed Gatherer*, 1890
Fig. 71
Oil on canvas, 18 ⅛ × 21 ⅝ in. (46 × 55 cm)
Initialed at lower left corner: *P.S.*
Indianapolis Museum of Art
Samuel Josefowitz Collection of the School of Pont Aven
Through the generosity of Lilly Endowment, Inc., the Josefowitz family, Mr. and Mrs. James M. Cornelius, Mr. and Mrs. Leonard J. Betley, Lori and Dan Efroymson and other Friends of the Museum
Guicheteau, I, no. 6
PROVENANCE: The artist; his widow; Mlle. Henriette Boutaric; sale Galerie Charpentier, Paris, March 21, 1955, lot 119; Samuel Josefowitz, Switzerland, by 1963; to the Indianapolis Museum of Art, 1998.

45. *The Little Cowgirl*, c. 1889
Fig. 70
Oil on canvas, 14 ⅝ × 21 ⅛ in. (37 × 53.5 cm)
Private collection
Guicheteau, I, no.157
PROVENANCE: Pierre Bonnard, possibly in 1907; purchased by Mlle. Henriette Boutaric; sold October 1958.

46. *The Gate*, 1890
Fig. 67
Oil on canvas, 19 ⅞ × 24 ⅜ in. (50.5 × 62 cm)
Initialed at the lower left corner: *P.S.*
Musée d'Orsay, Paris
Gift of Mlle. Henriette Boutaric
Guicheteau, I, no. 26
PROVENANCE: The artist; his widow; Mlle. Henriette Boutaric collection; gift to the Musée d'Orsay, 1983

SÉRUSIER DRAWING
47. *Portraits of Gauguin and Laval with Other Sketches*, c. 1888–90
Fig. 47
Charcoal and ink on tan paper, 12 × 18 ⅞ in. (30.5 × 47.9 cm)
With the artists estate stamp at lower left
Collection of Dr. and Mrs. Michael Schlossberg, Atlanta, Ga.
Guicheteau, II, no. 23
PROVENANCE: Marguerite Sérusier; to Mlle. Henriette Boutaric; sale Ader Picard Tajan, Paris, June 20, 1984, lot 392.

In the past the second portrait was mistakenly identified as Ranson.

CHARLES FILIGER 1863–1928
48. *Landscape at Le Pouldu*, c. 1893
Fig. 11
Gouache on paper, 10 ¼ × 15 ⅛ in. (26 × 38.5 cm)
Musée des Beaux Arts, Quimper
PROVENANCE: Mlle. Marie Henry, Le Pouldu; Madame Rocques; Private collection, Paris; Galerie Daniel Malingue, Paris; purchased by the museum in 1984.

EMILE SCHUFFENECKER 1851–1934
49. *Portrait of Meyer de Haan*, c. 1892
Fig. 40
Pastel on paper, 22 ⅜ × 16 ½ in. (57 × 42 cm)
Musée du Petit Palais, Musée d'Art Moderne, Geneva
Grossvogel, no. 339.
PROVENANCE: Mlle. Marie Henry, Le Pouldu; sale Hôtel Drouot, Paris, June 24, 1959, lot 46.

Full references for works cited in shortened form will be found in the List of Abbreviations on p. 171

CHAPTER ONE

Paul Gauguin's Third Visit to Brittany
Bogomila Welsh-Ovcharov

1. See Washington, 1988, cat. no. 7.

2. See Cogniat and Rewald, 1962, p. 57. In his sketchbook dated to 1884–5 (Nationalmuseum, Stockholm) Gauguin's pen and ink essay entitled "Notes synthétiques" anticipated some of the principle ideas with which his symbolist art would be associated by 1889. He wrote: "Painting is the most beautiful of arts…Like music it acts as an intermediary of the senses, harmonious hues correspond to harmonious sounds." Chassé, 1921, p. 33, related that Gauguin's favorite pastime in Le Pouldu was playing the guitar or mandolin as well as the piano. Furthermore, the author states, p. 56, that according to Sérusier, Gauguin rented a piano from the neighboring town, Lorient, and learned to play it by intuition. His repertoire seems to have been limited to Schumann and Handel.

3. J. Rotonchamp, *Paul Gauguin*, Paris, 1925, p. 71.

4. See Gray, 1963, nos. 81, 82 and 83, who questioned if the animal on the right shoe of the latter pair, could not be a "fox." Rotonchamp, *op. cit.*, p. 71, asserts that Gauguin carved these rustic wooden shoes in Le Pouldu in 1889 and wore them the following winter in Paris.

5. Merlhès, 1984, no. 141, letter dated to about the fourth week of February or March 1, 1888.

6. Accompanied by Charles Laval, Gauguin left for Panama from Saint-Nazaire on April 10, see Merlhès, 1984, no. 122.

7. Washington, 1988, cat. no. 99, argues for a date of January 1890 and that the canvas was painted in Paris. See Pickvance, 1998, p. 17 and cat. no. 65 who supports the generally accepted conclusion that the painting was completed in Le Pouldu in the latter half of November 1889.

8. See M. Bodelsen, "The Missing Link in Gauguin's Ceramics," *Gazette des Beaux-Arts*, May–June 1959, pp. 329–44. Cf. Welsh-Ovcharov, 1981, pp. 38–9.

9. Cooper 1983, letter no. 36 dated to around October 20, 1889.

10. Throughout Brittany there are prehistoric menhirs and dolmens. These stone monuments, which reputedly held mystical secrets, seem not to have affected Gauguin's art in Le Pouldu. However, in Sérusier's Breton work after 1890 he evoked ancient mysteries connected to such sites in his depiction of the land and its people, see Guicheteau, I, 1976, no. 51 *The Sacred Wood* or *The Incantation,* dated to 1891.

11. Chassé, 1921, p. 25.

12. See Rennes, 1986.

13. Chassé, 1921, p. 28, documented that the Villa Mauduit in Le Pouldu represented a new sense of solitude that both artists required for their creative activities.

14. A. Gide, *Si le grain ne meurt*, Paris, 1929, pp. 244–5, and R. Welsh in this publication, p. 162, note 13.

15. J. M. Cuisenberche, *Gauguin et ses amis peintres – la collection Marie Henry – Buvette de la plage – Le Pouldu en Bretagne*, exh. cat. 1992, Yokahama, p. 176.

16. See R. Guyot and A. Laffay, "Au Pouldu: Sur les traces de Gauguin," *Arts de l'ouest Pont-Aven et ses peintres à propos d'un centenaire*, Rennes, 1986, pp. 201–9, who have given the most complete documentation of Marie Henry's life and the establishment of her inn.

17. See New York, 1987, p. 126, for Chassé's translation of this passage.

18. Chassé, 1921, p. 34.

19. See Paul Sérusier, *ABC de la Peinture Suivie d'une Correspondance Inédite*, eds., Mme. P. Sérusier and H. Boutaric, Paris, 1950, letter from Pont-Aven dated to 1889, pp. 39–41. Cf. R. Welsh, p.162, note 16, who dates it to September 27 or 29, 1889. Cf. Guicheteau, I, 1976, p. 24 note 26, who dates the letter to August 1889.

20. See also Wildenstein 329, 340, 341, 346 and 433 for others of Gauguin's depiction of this regional type of young girl.

21. W. Andersen, "Gauguin's Motifs from Le Pouldu – Preliminary Report," *The Burlington Magazine*, September 1970, pp. 615–20, who argued for a summer 1886 stay by Gauguin at Le Pouldu but only indirectly cited three canvases, W205, W206 and W206 bis., as seeming to represent Le Pouldu. By including W286, dated 1888, the author implied that the artist visited Le Pouldu in 1888 as well.

22. Cf. Welsh-Ovcharov, 1981, pp. 180, 181, 196, 198. To this list can be added other motifs identifiable to the region in and along Le Pouldu painted summer 1888. These are W281, W283, W284, W285 and W286. *La Fiancée* (W242) is interesting to consider as a motif probably reflecting the sea along Le Pouldu coastline. Laval as well likely visited, see his *Bathers* (Kunsthalle, Bremen), which depicts the rugged coastline of that area. See Welsh-Ovcharov, 1981, pp. 364–5.

23. Cooper, 1938, Letter XXIII, there published for the first time.

24. See Pickvance, 1998, p. 274, cat. no. 57, who situates *Life and Death* as having been inspired by a "memory image" of the black rocks at Le Pouldu. This canvas, as well as *Woman in the Waves* and *The Breton Eve* W336, are considered to have been painted in Paris before Gauguin's departure for Brittany in June.

25. *Dramas of the Sea: Brittany* (Guérin no. 7) and *Dramas of the Sea: Descent into the Maelstrom* (Guérin no. 8).

26. Rewald, 1956, n. 10, p. 311, first ascribed a winter stay for Gauguin by re-dating to "Pont-Aven, March 1889" an undated letter sent to Emile Schuffenecker from Pont-Aven. Cf. Malingue, 1946, letter LXXVII, pp. 152–3, ascribed erroneously by the latter to "Arles, December 1888." Scholars have continued to follow this deduction of a winter trip to Brittany in Gauguin's chronology. Cf. Welsh-Ovcharov, 1981, p. 170:

Gauguin was in Paris until May, letter LXXVII was there re-dated to the spring of 1889 from Pont-Aven; thus the author also assumed a trip back to Paris before Gauguin's return to Brittany in early June. Cf. Washington, 1988, cat. no. 47, Cooper, 1983, p. 257, no. 3, Jirat-Wasiutynski and Newton, 2000, p. 157 and pp. 242–3, no. 3, all of whom deduced a spring trip to Brittany by the artist.

27. See Rewald, *op. cit.*, p. 280 and note 9, p. 311, who relied on Emile Bernard's account for Gauguin's personal participation in helping to transport the canvases to the Volpini café published in *L'Orient*, n.d. (1939?), pp. 14–15.

28. Pickvance, 1999, p. 20.

29. See Rewald, 1956, p. 280. Cf. Cooper, 1983, letter 14.1, dated to July 1, 1889. Gauguin wrote Theo: "I am coming back to our exhibition… But if I had been there the whole would have been arranged more simply."

30. The artist's sketchbook (coll. The Israel Museum), dated to Arles/Brittany 1888–9, p. 85, reveals that Gauguin may have considered a preliminary satirical title for the exhibition. He jotted in pencil the words: "Indépendents (in cartouche) vivre alphabétique – Groupes sympatiques – Paris," the latter word "sympatiques" being an obvious pun on the word synthétique.

31. Cf. Malingue, 1946, letter LXXVII, who first ascribed the letter as "undated letter, Arles, December 1888." Cf. Rewald, 1956, note 10, p. 311, who assigned the letter to Pont-Aven, March 1889. See Merlhès, 1995, p. 26, who has re-dated the letter to the first days of June 1889 and concluded that Gauguin did not see the Volpini exhibition, p. 28. This fact is confirmed by Gauguin's letter to Theo "If I had been there [Volpini exhibition] the whole thing would have been arranged more simply," Cooper, 1983, letter 14.2, dated to June 1, 1889.

32. See Rewald, 1956, p. 280 and note 9, p. 311, who relied on Emile Bernard's account for Gauguin's personal participation in helping to transport the canvases to the Volpini café, published in *L'Orient*, n.d. (1939?), pp. 14–15.

33. Cf. Welsh-Ovcharov, 1981, pp. 42–6, who discusses the Volpini exhibition and van Gogh's abstention.

34. Cf. Rewald, 1956, p. 279, who does not question why de Haan did not participate. The published Volpini catalogue lists ten works by Laval, five from his Martinique period and five works which reflect his Brittany period.

35. See W. Andersen, "Gauguin and a Peruvian Mummy," *The Burlington Magazine*, April 1967, pp. 238–42, and the same author's book, *Gauguin's Paradise Lost*, New York, 1971, and H. Dorra, "The First Eves in Gauguin's Eden," *Gazette des Beaux-Arts*, 1953, p. 192, who first identified the inclusion of *The Breton Eve* in the Volpini exhibition. Cf. Welsh-Ovcharov, 1981, p. 202.

36. F. Fénéon, "Autre groupe impressioniste" *La Cravache*, July 6, 1889. The critic indicated that a temporary "catalogue manuscrit" could be inspected at the counter of Volpini's café. See Welsh-Ovcharov, 1981, p. 41–3. Cf. Merlhès, 1995, p. 28, where the date of the Volpini exhibition is given as June 8.

37. Merlhès, 1995, p. 30, published and dated the letter to June 30, 1889.

38. See Guérin, Paris, 1980. The artist Paco Durrio, the first owner of Gauguin's *Nirvana*, seems to have had also in his collection two now lost drawings related to *At the Black Rocks*; a watercolor for the single bather *Woman in the Waves*, p. 7, as well as the ink wash with sepia drawing *At the Black Rocks*, p. 24, which served as the basis for the title page of the Volpini catalogue. Guérin assigned both drawings to Gauguin's stay in Brittany in 1889. He considered *At the Black Rocks* (no. 71) a wood cut produced after a memory of the original drawing. Cf. Gray, 1963, p. 43, who identified the print *At the Black Rocks* as a lithograph. R. Field, *Paul Gauguin, The Paintings of the First Voyage to Tahiti*, 1977, fig. 61, identified the work as a "gravure reproduction." An impression (Cabinet des Dessins, Louvre) was pasted by the artist in his manuscript

Noa Noa, p. 186. See New York, 1987, p. 213, for the *At the Black Rocks* found on Gauguin's "Cover of Documents in Tahiti" (1891–2, 1893). Kornfeld, 1988, p. 200, identified the impression *At the Black Rocks* as a linecut. The authors state that linecuts have frequently been considered original woodcuts. This impression was reprinted in *Le Monde Illustré*, August 1899, p. 124.

39. Kornfeld, 1988, p. 201, concluded that the initials 'PGO' on the linecut *At the Black Rocks* were drawn by "someone other than the artist."

40. Cooper, 1983, fragment of a letter to Schuffenecker, no. 13, B. 4, dated to around June 10, 1889.

41. See Jirat-Wasiutynski and Newton, 2000, pp. 138–48, who discuss the new technical examinations of the pastel drawings and their related paintings. The authors argue for a spring 1889 execution for the works, thus situating them as having been completed in Paris. Cf. Welsh-Ovcharov, 1981, p. 104.

42. See Washington, 1988, cat. no. 81 and 83, for a detailed summary of the stylistic origins of the image and its symbolic interpretation. Gray, 1963, no. 75, a work that Gauguin gave to the Countess Denimal who was staying in Le Pouldu in 1889.

43. Cooper, 1983 letter 13, B.4, the fragment is dated to around June 10, 1889. See Malingue, 1946, letter CVIII dated to "Pont-Aven, early July, 1890." Gauguin's letter to Bernard clearly discusses the Volpini exhibition and should be re-dated to Pont-Aven, summer 1889. Gauguin announced to his friend: "Sérusier has just arrived." See R. Welsh for Sérusier's arrival after June, note 12 and Merlhès, 1995, p. 32, who gives a summer date for Sérusier's arrival in Pont-Aven. Cf. Chassé, 1921, p. 22, Sérusier recalled to the writer that during his Volpini exhibition he encountered Gauguin and declared to him: "I am part of your group." Cf. Merlhès, 1995, p. 28, Gauguin did not return to Paris after June 1889 and did not see the Volpini exhibition. See Guicheteau, I, 1976, cat. no. 14, *Nu au Dos*, who dates this drawing to 1890.

44. The date for this self portrait has been disputed in the recent literature. A date of 1888 was proposed on the evidence of the jute canvas employed for the painting which is comparable to that used by Gauguin and van Gogh in Arles during late 1888. See Pickvance, 1998, cat. 43, p. 271, who concluded it was painted in Paris during the first months of 1889 after Gauguin's return from Arles on the same coarse canvas that the artist had brought back from Arles. Cf. Graz, 2000, cat. no. 3, which re-dates this *Self Portrait* to Gauguin's return to Paris 1893–4, and states that it was painted in his studio at rue Vercingétorix. The author considers this *Self Portrait* as a pendant to his later *Self Portrait with Hat* (W506), dated to 1893, based on the similarity between the artist's physical appearance and iconography in both canvases.

45. De Haan seemed to have preferred the Dutch spelling of his middle name "Meijer" as his first name. In 1880 he signed his *Portrait of a Jewish Lady* as "M. I. (Isaäc)," perhaps after his father's name, Isaac Aron de Haan. The artist however was listed as "Meijer" on his birth certificate and he appears to have used his Dutch name "Meijer" for all his letters sent to Theo (coll. Rijksmuseum Vincent van Gogh, Amsterdam), with the exception of two signed "Meyer." During 1884–5 the artist listed his name as "M. J. Meyer (Jacob) de Haan" in the address book of the city of Amsterdam. Gauguin, as well as his acquaintances, seems to have referred to the Dutch artist simply as "de Haan" in his correspondence.

46. New York, 1959, letter 555, October 17, 1888.

47. See Chassé, 1921, 26, and R. Welsh's article in the present catalogue, p. 63, note 18. This confusion may have arisen from Theo van Gogh's recollection to his brother that de Haan had wanted to stay with Pissarro, but there was no room at his house. See New York, 1959, T17, dated September 1889. For an account of de Haan's relation with Theo and Vincent see W. Jaworska, "Jacob Meyer de Haan," *Nederlands Kunsthistorisch Jaarboek*, no. 18, 1967, pp. 197–201.

48. New York, 1959, letter b1039/1962 (collection Rijksmuseum Vincent van Gogh, Amsterdam) from Paris, dated April 1, 1889, in which de Haan informed Theo he had visited the art shop of Julien Tanguy where he had seen a canvas by "Coquin" (sic). De Haan's letter to Theo, b1040/V1962, from Pont-Aven dated April 25, 1889, reports that he had caught the flu during the first four days after his arrival.

49. New York, 1959, letter 555, dated October 17, 1888. Cf. Chassé, p. 54, who states that Gauguin had read a lot and especially reserved first place in his admiration for the Bible, Shakespeare and Balzac.

50. New York, 1959, T1 dated October 19, 1888.

51. See Welsh-Ovcharov, 1981, p. 347, for further works by de Haan that portray subjects related to Jewish practice and history.

52. However, little documentation survives to indicate the extent of the Dutchman's intellectual pursuits. See Chassé, 1921, p. 44, who recounts that in Le Pouldu de Haan's reading of Thomas Carlyle's *Sartor Resartus*, led to religious and metaphysical discussions with Gauguin. The same author, p. 33, noted that the artists in Le Pouldu seemed to have read little, neither books or journals, and that de Haan's Dutch bible, dating from 1639, had been relegated to the attic. An old photograph of de Haan's fresco *Scutching Flax*, reveals that the artist had added a Latin inscription on the lower left "Meyer de Haan fecit" which has evidently been removed during restoration of the work. This inscription along with that of "Ludus pro Vita" indicate de Haan's interest in Latin.

53. New York, 1959, letter b1320/V1962 (Rijksmuseum Vincent van Gogh, Amsterdam) dated October 8, 1890. Cf. Chassé, 1921, p. 54, who states that Gauguin had read a lot and especially reserved first place in his admiration for the Bible, Shakespeare and Balzac.

54. I am grateful to Jelka Kröger, for clarifying de Haan's religion as listed on his birth certificate by the artist's father Isaac Aron.

55. In the 1880s, de Haan's painting was known in Amsterdam by the title *Een moeilijke plaats in den Talmud* (A Difficult Section In The Talmud).

56. Chassé, 1921, pp. 32, 56.

57. The Scottish artist A. S. Hartrick who had met Gauguin in the summer of 1886 in Pont-Aven wrote in his memoir, *A Painter's Pilgrimage*, 1939, that Gauguin was a tall powerful man. The writer Charles Morice recalled in 1919, his first meeting with Gauguin in 1889 in Paris and noted the artist's "bluish eyes," a description also confirmed by Armand Seguin in 1903, see New York, 1987, pp. 100, 128. While Charles Chassé attributed "big green eyes" to the artist, likely based on the information supplied by Marie Henry, see Chassé, 1921, p. 28. However, Gauguin's naval records in 1868 from Cherbourg indicate that the artist had brown eyes, swarthy skin, average nose and measured "un mètre six cents trente," that is approximately 5 foot 3½ inches tall. Andersen, *op. cit.* (note 35), p. 107, stated that de Haan stood five feet tall. However, no known documentation exists to corroborate this fact.

58. Jaworska, *op. cit.,* p. 208, quotes de Haan's daughter, Mme. Marie-Ida Cochennec, as characterizing to the author in 1959 that Gauguin was considered a "bad type" in trying to take advantage of her mother's innocence.

59. See W. Jaworska, *Gauguin and the School of Pont-Aven*, New York, 1971. Andersen, *op. cit.,* p. 107 and pp. 120–1, concluded that Gauguin's interpretations of de Haan's physiognomy as devil–fox were influenced by the artist's jealousy over his pupil's affair with Marie Henry.

60. Merlhès, 1995, p. 30, letter datable to June 10, 1889.

61. See Guicheteau, II, 1989, p. 89, no. 35. The author dated the drawing to 1891 which would have postdated de Haan's and Gauguin's stay in Le Pouldu. Sérusier's drawing, which also includes a study of the maternal group, is to be re-dated to 1889. The artist used this study two years later as the subject for his painting *Les jeunes Mères*, dated 1891, see Guicheteau, I, 1976, no. 50.

62. See R. Welsh, pp. 62–3, who gives the chronology of the arrivals for Gauguin, Sérusier and de Haan in Le Pouldu. Cf. Washington, 1988, p. 47 and cat. no. 93, p. 167, places de Haan and Gauguin working together in Le Pouldu by October 2, 1889.

63. See *Le Chemin*, p. 132, for an illustration of Gauguin's drawing of the infant profile of "Mimi" dated to 1889, which is to be related to the drawing of the child's head in Gauguin's watercolor portrait of de Haan.

64. Chassé, 1921, p. 53, letter from Colin to the author. The family business "De Haan" bread and matzo factory operated from 1830 until the second World War. I am grateful to Fieke Pabst for the above information.

65. Chassé, 1921, p. 26.

66. The drawing was first owned by the Danish artist J. F. Willumsen who has recorded that it was presented to him by the artist. See M. Bodelsen, *Willumsen I Halvfemsernes Paris*, Copenhagen, 1957, p. 65, who documented that Willumsen stayed in Pont-Aven at the Pension Gloanec from some time before June 25 till July 26, 1890, and met Gauguin who was staying in Le Pouldu, only towards the end of his stay when the latter visited Pont-Aven accompanied by Sérusier and de Haan. Willumsen also went to Le Pouldu to see Gauguin. The Danish artist met Gauguin again in Paris in winter 1891 when the latter gave him the wood statuette *Lust*. The identification of the artist O'Conor in the drawing and its date of 1890 remain puzzling. See R. Johnston, "Roderic O'Conor in Brittany," *The Irish Arts Review*, vol. 1, no. 1, spring 1984, p. 17, who documents that O'Conor first met Gauguin in Pont-Aven only in 1894. If Willumsen's Danish annotations are correct it could establish that O'Conor was present in Brittany before 1891. Cf. R. Johnston, *Roderic O'Conor 1870–1940, Catalogue de l'oeuvre gravé*, Musée Pont-Aven, 1999, documents that O'Conor was not in Brittany before 1891. Furthermore, Willumsen's orthographic errors in his annotations on the drawing seem to indicate that he must have had only a nodding acquaintance with both "O' Connor [sic] and de Hahn[sic]."

67. See R. Welsh, p. 67, for this writer's discussion and Washington, 1988, cat. no. 92, pp. 165–7, for Françoise Cachin's thorough account of the symbolism in Gauguin's *Self Portrait*.

68. This drawing is to be placed in context with the artist's *Self Portrait with Yellow Christ* (W324), or as a possible preparatory study for another self portrait. See Rennes, 1986, p. 91, for an illustration of the drawing and reference to Gauguin's depiction of a "third" cyclopian eye above his forehead suggestive of the artist's clairvoyant powers.

69. The pastel remained in Marie Henry's collection. De Haan's summer apparel suggests the likely date of June–early July 1889 when the artist was known to have traveled to Paris and would have met Schuffenecker as well as have seen the Volpini exhibition. See New York, 1959, T12, dated to July 16, 1889, in which Theo informed his brother that de Haan had been in Paris and by this time was back with Gauguin in Brittany. See Jill Grossvogel, exh. cat. *Schuffenecker 1851–1934*, Musée de Pont-Aven, 1997, cat. no. 35.

70. See D. Sutton, exh. cat. *Gauguin and the Pont-Aven Group*, Tate Gallery, London, 1966, no. 123, who identified the brightly colored figure in the background as one of the Japanese prints which was hung by Gauguin in the new studio at the villa Mauduit in Le Pouldu, winter 1889–90. However, it remains unclear if the decorative figure in the background is a Japanese print or not. The colorful shapes reflect the artist's interest in creating a decorative ensemble in his canvas which alludes to rather than represents, actual oriental art.

71. See Malingue, 1946, letter cx, dated to Le Pouldu, August 1890, in which Gauguin describes himself as walking about "like a savage with long hair" and as having cut some arrows to shoot them on the beach just "like Buffalo Bill." Cf. Chassé, 1921, p. 36, who states that after Gauguin's return from Paris in 1890, the artist sported a huge Buffalo Bill felt hat and yellow pointed shoes.

72. See *Le Chemin, op. cit.*, p. 102 where C. Boyle-Turner suggests that the artist lodged not only at "Castel Treaz" (first known as Villa Mauduit) but had also rented often during their stay in Le Pouldu "diverse houses" as studio space. Cf. *Gauguin et ses Amis Peintres—La Collection Marie Henry, op. cit.*, p. 169 where J.-M. Cuisenberche concluded that Mr. Mauduit, the owner of the villa refused to rent his premises to the artists after several weeks. It appears however that the artists continued to rent this studio at least through October, see Malingue *op. cit.*, letter CX, undated "Moelan" October,1889. Cf. Chassé, 1921, p. 28, indicates that the villa Mauduit studio was kept until Spring 1890 when the artists moved their studio to the refurbished wooden shed attached to Marie Henry's inn.

73. See New York, 1959, 599, dated November 6, 1888.

74. New York, 1959, b1039V (Rijksmuseum Vincent van Gogh, Amsterdam), dated April 1, 1889. Apparently by that time de Haan had moved from Theo's apartment. Theo had recently arrived from Amsterdam where he was preparing for his upcoming marriage with Johanna Bonger. De Haan's misspelling of "Sezan" (sic), "Besnard (sic) and "Coquin" (sic), reveals the extent of his knowledge and contact with avant-garde artists at this date. On the reverse of the same letter, his pupil Isaacson also commented on seeing "a Césanne" (sic) and a "Bernard."

75. De Haan's return trip to Paris in summer 1889 was spent at Theo's in the company of Pissarro, see New York, 1959, T12, dated July 16, 1889. There is no record to support the claim that de Haan visited Paris in the spring of 1890. Theo's letter, T29, of March 19, 1890 makes it clear that Gauguin was in Paris without de Haan and one would have expected him to be mentioned in other letters from Theo to van Gogh (T29–39) dated from the first half of 1890 if de Haan had been in Paris.

76. Letter b1041V (Rijksmuseum Vincent van Gogh, Amsterdam), Pont-Aven, May 22, 1889.

77. See Malingue, 1946, letter LXXXIV, dated by the writer to Le Pouldu, August 1889, and Merlhès, 1995, p. 33.

78. Fénéon, *op. cit.,* regarding Gauguin's recently exhibited canvases, especially *Woman in the Waves,* which the writer described as imitating the cloisonist canvases exhibited at the Volpini exhibition by the artist Louis Anquetin.

79. Washington, 1988, p. 47, gives a date in June for the move to the Hôtel Destais. See Welsh pp. 62–3 concerning a stay in August at the Destais.

80. New York, 1958, T12, dated July 16, 1889. Theo informed his brother of de Haan's visit to Paris and indicated that by that day de Haan was "now with Gauguin."

81. See Malingue, 1946, letter LXXXVII, letter to Emile Bernard, dated to early September from Pont-Aven. It seems that de Haan already had it in mind to rent this large house with the studio which was 12 x 15 meters and overlooked the sea. Gauguin hoped that Bernard, along with Charles Laval and Henri Moret, would come to join them to live cheaply as a group, not unlike van Gogh's previous plans of setting up a center for communal artistic living in his Yellow House in Arles.

82. See Malingue, 1946, letter XC, "Moëlan" dated to October 1889.

83. For his dual portraits of de Haan and Gauguin (private collection) Louis Roy represented the Dutch artist wearing a similar type of woolen cap.

84. Gauguin's photo was taken by the painter Boutet de Montval in February 1891 in Paris, shortly after his return from Le Pouldu. The artist had pasted his photo on the back of the menu of the banquet honoring his departure for Tahiti, held at the Café Voltaire at 1 Place de l'Odeon on March 23, 1891. Such decorative Breton shirt fronts seemed to have been popular wear; see S. Keshavjee, "La Parisienne (1890) Un Portrait de Claude Emile Schuffenecker (1851–1934)," *La Revue du Louvre et des Musées de France*, no. 2, 1997, p. 72 and note 5, who discusses

the *Portrait of Mme Champsaur* wearing a costume reflecting the popularity of such Breton motifs in contemporary Parisian dress. Gauguin appears to have continued wearing his Breton vests on his return to Paris in 1893 from the South Seas, as his *Self Portrait* (W506) also indicates.

85. Rewald, 1956, pp. 457–8 and note 31, p. 489, dates the portrait after Gauguin's return from Brittany to the winter of 1890–1. Cf. Washington, 1988, cat. no. 29, p. 75, dates the *Self Portrait* to 1886 in Pont-Aven. See Pickvance, 1998, p. 17 and cat. no. 43, who has proposed that the canvas dates from the artist's last day in Arles in 1888.

86. For an excellent analysis see C. Christensen, "The Painting Materials and Technique of Paul Gauguin," *Conservation Research, Studies in The History of Art, 41, Monograph Series II*, National Gallery of Art, Washington D.C., 1993, pp. 63–103. This author dates Gauguin's *Self Portrait* "no earlier than his 1888 Arles trip." The author notes, however, that the "hatched brush strokes" on the artist's sack cloth paintings in Arles usually lack the small hatched strokes which are to be seen in this *Self Portrait*. The same author states that these small hatches clearly become evident again in Le Pouldu as for example in the coarse canvas used by the artist for his *Bonjour Monsieur Gauguin* (W322) of 1890 (sic 1889).

87. Sérusier, *ABC de la Peinture*, 1950, p. 54.

88. Laval's first *Self Portrait* (Rijksmuseum Vincent van Gogh, Amsterdam) dated 1888 and dedicated to van Gogh was sent as exchange with the artist in Arles (see New York, 1958, letter 562). Laval's second *Self Portrait*, dated 1889, must have been produced after the latter left Brittany in October, a date which Gauguin confirmed in a letter to Bernard stating that Laval has left for Paris, see Malingue, 1946, letter XC, "Le Pouldu, October 1889." See also Malingue, 1946, letter LXXXIX in which Gauguin indicates to Bernard that Laval had "not touched a brush during his six months in Brittany." See Rennes, 1986, no. 2, where Delouche concludes that Gauguin's *Self Portrait*, rededicated to Carrière, is to be dated to 1889–90 and relates the portrait in style and by the use of jute canvas to the *Self Portrait with Woman in the Waves*, a canvas which that writer places as being painted in early 1889 "after a short trip to Brittany." See Merlhès, 1989, p. 30, for Gauguin's drawing representing Laval in 1887, which is interesting to compare to that of Sérusier's portrait.

89. See Rewald, 1956, p. 277, who identified the bearded figure as Paul Ranson; see Guicheteau, II, 1989, p. 87, where the drawing is dated to 1890.

90. Rewald, 1956, pp. 457–8. It seems that Laval's *Self Portrait* from 1889, ended up in Emile Bernard's collection, see Chassé, 1921, illus. p. 80.

91. See Merlhès, 1995, p. 53, Gauguin's letter to Schuffenecker dated to October 25, 1890, reveals nevertheless that the artist was still communicating with Laval and that the latter was at this time attempting to help sell one of Gauguin's canvases. Gauguin calls Laval "an imbecile" for not knowing that Schuffenecker was storing his canvases.

92. Washington, 1988, cat. no. 89, p. 158, gives the date of the portrait as August, since Theo van Gogh confirmed reception of the painting on September 5, 1889. However the documentation suggests that Gauguin remained that month with de Haan at Le Pouldu. Cf. Chassé, 1921, p. 24, who quoted Mme Satre that her portrait was done prior to Gauguin's departure for Le Pouldu. She is represented wearing her wedding dress (information communicated to Robert Welsh and the present writer by the descendants of Madame Satre, Pont-Aven, 1971). See Graz, 2000, p. 159, for a photograph of this type of Pont-Aven costume.

93. Merlhès, 1995, p. 35 has identified the sitter who had puzzled scholars for years. Apparently the misspelling of her name as "de Nimal," has prevented previous writers from identifying the family. Her young daughter was evidently an amateur artist. Gauguin presented the countess with his wood relief *Les Ondines* (Fig. 26), and also dedicated a *Still*

Life (W378) to the young Denimal, inscribed "A la comtesse de N. Miss 89." The artist added a small dog to the dedication probably alluding to the pet that appears again in the *Still Life* and must have belonged to her. A drawing of the dog is found in the artist's sketchbook (coll. The Israel Museum, Fig. 166). The *Still Life* was probably painted in the Villa Mauduit studio along with W404 which depicts the same iron chair. Cf. Pickvance, 1994, who identified the sitter as a local girl Madeleine Delorme, who according to Chassé had posed once for Gauguin in Le Pouldu.

94. Cooper, 1983, letter 37.2, dated to circa November 8, 1889.

95. Malingue, "Du Nouveau sur Gauguin," *L'Oeil*, 38, July–August, 1959. The writer identified the round gouaches as tablemats. However it is more likely that the artist conceived them as referencing to his own reinterpretation of Quimper plates. One of these plate-like gouaches, formerly in Marie Henry's inn, sold Hôtel Drouot, March 16, 1959, lot 106, identified as by Gauguin, suggests both in its style and by the inclusion in the background of some Dutch windmills that it may actually have been painted by de Haan.

96. See R. Welsh, p. 64 and note 29. Cf. Jirat-Wasiutynski and Newton, 2000, p. 251 and note 42, who suggest that the inscription "ludus pro vita," may have been a reminiscence of Puvis de Chavannes' mural at Amiens, *Ludus pro Patria*. The artist's inclusion of the fleur-de-lis symbol, in conjunction with "Ludus pro Vita," may have extended its meaning beyond the etymological reference to suggest an ironic twist on the motto "Ludus pro Patria" which to the younger generation of the 1880s represented a political motto of France; as a message of "fight for the Fatherland," a cry of unanimity against the present divided political views in Paris.

97. Gauguin decorated ordinary Breton pottery with motifs, see *Le Chemin, op. cit.*, p. 120. The artist had placed another "biberon" ceramic in his *Still Life* dated "86" (W208) inscribed "Pension Glouanec," as well as in his canvas (W209), a work rejected by D. Cooper and accepted and re-dated by M. Bodelsen to the artist's 1888 stay in Pont-Aven. A *Still Life* (National Gallery of Canada), uncatalogued by Wildenstein, but included in Bodelsen's revised lists as attributed to Gauguin also includes the "biberon" and is dated to "circa 1889."

98. See Wildenstein W375, a *Still Life* which includes a Japanese print as well as his portrait jug. This *Still Life* must have been painted in the artist's studio in Pont-Aven sometime in late June–July after Gauguin had received his jug portrait which he requested to be sent by Schuffenecker to Pont-Aven. See Merlhès, 1995, p. 30, for the letter dated to June 10, 1889. See Malingue, 1946, letter xc, dated to "Pouldu, October 1889," in which Gauguin informs Bernard that his enormous studio is decorated with their respective Volpini prints as well as Japanese prints.

99. See New York, 1959, T28, dated to February 9, 1890.

100. See Welsh-Ovcharov, 1981, p. 355, who attributes this canvas not to Gauguin but to de Haan. This canvas (Ny Carlsberg Glyptotek) did not originate from Marie Henry's collection. See H. Rostrop, *Malerie of Tegninger*, I, Ny Carlsberg Glyptotek, Copenhagen, 1966, p. 50, no. 909, who traced the *Still Life* to the collection of the artist L. Roy. Wildenstein erroneously reproduced this *Still Life* under 380 and lists it as in the collection of the Glyptotek, Copenhagen. However, the catalogue entry documents the original signed and dated *Still Life* (Judy and Michael Steinhardt Collection; Fig. 51) which is reproduced in a color illustration in Pickvance, 1998, cat. no. 62, p. 114. De Haan's *Still Life with Pot and Onions* was sold at the Hôtel Drouot, June 23, 1959, no. 79. Two related versions exist with the same earthenware pot and onions, dedicated to de Haan's brother, one study included green apples in the composition. The latter study was sent by de Haan to Theo and is cited in New York, 1959, T28, dated February 9, 1890.

101. Cooper, 1983, letter 15.2, dated to August 15, 1889. Cf. Merlhès, 1995, p. 33, letter from "beginning of August."

102. Letter b1042 (Rijksmuseum Vincent van Gogh, Amsterdam), "Pouldu, October 22, 1889"

103. Washington, 1988, cat. no. 63, where F. Cachin documents that Degas had recently purchased Manet's *Ham* in June 1888 and that Gauguin must have seen it during his visit to Degas's house in Paris in January and February 1889. Leigh Bullard Weisblat, *The Eye of Duncan Phillips: A Collection in the Making*, New Haven and London, 1999, cat. no. 51, p. 110, also suggest that comparison of Gauguin's *Ham* with de Haan's leads to the conclusion that it must have been painted in Le Pouldu.

104. See Guyot and Laffay, *op. cit.*, p. 203, who confirm that the 30-year-old, unwed mother Marie-Jeanne Henry gave birth to Marie-Léa Henry (Mimi) on February 28, 1889. She was registered by her mother six days later in Clohars-Carnoët on March 4, 1889, cf. Welsh-Ovcharov, 1981, p. 356, Cusinberche, *op. cit.*, pp. 168–9 and Pickvance, 1994, p. 110, who have followed the date on the birth certificate.

105. See Welsh-Ovcharov, 1981, for an analysis of de Haan's two portraits, p. 352 and pp. 356–7.

106. Chassé, 1921, pp. 46–7.

107. Hôtel Drouot sale, June 23, 1959, lot 76, *Maternité*, and lot 78, *Still Life with Profile of Mimi*, revealed that traces had been found which indicated that Gauguin had collaborated in these canvases in the area of the infant's head and also on de Haan's landscape (lot 164) *La Ferme au Pouldu*. See C. Boyle-Turner, *Paul Sérusier*, Ann Arbor, 1983, p. 28, who has also detected Gauguin's hand in Sérusier's *Thatched Cottage with three ponds* in the middle ground of the canvas.

108. Malingue, 1946, letter LXXXIV, "Le Pouldu, August 1889."

109. Cooper, 1983, letter 37.2, dated to November 8, 1889, and letter 17.1, dated to the first days of September, see also note 1 where the writer suggested a series of summer canvases that could have been included in his shipment to Theo. For Theo's disappointment see New York, 1958, T16, dated to September 5, 1889.

110. See V. Jirat-Wasiutynski, "Vincent van Gogh's Magical Conception of Portraiture and Paul Gauguin's *Bonjour Mr. Gauguin*," *RACAR*, vol. 3, no. 1, pp. 65–7. Gauguin also produced a second version (W322).

110. This painting in the collection of the Musée de Pont-Aven has remained unattributed, although both Verkade and de Haan have been mentioned as possible authors (information in conversation with Catherine Puget, July 2000). The provenance in fact, goes back to Marie Henry and documentation reveals that this work was listed as part of de Haan's oeuvre. See Dauchot, *op. cit.*, no. 13. Jaworska, *op. cit.*, pp. 215–26, does not include the canvas in her catalogue of de Haan's work.

111. De Haan's Cézannesque *Landscape with Trees* (collection of the Musée de Pont-Aven) which remained unattributed until recently, is a good example. The provenance of this painting in fact goes back to Marie Henry and documentation reveals that this work was listed as part of de Haan's oeuvre. See Dauchot, *op. cit.*, who identified the work as no. 13. Jaworska, *op. cit.*, pp. 215–26, does not include the canvas in her catalogue of de Haan's work.

112. Sérusier, *ABC de La Peinture, op. cit.*, pp. 42–5, letter to M. Denis dated to "Pouldu" before September 15–17, 1889.

113. De Haan's canvas formerly in Marie Henry's collection. See Dauchot, *op. cit.*, no. 14 and Jaworska, *op. cit.*, no. 11. De Haan apparently had also produced at this period a sketch representing harvesters which has been attributed to Gauguin. See Guicheteau, I, 1976, no. 19, who dates the drawing to 1890.

114. Sérusier, *op. cit.*, pp. 45–7, letter here re-dated to early July 1890. See R. Welsh, p. 62.

115. Guicheteau, II, 1989, no. 12, dates the work to 1889 but the canvas suggests both in style and color a date of 1890, after the artist had seen de Haan's and Gauguin's decoration of the dining room. A further refer-

ence to de Haan's wall painting by Sérusier is found in the artist's placement of a similar earthen jug in his composition next to his figure in *La Grammaire (L'Etude)*, dated *c.* 1892, Guicheteau, cat. no. 71. The literature on Sérusier has had problems in dating with certainty the artist's oeuvre produced during his two summers spent working with Gauguin in Le Pouldu. In fact, the artist's work cannot be dated with any specific certitude since the majority of his works are undated. Given his brief, maximum three-week, stay with Gauguin in the summer of 1889, it is difficult to ascertain whether it would have been possible for Sérusier to have produced in Le Pouldu that summer some of the work which has been dated to this period, as for example Guicheteau, I, 1976, nos. 8 and 9. From this perspective it is also unclear whether Sérusier's canvas *The Gate with Flowers* (Fig. 66) should be dated to 1889 or 1890, since in style and symbolic content it is closer to Gauguin's work of 1890. See C. Boyle-Turner, "Gauguin, Sérusier und de Haan in Le Pouldu," Graz, 2000, p. 94, who discusses and dates Sérusier's *The Gate with Flowers* to 1889–90.

116. Sérusier, *ABC de la Peinture*, 1950, pp. 41–2, the artist's letter from Le Pouldu to Maurice Denis is to be dated summer 1890. The artist states that they had adopted Richard Wagner's credo as their own; and then he proceeds to write it out in full for the benefit of the correspondent.

117. See H. Dorra, "Le Texte 'Wagner' de Gauguin," *Bulletin de la Société de l'histoire de l'art français*, 1984 (1987 published) pp. 281–8. See R. Welsh, p. 63 and note 16 who dates the inscription to summer of 1890. See Armand Seguin, "Paul Gauguin," *L'Occident*, in which the artist revealed that Wagner's inscription had been inscribed in emerald green on the wall of the inn.

118. See V. Merlhès, "Paul Gauguin, A ma fille Aline, ce cahier est dedié," *Société des amis de la bibliothèque d'art et d'archéologie*, Paris, 1980. In 1893 Gauguin transcribed for his daughter Aline a lengthy passage from Wagner's philosophy which covered over three pages of this notebook. Wagner's ideas concerning the call for a harmonious fusion of all arts and a return to an original divine souce parallel Gauguin's and his group's altruistic beliefs. They were intent on following a similar path in order to create a spiritual art unblemished by material consideration, an art which Wagner predicted would glorify the artist and enshroud him in celestial light and perfumes. See Delouche, 1996, p. 94, who published a citation from Wagner as perhaps inscribed in the *livre d'or* of the Hôtel Glouanec in 1894 upon his return to Pont-Aven.

119. New York, 1959, letter 542 to Theo dated to September 24, 1888 and Letter dated March 30, 1888 in which van Gogh compares for his sister Wilhelmien Wagner's musical orchestrations to the effect achieved by certain colors juxtaposed next to each other.

120. Cooper, 1983, letter 36.2, dated around October 20. However, references to the artist's *Seaweed Gatherers* and the decoration of the dining room, works which were undertaken in the winter, suggest that the letter is to be re-dated to sometime in late November–December 1889. Gauguin's reference to his *Seaweed Gatherers* in the same letter as that about the completion of the wall decoration for the inn is especially interesting, since de Haan's composition for *Scutching Flax* included a similar large earthenware vessel to that which figured in his teacher's canvas. For Sérusier's interest in this motif see note 120.

121. Cooper, 1983, letter 37.2, dated *c.* November 8, 1889.

122. Gray, 1963, p. 41 and no. 73, *Les Martiniquaises*. The same author has remarked on the resemblance of the nude figure in *Be In Love* to that of a figure represented on a cane sculpted by Gauguin, no. 81, and once owned by the artist E. de Chamaillard. After Gauguin's return from Martinique he executed at least four wood reliefs which anticipate *Be In Love* both in composition and iconography. Gray dates these works, nos. 71, 72, 73 and 74 to 1888–9.

123. Cooper, 1983, letter 37, 3.4, dated *c.* November 8, 1889.

124. See Gray, 1963, A-20, who identified the fowl on the wood panel as

swans. Geese were however also a favorite motif for Gauguin's ceramics. For the motif of geese in his paintings see Wildenstein, W277, W278. See M. Bodelsen, *Gauguin and van Gogh in Copenhagen in 1893*, Ordrupgaard, Copenhagen, 1984, no. 32, who identified Gauguin's canvas, *Geese* dated 1889, as the canvas published in Wildenstein *Supplément*, January, 1966, as no. 13, fig. 47. This canvas, exhibited in 1893 in Copenhagen, has been identified as depicting not swans but three geese splashing in a lake. This is corroborated by the reflection of a goose girl in the water. In consideration of the above facts, we must re-think Gauguin's symbolic representation for his cover of the Volpini lithographs (Guérin no. 1). This cover, a project for a plate, included a young girl in profile in conjunction with a fowl. If the bird does not represent a swan, but a goose, it is difficult to continue to maintain that Gauguin's design held specific allusions to the myth of Leda and the swan, and if so only from a satirical point of view. Cf. Welsh-Ovcharov, 1981, p. 195.

125. Gray, 1963, no. 84, has suggested that the exotic head of the nude on the barrel is similar to the figure in *Be In Love and You Will Be Happy*, extreme upper left.

126. Gray, 1963, p. 206, indicated that the fowl is roosting on top of de Haan's head. Cf. Andersen, "Review of Christopher Gray, Sculpture and Ceramics of Paul Gauguin," *Art Bulletin*, 46, no. 4, December 1964, p. 583, who described the rooster as in the act of copulation.

127. I am especially grateful to Professor Simone Ackerman, Fordham University and CUNY, for confirmation on this practice and for her many discussions and information on Jewish history. The cock/rooster was also associated with the sun and in occult symbolism by extension with fire. In 1895 the Nabi artist Paul Ranson also included the rooster in his symbolist canvases representing harvest scenes.

128. See J. Zürcher, *Meijer de Haan's Uriel Acosta*, Amsterdam, June 1888, who in his remarks compared de Haan to Carlyle's philosophy. See R. Welsh, note 35.

129. Washington, 1988, p. 169.

130. See R. Welsh, "Sacred Geometry: French Symbolism and Early Abstraction," exh. cat. *The Spiritual in Abstract Painting. 1890–1985*, Los Angeles County Museum, 1986, pp. 63–87, who discusses Gauguin and Sérusier in respect to contemporary mystsical issues and interest concerning Eastern religions in France.

131. Andersen, *op. cit.*, pp. 107–8.

132. See D. W. Druick and Peter Zegers, "Le Kapong et la pagode Gauguin à l'Exposition universelle de 1889," Paris, 1991, pp. 114–15, who identify that this terracotta was inspired by the bas-reliefs in the temples at Angkor Wat, which were seen by Gauguin at the Cambodian pavilion at the Exposition universelle of 1889.

133. The literature on Gauguin proposes a date between late 1890 and early 1891 for *The Loss of Virginity* (Fig. 86), to suggest that the canvas could have been completed either in Le Pouldu or Paris. Rotonchamp (*op. cit.*, p. 81), concluded that it was produced only after Gauguin's return to Paris, in winter 1891 when he had come in contact with symbolist writers. In this case, it may have been that the writer and art critic Octave Mirbeau, who was the first known owner of the chalk drawing which served as study for the painting (Fig. 81), may have received his drawing from the artist that winter in Paris. See Washington, 1988, p. 196 which upheld Rotonchamp's Paris dating for the canvas. However others have concluded that the site for the painting indicates that the artist could have conceived this work in Brittany without need of symbolist stimulus from Parisian theoriticians, see D. Sutton, "La Perte du Pucelage by Gauguin," *Burlington Magazine*, 91, no. 553, April 1949, pp. 301–3, and Andersen, *op. cit.*, 1970, p. 615, who concluded that the painting was completed in Le Pouldu. Cf. Welsh-Ovcharov, *op. cit.*, pp. 224–6 who argues for a winter 1890–91 date in Paris and that the work represents a final résumé of Gauguin's Breton experience.

134. Gray, 1963, pp. 80–1, draws an interesting conclusion that after Gauguin's South Seas sojourn he tended to substitute the lizard for the snake in his symbolist work and that later he replaced the earlier representation of the fox with the fox–wolf symbol. However neither foxes nor wolves are to be found in the South Seas, a fact which may have led the artist to adopt in these works a fox–wolf–dog type. It seems nevertheless, that the artist continued to associate the symbol of this fox–wolf–dog image with sexual allusions in association with young girls, see Gray, 1963, no. 101, *Bust of a Tahitian Girl* dated to 1894 or 1895 where the artist included a double image of this animal resting in the young girl's hair.

135. See K. Varty, *Reynard, Renart, Reinaert and other Foxes in Medieval England. The Iconographic Evidence*, Amsterdam, 1999. The bushy-tailed fox in the twelfth to fourteenth century in France figured as a symbol of the vices; hypocrisy, vanity and gluttony. The animal was sometimes represented in a shorter tailed version in Church decoration as a symbol of the fox-preacher to illustrate early proverbs. By the fourteenth century, the fox's reputation in France had turned the earlier villainous hero into a symbol representing a critical voice in contemporary Church issues. Gauguin, who read the seventeenth-century writer La Fontaine, would also have been familiar with the fables of the Fox and the Rooster which may have stimulated his fantasy to find associations between those animals and his pupil, de Haan. See R. Field, "Paul Gauguin: An Exhibition," *The Print Collector's Newsletter*, vol. XIX, 4, Sept.–Oct., 1988, who included a reference, albeit remote, proposed by Alan Birnholz (*Art International*, 1977) that one can perceive the image of a fox in the configuration of the lioncloth in Gauguin's *Yellow Christ*, W327.

136. See Z. Amishai-Maisels, "A Gauguin Sketchbook: Arles and Brittany," *The Israel Museum News*, April 10, 1975, pp. 195–7. The sketchbook is dated to the artist's Arles and Brittany periods in 1888–9. Gauguin's "fox" drawing, p. 195, indicates that it may be the period when he was acquainted with the Countess Denimal. See Malingue, *op. cit.*, letter no 89, "Le Pouldu, October, 1889" from the second half of 1889, in which Gauguin remarks that the Countess, who was staying Le Pouldu, and who had admired the finished wood relief *Be in Love and You Will be Happy* was planning to intercede on his behalf with her friends including Rouvier, the Minister of Fine Arts, to find a buyer for his carving. In 1899 Gauguin used the same image for a watercolour drawing *Manou nehenehe* as one of a series of eleven humorous menus designed for a feast organized by one of his Tahitian friends (Fig. 167). See R. Rey, *Onze Menus de Paul Gauguin, menus propos*, Geneva, 1950. He used it again for his canvas W602, dated 1902.

137. Amishai-Maisels, *op. cit.*, 1975, p. 73, links Gauguin's *Mystère* to the artist's cartoons appearing in the same sketchbook, pp. 22–4, dating to his Arles period.

138. Andersen, *op. cit.*, p. 108 and fig. 78, p. 309. Jaworska, *op. cit.*, *Gauguin and The School of Pont-Aven*. See Guérin, 1927, no. 12 and nos. 13–14. On his return to Paris in 1891 Gauguin produced a preparatory pen and ink study for his etching of the symbolist poet Stephane Mallarmé (Fig. 188). In this drawing he also included a small sketch of a faun and again transmuted the writer's natural appearance by giving the sitter faun-like ears and pointed features. In this instance, Gauguin's transformations were meant as a tribute to the symbolist writer's well-known poem "L'Après midi d'un faun" published in 1876.

139. Rewald, 1956, p. 450.

140. Gauguin employed the symbolist motif of the closed eyes as early as 1886 in Pont-Aven for his *Portrait of Charles Laval* and again in 1888 for his canvas *Vision after the Sermon*. Washington, 1988, p. 127, compared Redon's theme of the severed head with that by Gauguin, his *Self Portrait* in the form of a ceramic jug, dated 1889 (Gray, 1963, no. 65). These symbolist themes reveal the artist's indebtedness to Redon's art in

reference to mystical associations with Orpheus. In addition, the image of the severed head also became a popular theme in esoteric literature representing spiritual evolution, as for example in Edouard Schuré's *Les Grands Initiés* published in 1889.

141. This print is from Redon's lithographic series *Hommages à Goya* (1885). Examples of Redon's other types of visionary heads appeared in his series *Tentation de Saint-Antoine* (1888), which can be compared to the "hypnotic" features in de Haan's portrait in *Nirvana*. For a description and analysis of this print in the context of Redon's mystical beliefs see F. Leeman, "Redon's Spiritualism and the Rise of Mysticism," exh. cat. *Odilon Redon. Prince of Dreams 1840–1916*, The Art Institute of Chicago, 1991–4, pp. 224–5. See New York, 1987, p. 104, who included Armand Seguin's recollection on Gauguin published in *L'Occident* in 1903, in which the artist recalled that Gauguin and his students at Le Pouldu leafed through Redon's lithographs from the above-mentioned series. There is however no documentation that this material was with Gauguin in Le Pouldu.

142. A. Humbert, *Les Nabis et leur époque*, Geneva, 1954, p. 50.

143. See Z. Amishai-Maisels, *Gauguin's Religious Themes*, New York, 1985, pp. 401–5, who suggested that it was Sérusier who in 1888 helped Gauguin to develop his new religious philosophy. The writer concluded that Gauguin's reading of Balzac's books *Séraphîta* and *Louis Lambert* as well as Schuré's *Les Grands Initiés* was crucial for both artists' esoteric ideas about religion and art. Yet at the same time the author stated that Gauguin's highly personal religious iconography during 1889–90 was influenced by Carlyle and Milton. See R. Welsh, "Sacred Geometry: French Symbolism and Early Abstraction," exh. cat. *The Spiritual in Art. Abstract Painting. 1890–1985*, Los Angeles County Museum, 1986, p. 67, the author states that Gauguin's ideas in 1889–90 may have derived from an interchange of ideas with Sérusier and Schuffenecker. However, he points out that as early as January 14, 1885, Gauguin's letter to Schuffenecker had already alluded to his knowledge of occult ideas in his discussion of the numbers three and seven which derived from his reading of Balzac's Swedenborgian novel *Louis Lambert* rather than on occult readings.

144. Jirat-Wasiutynski and Newton, 2000, p. 158 and p. 247, note 42. Cf. Washington, 1988, p. 167.

145. See J. B. de la Faille, *The Works of Vincent van Gogh. His Paintings and Drawings*, Amsterdam, 1970, F476, and J. Hulsker, *The New Complete Van Gogh – Paintings, Drawings and Sketches*, Amsterdam/Philadelphia, 1996, JH1581. New York, 1958, letter 544a, van Gogh to Gauguin dated to October 3, 1888. Interestingly, in contrast to van Gogh's reference to his image as a Buddhist monk, Gauguin identified himself in his *Self Portrait* dedicated to van Gogh (W239), that summer with Jean Valjean, the outcast hero of Victor Hugo's famous Romantic novel, *Les Misérables*.

146. See Merlhès, 1989, pp. 113–18, who discussed Burnouf's article as having been read by van Gogh by the end of August or beginning of September 1888 and which influenced van Gogh's *Self Portrait* painted between September 9 and 15. The author suggested, p. 192, that Burnouf's article may also have been read by Gauguin.

147. Although Schuré's book makes no mention of the Buddha, this author had already compared the Buddha and Christ in his earlier article "Le Bouddha et sa légende: Une résurrection de Bouddha," *Revue des Deux Mondes*, LXX, July 1, 1885, p. 38, in which the author relates the concept of nirvana to Schopenhauer's pessimistic interpretation as annihilation of the soul. Schuré stated that the doctrine of nirvana is only perceivable to the initiates and is considered a spiritual evolution in harmony with all the laws of the universe. I am grateful to Serena Keshavjee for bringing this article to my attention. See Welsh, *op. cit.*, 1986, p. 68, who identified that by 1884 Lady Caithness in *Fragments glanés dans le théosophie occulte d'Orient* had already provided the French public with the theo-

sophic definition of 'nirvana' as "the subjugation of the passions and with the practice of universal charity."

148. The basis of the Buddha's teaching lies in the Four Noble Truths; 1) Dukkha: the Noble Truth of Suffering, and Pain. 2)Samudaya: the arising of Dukkha which manifests itself in various ways and gives rise to all forms of suffering. 3) Nirohdah, which is the cessation of Dukkha, – Nibbāna, known more popularly in its Sanskrit form of Nirvāna. It is incorrect to define Nirvana as a negative or positive idea. If at all, writers have stated that it is the annihilation of the illusion, of the false idea of self; it is the idea of Absolute Truth, and in fact, Buddha unequivocally uses the word Truth in place of Nirvāna. The Absolute Truth according to Buddhism is that there is nothing absolute in the world; everything is relative and impermanent. A significant issue is that Buddhism considers Truth/Nirvana as not produced by a mystic spiritual state. 4) The final Noble Truth is Magga: "The Path" that leads to Nirvana. One extreme path is the search for happiness through pleasure of the senses and the other extreme that of different forms of ascetiscm. Buddha, however discovered from experience that the Middle Path was composed of 8 steps: the Noble Eightfold Path of: Right, Understanding, Thought, Speech, Action, Livelihood, Effort, Mindfulness and Concentration, leading to Insight, Enlightment, to Nirvana.

149. Malingue, 1946, letter CXI, dated to "Le Pouldu, August 1890."

150. Amishai-Maisels, *op. cit.,* 1975, p. 220, who discussed his sketchbook from Brittany and Arles. Furthermore, Gauguin's essay on Van Gogh, "Natures Mortes," *Essais d'Art Libre,* January 4, 1894, pp. 273–5, specifically associated the words "I am sound of Spirit, I am the Holy Spirit" with van Gogh who had presumably traced the words on a wall in his Yellow House. See B. Welsh-Ovcharov, *Van Gogh in Perspective,* Englewood Cliffs, New Jersey, 1974, pp. 42–4.

151. Amishai-Maisels, *op. cit.,* 1985, pp. 404–5, who dates the watercolor to 1889 and relates it in style to the artist's statuette *Lust.* This author was the first to associate Gauguin's *Ictus* with the artist's religious syncretism as linked to his association with van Gogh. She identified the cross-legged pose of the "youth" as "a non-Buddhist pose" based on the fifth-century dynasty Egyptian Scribe in the Louvre, its left hand is raised in a "Borobudur" gesture which could suggest a Buddhist association. See Merlhès, 1989, pp. 194–5, who discussed Gauguin's annotation of Ictus and its relation to the image of the fish "ikthus" which was associated as a symbol of their faith by early Christians, and which van Gogh may have included in his letter to Gauguin as a sign of artistic brotherhood.

152. See Cooper, 1983, letter VG/PG.4, van Gogh's letter to Gauguin dated to January 23 or 24, 1889. For discussion of the letter see, Amishai-Maisels, *op. cit.,* 1985, pp. 404–5 and Merlhès, 1989, p. 194; Pickvance, 1998, cat. 44. In the South Seas, the artist was evidently intrigued by the combination of the Christian symbol of the fish with Eastern religious symbols. On page 37 of his manuscript, "L'Esprit Moderne et le Catholicisme," written in Tahiti in 1897–8 and completed in Atuana in 1902, Gauguin made a drawing, a copy after a gnostic intaglio, representing a Christ–Horus brandishing the symbol of the fish and standing on the crocodile symbol for the Egyptian god, Horus; see P. Verdier "Manuscript de Gauguin: l'Esprit moderne et le Catholicisme," *Wallfraf-Richartz-Jahrbuch,* Cologne, 1985/6, p. 281. See Gray, 1963, p. 220, who published a photograph illustrating a section of the reliefs of the Temple of Borobudur in Java: a print known to have been owned by Gauguin. The hand gesture of the middle figure to the left on the upper section of this frieze depicts a comparable type of raised hand as that found in the watercolor *Ictus.*

153. Redon's illustrations were inspired by Flaubert's discussion of the parallels between the life of Christ and the Buddha.

154. See Welsh, *op. cit.,* 1986, pp. 66–7, for a discussion of Schuffenecker's

interest in Buddha and pp. 70–3 for Ranson's occult interests including his sources for *Christ and Buddh,a* a work dated by the author to *c.* 1890–2.

155. Malingue, 1946, letter LXXXI, dated to "Paris, March 1889." The letter should be re-dated to either Thursday May 23 or the following Thursday May 30, since the artist announced to Bernard his intention to leave for Brittany on "Tuesday next," which would have meant that Gauguin intended to depart either Tuesday May 28 or Tuesday June 4 for Pont-Aven. This letter relates to letter LXXX dated to "February 1889" which should be re-dated to Monday May 20 or Monday June 2, 1889 since Gauguin in this letter invited Bernard to join him "next Wednesday" at the Exposition universelle.

156. See Druick and Zegers, *op. cit.,* 1989, pp. 116–17, for a discussion of this figure's hand position holding the spindle having been influenced from a sacred hand gesture associated with holding a lotus as found in Cambodian sculpture which the artist would have seen in 1889 at the Exposition universelle (see Fig. ?).

157. It remains an enigma as to whether or not Gauguin's inscription was meant to be read in the singular or the plural. "Touts" does not exist in the modern French language. The masculine declension for the singular noun, nirvana, would be "Tout," the plural would be "Tous" meaning every subject in the work is an illustration of "All Nirvana." If the artist intended "Toutes," the meaning would refer solely to feminine subjects. Thus, the three female bathers, the rocks and the waves would signify that only these are "All Nirvana." See Jirat-Wasiutynski and Newton, 2000, p. 247, note 47, whose infrared reflectograph indicates very strongly that the numerous swirling lines in the lower right corner suggest that the snake-like form in de Haan's hand may have been initially placed here on the canvas. If this placement is confirmed by further tests, we may consider that Gauguin's syncretist use of the snake as related to the figure of de Haan takes on new meaning when placed beneath the words "Tous Nirvana." In this case, if the symbol is read as a snake it can be interpreted not only as the serpent associated with "the Fall" in Christian iconography, but also, as in Redon's syncretism, with the cabalistic symbol of eternal life.

158. P. Gauguin, "Diverses Choses," in the manuscript *Noa Noa,* Cabinet des Dessins, Louvre, 1896–8, p. 272. See Amishai-Maisel, *op. cit.,* pp. 436–7, who referred to Gauguin's quote in relation to the artist's religious beliefs as stated in his treatise "L'Eglise Catholique et les Temps Modernes" written in the second half of 1897; and which appear also in the second part of the *Noa Noa* manuscript. The present author has italicized the words in Gauguin's statement. The translation reads: "Buddha, a mere mortal who did not conceive or comprehend all the intelligence of the human heart, reached eternal bliss, Nirvana – the soul's last stage in its progressive advance through the ages. All people, by virtue of the attainment of wisdom, are able to become Buddhas." Perhaps Gauguin's syncretism extended beyond his symbolism to integrate both the adjective and the noun, thereby illustrating the inscription, "Touts Nirvana."

159. Malingue, 1946, letter XCVIII, dated to Pont-Aven, January 1890.

160. Cooper, 1983, letter 39.2, letter to van Gogh dated to January 28, 1890.

161. Cooper, 1983, letter 38.3–38.4, dated to January 10, 1890.

162. Merlhès, 1995, p. 4.1, Gauguin's postcript to Emile Bernard dated to the week of January 23, 1890.

163. New York, 1958, letter T28, February 9, 1890.

164. Malingue, 1946, letter CVII, dated to Le Pouldu, June 1890.

165. Cooper, 1983, letter 26.1, dated to August 2, 1890.

166. Cooper, 1983, letter 27.1, dated to mid September 1890.

167. Malingue, 1946, letter CXII, dated to Le Pouldu, September 1890.

168. Gauguin at this period was still awaiting news from Dr. Charlopin, an inventor and collector who had promised in the summer to purchase a

batch of works from the artist for 5000 francs. This business transaction ended in failure by the end of the year. See Cooper, 1983, letter 27.2, dated to mid September and note 1

169. New York, 1958, b1320V.1962, dated Le Pouldu, October 8, 1890. De Haan's letter revealed to Theo that he had lately been busy with sculpture. No trace remains of de Haan's sculpture, aside from an alms box in The Israel Museum of Art, Jerusalem.

170. Malingue, 1946, CXIII, letter Pont-Aven, October 1890.

171. Merlhès, 1995, p. 53, letter dated to October 29, 1890.

172. New York, 1958, b1043 V.1962, dated to February 1, 1891. De Haan's letter to Johanna gives his address as 35 rue Delambre. The same address evidently also housed another Dutch acquaintance of Theo's, William Haberling Weternschans from Amsterdam who had been living there since 1886. Theo's address book contained the latter's name and address. See R. de Leeuw and F. Pabst "Le Carnet d'addresses de Theo van Gogh" exh. cat. *Van Gogh à Paris, op. cit.,* 1988, p. 360. Rotonchamp, *op. cit.,* p. 78, states that this address was a modest furnished hotel in which Gauguin stayed at that time. It appears that at least until May 1891 the artist continued to use this address.

173. See Rewald, 1956, p. 469, who relates that de Haan introduced Verkade to Gauguin who was eating in a restaurant on the rue de la Grande Chaumière.

174. Sérusier, *op. cit.,* p. 54.

CHAPTER TWO

Gauguin and the Inn of Marie Henry at Le Pouldu
Robert Welsh

1. Edited by M. A. Anquetil, M. Barbey, J. M. Cuisenberche et al, *Le Chemin de Gauguin, genèse et rayonnement*, Saint Germain en Laye, Musée Departémental du Prieré, 2nd edition, 1986; especially pp. 98–135; hereafter *Le Chemin*.

2. Paris, 1921, pp. 25–52 for the Mothéré text. Chassé, *Gauguin et son Temps* (Paris, 1955, pp. 66–79), gives a modified version of the Mothéré account.

3. J. Rewald was the first to discuss the inn decoration within an art-historical context (1956, pp. 291–9). The present writer in "La Plafond peint par Gauguin dans l'auberge de Marie Henry, au Pouldu," in *Le Chemin*, pp. 124–6, discusses the ceiling decoration.

4. W. Andersen, "Gauguin's Motifs from Le Pouldu – Preliminary Report," *The Burlington Magazine*, September 1970, pp. 615–20, Wildenstein nos. 205, 206 and 206 bis, and Welsh-Ovcharov, Toronto, 1981, pp. 180–81, 190, 198, 202.

5. The documents relating to the purchase of the land by Marie Henry are in *Le Chemin*, pp. 114–15.

6. Verso *Bather*, W 241.

7. Gauguin's relationship with Captain Jacob is discussed in Chassé, 1955, p. 65, Merlhès, 1984, p. 490 and F. Cachin, Washington, 1988, no. 49. The artist dedicated a *Still Life* to Jacob in gratitude for helping him move from Pont-Aven to Le Pouldu, see Wildenstein, 291.

8. Chassé, 1955, pp. 64–5, accepts an account that Sérusier spent several days in Le Pouldu in May 1889 without supplying proof of this improbable occurrence. In fact the artist's obligations as "massier" at the Academy Julien would have prevented such a trip.

9. Reproduced by M. Denis in his text on "Paul Sérusier, sa vie, son oeuvre," first published in *Paul Sérusier: ABC de la Peinture*, second edn., Paris, 1942, pp. 54–5; Sérusier simply headed the letter, "Pouldu, Vendredi."

10. M. Denis, *Journal,* vol. I: *1884–1904*, Paris, 1957, pp. 77–8.

11. P. Sérusier, *ABC de la Peinture*, p. 38, letter headed Paris, 1889.

12. Malingue, 1946, letter CIX. Letter CVIII addressed to Emile Bernard also contains an allusion to Sérusier and should certainly be redated to Summer 1889, since it concerns the Volpini exhibition. Chassé, 1955, p. 37, gives the date of Filiger's arrival in Pont-Aven.

13. Malingue, letter LXXXIV; Welsh-Ovcharov, 1981, p. 348 and Cooper, 1983, letter 15. In all these letters sent from Le Pouldu in August, Gauguin mentions de Haan as his companion, but not Sérusier. Moreover, in a little-known letter to Emile Schuffenecker, written in late 1889 when Gauguin was still set on Tonkin as his projected Pacific Ocean paradise, he states that it was de Haan who had requested him to leave Pont-Aven for Le Pouldu in order that he, de Haan, might receive instruction in Impressionism; this letter is to be dated October 1889 according to Malingue, letter XC, where Gauguin's project to leave for Tonkin is discussed (fragment of letter quoted in H. Perruchot, *La Vie de Gauguin*, Paris, 1961, p. 201). By establishing that Gauguin's first lengthy stay in Le Pouldu was in August 1889, we can deduce that *La Belle Angèle* should be dated to the preceeding month of July, since it was one of the paintings Gauguin sent to Theo at the beginning of September. Cf. Cooper 17, Malingue, letters LXXXIV and LXXXVII, and a letter from Theo to Vincent dated to September 5, 1889 (T16 cited by Wildenstein, 315), which stated that Sérusier was to have rejoined Gauguin and de Haan at the Hôtel Destais, probably after his stay at his family's summer residence at Villerville where a fellow student from the Academy Julien had seen him "the other evening," August 14, (letter cited by Guicheteau, I 1976, p. 24, note 28). According to the present writer the other hypotheses concerning Sérusier's comings and goings during the summer of 1889 are less firmly backed up. Sérusier's presence at the Hôtel Destais can be deduced from the reminiscences of André Gide in *Si le grain ne meurt* (Paris, 1929, pp. 244–5, first edition 1920). The writer relates his one-night stop-over at Le Pouldu during a tour between Quiberon and Quimper. On this occasion, he met for the first time Gauguin, Séruzier (sic) and a third fellow who he took to be Filiger, but who in reality, must have been de Haan. Scholars have followed Rewald (1956, p. 175) in situating the date of Gide's stay at Marie Henry's inn during the month of October. However at that date Gide had returned to Paris and was working on his *Cahiers d'André Walter*. In the writer's *souvenirs* Le Pouldu is reduced to four buildings, two of which were "inns" at the crossroads, a description which corresponds to the site of the Hôtel Destais and not Marie Henry's inn.

14. Denis, "Paul Sérusier," *op. cit.,* pp. 47–9, since the letter was headed "Jour de Venus [Vendredi]. Pont-Aven" and contains a postscript from Le Pouldu saying the original letter was written "three days ago," it is to be dated to the last Friday in September 1889.

15. Chassé, 1921, p. 25, cites documents which establish that Gauguin arrived October 2 and departed November 7, 1890, from Le Pouldu. De Haan's registration at Marie Henry's inn on October 14, 1889, is established in an unpublished letter of November 30, 1921, from Mothéré to Chassé which is now in the Fonds Charles Chassé, archives departémentales du Finistère, Quimper. Sérusier's letter of about October 14 to Denis appears in Denis, "Paul Serusier," *op. cit.*, pp. 50–2.

16. Sérusier's version of this text was attached to his letter of about September 27–30, 1889, to Denis, a recopied two paragraph version of this text is reproduced in Denis, *ibid.*, p. 49.

17. Tual, "Deux tableaux de Gauguin au Pouldu," *La Dépêche de l'Ouest*, July 16, 1925. Tual gives the date of the rediscovery of the murals on the entrance wall as May 1924 and his eye-witness transcription of the quotation from Wagner as: "I believe in a last judgement where those who have dared to profit from pure and sublime art and who have soiled and debased it by their greed shall be condemned to suffer terrible pain!" For the location of the inscription, see Chassé, 1921, p. 48. On

the derivation of this text, see H. Dorra, "Le 'Text Wagner' de Gauguin," *Bulletin de la Société de l'histoire de l'art français,* 1984 [published 1986], pp. 281–8.

18. Chassé, 1921, p. 26, claims that de Haan met Pissarro in London where he was referred to Gauguin for instruction. However, there is no record or likelihood of Pissarro visiting London in 1888 or 1889 (J. Bailley-Herzberg ed., *Correspondance de Camille Pissarro,* Paris, 1980, vol. I, pp. 42–3), so that a visit made by Pissarro between May 23 and June 20, 1890, may have been known to Marie Henry via Gauguin or de Haan and later associated this voyage with the first encounter with de Haan. Cf. also L. Jampoller, "Theo van Gogh and Camille Pissarro: Correspondence and an exhibition," *Simiolus,* XVI, no. 1, 1986, pp. 50–61.

19. For Theo's relationship with de Haan see New York, 1959, letters T3, 9, 11 and 17. Unfortunately these letters are quoted only fragmentarily in the French edition of van Gogh's correspondence. De Haan's departure from Paris and first impressions of Pont-Aven are recorded in unpublished letters to Theo of April 1 and 25 and May 22, 1889, now at the Rijksmuseum Vincent van Gogh, Amsterdam.

20. Unpublished letter, Rijksmuseum Vincent van Gogh, Amsterdam. In this letter de Haan speaks of having worked on his own for a period of "two months," which in reality would have been September and the first half of October. One might imagine that he either stayed on at the Hôtel Destais or at some point moved into the third floor of the "grande maison" (that is the Villa Mauduit, now Castel Treaz, mentioned in several letters by Gauguin (Malingue, 1946, letter LXXXVII and XC and Cooper 37) which served as the studio in Autumn 1889.

21. Cooper, 1983, 37, letter dated *c.* November 8 to Theo van Gogh; Malingue CXIII, letter of November 1889 to Emile Schuffenecker.

22. New York, 1959, letter T49, now at the Rijksmuseum Vincent van Gogh, Amsterdam has been overlooked in the literature on Gauguin, doubtless because it appears only in the Dutch edition of the van Gogh correspondence, *Verzamelde Brieve van Vincent van Gogh II* (Amsterdam–Antwerp, 1955), pp. 307–9. This letter also allows us to correct the dating of Gauguin's letter to van Gogh which describes the decor of the room from "around October 20" (Cooper 36) to a day or so before T49 of mid-December, which states that Gauguin had just sent a report of the dining room to van Gogh.

23. As reported by Chassé, 1921, p. 54.

24. The inscription is visible in the photographs taken *c.* 1924, at the right of the panel where the still life was painted.

25. The *Breton Girl Spinning* may hint at the theme of a Breton Calvary or *Pardon.* The background probably depicts the opening to the beach at Le Pouldu at the termination of the rue des Grands Sables where Marie Henry's inn was located. It is similar to that of the artist's *Breton Calvary: The Green Christ* (W328), about which Gauguin wrote to Theo, *c.* November 20, 1889, "Brittany, simple superstition and desolation. The small hill is guarded by a ribbon of cows disposed as a calvary [procession]. I have sought in this painting that which fully breathes of belief, passive suffering, a primitive religious style[…]" (Cooper 22), and perhaps it is also the landscape setting of *Christ in the Garden of Olives* (Fig. 72).

26. H. Dorra, "Gauguin's Dramatic Arles Themes," *Art Journal,* XXXVIII; Spring 1971, p. 12, and Washington, 1988, cat. no. 91.

27. As suggested by H. Dorra, "The First Eves in Gauguin's Eden," *Gazette des Beaux-Arts,* March 1953, pp. 192–3.

28. For example via the mystic novels of Balzac that he admired, or from his guardian, Gustave Arosa, who is said to have been interested in such genre and who is known to have provided Gauguin with photographs of the Borobudur temple reliefs, where similar gestures occur. For the dates at which these photographs were acquired by the artist see Gray, 1963, p. 128; M. Bodelsen, *Gauguin's Ceramics: A Study in the Development of His Art,* London, 1964, p. 79; and Z. Amishai-Maisels, "Gauguin's

Religious Themes," Ph.D. Hebrew University, Jerusalem, New York and London, 1985, p. 177, who conclude that Gauguin had acquired the photograph of Borobudur before 1889. R. Brettell, in Washington, 1988, p. 155, proposes that the photographs of the Borobudur reliefs were obtained by the artist only in 1889, during the artist's visits to the Exposition universelle. At that same time Gauguin informed Emile Bernard (Malingue 1946, LXXXI) of his interest in the Javanese Hindu dances where similar hand gestures were to be found.

29. Cf. Jirat-Wasiutyński and Newton, 2000, p. 181 and p. 251, note 42, and B. Welsh-Ovcharov, p. 34 and note 96 in this catalogue.

30. Chassé, 1921, pp. 46–8 and Chassé, 1955, pp. 73–4, cites Marie Henry's reminiscence concerning the decoration of the inn. Among the painted studies on cardboard we can identify W319, W371 and W392. The "lithographs" correspond to the zincographs on saffron-coloured paper produced for the Volpini exhibition. See Welsh-Ovcharov, 1981, pp. 194–201 and Washington, 1988, pp. 130–43. The "small canvas" is *Still Life with Blue Bowl,* W403. See Jean-Marie Cusinberche, "L'Itinéraire de Paul Gauguin en Bretagne," exh. cat. *Gauguin et ses amis peintres – la collection Marie Henry "Buvette de la Plage" Le Pouldu, en Bretagne,* Yokahama, Hiroshima, Kyoto, 1992, pp. 169–73, for discussion of the arrangement of the decoration in the dining room.

31. See New York, 1959, Letter 592 to Theo, and Cooper, 1983, letter 24, for the possibility that Gauguin either was offered or acquired at least one of the versions of *La Berceuse* or one of the post-Paris period *Sunflowers.* B. Welsh-Ovcharov, "The Ownership of Vincent van Gogh's Sunflowers," *The Burlington Magazine,* March 1998, pp. 184–92.

32. Gauguin did not make the clay pots but merely painted them. One of them bore the inscription "Joie de vivre" (illus. *Le Chemin,* p. 120), while the other (Sale Hôtel Drouot, June 24, 1959, lot 53) is a cider pot that bears the inscription "Cidre gratis." One of the statuettes was the *Martinique Woman* (Fig. 99), which Marie Henry designated as "the negress in painted plaster," but Gray gives the medium as wax. The second figurine Henry calls "the javanese statuette"; elsewhere in her account (Chassé, 1921, p. 40) she states, "He picked up at the Javanese pavilion of the Exposition universelle a fragment of a frieze depicting a dancer and he carefully hung it in the dining room at Le Pouldu." Since this "fragment" so obviously served as the source for the painting *Caribbean Woman* and for the wood sculpture given to the Danish painter J.F. Willumsen known as *Lust* (Fig. 82), it seems possible that at some point it was replaced on the wall by another relatively small wood statuette, the *Standing Figure of an Old Woman* (Gray, 1963, no. 77), a carving probably in oak and stained green, the predominant color of the bust of Meyer de Haan. If this speculative hypothesis has any validity, then somewhere along the way Gauguin must have decided to substitute an image of impending (female) death for the simple idea of deduction surrounding the *Bust of Meyer de Haan.* This would reinforce the conclusion arrived at below, that an essential feature of the iconography throughout 1889 was the life–death polarity which he manifested in a number of major works.

33. See Chassé, 1921, p. 74, who derived the attribution and title for the painting based on the records of Marie Henry, which are somewhat equivocal regarding the attributions of specific paintings. A photograph from Marie Henry's identified the painting as "Paradis Perdu" (1890). See Malingue, "Du Nouveau sur Gauguin," *L'Oeil,* nos. 55–6, July–August 1959, p. 34, who accepted the attribution to Gauguin as well as the title for the work. For a similar disposition of silhouette-like figures see Guicheteau, I, 1976, pp. 197–211. The second attribution rests primarily upon a visual comparison of the *Adam and Eve* with Sérusier's *Young Breton Girl at a Riverbank* (Guicheteau, no. 29 and Welsh-Ovcharov, 1988, no. 139), but it is also based on his report, in the letter of Summer 1890 to Denis, of his transformation in his oil paintings on canvas in favor of mixed colors conceived in his personal manner. The brush technique of these two paintings is remarkably similar. See

Z. Amishai-Maisels, *Gauguin's Religious Themes*, New York, 1985, p. 490, who rejects the painting as a work by Gauguin on stylistic and iconographic grounds. See R. Welsh, "Gauguin et l'auberge de Marie Henry au Pouldu," *Revue de l'Art*, 86/1989–4, p. 38. Cf. Jirat-Wasiutyński and Newton, 2000, p. 250, note 27 who uphold the attribution to Gauguin and the early title "Paradis perdu."

34. See for example V. Jirat-Wasiutyński, "Paul Gauguin's *Self Portrait with Halo and Snake*: The Artist as initiate and Magus," *Art Journal*, Spring 1987, pp. 22–8. Cf. Washington, 1988, nos. 92–4.

35. Some degree of identification between de Haan and Carlyle's professor might even have been intended, since in Book I, chapter 3, Teufelsdröckh is described as having created the impression of an "eternal" or "wandering jew." Elsewhere he shows a penchant for a variety of mystical interests including the Cabalistic interpretation of the original Adem–Kadmon and the Fall of Man. Furthermore, it is more than likely that Gauguin had discovered *Sartor Resartus* thanks to van Gogh, who had read the book in March 1883 and wrote to his friend Anton van Rappord of his admiration for the text, commenting on how much he appreciated "the humanity" inspired by Goethe's ideas and the example of Jesus (New York, 1959, R30). Finally, Book III, chapter 3 entitled "symbolism" must have been of great interest for Gauguin as well as de Haan. There symbols are perceived as a union of the finite and infinite which permit humanity to recognize and venerate "one actual God." Cf. p. 52 on de Haan's reading Carlyle in Holland.

36. See Malingue, 1946, LIII

37. Chassé, 1921, p. 48. Cf. M. Maufra, "Souvenirs de Pont-Aven et du Pouldu," *Bulletin des Amis du musée de Rennes*, no. 2, summer 1978, p. 20, pp. 23–4, recalled that the window panes painted in blue and yellow colour imitating stained glass were decorated with white geese.

38. *Le Chemin*, pp. 124–6.

39. "Honni soit qui mal y pense" [Shame on him who thinks evil] is the motto of the Garter of Malta established by Edward III of England. According to tradition the saying originated from a remark made by the king to one of his ladies of the court to warn them against moral judgments made on deceptive appearances.

40. Marie Henry (cited by Wildenstein under W390) who understood that Gauguin brought the painting from Pont-Aven in order to hang it in the inn. But the date of 1890 which she assigned to the work contradicts this assertion and permits us to revisit the attribution. See footnote 33.

CHAPTER THREE
"Labor:" Painters at Play in Le Pouldu
Victor Merlhès

1. See Merlhès, 1995, pp. 27–30.

2. "Notes sur l'Art à l'Exposition universelle," *Le Moderniste Illustré*, July 4, and 13, 1889.

3. *Ibid.*

4. L. de Fourcaud, "Le Village Javanais," *Revue de l'Exposition universelle de 1889*, Paris, 1890, vol. I, p. 113.

5. See "Le Kampong et la Pagode: Gauguin à l'Exposition Universelle de 1889," in Paris, 1991, pp. 101–42.

6. Two photographs of friezes of the Borobudur Temple and one of a Javanese Buddha that the painter considered, or apparently considered, as reproductions of Cambodian art. Several elements of these documents reappear in numerous works of Gauguin.

7. Gérome, "Courrier de Paris," *L'Univers Illustré*, February 2, 1878, p. 66.

8. See Merlhès, 1984, vol. I, p. 70 ff. and notes 151–52.

9. Letter to Félix Bracquemond, end 1886–beginning 1887, in Merlhès, 1984, vol. I, p. 143.

10. Julien Rambert, "L'Art français," in C.-L. Huard, *Livre d'or de l'Exposition*, no. 49, December 7, 1889, pp. 778–82.

11. *Diverses Choses*, manuscript, Musée du Louvre, Paris, pp. 314-17; *Avant et Après*, facsimile edn, Leipzig, 1918, pp. 31–4.

12. See Merlhès, 1984, vol. I, notes 20, 37.

13. "Notes sur l'Art à l'Exposition universelle," *Le Moderniste Illustré*, July 13, 1889.

14. *Exposition rétrospective du travail et des sciences anthropologiques. Catalogue officiel*, vol. II, Lille, 1889, pp. 107–8.

15. Ippolito Rosellini, *I Monumenti dell'Egitto e della Nubia*, vol. II (Monumenti Civili), Pisa, 1834, pl. xxxv. Rosellini (1800–43) was the companion and disciple of J.-Fr. Champollion.

16. This bi-axial symmetry was to be used again even more systematically in the ceiling of the Buvette conceived by Gauguin. The peasants of Beni Hassan can be superimposed exactly like mirror images of one another. As for de Haan, he skillfully paints the two complementary profiles as representative of a symbolic type.

17. *Le Monde Illustré*, October 26, 1889, p. 260. Republished in *Le Petit Moniteur illustré*, November 17, 1889, p. 725.

18. *Livre d'or de l'Exposition*, 1889, no. 37, pp. 586 , 589. There were certainly other reproductions of the work, such as a small one in *L'Universel Illustré* of November 30, 1889, p. 339.

19. See Caroline Mathieu, "Architecture métallique et polychromie," in *1889: La Tour Eiffel et L'Exposition universelle*, Paris, Musée d'Orsay, 1989, pp. 62–4.

20. See *Puvis de Chavannes, 1824–1898*, exh. cat. Paris and Ottawa, 1976–7, cat. nos. 41, 42. Puvis's first canvases glued to the walls of the Amiens Museum had as titles *Concordia* and *Bellum* (*War* and *Peace*). When in Polynesia Gauguin titled a duet in sculpted wood *La Paix et la Guerre*.

21. A text written by Emile Bernard at this time cited *Les Forgerons* (*The Blacksmiths*) among Puvis's red-chalk drawings seen in the Exposition universelle ("Au palais des Beaux-Arts. Notes sur la peinture," *Le Moderniste Illustré*, no. 14, July 27, 1889, p. 110). This is the theme of Puvis's *Labor*.

22. *Puvis de Chavannes*, op. cit., cat. no. 47.

23. *Ludus* is the game but it is also the school. In *Ludus pro Patria* "game" can be understood in the sense of exercise or training, not in the sense of struggle as has been proposed. One would not thus translate *Ludus pro Vita* as "Struggle for Life." It is, however, possible that a mediocre Latinizing writer erroneously believed he was expressing the idea of "struggle."

24. "The painting represents the French martyr Joan of Arc and is the only painting of this modern master in which he expresses such intense spiritual and religious emotion. It has this rare quality and charm that distinguish the finest examples of primitive art." ("Fresco by Gauguin found in Brittany Inn," anonymous article, *The New York Herald*, January 23, 1927).

25. Purchased in 1881 by Erwin Davis of New York, who then bought it in at his sale of 1889 and gave it to the Metropolitan Museum of Art, New York. See Charles Sterling and Margaretta M. Salinger, *French Paintings*, II, The Metropolitan Museum of Art, New York, 1966, pp. 207–10, acc. no. 89.21.1.

26. G.-A. Aurier, "Le symbolisme en peinture. Paul Gauguin," *Mercure de France*, March 1891, pp. 155–65.

27. "Au Panthéon," *Mercure de France*, April 1893, pp. 369–70. Like the majority of works decorating the Panthéon, Lenepveu's paintings were glued canvases, not frescos.

28 Geneviève (*c.* 421-*c.* 502), a virgin dedicated to God at the age of fifteen; popular belief attributed to her the protection of Lutèce (later Paris) menaced by the Huns in 451. She organized the provisioning of the city besieged by Clovis (497). The Panthéon is built on the site of the former church of Sainte-Geneviève-des-Monts, where the relics of the saint were preserved.

29. Paul Gauguin, *Racontars de Rapin*, facsimile, Tahiti, 1994, p. 24.

30. Among others at the Palais des Beaux-Arts were Léon Benouville's canvas, *Joan Listening to Her Voices* and Henri Chapu's statue, *Joan of Arc Hearing Her Voices*, etc.

31. See the Plan of the Exposition universelle (Boussod & Valadon) published in *Paris Illustré*, July 20, 1889.

32. Letter to Daniel de Monfreid, Tahiti, October 1892.

33. "We gathered in a barn at night among neighbors, some ten adults. The men handled the mallet, brake or staffs; the children passed them handfulls of flax, ready to be braked; the women were busy spinning the tow to extract thread from it. And each told his tale, while working." Geneviève Massignon, *Contes traditionnels des Teilleurs de lin du Trégor*, Paris, 1965, pp. 12–15.

34. *Technique and Meaning in the Paintings of Paul Gauguin*, Cambridge, 2000, pp. 176–9.

35. François Anatole Gruyer wrote in the *Catalogue Officiel* of the Exposition rétrospective du travail (vol. 2, pp. 107–8) "Commonly – but wrongly – all mural painting are designated with the name fresco. (...). Fresco painting (from 'fresco,' fresh) is executed with water-based paint, on a wall or some other surface covered with a fresh coating. This coating is composed of a mixture of chalk and river sand, fine, washed and carefully sifted. The Italians, who have excelled and still excel in the handling of the fresco, made and continue to make use of a mixture of chalk and 'pouzzolana' for this coating. Once the coating is dry, then the painting applied to it is no longer fresco; it is distemper or tempera. The coating 'intonaco,' which is applied each day to the wall must only cover a surface that can be painted in fresco that day before it dries. The only colors suitable for use in fresco are those in which no alteration is caused by the chalk. (...) Often painters combined several processes. Does one not often see, in frescos, certain sections rendered in tempera? Is not tempera mixed frequently with oil painting? Has distemper not played a great role in famous paintings reputedly painted in oil, etc., etc.?" These mixed techniques confound experts but they please painters and that is the essential thing. Let us recall that Gauguin was able to read these explanations in the Palais des Arts libéraux and that he could have seen an actual demonstration of the process.

36. *Avant et Après*, manuscript, p. 17.

37. This tale retold by Boccaccio in the *Decameron* of 1353 (IVth day) had its origin in the story of *Barlaam and Josaphat* by the Byzantine theologian Jean Damascène (674–749). It begins the third part of the *Contes et Nouvelles en vers* by La Fontaine in 1671. It inspired two paintings by Pierre Subleyras, one in the Louvre and the other in the Museum of Fine Arts, Boston.

38. Honoré de Balzac, *Maître Cornélius*, 1831. The expression is already present in La Fontaine: "After all I did not undertake / To tell all that he obtained from her; / Small details, kisses given and taken / The little goose; well what one calls / In good French the preludes of Love; / For both of them knew more than one trick" ("The Prayer of S. Julien" in *Contes et Nouvelles en vers*, 2nd part).

39. *Avant et Après*, manuscript, p. 147.

40. "Souvenirs de Pont-Aven et du Pouldu" (extracts from an unpublished manuscript by Maxime Maufra) in *Bulletin des Amis du musée de Rennes*, no. 2 (Summer 1978), p. 23.

41. Letter to Vincent van Gogh, Le Pouldu end October–beginning November 1889.

42. The escutcheon of the Dukes of Brittany was emblazoned with ermines. Through her marriages to Charles VIII (1491) and Louis XII (1499), Duchess Anne of Brittany assured the alliance of the fleur de lys and the ermine.

43. A tiny sketch of this motif (no doubt inspired by diverse hieroglyphs, in particular the cross of life sculpted on the Pouldu barrel) appears at the top of a page on which Gauguin traced the sketch of a Cambodian "apsara" and some heads from a Boticelli fresco (see Druick and Zegers, *op. cit.* 1989, pp. 118–19). "Why real roses, real leaves? asked Gauguin. How much poetry there is in decoration. Yes, Gentlemen, one needs a remarkable imagination to decorate even an ordinary surface and it is an art more abstract than the servile imitation of nature" ("Notes sur l'Exposition universelle," *Le Moderniste Illustré*, July 4, 1889).

44. In *Alcools*, Paris, 1913; 4th quatrain of this poem dedicated to Félix Fénéon. In translation:
Men know so many games, love, "mora"
Love game of navels or game of the great goose
"mora" game of the number illusory of fingers
Lord, Lord let me fall in love one day.

45. See *Le Carnet de Paul Gauguin*, Paris, 1952, p. 220; see also Merlhès, Tahiti, 1989, pp. 194–5 and 219: "From the Greek expression 'Iêsous Khristos Theou uios Sôter' – Jesus Christ Son of God the Saviour – in Greek the acrostic forms the word "Ikhtus" (fish). And that was how the image of the fish, frequent in the paintings of the catacombs, became a symbol of their faith for the first Christians. Below the letter that he sent to Gauguin on January 22, 1889, Vincent again drew the mystical fish in recollection of their discussions in Arles and as an emblem of belonging to a same brotherhood of artists and apostles."

46. Vincent to Theo, letter 564, 3rd week of December 1888.

47. See Merlhès, 1989, pp. 85–107.

48. Gospel according to Mark, 16: 17–18.

49. Acts of the Apostles, 28: 3–5.

50. Louis Réau in his *Iconographie de l'art chrétien, III, Iconographie des Saints,* Paris, 1957, vol. 3, 11.1047–8, enumerates diverse statues, stained glass, frescoes, breviaries, tapestries and paintings that illustrate the scene.

51. A survey of his works would reveal that for at least a year the artist had not ceased to think about representation and the symbolism of the only part of the body which, along with the head, is generally bare: the hands (and sometimes the feet). Numerous attempts were made to express everything else, like the eyes, ears, nose. [...] but this is another chapter. Yet another would be that addressing the question of line, sinuous, undulating, serpentine curves in Gauguin's work during this period.

52. Letter to Emile Schuffenecker, January 14, 1885, Merlhès, 1984, vol. 1, no. 65, pp. 87–9.

53. Jan Zürcher, *Meijer de Haan's Uriël Acosta*, [June] 1888 (16 pp.). His translation of *Sartor Resartus* had appeared in Amsterdam in 1880. Johannes Willem Cornelis Anton, so-called Jan Zürcher (Amsterdam 1851–The Hague 1905), student of his father, the painter and etcher A. F. Zürcher, (1825–76), enrolled at the Rijksakademie in Amsterdam around 1880 after having complete a doctorate of lettres in Berlin; he was a professor of languages, translator, art critic (especially for *Het Nieuws van den Dag*), painter and etcher. His novel *Roeping : Winfried's verhaal uit den polder* (Amsterdam, 1899) would comprise his autobiography. *Sartor Resartus* first appeared in the monthly issues of *Fraser's Magazine* between November 1833 and August 1834, as a book in Boston in 1836 and London in 1838. It was translated into Dutch by J. Zürcher in 1880.

54. *Le Paradis Perdu* de Milton, traduction nouvelle par M. de Chateaubriand, Paris, 1836. Numerous editions or re-editions followed (more than eleven between 1837 and 1881), often preceded by the "Réflexions sur la vie et les écrits de Milton" by Lamartine. The two pages reproduced here are those of the edition Roux–De Vresse, of 1857. The archangel brandishes a kris, or undulating sword, similar to the one in *The Spinner*.

Paradise Lost was translated into French by N. F. Dupré de Saint-Maur as early as 1730. The prose translation by Louis Racine (son of the great dramatic poet) dates from 1755, that of the abbot Le Roy from 1775, that of Chateaubriand from 1836, that of de Pongerville from 1858, etc.-

55. Merlhès, 1984, vol. 1, letter 141, to E. Schuffenecker, February 20, 1888; completed in Merlhès, 1989, pp. 61–3.

56. *Paradise Lost*, Book VIII, vv. 72–80.

CHAPTER FOUR

Searching for "Nirvana"

Eric Zafran

1. *Internationale Kunst-Ausstellung*, Cologne, May 5 – September 30, 1912, p. 35, no. 166.

2. According to Armand Seguin, an artist acquainted with Gauguin, Durrio was "Gauguin's last student." See "Paul Gauguin," *L'Occident*, no. 16, March 1903, p. 304. Durrio is also among the "disciples"of Gauguin depicted in the symbolic *Last Supper*, a homage to Gauguin painted in 1906 by Pierre Grieud for which see the exhib. cat. *Gauguin et l'Ecole de Pont-Aven*, Musée de Pont-Aven, 1997, np.

3. For Durrio and his relationship to Gauguin, see F. Cossio del Pomar, *Arte y Vide de Pablo Gauguin*, Madrid, 1930, pp. 54, 107, 149, 210, and 215. On Durrio and his collection of Gauguins see Th.-L. Lefèbvre, "Que sont devenus les 150 Gauguin de la collection Durrio," *Arts*, February 18, 1949, pp. 1 and 4; Robert Rey, "Paco," in *Onze Menus de Paul Gauguin*, Geneva, 1950, pp. 15–22; Ghislaine Plessier, "Un ami de Gauguin: Francisco Durrio (1868–1940)," *Bulletin de la Société de l'histoire de l'art français*, 1982, pp. 199, 204 –5; Marc Saul Gerstein, "Impressionist and Post-Impressionist Fans," PhD dissertation, Department of Fine Arts, Harvard University, May 1978, pp. 308–9.

4. John Richardson, *A Life of Picasso*, I, New York, 1991, pp. 210 and 230.The Vollard gallery record kindly supplied by Victor Merlhès indicates that the seller of the stolen Gauguins used the name Garcia Lazano and that his "commissionnaire" Pons was paid on March 31, 1904 "150 fr. pour un / lot de Gauguin dont 2 toiles / *Nirvana* et *petit cavalier fond bleu* / 2 grès et six dessins zing…"

5. In correspondence of June 2, 2000. See Donald E. Gordon, *Modern Art Exhibitions, 1900–1916*, II, Munich, 1974, pp. 172–3

6. *Internationale Kunst-Ausstellung, Illustr. Katalog*, Cologne, 1912, p. 35, no. 166.

7. *Exposition rétrospective, Hommage au génial Artiste Franco-Péruvien, Gauguin*, Association Paris-Amerique Latine, Paris, December 1926, no. 91.

8. *Paul Gauguin 1848–1903*, Kunsthalle, Basel, July – August, 1928, p. 27, no. 150; and *Paul Gauguin 1848–1903, Ausstellung*, Galerien Thannhauser, Berlin, October 1928, no. 127.

9. *The Durrio Collection of Works by Gauguin*, The Leicester Galleries, London, May – June, 1931, p. 11, no. 67. According to the review in *Apollo*, 14, no. 79, July 1931, p. 67 this collection "until recently [was] the property of the Spanish sculptor Francisco Durrio, an intimate friend of the artist."

10. Raymond Cogniat, "La Vie ardente de Paul Gauguin," Gazette des Beaux Arts, Paris, December, 1936, p. 66, no. 89.

11. Letter of November 1, 1937 from Félix Wildenstein to A. Everett Austin, Jr., in the Atheneum files.

12. Dated January 5, 1942 in the Atheneum files.

13. The October 1943 "List of Paintings Lent by Dealers At the Wadsworth Atheneum" is in the Atheneum Archives. See Eugene Gaddis, *Magician of the Modern: Chick Austin and the Transformation of the Arts in America*, New York, 2000, pp. 364–5.

14. Letter of November 1, 1943 from R. W. Huntington to Chick Austin in Atheneum Archives.

15. Confirmation of the purchase is in a letter of December 21, 1943 from Félix Wildenstein to R. W. Huntington in the Atheneum files.

16. Chick Austin, Gauguin text, no. 173 in Atheneum files. See Gaddis, 2000, pp. 368 and 390.

17. Cossio del Pomar, Madrid, 1930, pp. 71 and 127; in addition a photograph of Paco Durrio is reproduced on p. 213.

18. Wayne Anderson, "Gauguin and a Peruvian Mummy," *Burlington Magazine*, April 1967, pp. 240–41. Gauguin's sketches after the mummy are found in the Album Walter. See *Le Chemin*, 1986, pp. 66 and 229.

19. Anderson, *op. cit.*

20. Ibid.

21. Ibid.

22. Idem, *Gauguin's Paradise Lost*, New York, 1971, p. 121.

23. Jean Leymarie, *Gauguin: Aquarelles, pastels et dessins*, Basle, 1960 and Geneva 1988, pp. 35–6.

24. Alfred Warner, *Paul Gauguin*, New York, 1967, pp. 39–40.

25. Thomas Buser, S.J., "Gauguin's Religion," *Art Journal*, xxxvii/4, Summer 1968, p. 378.

26. Edouard Schuré, *Les Grands Initiés*, Paris, 1956, p. 19.

27. Wladyslawa Jaworska, "Jacob Meyer de Haan 1852–1895," *Nederlands Kunsthistorisch Jaarboek*, 18, 1967, pp. 211–12.

28. Ziva Amishai-Maisels, *Gauguin's Religious Themes*, New York and London, 1985, pp. 133–4.

29. Ibid., pp. 135–9.

30. Ibid., pp.146–7.

31. Ibid., p. 147.

32. Richard Boyle, *The Early Work of Paul Gauguin: Genesis of an Artist*, Cincinnati, 1971, p. 10.

33. Vojtech Jirat-Wasiutynski, *Paul Gauguin in the Context of Symbolism*, New York and London, 1978, pp. 333–4.

34. Ibid.

35. Idem, "Paul Gauguin's 'Self-Portrait with Halo and Snake' : The Artist as Initiate and Magus," *Art Journal*, Spring 1987, pp. 22–5.

36. Ibid., p. 26.

37. Ibid.

38. Jirat-Wasiutynski and Newton, Cambridge, 2000, pp. 157–8.

39. Ibid.

40. Philippe Verdier, "Un Manuscrit de Gauguin: *L'Esprit Moderne et Le Catholicisme*," *Wallraf-Richartz-Jahrbuch*, 1985/86, pp. 284–5.

41. Welsh-Ovcharov, 1981, pp. 221–2.

42. Ibid.

43. Françoise Cachin, "Meyer de Haan," Washington, 1988, p. 169.

44. Charles Stuckey, in Paris, 1991, p. 56.

45. Isabelle Cahn, in Paris, 1991, p. 175.

46. Denise Delouche, *Gauguin et la Bretagne*, Paris, 1996, p. 100.

47. Naomi Margolis Maurer, *The Pursuit of Spiritual Wisdom: The Thought and Art of Vincent van Gogh and Paul Gauguin*, Madison and Teaneck, 1998, p. 136.

48. Ibid.

49. Paul Robert, *Le Petit Robert*, Paris, 1989, p. 1272.

50. E. Burnouf, *Introduction à l'histoire du Buddhisme Indie*, Paris, 1844, pp. 17–19.

51. J. Barthélemy Saint-Hilaire, *Le Bouddha et sa religion*, Paris, 1866, pp. i–xxvii, and 132–9; see also the English translation *The Buddha and his Religion*, Middlesex, UK, 1998, pp. 13–15 and 139–40.

52. Idem, *Buddhism in India and Sri Lanka*, New Delhi, 1975, p. 160. See also R. Spence Hardy, *A Manuel of Buddhism, In Its Modern Development*, London and Edinburgh, 1860, especially p. 38.

53. Barthélemy Saint-Hilaire, *The Buddha*, 1998, pp. 140–1.

54. P. Larousse, *Grand Dictionnaire universel de XIXe siècle*, 1865–76, vol. 11, p. 1016.

55. Ibid, *Supplément*, I, 1878, p. 1118.

56. Shehira Doss-Davezac, "Schopenhauer according to the Symbolists," in *Schopenhauer, philosophy, and the arts*, ed. Dale Jacquette, Cambridge, UK, 1996, pp. 249–53.

57. Ibid., p. 271.

58. P. Challemel-Lacour, "Un Bouddhiste contemporain en Allemagne," *Revue des deux Mondes*, March 15, 1870, pp. 327 and 329.

59. Théodule Ribot, *La Philosophie de Schopenhauer*, Paris, 1874, pp. 145–9.

60. J. Bourdeau, *Schopenhauer, pensées maximes et fragments*, Paris, 1880, p. 42.

61. P. Larousse, *Grand Dictionnaire universel, Supplément* II, Paris, 1890, p. 1637.

62. Gustave Flaubert, *The Temptation of St. Anthony*, trans. by Lafcadio Hearn, New York, 1910, pp. 159–66.

63. See Alain Mercier, *Les Sources esoteriques et occultes de la poesie symboliste (1870–1914)*, vol. 1, Paris, 1969, pp. 74–5; and Joseph Vianey, *Les Sources de Leconte de Lisle*, Montpelier, 1907, pp. 41–3. Also Henri Cazalis, *Le Livre du Néant*, Paris, 1872, pp. 70–9.

64. On Gauguin and Mallarmé see H. R. Rookmaaker, *Gauguin and 19th Century Art Theory*, Amsterdam, 1972, pp. 150–1; and also G. Inboden, *Mallarmé und Gauguin*, Stuttgart, 1978.

65. See Doss-Davezac, 1996, p. 250.

66. Robert Greer Cohn, "Laforgue and Mallarmé," in *Jules Laforgue, Essays on a Poet's Life and Work*, ed. Warren Ramsey, Carbondale, 1969, p. 67.

67. See Jules Laforgue, *Les Complaintes*, ed. Jean-Pierre Bertrand, Paris, 1997, p.154.

68. Ibid., p. 47. The English translation follows:

> Then mad before this sky which has always ignored us,
> I dreamed of preaching the end, in the name of Buddha!
> Oh! Pale mutilated one [part of the unique whole]; let those who
> love me follow me!
> Making of their cities a single Ninevah,
> To lead these dear bourgeois, scourged by alleluias,
> To the maternal Holy Sepulchre of Nirvana!

69. Wayne Andersen, "Introduction," *The Writings of a Savage: Paul Gauguin*, ed. Daniel Guérin, New York, 1996, p. xxv.

70. Merlhès, 1989, pp. 116–17 and 192, 194. See also Tsukasa Kodera, "Japan as primitivistic utopia: van Gogh's *japonisme* portraits," *Simiolus*, vol. 14, no. 3/4, 1984, p. 198.

71. See Malingue, 1946, p. 201.

72. See Pierre-Louis Mathieu, *Gustave Moreau, Monographie et nouveau catalogue de l'oeuvre achévé*, Paris, 1998, p. 332, nos. 187 and 188.

73. In Schuffenecker's letters of the 1890s to Jules Bois in the collection of the Getty Research Institute, Los Angeles, no. 87–A325.

74. See *Claude Emile Schuffenecker*, Hirschl and Adler, New York City, 1958, cover; and Jill Elyse Grossvogel, *Claude Emile Schuffenecker, Catalogue raisonné*, vol. I, San Francisco, 2000, under nos. 34–36.

75. See the exhib. cat. *Paul-Elie Ranson: Du Symbolisme à l'art nouveau*, Musée départemental Maurice Denis Le Prieuré, Saint-Germain-en-Laye, 1997, nos. 5, 18, and 33.

76. Formerly with the Ranson family and since 1961 in the collection of Mr. and Mrs. Arthur Altschul, New York. See *Ranson*, 1997, p. 52, no. 6; and also the exhib. cats. *The Spiritual in Art*, Los Angeles County Museum of Art, 1986, p. 73, pl.17, and *Neo-Impressionists and Nabis in the Collection of Arthur G. Altschul*, Yale University Art Gallery, New Haven, 1965, p. 85, no.35.

77. See Sven Sandstrom, *Le Monde imaginaire d'Odilon Redon*, Lund and New York, 1955. p. 142, fig. 113; and Richard Hobbs, *Odilon Redon*, London, 1977, p. 103, fig. 64.

78. Sandstrom, *op. cit.*, 1955, p. 143, fig. 114; and Hobbs, *op. cit.*, 1977, p. 111, fig. 71.

79. Guicheteau, 1989, pp. 68–9.

80. See Douglas Druick and Peter Zegers, in Paris, 1991, pp. 123, and 130–3.

81. Guérin, 1927, nos. 31 and 63; Kornfeld, 1988, p. 76, no. 17 and p. 180, no. 45; the sculpture is Gray p. 217, no. 94; the painting is in the Pushkin Museum, Moscow, Wildenstein 629.

82. Amishai-Maisels, *op. cit.*, 1985, p. 407.

83. Ibid. See also Verdier, *op. cit.*, 1985/6, p. 284.

84. Quoted in New York, 1987, pp. 249–50.

85. Verdier, *op. cit.*, 1985/6, pp. 305 and 325.

86. Verdier, *op. cit.*, 1985/6, p. 301.

87. For these two paintings, their titles, and their relationship, see Edward J. Henning, "*Woman in the Waves* by Paul Gauguin," *The Bulletin of the Cleveland Museum of Art*, October 1984, p. 284; Rennes, 1996, pp. 98–9.

88. The drawing is reproduced in Guérin, 1927, p. xxiv. The linecut sometimes incorrectly referred to as a woodcut or as a gravure reproduction is properly identified in Kornfeld, 1988, p. 200.

89. See Washington, 1988, p. 146.

90. Exhibited Kunstmuseum, Basel, *Gauguin Ausstellung*, December 1949 – January 1950, no. 37, pl. 15. According to a letter from Sylvie Crussard of the Wildenstein Foundation dated May 25, 1990, this painting will be included in the forthcoming Gauguin catalogue raisonné.

91. See Washington, 1988, p. 49.

92. The letter is quoted in Belinda Thomson, ed., *Gauguin by Himself*, Boston, 1993, p. 116.

93. Fereshteh Daftari, *The Influence of Persian Art on Gauguin, Matisse, and Kandinsky*, New York and London, 1991, pp. 71–80.

94. For a thorough review of Gauguin's working methods and the markedly few changes in his compositions revealed by reflectography and x-ray, see Jirat-Wasiutyenski and Newton, 2000, esp. pp. 95–6, 107–8, and 121.

95. This sheet of studies was formerly in the Otto Wertheimer collection, Paris; sold Sotheby's London, April 4, 1974 (lot 291).

96. Wildenstein, 458. For a discussion of its meaning see Ziva Amishai-Maisels, "Gauguin's 'Philosophical Eve,'" *Burlington Magazine*, 1973, pp. 374–5. The drawing is now at the Musée d'Orsay, formerly in the Cabinet des dessins du Louvre, RF 29.332.

97. See Gudrun Inboden, *Mallarmé und Gauguin*, Stuttgart, 1978, p. 77. For example see the poem by Mallarmé which begins "Ses purs ongles…" in Stéphane Mallarmé, *Poësies*, Paris, 1989, p. 98. The poet discusses his ideas about le Néant in his *Correspondence 1862–1871*, Paris, 1959, pp. 207–8, 242–3, 259, and 279.

98. Wildenstein, 239. See Lesley Stevenson, *Gauguin*, New York, 1990, p. 75.

99. See Daniel Guérin, ed., *The Writings of a Savage: Paul Gauguin*, New York, 1996, p. 41.

100. See Charles Estienne, *Gauguin*, Geneva, 1953, p. 49.

101. In Washington, 1988, p. 1.

102. Kornfeld, 1988, pp. 199–202, no. 52.

103. Wildenstein, 453; see Pickvance, 1998, pp. 282–3, no. 87.

104. Wildenstein, 523. Sold Sotheby's, New York, November 16, 1983, 10 and 37. On the subject of this painting formerly in the Art Institute, Chicago see Henri Dorra, "Gauguin's Unsympathetic Observers," *Gazette des Beaux-Arts*, 6th series, November 1976, p. 369; and idem., "Gauguin's Dramatic Arles Themes," *Art Journal*, Fall 1978, p. 14.

105. Guérin, 1927, no. 69; Kornfeld, 1988, p. 192, no. 49.

106. Guérin, 1927, no. 59; Kornfeld, 1988, p. 214, no. 55.

107. Henning, 1984, p. 284.

108. See Marc S. Gerstein, "Paul Gauguin's 'Arearea,'" *Bulletin*, The Museum of Fine Arts, Houston, Fall 1981, vol. VII, no. 4, p. 12, fig. 10.

109. See Gray, 1963, nos. 75 and 87. Françoise Cachin, "Un bois de Gauguin: *Soyez mysterieuses,*" *La Révue du Louvre*, 1979, p. 215, fig. 1; and *La Sculpture des peintres*, exhib. cat., Fondation Maeght, Saint Paul, France, 1997, no. 26.

110. Sold Sotheby's London, June 28, 1989, lot 303 and again October 21, 1998, lot 17.

111. Wildenstein, nos. 463 and 465.

112. Guérin, 1927, no. 15; Kornfeld, 1988, no. 16.

113. Welsh-Ovcharov, 1981, p. 349.

114. See *Gauguin und die Schule von Pont-Aven*, exhib. cat., Kunsthalle der Hypo-Kulturstiftung, Munich, 1998, p. 169, no. 110.

115. The fragmentary text on the verso seems to be a diatribe about the morality and rights of women.

116. For example according to Ronald Pickvance, *The Drawings of Gauguin*, London, 1970, p. 27; the only occasion on which it has been indicated that the watercolor was done after the panel painting is Rennes, 1986, p. 95.

117. Verdier, 1985/86, p. 283; and David Sweetman, *Paul Gauguin, A Complete Life*, London, 1995, p. 432.

118. Guérin, 1927, II, no. 53; Kornfeld, 1988, p. 160, no. 38. See also the fac-similie edition of *Noa Noa*, Stockholm, 1947, p. 174.

119. Wildenstein, 625.

120. Joanne Teilhet-Fisk, *Paradise Reviewed*, Ann Arbor, 1975, p. 155.

121. See Richard Brettell in Washington, 1988, p. 494.

122. Teilhet-Fisk, *op. cit.,* 1975, p. 156; and Margolis Maurer, *op. cit.,* 1998, p. 174.

123. Stevenson, *op. cit.,* 1990, p. 170.

124. See Rey, *Onze Menus, op. cit.,* 1950, p. 75. The Gauguin menus were exhibited at Didier Imbert Fine Art, Paris in 1985.

125. See Richard S. Field, *Paul Gauguin: Monotypes*, Philadelphia, 1973, p. 71, no. 33.

126. See Kornfeld, 1988, nos. 58 and 69.

127. Wildenstein, 626. See Jaworska, 1972, p. 106.

128. Wildenstein, 628.

129. Wildenstein, 594.

130. See Robert Goldwater, *Paul Gauguin*, New York, 1983, p. 78.

131. See Kirk Varnedoe, "Gauguin," in *"Primitivism" in 20th Century Art*, I, ed., William Rubin, New York, 1984, pp. 179–209.

132. Ronald Johnson, "Primitivism in the Early Sculpture of Picasso," *Arts Magazine*, June 1975, vol. 49, no. 10, pp. 64–6; and idem, "The 'Demoiselles d'Avignon,' and Dionysian Destruction," *Arts Magazine*, October 1980, vol. 55, no. 2, pp. 96–8; and William Rubin, "Picasso," in *Primitivism*, 1984, p. 243.

133. Richardson, I, 1991, pp. 221, 230, 264, and 456–9.

134. Christian Zervos, *Pablo Picasso*, Paris, 1954, VI, p. 61, no. 495; and Pierre Daix, *Picasso, Catalogue raisonée de l'oeuvre peint, 1900–1906*, Neuchâtel, 1988, p. 214, no. VII, 7.

135. For what has been called Picasso's "masking of the figure" in these paintings of late 1906 see Maragret Werth, "Representing the Body in 1906," in the exhib. cat. *Picasso: The Early Years, 1892–1906*, Washington and Boston, 1997, pp. 283–84.

136. For the possible Gauguin influence on *Les Demoiselles* see William Rubin, "La Genèse des *Demoiselles d'Avignon*," in the exhib. cat. *Les Demoiselles d'Avignon*, II, Musée Picasso, Paris, 1988, pp. 459–61. And for a carefully considered review of its sources and evolution see Richardson, II, 1996, pp. 11–27.

CHAPTER FIVE
Gauguin Inside Out
Charles Stuckey

1. Wayne Anderson, *Gauguin's Paradise Lost*, New York, 1971, p. 121, considers the background nudes in *Nirvana* to be, roughly speaking, embodiments of death and rebirth, who flank de Haan, portrayed as a sexual predator indifferent to his victims' fates. See Eric Zafran's account, pp. 103–29 in this publication, of attempts at interpretation of *Nirvana*.

2. See Jean Seznec, "The Temptation of St. Anthony in Art," *Magazine of Art*, March 1947, pp. 91–2; and Theodore Reff, "Cézanne, Flaubert, St. Anthony and The Queen of Sheba," *The Art Bulletin*, vol. XLIV, no. 2 (June 1962), pp. 113–25. Of course, Gauguin was among the most important early collectors of paintings by Cézanne, and one of Cézanne's treatments of the Temptation theme (today, Musée d'Orsay, Paris) was familiar to Emile Bernard, who made reference to it in an 1892 booklet. See John Rewald, *The Paintings of Paul Cézanne, A Catalogue Raisonné*, New York, 1996, vol. I, p. 206 (no. 300). Thus, Gauguin was probably aware of similarities between *Nirvana* and images of the *Temptation of St. Anthony*.

3. According to Zafran (p. 108), Amishai Maisals (1969), first called the title "sarcastic," and Jirat-Wasiutynsky, 1975/78 referred to it as "ironic."

4. Jean-Jacques Luthi, *Emile Bernard, Catalogue raisonné de l'oeuvre peint*, Paris, 1982, pp. 14 (cat. 67), 34 (cat. 204), and 40 (cat. 252). Indeed the critical success of Puvis's work was a major factor in popularizing the nude-in-a-landscape theme during the 1880s, with such artists as Cézanne, Degas and Renoir.

5. The most important account of the Volpini exhibition remains Welsh-Ovcharov, 1981, pp. 41–6. Apparently Gauguin cut the "aux Roches noires" illustration from one copy of the catalogue and pasted it on to the cover of a drawings portfolio that he made on his first trip to Tahiti; for a reproduction, see Washington, 1988, p. 213. Gauguin later made a woodblock print from this same composition, a proof of which he pasted into his *Noa Noa* manuscript, p. 186, see Kornfeld, 1988, pp. 200–1.

6. But, see Pickvance, 1998, p. 274 (no. 57), who argues that the works would have been painted in Paris where Gauguin remained during the first half of 1889.

7. There would seem to be a remote possibility that the Cairo and Cleveland paintings at some early stage were parts of a single horizontal composition, similar in format to the scene in the background of *Nirvana*. Technical examination of the Cleveland painting does not support such a thesis, but the Cairo painting remains to be studied from a technical point of view. See Louise d'Argencourt with Roger Diederen, *European Paintings of the 19th Century*, vol. 1, The Cleveland Museum of Art, 1999, pp. 274–9.

8. See Charles Stuckey entry in Washington, 1988, p. 274 (cat. no. 150); and Naomi Margolis Maurer, *The Pursuit of Spiritual Wisdom. The Thought and Art of Vincent van Gogh and Paul Gauguin,* Madison and London, 1998, p. 136.

9. See, among others, John Tancock, *The Sculpture of Auguste Rodin: The Collection of the Rodin Museum Philadelphia*, Philadelphia, 1976, pp. 96–8 and 173–5; and Albert E. Elsen, *"The Gates of Hell" by Auguste Rodin*, Stanford, CA, 1985, pp. 125–9 and 152; and Ruth Butler, *Rodin, The Shape of Genius*, New Haven and London, 1993, pp. 214–25. The enormously

important dialogue between Rodin and Gauguin has scarcely been noted in the literature. See Charles Stuckey, in Paris, 1991, pp. 52–4.

10. Degas, *Woman with Chrysanthemums*, 1858/65, Metropolitan Museum of Art, New York; Courbet, *Woman's Head and Flowers*, 1871, Philadelphia Musuem of Art; Renoir, *Young Woman Sewing*, 1879, The Art Institute of Chicago, and *Woman with a Fan*, 1881, Sterling and Francine Clark Art Institute, Williamstown.

11. Merlhès, 1984, p. 234 (letter 166).

12. *Ibid.*, p. 232 (letter 165).

13. Stuckey in Washington, 1988, pp. 273–4 (cat. no. 150).

14. Gray, 1963, p. 307 (cat. A-10); For more recent information on the same work, see Jean-Marie Cusinberche, *Gauguin et ses amis peintres en Bretagne*, Milan, 1993, vol. I, 57 and vol. II, 10–11; and Christie's, *Impressionist & Nineteenth Century Art*, London, June 30, 1999, lot 207.

CHAPTER SIX

A Technical Study of "Nirvana"

Stephen Kornhauser

1. In 1926 the painting was described as a gouache when it appeared in an exhibition in Paris. In 1956 John Rewald referred to it as being gouache on silk. Jean Leymarie (*Gauguin: Aquarelles, pastels et dessins*, Basle, 1960, pp. 35–6) catalogued it as essence on silk. During the next twenty-eight years references fluctuated until 1987 when it was correctly identified by Vojtech Jirat-Wasiutynski, "Paul Gauguin's 'Self-Portrait with Halo and Snake': The Artist as Initiate and Magus," *Art Journal*, Spring 1987, pp. 22–5.

2. Essence is a modified oil paint in which the oil is leached from tube paint and the pigment is dissolved again in turpentine and used as a medium. It is characteristically very lean and matte in appearance.

3. Carol Christensen, "The Painting Materials and Techniques of Paul Gauguin," *Studies in the History of Art 41, Monograph Series II, Conservation Research*, National Gallery of Art, Washington, 1993, pp. 63–103; Jirat-Wasiutynski and Newton, 2000; Andrea Kirsh and Rustin S. Levenson, *Seeing Through Paintings: Physical Examination in Art Historical Studies*, New Haven and London, 2000, pp. 34–5.

4. Christensen, *op. cit.*, p. 72. Carol Christensen mentions that Gauguin often complained that his paintings showed signs of separation between layers. This appears to have been a reoccurring problem throughout his career.

5. Scumble is a term used most often in oil painting to define a thin, translucent layer of paint applied over a darker layer to make it cooler, less intense or more atmospheric. The letters have been slightly abraded which further intensifies them.

6. Metallic powders were used by other artists including Degas (Christensen, p. 83). Gauguin also used gold-colored powder in *En*

Bretagne (Whitworth Art Gallery, The University of Manchester) and Carol Christensen notes (p. 102) that he ordered both red and yellow toned gold powders.

7. The wood was identified from samples provided to Dr. Regis Miller at the Center for Wood Anatomy Research, U.S Forest Products Laboratory, Madison, WI: correspondence nd.

8. Scalloping is a term used to describe the "serrated" edge along the perimeter of a fabric support. It is caused by the localized tension of the tacks. Its absence means that the work was not originally more tightly stretched or that it was cut from the center of a larger taut fabric.

9. Christensen (p. 67) mentions that Gauguin abandoned coarse fabrics during this period and painted mostly on moderate canvas with thread counts of 10–12 per cm. Were this a linen, it would be exceptionally fine, but as a cotton it was considered on the coarse side. Fiber samples were identified under a stage microscope by Margaret Ordonez, Textile Conservation Department, at the University of Rhode Island: correspondence nd.

10. Pure cotton fabric does not appear to have been sold by artists' suppliers although cotton-linen student grade was available. Anthea Callen (*The Art of Impressionism: Painting technique and the making of modernity*, New Haven and London, 2000, p. 30) records that the 1855 Lefranc catalogue lists "toile Madapolam," a closely woven cotton. There is at least one other picture of this period, *Self Portrait, Les Misérables* (Fig. 157), where Gauguin employs a cotton fabric; and pictures such as *Study of a Breton Woman* (Private collection) traditionally believed to be on silk might be re-examined.

11. Both the medium and pigments were examined using Fourier Transform Infra-Red (FTIR) and a Scanning Electronic Microscope (SEM) with Energy Dispersive X-Ray. I would like to thank Dr. Henry A. DePhillips, Jr., Vernon K. Kreible Professor of Chemistry at Trinity College for his research in this project.

12. David Bomford, John Leighton and Ashok Roy, *Art in the Making: Impressionism*, exh. cat. London, National Gallery, 1990, p. 59.

13. Lefranc & Cie, *Catalogue of Artists' Supplies*, Paris, nd, p. 95. The Lefranc archive dates the catalogue to 1889.

14. Bomford et al, p. 57.

15. *Catalogue General de la Maison Geo. Rowney & Co.,* London, nd, pp 10–11.

16. Marjorie B. Cohn, *Wash and Gouache,* The Center for Conservation and Technical Studies, Fogg Art Museum, Cambridge, 1977, p. 49. Zinc oxide white was used by English watercolorists because it was more adaptable to a wash style of painting. French painters had more of a tradition of using opaque whites.

17. F. Lloyds, *Practical Guide to Scene Painting*, London, 1875, p. 14.

18. Lefranc & Cie, *Catalogue of Artists' Supplies,* p. 111.

19. The secondary figures show fewer changes since they may have been resolved in the Cleveland and McNay pictures.

20. Gauguin did his underdrawing on the fabric in pencil rather the more common charcoal, possibly because the charcoal particles would mix with the water-based gouache and distort his colors.

ABBREVIATIONS

FREQUENTLY CITED SOURCES

Chassé, 1921 — Charles Chassé, *Gauguin et le Groupe de Pont-Aven*, Paris, 1921

Chassé, 1955 — Charles Chassé, *Gauguin et son temps*, Paris, 1955

Cogniat and Rewald, 1962 — R. Cogniat and J. Rewald, *Paul Gauguin. A Sketchbook*, New York, 1962

Cooper, 1938 — Douglas Cooper, *Vincent van Gogh. Letters to Emile Bernard*, New York, 1938

Cooper, 1983 — Douglas Cooper, *Paul Gauguin. 45 Lettres à Vincent, Théo et Jo van Gogh*, Collection Rijksmuseum Vincent van Gogh, Amsterdam, 1983

Gray, 1963 — Christopher Gray, *Sculpture and Ceramics of Gauguin*, Baltimore, 1963; reprinted New York, 1980

Guérin, 1927 — Marcel Guérin, *L'Oeuvre gravé de Gauguin*, Paris, 1927; revised ed. San Francisco, 1980.

Guicheteau, I, 1976; II, 1989 — Marcel Guicheteau, *Paul Serusier*, Paris, 2 vols, 1976 and 1989

Jirat-Wasiutyński and Newton, 2000 — Vojtech Jirat-Wasiutyński and H. Travers Newton*, Technique and Meaning in the Paintings of Paul Gauguin* , Cambridge, 2000

Kornfeld, 1988 — Eberhard Kornfeld, Elizabeth Mongan, and Harold Joachim, *Paul Gauguin: Catalogue raisonné of his Prints*, Bern, 1988

Malingue, 1946 — M. Malingue, *Lettres de Gauguin*, Paris, 1946

Merlhès, 1984 — Victor Merlhès, *Correspondence de Paul Gauguin, Documents, Témoinages, 1873–1888*, Paris, 1984

Merlhès, 1995 — Victor Merlhès, *De Bretagne en Polynésie, Paul Gauguin, Pages inédites*, Paris–Tahiti, 1995

New York, 1959 — *The complete Letters of Vincent van Gogh*, New York, 1959

New York, 1987 — C. Stuckey and M. Prather eds., *Gauguin, A Retrospective*, exh. cat., New York, 1987

Paris 1989 — *Gauguin, Actes du colloque Gauguin, Musée d'Orsay, 1989*, Paris, 1991

Pickvance, 1998 — Ronald Pickvance, *Gauguin*, exh. cat. Fondation Pierre Giannada, Martigny, 1998

Rennes 1986 — D. Delouche et al., *Arts de l'ouest, Pont-Aven: Pont-Aven et ses Peintres – Centenaire*, exh. cat. Rennes, 1986

Rewald, 1956 — John Rewald, *Post-Impressionism: From Van Gogh to Gauguin*, New York, 1956

Washington, 1988 — *The Art of Paul Gauguin*, exh. cat. National Gallery of Art, Washington; The Art Institute, Chicago; Grand Palais, Paris, 1988–9

Welsh-Ovcharov, 1981 — Bogomila Welsh-Ovcharov, *Vincent van Gogh and the Birth of Cloisonism*, exhib. cat., Toronto, 1981

Wildenstein — Georges Wildenstein, with Raymond Cogniat, and Daniel Wildenstein eds., *Gauguin: Catalogue*, Paris, 1964

Hertz, Henri, "Paul Gauguin," *L'Art Vivant*, March 15, 1927, ill. p. 640

Cossio del Pomar, F., *Arte y Vida de Pablo Gauguin*, Madrid, 1930, and Buenos Aires, 1945, p. 73, ill. 17, and pp. 109, 363

Malingue, Maurice, *Gauguin Le peintre et son oeuvre*, Paris, 1948, pp. 41 and 152 (illus.)

Sutton, Denys, "The Paul Gauguin Exhibition," in *Burlington Magazine*, October 1949, p. 284

Van Dovski, Lee, *Paul Gauguin*, Bern, 1950, p. 346, no. 204

Estienne, Charles, *Gauguin*, Geneva, 1953, p. 49 (ill.)

Hanson, Lawrence and Elizabeth, *Noble Savage: The Life of Paul Gauguin*, New York, 1954, p. 170

Rewald, John, *Post-Impressionism*, New York, 1956, p. 447 (ill.); 2nd edition, 1962, p. 447

Goldwater, Robert, *Gauguin*, New York, 1957, ill. p. 59

Rewald, John, *Gauguin Drawings*, New York, 1958, p. 26, no. 25 (ill.)

Wadsworth Atheneum, *Handbook*, Hartford, 1958, p. 131 (ill.)

Malingue, Maurice, "L'Homme qui a reinventé la peinture," in *Gauguin, Collection Genies et Realités*, Paris, 1960, p. 119

Leymarie, Jean, *Gauguin; Water-colours, Pastels, and Drawings in Colour*, London and Basle, 1960, no. 14 (ill.); 2nd edition Geneva, 1988, pp. 36–7 (ill.)

Gray, Christopher, *Sculpture and Ceramics of Paul Gauguin*, Baltimore, 1963, pp. 194 and 206

Wildenstein, Georges and Cogniet, Raymond, *Paul Gauguin*, vol. 1, Paris, 1964, p. 121, no. 320

Werner, Alfred, *Paul Gauguin*, New York, London, 1966, pp. 39–40 (ill.)

Sutton, Denys, "Introduction," *Gauguin and The Pont-Aven Group*, The Tate Gallery, London, 1966, pp. 12–13

Andersen, Wayne, "Gauguin and a Peruvian Mummy," *Burlington Magazine*, vol. cix, no. 769, April 1967, pp. 240–41, fig. 83

Jaworska, Wladyslawa, "Jacob Meyer de Haan, 1852–1895," *Nederlands Kunsthistorisch Jaarboek*, 18, 1967, pp. 210–12 and 223, fig. 9

Faison, S. Lane, Jr., "Baroque and Nineteenth-Century Paintings [in The Wadsworth Atheneum]," *Apollo*, December 1968, pp.71–2, fig. 17

Buser, T., "Gauguin's Religion," *Art Journal*, XXVII, 4, summer 1968, pp. 378–9, fig. 3

Andersen, Wayne, "Gauguin's Motifs from Le Pouldu – Preliminary Report," *Burlington Magazine*, September 1970, p. 619

Pickvance, Ronald, *The Drawings of Gauguin*, London, 1970, p. 27, pl. 41

Roskill, Mark, *Van Gogh, Gauguin, and the Impressionist Circle*, Greenwich, CT., 1970, p. 243

Boyle, Richard, J., "Introduction," *The Early Work of Paul Gauguin: Genesis of an Artist*, The Cincinnati Art Museum, 1971, p. 10

Jaworska, Wladyslawa, *Paul Gauguin et L'Ecole de Pont-Aven*, Neuchatel, Switz., 1971, p. 104; and as *Gauguin and the School of Pont-Aven*, trans. by Patrick Evans, Greenwich, CT., 1972, p. 106, ill. p. 104

Wildenstein, D., and Cogniat, R., *Paul Gauguin*, Milan, 1972, p. 86, fig. 2

Delevoy, Robert L., *Symbolists and Symbolism*, New York, 1973, ill. p. 31

Daval, Jean-Luc, *Journal de l'art modern 1884–1914*, Geneva, 1973, p. 91 (ill.)

Hunter, Sam and Jacobus, John, *Modern Art From Post-Impressionsim to the Present: Painting, Sculpture, Architecture*, New York, 1976, pp. 34–5, fig. 29

Field, Richard S., *Paul Gauguin: The Paintings of the First Voyage to Tahiti*, New York and London, 1977, pp. 129, 181, 271, pl. 63

Birnholz, A. C., "Double Images Reconsidered: A Fresh Look At Gauguin's Yellow Christ," *Art International*, vol. XXI, 5, Oct.–Nov. 1977, p. 32, fig. 5

Inboden, Gudrun, *Mallarmé und Gauguin*, Stuttgart, 1978, pp. 76–7, and 133

Jirat-Wasiutyński, V., *Paul Gauguin in the Context of Symbolism*, New York and London, 1978, pp. 333-34, fig. 150

Shone, Richard, *The Post-Impressionists*, London, 1979, p. 70, fig. 84

Fezzi, Elda, *Gauguin: Every Painting*, trans. Susan Brill, New York, 1980, vol. 1, p. 80, no. 317

Welsh-Ovcharov, Bogomila, *Vincent van Gogh and the Birth of Cloisonism, An Overview*, Art Gallery of Ontario, Toronto, 1981, p.50, pl. 15

Sugana, G.M., *Tout l'oeuvre peint de Gauguin*, Paris, 1981, p. 99, no. 198

Wilkinson, Alan G., *Gauguin to Moore: Primitivism in Modern Sculpture*, Art Gallery of Ontario, Toronto, 1981–2, p. 28, fig. 3

Teilhet-Fisk, Jehann, *Paradise Reviewed*, Ann Arbor, 1983, p. 155

Henning, Edward B., "The Woman in the Waves," *Art News*, vol. 83, no. 3, March 1984, p. 106

Ibid, "*Woman in the Waves* by Paul Gauguin," *The Bulletin of the Cleveland Art Museum*, vol. 71, pt. 8, October 1984, pp. 284 and 286, fig. 12

Amishai-Maisels, Ziva, *Gauguin's Religious Themes*, New York and London, 1985, p. 149

Demont, Bernard, "L'ambiguité dans la peinture de Gauguin entre 1885 et 1894," *L'Oeil*, March 1985, no. 356, p. 38, fig. 8

Verdier, Philippe, "Un Manuscrit de Gauguin: L'Esprit Moderne et Le Catholicisme," *Wallraf-Richartz-Jahrbuch*, v. xlvi/xlvii, 1985/6, p. 285

Le Pichon, Yann, *Sur les traces de Gauguin*, Paris, 1986, ill. p.133

Rewald, John, *Von van Gogh bis Gauguin, die Geschichte des Nachimpressionismus*, Cologne, 1987, ill. p. 297

Prather, Marla and Stuckey, Charles F., editors, *Gauguin: A Retrospective*, New York, 1987, p. 114, colorplate 34

Regier, Kathleen J., *The Spiritual Image in Modern Art*, Wheaton, IL, Madras, London, 1987, illus. p. 47

Jirat-Wasiutyński, V., "Paul Gauguin's 'Self-Portrait with Halo and Snake':The Artist as Initiate and Magus," *Art Journal*, Spring, 1987, pp. 25–6, fig. 7

Thomson, Belinda, *Gauguin*, London, 1987, pp. 100 and 103, fig. 83

Huyghe, René, *Gauguin*, New York, 1988, ill. p. 47

Cachin, Françoise, *Gauguin*, Paris, 1988, p. 116, fig. 123

Brettell, R., Cachin, F., et al, *The Art of Paul Gauguin*, National Gallery of Art, Washington, D.C., 1988, p. 169 (ill.)

Vandepitte, Francisca, "Het Exotisme bij Gauguin," *Gentse Bijdragen*, xxvii, 1988, p. 117

Dietrich, Linnea S., "Gauguin: The Eve of My Choice," *Art Criticism*, IV/2, 1988, pp. 49 and 59

Leymarie, Jean, *Gauguin: Aquarelles, Pastels, Dessins*, Geneva, 1988, colorplate 37

Damigella, Anna Maria, *Gauguin Art Dossier*, Florence, 1989, reprinted 1999, pp. 32–33, ill

Welsh, Robert, "Gauguin et l'auberge de Marie Henry au Pouldu," *Revue de l'Art*, vol. 86, 1989, p. 40

Daix, Pierre, *Paul Gauguin*, Paris, 1989, p. 182

Stuckey, Charles "L'enigma des pieds coupes;" Jirat-Wasiuntyński, V., and Newton, Travers, "Tradition et innovation dans la technique picturale de Paul Gauguin;" Cahn, Isabelle, "Les Gauguin dans Gauguin; peintures et ceramiques dans le tableau;" in *Actes du colloque Gauguin, Musée d'Orsay, Paris, 1989*, Paris, 1991, pp.56, 76, 175 (illus.), and 183

Motoe, K., et. al, for Asahi Graphic, *Paul Gauguin*, Tokyo, 1990, colorplate 19

Stevenson, Lesley, *Gauguin*, Greenwich, CT and London, 1990, pp. 98–9 (illus.)

Vance, Peggy, *Gauguin: The Masterworks*, London, 1991, p. 92, color plate page 93

Walter, Ingo F., *Paul Gauguin, 1848–1903: The Primitive Sophisticate*, Cologne, 1993, p.33

Kapos, Martha, ed., *The Post-Impressionists: A Retrospective*, New York, 1993, p. 135, pl. 38

Thomson, Belinda, ed., *Gauguin by himself*, Boston, 1993, pp. 116 and 395, fig. 82

Rubin, James H., *Manet's Silence and the Poetics of Bouquets*, Cambridge, MA., 1994, pp. 212–13, fig. 90

Museum of Modern Art, *Masterpieces from The David and Peggy Rockefeller Collection: Manet to Picasso*, New York, 1994, p. 82

Merlhès, Victor, *De Bretagne en Polynesia, Paul Gauguin, pages inédites*, Tahiti, 1995, p. 34

Delouche, Denise, *Gauguin et la Bretagne*, Paris, 1996, p. 100, fig. II

Losch, Michael, "The Iconography of Sleep and the Life-Cycle: The Influence of Theosophical Literature and the Art of Paul Gauguin on George Lacombe's *Le Lit*," *Nineteenth Century French Studies*, 24, nos. 3 and 4, Spring–Summer, 1996, pp. 451, 457, and 459, fig. 6

Maurer, Naomi, *The Pursuit of Spiritual Wisdom: The Thought and Art of Vincent Van Gogh and Paul Gauguin*, Madison and Teaneck 1998, p. 136, fig. 270

Ronald Pickvance, *Gauguin*, exh. cat., Fondation Giannadda, Martigny, Switzerland, 1998, p. 274

Visiting Masterpiece: Paul Gauguin "Barbaric Tales", (brochure) The Israel Museum, Jerusalem, November 1999, pp.4–5 (ill.)

Jirat-Wasiutyński, V., and Newton, H. Travers, Jr., *Technique and Meaning in the Paintings of Paul Gauguin*, Cambridge, UK, 2000, pp. 157–9, fig. 79

Crepaldi, Gabriele, *Art Book Gauguin*, London and Milan, 1999, p. 138 (colour pl.)

D'Argencourt, Louise and Diederen, Roger, *The Cleveland Museum of Art Catalogue, European Paintings of the 19th Century*, Cleveland, 1999, vol. 1, p. 279.

Kirsh, Andrea and Levenson, R.S., *Seeing Through Paintings*, New Haven and London, 2000, pp. 31, 34–5, figs. 40–42

Dorra, Henri, "Von bretonischen Spassen zum grossen Dilemma der Menschheit," in *Paul Gauguin von der Bretagne nach Tahiti*, Landesmuseum Joanneum, Graz, 2000, pp. 84–85, ill.

Paris, Grand Palais, *Salon d'Automne, Oeuvres de Gauguin*, October 6–November 15, 1906, no. 119(?)

Cologne, *Internationale Kunst-Ausstellung,* May 5–September 30, 1912, no. 166 (as *Nirvana (Tahiti)*)

Paris, Association Paris-Amérique Latine, *Exposition rétrospective, Hommage au genial Artiste Franco-Peruvien, Gauguin,* December 1926, no. 91 (as "*Nirvana (Portrait de Hann)*")

Basel, Kunsthalle, *Paul Gauguin*, July–August 1928, no. 150 (as *Nirvana, Bildnis von M. de Haan*)

Berlin, Galerien Thannhauser, *Paul Gauguin*, October 1928, no. 127 (as *Nirvana: Bildnis von M. de Haan*)

London, The Leicester Galleries, *The Durrio Collection of Works by Gauguin*, May–June 1931, no. 67 (as *Portrait de Meyer de Haan – gouache*)

Paris, Gazette des Beaux-Arts, *La Vie Ardente de Paul Gauguin*, December 1936, no. 89

New York, Wildenstein & Co., *Paul Gauguin*, April 3–May 4, 1946, no. 43

Houston, Texas, The Museum of Fine Arts, *Paul Gauguin: His Place in the Meeting of East and West*, March 27–April 25, 1954, no. 17

Cambridge, Mass., Fogg Museum of Art, Harvard University, *From Sisley to Signac*, May 2–31, 1955, no. 9

Chicago, The Art Institute of Chicago *Gauguin – Paintings, Drawings, Prints, Sculpture*, February 12–March 29, 1959, no. 25; and New York, The Metropolitan Museum of Art, April 21 – May 31, 1959, no. 29.

New York, Wildenstein & Co., *Modern French Painting: 19th and 20th Century Masters*, April 10–25, 1962; and Waltham, Mass., Poses Institute of Fine Arts, Brandeis University, May 10–June 13, 1962, no. 21

Los Angeles, University of California, *Years of Ferment: Birth of Twentieth Century Art*, January 24–March 7, 1965, no. 4

London, The Tate Gallery, *Gauguin and the Pont-Aven Group*, January 7–February 13, 1966, no. 55

Cincinnati, Cincinnati Art Museum, *The Early Work of Paul Gauguin: Genesis of an Artist*, March 18–April 26, 1971, no. 20

Toronto, Art Gallery of Ontario, *Vincent Van Gogh and the Birth of Cloisonism*, January 23–June 14, 1981; and Rijksmuseum Vincent van Gogh, Amsterdam, April 9–June 14, 1981, no. 68

Essen, Museum Folkwang, *Paul Gauguin. Das verlorene Paradies*, June 17–October 18, 1998, no.6

Page numbers in italics indicate artwork, photographs, and diagrams. Those in bold italics indicate Exhibit pieces.

The organizers are grateful to all those museums, galleries, and private individuals who have supplied photographs of works in their collections. Others who have kindly helped to provide photography are listed below

Agence photographique de la Réunion des musées nationaux, Paris, Figs. 49, 66, 67, 76, 84, 156, 177, 192, 193

Artists Rights Society (ARS), New York © 2000 Estate of Pablo Picasso, Figs. 171, 172, 195; Munch Museum / Munch-Ellingsen Group Fig. 180

Association des amis de la Maison Marie Henry, Le Pouldu, Fig. 124

Berry-Hill Galleries, Inc., New York, Fig. 164

Bibliothèque Nationale de France, Figs. 110, 111, 119, 120, 134,

Kunsthandel Ivo Bouwman, The Hague, Fig. 140

Centre des Monuments Nationaux, photo Patrick Cadet, Fig. 131

Christie's, New York, Fig. 62

Studio Monique Bernaz, Geneva, Fig. 40

Fondation Pierre Gianadda, Martigny, Figs. 26, 135, 158

Victor Merlhès (documentation and photography), Figs. 112, 113, 114, 115a, 116, 117, 118, 119, 120, 121, 122, 123, 127, 132, 138, 139, 141, 142, 143

Hirschl & Adler Galleries, Inc., New York, Fig. 111

Galerie Hopkins, Thomas, Custot, Paris, Fig. 42

Jewish Historical Museum, Amsterdam, Fig. 56

Knoedler and Company, New York, Fig. 145

Galerie Daniel Malingue, Paris, Fig. 87

Sean McEntee photography, Fig. 1

Sotheby's, London, Fig. 65

Sotheby's, New York, Figs. 12, 159, 163

Irene and Howard Stein, Atlanta, Fig. 153

Malcolm Varnon, Inc., © 2000, Fig. 148

Wildenstein Archives, New York, Fig. 16

© Robert Welsh and Bogomila Welsh-Ovcharov Figs. 89, 90, 93, 95, 96, 97

Bruce M. White photography, Fig. 9

Photo Ole Wolbye, Copenhagen, Figs. 9, 184, 186